3000 800067 46860

W9-DJN-184

St. Louis Community College

Florissant Valley Library
St. Louis Community College
3400 Pershall Road
Ferguson, MO 63135-1408
314-513-4514

The Black Hole of the Camera

The publisher gratefully acknowledges the generous contribution to this book provided by a Hamel Family Grant through the Department of Communication Arts at the University of Wisconsin-Madison.

The Black Hole
of the Camera

The Films of Andy Warhol

J.J. Murphy

UNIVERSITY OF CALIFORNIA PRESS

Berkeley · Los Angeles · London

University of California Press, one of the most distinguished
university presses in the United States, enriches lives around
the world by advancing scholarship in the humanities, social
sciences, and natural sciences. Its activities are supported
by the UC Press Foundation and by philanthropic
contributions from individuals and institutions. For
more information, visit www.ucpress.edu.

University of California Press
Berkeley and Los Angeles, California

University of California Press, Ltd.
London, England

© 2012 by The Regents of the University of California

Library of Congress Cataloging-in-Publication Data

Murphy, J. J., 1947–
 The black hole of the camera : the films of Andy Warhol /
J. J. Murphy.
 p. cm.
 Includes bibliographical references and index.
 ISBN 978-0-520-27187-6 (cloth : alk. paper)
 ISBN 978-0-520-27188-3 (pbk. : alk. paper)
 1. Warhol, Andy, 1928–1987—Criticism and
interpretation. I. Title.
 PN1998.3.W366M68 2012
 709.2—dc23 2011032948

Manufactured in the United States of America
21 20 19 18 17 16 15 14 13 12
10 9 8 7 6 5 4 3 2 1

In keeping with a commitment to support environmentally
responsible and sustainable printing practices, UC Press
has printed this book on Rolland Enviro100, a 100%
post-consumer fiber paper that is FSC certified, deinked,
processed chlorine-free, and manufactured with renewable
biogas energy. It is acid-free and EcoLogo certified.

For Nancy Mladenoff

Contents

Illustrations

PLATES

(following p. 144)

TABLE

Acknowledgments

I first encountered the films of Andy Warhol while an undergraduate in college. As an avid reader of Jonas Mekas's passionate weekly columns in the *Village Voice,* I was open to all forms of cinema. Yet the Warhol films I saw seemed unlike anything else I was viewing at the time. They influenced me enormously, and, in retrospect, were clearly determining factors in my wanting to become a filmmaker. My biggest regret is not seeing Warhol's twenty-five-hour opus **** *(Four Stars)*. At the time, I didn't realize that it would only be screened once. When I saw it during its theatrical run, I was completely disappointed that it had been reduced to only two hours. After seeing *The Chelsea Girls,* I had a discussion with the projectionist about the film. He acted surprised that I hadn't met Andy and invited me to come along to the Factory. In view of Mary Woronov's example, I have no regrets about not taking him up on his offer. When she visited the Factory on a class field trip from Cornell, Gerard Malanga convinced her to sit for a *Screen Test*. In *Eyewitness to Warhol,* she writes about her classmates, who were heading back to Cornell without her: "They looked like foreigners now, as the steel doors of the elevator shut on their faces and I forgot I ever knew them."

I would later see Gerard Malanga at poetry readings at St. Mark's, would meet Buddy Wirtschafter on several occasions, and would hear Taylor Mead read poems at a Village bar. By then Warhol's films had been withdrawn from circulation and were no longer available for view-

ing, except for those that were shown as part of Essential Cinema at Anthology Film Archives. I made sure I saw every one of those screened at Anthology. I also attended a public screening when Ondine showed *Vinyl* to a crowd of mostly punks in the late 70s. When I eventually started teaching film in college, and the films began to be reissued, I often showed Warhol films to my students as part of my class on avant-garde cinema. I was surprised at how positively so many of them responded. Some of my graduate students put on a series of Warhol films at our cinematheque and organized a colloquium on his work. I was later asked about the possibility of co-curating a Warhol show at a museum. In anticipation, I began writing about the films. Nothing ever came of the museum show, but, without knowing it, I had inadvertently started this project. I had been aware that Callie Angell, whom I knew from the film scene in New York City in the 1970s, had been laboring on a catalogue raisonné for many years. Because she was privy to the archival materials, I was content to wait for her book to be released. Her invaluable catalogue raisonné on the *Screen Tests* was eventually published in 2006. Her untimely passing in the spring of 2010 represented an immeasurable loss. I think it's fair to say that without her tireless efforts, my own book could not have been written.

I wish to thank my students, whose enthusiasm has shaped this project. I would especially like to express my appreciation for receiving two UW-Madison Graduate Summer Research Grants, which allowed me to start and finish this book, as well as an additional grant to assist with the late stages of this project. Thanks to Susan Cook for being such an understanding and supportive graduate school dean. George and Pamela Hamel are very special people. Two Hamel Family Faculty Research Grants through the Department of Communication Arts at UW-Madison allowed me to rent many of the Warhol films and to do research at The Andy Warhol Museum in Pittsburgh. A final grant from them allowed me to include color stills in the book. Thanks to the Hamels and to my department chair, Susan Zaeske, for assisting me on this project when I really needed it. My department administrator, Linda Lucey, went beyond the call of duty to accommodate my sometimes unreasonable requests.

I'm grateful to Geralyn Huxley and Greg Pierce for their generous assistance on the two occasions that I did research at The Andy Warhol Museum in Pittsburgh. I have fond memories of those visits and the chance to talk about the films with two people equally obsessed with Warhol films. Greg not only showed great hospitality during my visits,

but he also went the extra mile to get me the stills I needed, and generously shared his own knowledge on Warhol. Thanks to Greg Burchard of The Warhol Museum for providing leads on locating photos. Thanks also to Claire K. Henry, the Curatorial Assistant of the Andy Warhol Project, for providing additional information on dates and running times of the films, and to Kitty Cleary of the Circulating Film and Video Library at MoMA. I extend appreciation to several people who attended a Warhol Symposium at the Wexner Center for the Arts during fall of 2008. It was certainly worth traveling to Columbus to attend it, especially because it afforded me an opportunity to hear Mary Woronov speak about the films and to chat with her briefly. The title of this book derives from her. Thanks to Gerard Malanga for taking the time to respond to my query about *The Velvet Underground*. I feel extremely lucky to have such a great image on the cover. I owe that to photographer Santi Visalli.

Thanks to the staff at UC Press, including Eric Schmidt, Kim Hogeland, Emily Park, and Mari Coates. I would like to single out my editor, Mary Francis, for her dogged interest in this project from the very start, as well as for her astute suggestions and comments on the manuscript. I received incisive and invaluable feedback from my copy editor, Sue Carter, and from various readers, including Scott MacDonald and David Bordwell. David has been a close friend and colleague for nearly forty years, and I've learned more from him than anybody. My graduate student, John Powers, was the first person to read the manuscript, and I thank him for his insightful feedback. He has made an enormous contribution to the final version, as has Stew Fyfe. I am blessed with having very wonderful colleagues: Jeff Smith, Kelley Conway, Vance Kepley, Lea Jacobs, Sabine Gruffat, Ben Singer, Michele Hilmes, Jonathan Gray, Mary Beltrán, and Bill Brown. Thanks to Richard Neupert and Kristin Thompson for their measured advice. Kathryn Millard and Madeleine Gekiere have, each in their own way, provided inspiration throughout the process.

A number of former graduate advisees have written about Warhol and avant-garde cinema over the years, including Jim Peterson, Jim Kreul, Jonathan Walley, and Eric Crosby, who's now at the Walker Art Center. Jared Lewis and Mike King generously projected the Warhol films for me. Not all projectionists get excited at the prospect of screening *Empire* and *Sleep*, or all the *Screen Tests*. Thanks to other members of our staff, in particular Boyd Hillestad, Joel Ninmann, Peter Sengstock, Andy Schlactenhaufen, Justin Daering, and Cassie Wentlandt. Erik Gunneson has helped me immeasurably over the course of twenty years, including on this project. Meg Hamel, Jim Healy, and Jane Simon

deserve special mention as well. Thanks also to David James and Reva Wolf, as well as the many other Warhol scholars, who have made this book possible. Thanks also to Intellect for permission to reproduce parts of the introduction that appeared previously in the first issue of the *Journal of Screenwriting*.

I'm sure my partner Nancy Mladenoff is a bit tired of Warhol at this point, but luckily she spends enough hours in her studio and on field-work that she understands my total obsession with this project. This book is dedicated to her. When people would hear that I was writing a book on Andy Warhol's films, I always found it amazing that so many would have such strong opinions about Warhol and his films, even without having seen any of them. I hope this book sparks people to view Warhol's films, and hopefully see them in a new light. I have to confess that writing it has been one of the most pleasurable experiences in my life.

Introduction

Try Not to Blink

The film begins with a close-up of Ann Buchanan, framed from the neck up. As we view the image, the lighting is distinctly flat. Her left cheek is a bit hotter than the one on the right, which makes her left eye more prominent. We see two points of light reflected in her left eye, while a single point appears in her right one. Her hair is unkempt; her facial expression is remarkably neutral. Buchanan stares directly at us, almost as if transfixed by the camera. Her eyelids quiver ever so slightly at one point, but she doesn't blink. Her throat and cheek also move imperceptibly, but Buchanan never loses her concentration. A pinpoint of light appears on the inside part of her right eye, which later flutters again. A minute and a half into the film, what appears to be a tear forms at the bottom of Buchanan's right eye. A half-minute afterward, a tear falls from it, followed by another one ten seconds later. Her throat moves, and a third tear rolls down the right side of her cheek. Meanwhile Buchanan's left eye fills with tears as well, as another from her right eye rolls down her face. Nearly three minutes into the film, a new tear drips from her chin, followed by a tear from her left eye, which continues for the rest of the film. This is Andy Warhol's four-minute silent *Screen Test: Ann Buchanan* (1964), which appears as part of his *The Thirteen Most Beautiful Women* (1964–65) and *Four of Andy Warhol's Most Beautiful Women* (1964–69).

The fact that Ann Buchanan cries during her *Screen Test* is unnerving. The shock of this is compounded by the utter discrepancy between

her deadpan expression and the tears that fall from her eyes. How in the world has she managed to cry? Do her tears stem from the tension of trying not to blink, or do they derive from her being able to employ the technique of emotional recall? Buchanan was not a Method actor, however, so her *Screen Test* confounds our expectations. Warhol expert Callie Angell indicates that this was his favorite *Screen Test,* and it is easy to see why.[1] Buchanan's rigid stare and wide eyes are very doll-like in appearance, so that her spontaneous gesture of crying while being filmed reminds us of one of those crying dolls, inanimate yet capable of an uncanny display of emotion.

Critic Amy Taubin describes the process of Warhol's *Screen Tests:* "Like all newcomers to the factory, I was screen-tested: I was escorted into a makeshift cubicle and positioned on a stool; Warhol looked through the lens, adjusted the framing, instructed me to sit still and try not to blink, turned on the camera and walked away."[2] Originally inspired by mug shots of criminals, Warhol's *Screen Tests* proved challenging to the assorted people who sat for them.[3] They were forced to sit rigidly before the camera for a 100-foot roll of film for nearly three minutes, an activity that seems easier in theory than practice. Ronald Tavel, who collaborated with Warhol on a number of films, remarks that nonprofessional actors can't relax in front of a movie camera: "But if you know what to choose in film, their goodness or envy, it was just them under that pressure. It was their *worst* qualities often, having to behave under tension."[4] Or as Mary Woronov, who appeared in numerous Warhol films, aptly put it in *Eyewitness to Warhol:* "Next to the muzzle of a gun, the black hole lens of the camera is one of the coldest things in the world."[5] Warhol clearly understood this, and over the five-year period that he actively made films, this principle became a central tenet of his filmmaking practice.

The silent *Screen Tests,* which Warhol made between 1964 and 1966, documented a variety of personalities, including many different types of artists from the downtown scene, but also "models, speed freaks, opera queens, street people, performers, a smattering of celebrities and the wealthy as well as all grades of Factory personnel, from anonymous freshmen to superstars and other seniors."[6] The *Screen Tests* were more a form of portraiture than a typical Hollywood screen test, in which subjects were auditioning for a role in a larger production. Yet they were a form of competition. Woronov remarks: "Like medieval inquisitors, we proclaimed them tests of the soul and we rated everybody. A lot of people failed. We could all see they didn't have any soul. But what appealed most of all to us, the Factory devotees, a group I quickly

FIGURE 1. *Screen Test: Ann Buchanan*, 1964 (16mm film, b/w, silent, 4 minutes @ 16 fps. Film still courtesy of The Andy Warhol Museum)

became a part of, was the game, the cruelty of trapping the ego in a little fifteen minute cage for scrutiny."[7] If the *Screen Tests* became a competitive arena, this was even truer of the other films, largely because more was at stake, with new superstars regularly replacing old superstars and everyone vying for Andy's attention in her or his quest for stardom.

During the period in which the famous Pop artist turned his creative attention to film, Warhol engaged several major collaborators, such as the playwright Ronald Tavel, Edie Sedgwick's friend and confidant Chuck Wein, and Paul Morrissey, who possessed organizational skills that most others around him lacked. Gerard Malanga and Billy Name (Linich) assisted Warhol in the daily operations of the silver-painted art studio known as the Factory. Besides attracting the already famous, it became a magnet for a number of individuals who wanted to become part of the celebrity culture that Warhol had come to embody: Mario Montez, Ondine, Edie Sedgwick, Ivy Nicholson, Mary Woronov, Ingrid Superstar, Viva, and other colorful personalities. The Factory became a social scene that thrived on gossip, shifting favoritism, mind games, sexual intrigue, and power plays, all of which Warhol used as raw material for his unorthodox approach to the medium. The resulting films challenged industrial conventions of cinema in the same radical manner that Pop art altered what most people considered to be painting and sculpture.

Imagine what a professional crew might have thought on the set of Warhol's *Kitchen* (1965). They would certainly be baffled by actors who haven't fully memorized their lines (the script being hidden in various places on the set), the scenario writer whispering lines of dialogue from offscreen, production stills being recorded during the shooting of the film, the set designer appearing on camera as part of the production, the dialogue being drowned out by an electric blender, long periods of

inactivity, two pairs of characters with the same names, and so forth. Warhol had no interest in authorial control, but wanted to shift the burden from the director to the performers and crew members. He showed little concern for plot (which he considered old-fashioned) or technical matters. Warhol was intent on walking the fine line between contrived performance and more authentic behavior by non-actors, which is why he wanted to keep the camera running constantly; he didn't want to miss anything. Even when he worked with an actual script, as with Ronald Tavel, Warhol subverted what was written down. He was fascinated by notions of indeterminacy and unpredictability, which explains why he preferred improvisation. Warhol, however, recognized that films often depended on some type of dramatic conflict to make them interesting. Mark McElhatten describes his method in poetic terms: "He understood valence and entropy within the group chemistry of certain individuals when set within camera range, and the chemicals needed to make them shimmer and flare."[8] Warhol's own brand of psychodrama often became his "chemicals," or secret recipe for making something happen in a film.

More than any other fine artist of his time, Warhol chose to engage with media in a whole-hearted way. He didn't just dabble in film; he was consumed by making films, as is evident by his prodigious output in such a short period. Warhol is often described as reinventing the history of cinema by giving it a different inflection, as he moved in phases from his silent recordings to synchronous sound and the use of a scenario, to creating an independent film studio with his own brand of superstars, to using color, to delving into expanded cinema, to making sexploitation films. After he was shot and critically wounded by Valerie Solanas, Warhol assumed the role of producer by lending his brand name to subsequent films. Yet Warhol's shifts do not represent a logical progression, but were often occurring simultaneously.

Even in the early films, transformation and narrative were crucial elements to Warhol's cinema. He intuitively grasped that the camera and the passage of time had the inherent potential to transform the event. *Henry Geldzahler* (1964), for instance, appears to be staged as a psychoanalytic encounter, with the subject of the film even sitting on a couch. David James recognizes this aspect of Warhol's early films in *Allegories of Cinema*: "The situation is that of psychoanalysis; the camera is the silent analyst who has abandoned the subject to the necessity of his fantastic self-projection."[9] In an interview, Henry Geldzahler responds to viewing his *Screen Test:*

But seeing the film, I suddenly realized that Andy's nature really is a great portraitist, and that if you sit somebody in front of a camera for an hour and a half and don't tell them what to do, they're going to do everything, their whole vocabulary. I went through my entire history of gestures. I could see from viewing the film later on that it gave me away completely—the extent to which I am infantile, the extent to which I am megalomaniacal—all the things one tries to hide come through on the film.[10]

Besides relying on temporal duration to create transformation, Warhol employed other strategies such as manipulating performers through deliberate last-minute changes. Tavel told David James: "So another technique was to have people come in with the greatest security about what they were going to do, and then tell them, No. But at least they're still working off a basis of some idea. And when they're made to switch, you get a lot of fascinating things going on."[11] Another tactic involved casting performers who either were high on drugs or alcohol before filming started or became high during filming. Some examples include Marie Menken getting drunk in *The Life of Juanita Castro* (1965), cast members using amyl nitrate in *Horse* and *Vinyl* (both 1965), Edie getting stoned in *Poor Little Rich Girl* and *Face* (both 1965), Edie and Gino Piserchio drinking martinis in *Beauty # 2* (1965), Eric Emerson tripping on LSD and Ondine and Brigid Berlin shooting amphetamine in *The Chelsea Girls* (1966), Patrick Tilden-Close being high in *Imitation of Christ* (1967–69), and the cowboys drinking beer and smoking marijuana in *Lonesome Cowboys* (1967–68).

Another strategy was to deliberately cast insecure or unstable individuals as actors. In *Face,* a synch-sound film shot entirely in close-up, like a *Screen Test,* Chuck plays a "mind game" on Edie while she's high, thereby undercutting her sense of reality. The close-up allows the viewer to register her stunned and confused reaction. Béla Balázs, the Hungarian film theorist, observes:

The camera can get so close to the face that it can show "microphysiognomic" details even of this detail of the body and then we find that there are certain regions of the face which are scarcely or not at all under voluntary control and the expression of which is neither deliberate nor conscious and may often betray emotions that contradict the general expression appearing on the rest of the face.[12]

For nearly three minutes, we scrutinize Edie's face as the camera records her. In this sense, *Face* comes closest to achieving the kind of involuntary revelations that Warhol accomplished in films such as *Screen Test: Ann Buchanan, Henry Geldzahler,* and *Screen Test # 1* (1965).

Erving Goffman provides a useful framework for understanding what occurs here, especially with respect to the situation's impact on Edie's sense of self, or identity. In *The Presentation of Self in Everyday Life,* Goffman proposes that all human beings play roles in various social interactions; Goffman uses a dramaturgical approach to explain what transpires during them. Goffman's concept of the self is not something essential (as Balázs seems to believe), but rather an image that a person projects.[13] He writes: "A correctly staged and performed scene leads the audience to impute a self to a performed character, but this imputation—this self—is a *product* of a scene that comes off, and is not a *cause* of it."[14] Goffman suggests that when appearing in a social situation a person "knowingly and unwittingly projects a definition of the situation, of which a conception of himself is an important part."[15] When something incompatible happens, such as disruption of dialogue, it has important ramifications:

> First, the social interaction, treated here as a dialogue between two teams, may come to an embarrassed and confused halt; the situation may cease to be defined, previous positions may become no longer tenable, and participants may find themselves without a charted course of action. The participants typically sense a false note in the situation and come to feel awkward, flustered, and, literally, out of countenance.[16]

Edie, who is in a vulnerable position because she's high from smoking marijuana, becomes so confused and flustered after Wein's statement that she doesn't know how to react; their interaction is based on a shared assumption or worldview, which, for the sake of the film, Wein has undermined for dramatic effect.

Once Warhol began working with Ronald Tavel to make scripted, synch-sound films, the employment of psychodrama became a standard technique for creating potentially combustible dramatic situations. Tavel's approach was to think of the scripts he wrote as scenarios. He explains: "They provide a field in which whatever happens will develop its own meaning rather than have the author's imposed meaning. The quality of my work can be judged by how well it provided for things to happen; I didn't impose my personal vision. This way of working was part of what Andy was doing."[17] Working this way, Tavel says, is not haphazard or unplanned: "If you want to capture spontaneity, improvisation, the accident, and so forth, you must set up an environment in which the spontaneous, the accidental, the improvisational, the unexpected, will take place. That takes planning. If you just turn the camera on people

without saying anything else, they just tighten up."[18] That preparation included having Tavel interview the performers beforehand in order to determine their hang-ups or weaknesses so that these could be exploited in the writing and filming. He indicates that this was and continued to be Warhol's standard practice at the Factory.[19]

Narrative is often viewed as problematic within avant-garde media history. Jackie Hatfield has argued: "Rather than this history being weighted towards anti-narrative, the reality has been that, from the Futurists and the Surrealists, through Fluxus, and to date, artists have played around with narrative rather than being predominantly against it."[20] Warhol had a porous and variable notion of narrative. He was not at all interested in classical narrative, with its emphasis on plot, causality, and dramatic or character arcs, which he associated with commercial Hollywood cinema. He was, however, interested in dramatic conflict, but often on a much smaller scale, almost as if he was curious to see how his performers would respond in certain situations while being filmed. For Warhol, drama involves quarrelling, jibes, rivalry, one-upmanship, sexual tension, power shifts, unexpected outbursts of emotion, altered states of mind, and especially unpredictable behavior. He is most intrigued by dramatic incident and spectacle.

Warhol conceived of narrative as a series of situations in which his nonprofessional performers would engage in improvised role playing as opposed to following a carefully constructed plot. His films were high-wire acts in the sense that his strategy involved putting certain elements into play and merely recording what happened. Yet Warhol was always looking for the spark that would ignite conflict. The film *Afternoon* (1965) shows his method. Warhol puts Edie together with her rich Cambridge friends—Donald Lyons, Arthur Loeb, and Dorothy Dean—as well as the working-class Ondine. The fascination of the film lies in hearing the unseen Warhol attempt to goad his performers into conflict by having Ondine interact with Edie and her wealthy pals, who, for all practical purposes, inhabit a different universe. The class conflict fails to produce the intended results, but the "behind-the-scene" machinations are apparent in Warhol's recorded commentary.

Many of Warhol's films contain scenes that develop into psycho-drama. The most famous example is Ondine's explosive outburst in *The Chelsea Girls,* where he physically assaults Ronna Page and throws an extended tantrum. Another instance from the same film is Eric Emerson's narcissistic, LSD-fueled monologue. There are countless other examples, including Tavel inciting the cowboys to violent and sadistic behavior in

Horse, the fight that erupts in *Lonesome Cowboys,* Chuck Wein's off-screen taunting of Edie in *Poor Little Rich Girl* and *Beauty # 2,* and the scary bedroom encounter between the strung-out Patrick Tilden-Close and the mentally unstable Andrea Feldman in *Imitation of Christ.* Another example is Warhol's casting of Valerie Solanas in *I, a Man* (1967–68) in a scene where Tom Baker attempts to convince an unwilling Solanas to let him into her apartment, a scene that was restaged in Mary Harron's biopic, *I Shot Andy Warhol* (1996), with Lili Taylor playing the part of Solanas.

Warhol's version of the scene has much greater dramatic impact than the restaging, partly because Solanas, who advocated the violent overthrow of patriarchy, hated men. The dramatic tension comes from placing Solanas in a situation where Baker's intended goal is to seduce her. As Baker becomes more aggressive, Solanas becomes more uncomfortable, a dynamic that pushes the scene to the point where it slips over the line from something staged into a form of psychodrama. This is exactly the quality that is lacking in Harron's scenes, even though Solanas is played by an extremely gifted performer.

"Psychodrama" is a term that refers to a form of psychotherapy developed by Jacob L. Moreno, who emigrated from Vienna to the United States in 1925 and created the first theater of psychodrama in Beacon, New York, in 1936.[21] During World War II, Moreno created the New York Theater of Psychodrama, which he renamed the Moreno Institute in 1951. Moreno's psychodrama became influential during the 1960s, when his therapy sessions attracted the attention of actors and directors associated with professional theater and were even broadcast on television.

Psychodrama involves the patient's spontaneous improvisation of a particular critical life situation within a clinical theatrical setting. Moreno's definition of psychodrama was rather broad and seemed to shift over time. The esteemed theater critic Eric Bentley, who became interested in the relationship between professional theater and psychodrama during the 1960s, describes a typical session:

> Perhaps a hundred people are placed on three sides of a platform. The platform itself has steps on all sides, is in this sense an "open stage." A patient, here called a protagonist, presents himself for a psychodramatic performance. A director-psychiatrist talks with him briefly, to find out what he sees as his problem, and what scenes from his life might be enacted. A scene being chosen, the roles of others taking part in it are played either by trained assistants or by anyone else present who might volunteer.[22]

Bentley emphasizes that success in psychodrama depends on the degree of spontaneity and self-illumination achieved by the patient in the process of active role playing. The protagonist often undergoes an intense emotional experience that leads to deep personal insight, which builds to some type of dramatic climax. The director, according to Bentley, "now ends the playacting and asks the audience to share common experience with the protagonist."[23]

In the ensuing discussion of Warhol's films, I use the word "psychodrama" in a different sense from Moreno, to refer to those peak moments of dramatic interaction where the artifice of the performance or situation suddenly breaks down, and the performer as well as the audience experiences a heightened sense of reality. The films of John Cassavetes contain many such moments. In his first feature film, *Shadows* (1957–59), the lovemaking scene between Lelia and Tony serves as an example. The scene is scripted, but it involves what Ray Carney has referred to as a number of radical tonal shifts.[24] The audience has the expectation that their tryst will develop into a romantic plotline, but Lelia recoils from the lovemaking. We learn, among other things, that this is her first sexual encounter, and to our surprise she tells him, "I didn't know it could be so awful."

Rather than feeling a sense of elation, Lelia has become unmoored, which causes her to vacillate in her reactions to Tony. What has been occurring in this scene is a kind of emotional flip-flop that reflects the inner turmoil Lelia experiences following her impulsive decision to have sex with a person she hardly knows. After Tony attempts to placate Lelia by telling her he loves her, Lelia appears to have a psychic breakdown. The scene has shifted from being scripted to something that seems real rather than acted. Carney also suggests that the scene mirrors the dynamic of Lelia and Tony's relationship in real life. He writes: "Cassavetes once again drew on his actors' real feelings and personalities to lend authority to their line deliveries: Tony and Lelia had actually had a difficult romantic relationship that had not worked out well. There was a residue of mixed feelings about their relationship when the scene was shot that undoubtedly added to its authenticity."[25]

There are other instances of psychodramatic situations in American independent films of the 1960s, including Jonas Mekas's production of The Living Theatre's *The Brig* (1964), the films of Norman Mailer, William Greaves's *Symbiopsychotaxiplasm: Take One* (1968), and Milton Moses Ginsberg's *Coming Apart* (1969). What Warhol was doing was "in the air" at the time, but *how* he did it remains completely origi-

nal, and the results on screen remain deeply intriguing and disturbing today.

Although Andy Warhol is widely regarded as one of the most important American avant-garde filmmakers of the 1960s, not to mention the only one to have a significant commercial breakthrough, with *The Chelsea Girls*, he nevertheless occupies a curious position within the history of cinema. In many ways, the initial positioning of Warhol's films set the tone for how they are perceived even today. In *Visionary Film*, P. Adams Sitney focuses on the minimal aspects of only a few of Warhol's early films, notably *Sleep* (1963), *Eat* (1964), and *Empire* (1964), as precursors to the American strain of structural film. Sitney suggests that whereas filmmakers such as Stan Brakhage and Peter Kubelka controlled each single frame of their works—an extreme version of authorial control derived from the Romantic tradition—"Warhol made the profligacy of footage the central fact of all his early films, and he advertised his indifference to direction, photography, and lighting."[26] Sitney's arguments about Warhol are both subtle and nuanced, but he nevertheless considers "duration" to be a defining characteristic of the early minimal films. Sitney asserts that Warhol was the first filmmaker to exhaust or alter a viewer's perceptual capacities by overwhelming her or him with emptiness or sameness.[27]

These ideas have been repeated in A.L. Rees's *A History of Experimental Film and Video*. Rees writes:

> But the main mentor of structural film was Andy Warhol, whose brief filmmaking career also dated from 1963, and whose urban, disengaged and impersonal art challenged Brakhage's Romanticism. Warhol's tactics—static camera, long-take, no editing—opposed current avant-garde styles and avoided personal signature (literalised by Brakhage's hand-scratched name on his films of this period).[28]

Rees subsequently reinforces the connection to structural film: "At the same time, Warhol's objective camera-eye inspired a turn towards the material aspect of film. With loop-printing, repetition and blank footage—devices unique to the film medium—Warhol made works of extreme duration."[29]

Such critical readings, however, ignore the sheer power and impact of films like *Screen Test: Ann Buchanan*. They have also caused avant-garde film circles to pay less attention to Warhol's later efforts, namely his move from silent to sound cinema and his subsequent excursion

into narrative and expanded cinema. Compounding this situation has been the fact that nearly all of Warhol's films were out of circulation for many years, thus preventing scholars and the public from seeing most of his cinematic output.[30] Largely through the efforts of the Andy Warhol Foundation for the Visual Arts, the Museum of Modern Art, and the Whitney Museum of American Art, Warhol's films continue to be restored and have been resurfacing gradually over the years, allowing for a new look at this neglected work. Indeed, a review of Warhol's narrative sound films proves his project to be much broader in scope than recognized previously. The emphasis on a fixed camera and duration as being exemplary of Warhol's style simply does not do justice to the variety of techniques and strategies that Warhol employed extensively in his later sound films, especially his use of a mobile camera. Even Warhol's numerous *Screen Tests* (which number 472) exhibit a great deal more camera variation than has been acknowledged. The early films turn out to be much more complicated as well, and would seem to be more productively discussed in terms of transformation and narrative rather than duration and minimalism.

The positioning of Warhol's early so-called minimal films as a distinct and separate category has mainly to do with how his work has been periodized by scholars and critics, who have tended to see a decisive break between the silent and sound films. There is no question that the minimal films (other than the silent *Screen Tests*) have assumed privileged importance, even though they represent only a small fraction of Warhol's total film output. Such a schematization ignores important aspects of the films themselves, as well as anomalous early films like *Elvis at Ferus* (1963), *Tarzan and Jane Regained, Sort Of . . .* (1963), *Taylor Mead's Ass, Couch,* and *Soap Opera* (all 1964). The overemphasis on duration and minimalism also distorts important early influences on Warhol's filmmaking, namely the films of Jack Smith, Ron Rice, and Kenneth Anger.

The tendency of many critics and historians of avant-garde cinema has been to focus on the minimal films as foils to the Romantic expressionism of Brakhage and as precursors to structural film, while ignoring Warhol's subsequent move into narrative and sound as an aberration. It is clear that the early films need to be integrated more fully into a discussion of the later work. Warhol's films demonstrate an ongoing experimentation with the medium, especially with the boundaries of narrative. David James recognizes the difficulty of attempting to find coherence in Warhol's filmmaking practice. He writes: "Warhol's career

as a filmmaker contains so many abrupt lurches into new directions and shifts to different scales of production that description of it in terms of a single expressive urgency is as difficult as organizing it in standard generic categories. Its only continuity appears to be that of discontinuity, its only coherence that of fracture."[31]

Yet, besides the body of silent *Screen Tests* (which are not part of this study), Warhol's films fall into a number of distinct stages: the early films made in 1963–64, films made from scenarios by Ronald Tavel, those made with Chuck Wein, sound portraits, expanded cinema, the sexploitation films, and the Warhol-produced films by Paul Morrissey.[32] These categories are by no means mutually exclusive. *My Hustler* (1965), for example, was made with Chuck Wein, but later became the first of the commercial sexploitation films. Surprisingly, it doesn't feature Edie. Warhol's double-screen sound portrait of Edie, *Outer and Inner Space* (1965), is best understood as a precursor to Warhol's expanded cinema phase. Two of Ronald Tavel's scenarios, *Hanoi Hannah* and *Their Town*, turn up as part of *The Chelsea Girls*.

The collaborative nature of Warhol's working methods makes authorship a central issue, so that it becomes important to discuss the differences between the various films Warhol made with collaborators such as Ronald Tavel, Chuck Wein, and Paul Morrissey (who claims a number of Warhol films as his own). And, even though Warhol has been viewed as a colorist in painting and printmaking, little attention has been paid to the color design of such Warhol films as *Lupe* (1965), *The Chelsea Girls*, *Bike Boy* (1967–68), and *Blue Movie* (1968). Performance in Warhol films turns out to be another area of confusion, especially in relation to his most famous female superstar, Edie Sedgwick. The repeated notion that Edie simply plays herself fails to account for the wide variations in performance we see in *Kitchen, Poor Little Rich Girl, Face, Beauty # 2, Restaurant, Afternoon, Space, Outer and Inner Space,* and *Lupe* (all 1965).

Another significant matter concerns the relationship that Warhol films bear to reality and to cinematic codes of realism. Warhol films exhibit a love/hate relationship with Hollywood, but a number of them engage various Hollywood genres, such as the melodrama and the Western, beyond simple parody. Warhol films also display a concern for deconstructing Hollywood-derived images of glamour, much like his paintings and silk screens. In addition there is the question of Warhol's relationship to new technologies—video, the tape recorder, and television—which also had a significant yet underestimated impact on his work. His

films also play a seminal role in the development of American independent cinema.

In the following chapters, I discuss virtually all the Warhol films that are currently in circulation, with the exception of a commissioned film entitled *Sunset* (1967). It is essentially a landscape film with a voice track by Nico, but it stands as something of an anomaly in Warhol's body of work. I do include the unreleased *San Diego Surf* (1968), which is not currently in circulation, because it was made as one of the sexploitation films. I analyze not only the early films but also the synch-sound films. In the second chapter, for instance, I look closely at Warhol's collaboration with the playwright Ronald Tavel, who wrote scenarios for some of Warhol's most notable sound films, such as *Screen Test # 1* and *Screen Test # 2*, *The Life of Juanita Castro*, *Horse*, *Vinyl*, and *Kitchen*. In these films, Warhol pushes his ideas about transformation and narrative to new levels of complexity through the use of psychodrama. After filming a number of Tavel's scenarios, Warhol more or less abandoned the concept of using written scripts. He developed the idea of the "superstar" as a way of shifting the burden from the written page to the performer. This led Warhol to collaborate with Chuck Wein to produce a number of films starring Edie Sedgwick, including *Poor Little Rich Girl*, *Restaurant*, *Face*, *Afternoon*, and *Beauty # 2*. Wein relied on techniques similar to those of Tavel to create dramatic conflict, but the films he made with Warhol are really quite different.

Subsequent to his involvement with The Velvet Underground, Warhol began to experiment with intermedia and multiple-screen projection, or what became known as "expanded cinema," through the Andy Warhol "Up-Tight" events and The Exploding Plastic Inevitable (EPI), which involved combining various art forms (including live music by The Velvet Underground) to provide a more immersive experience for the spectator. Warhol also utilized double-screen projection in such films as *Outer and Inner Space*, *Lupe*, *More Milk Yvette*, and *The Chelsea Girls*, which became the first of his films to play in a commercial theater. During this same period, Warhol became one of the first artists to explore not only the new medium of video in his labyrinthine portrait of Edie, *Outer and Inner Space*, but also the limitations of live performance and the power of television in *Since* (1966), his film on the Kennedy assassination. During this same period, Warhol concurrently made what can be viewed as a series of sound portraits, notably *John and Ivy*, *Paul Swan* (both 1965), *Eating Too Fast*, *The Closet*, *Ari and Mario*, *Mrs. Warhol*, and *Bufferin* (all 1966).

Paul Morrissey's influence gradually led Warhol to produce a series of sexploitation films—*I, a Man; Bike Boy;* and *The Nude Restaurant* (1967)—that played in commercial venues. Two of them, *Lonesome Cowboys* and *Blue Movie,* were banned as obscene. These films often have been dismissed as evidence of Warhol's decline as a filmmaker, especially by Sitney and Koch; I argue that a reappraisal is in order. After Warhol was shot by Valerie Solanas in 1968, Paul Morrissey directed a number of films—*Flesh* (1968–69), *Trash* (1970), *Women in Revolt* (1971), and *Heat* (1972)—which Warhol merely produced. While these are generally considered Warhol films, I analyze how they operate according to entirely different aesthetic strategies and procedures.

In discussing the various stages of Warhol's film oeuvre, I argue that the concepts of transformation and narrative are consistent strategies throughout both the silent and sound phases of his career. Viewing the early silent films as more concerned with transformation and narrative than with minimalism and duration makes Warhol's move into sound less of an aesthetic rupture by emphasizing the continuity rather than discontinuity of his overall cinematic project. I also contend that psychodrama is often used as the means to create dramatic conflict or tension within his films. I find it to be a constant element throughout the various radical shifts that Warhol made in his films. It's already there in the early films, such as *Henry Geldzahler,* but I hope to show that it runs throughout the other stages of Warhol's film career as well, including the much maligned sexploitation films.

The Early Films of Andy Warhol

Obeying the Machine

The standard critical account of Warhol's early films is that they consist of simple actions, such as someone sleeping or eating or getting a haircut, or a blow job, or couples kissing, or an eight-hour recording of the Empire State Building. Warhol's films are described as being about duration, the experience of real time, and not very much is said to happen in them. Jonas Mekas has suggested that they're like the earliest Lumière films: simple fixed-camera recordings of the most banal events. Mekas, one of the staunchest early advocates of Warhol's work, sees his films as causing a perceptual shift in the viewer: "The world becomes transposed, intensified, electrified. We see it sharper than before. Not in dramatic, rearranged contexts and meanings, not in the service of something else (even Cinéma Vérité did not escape the subjection of the objective reality to ideas) but as pure as it is in itself: eating as eating, sleeping as sleeping, haircut as haircut."[1] Mekas views Warhol's early films as creating a heightened new awareness of everyday reality.

In many ways, Sitney's attempt to connect Warhol's films to duration and minimalism and Mekas's effort to situate the films within a tradition of realism have helped to restrict our understanding of Warhol's rather ambitious cinematic project. Mekas's employment of Louis Lumière to explain Warhol's silent films, for instance, is largely responsible for creating the notion that such films as *Sleep, Empire, Eat, Haircut (No. 1)* (1963), *Kiss* (1963–64), and *Blow Job* (1964) are documentary-like recordings. Warhol's decision, however, to change the projection speed

from 24 to 16 frames per second altered the temporal aspect of the films, thus changing the pro-filmic event into something other than a simple recording.

The transformative aspects of Warhol's early films have also been ignored. Instead of Lumière, Mekas just as easily might have invoked the tradition of Georges Méliès. The deliberate temporal disjunctions in *Sleep, Eat,* and *Couch* (1964) go beyond a mere change in projection speed. *Sleep,* for instance, was shot over a period of weeks and painstakingly edited into a serial work dependent on the clear and obvious repetition of imagery. The sequence of 100-foot rolls in *Eat* likewise has been altered, so that the mushroom that Robert Indiana eats magically shrinks and grows in size, again suggesting an animated effect that seems to be influenced more by Méliès than Lumière. *Couch* also alters temporal sequence. In *Soap Opera,* one actor transforms into another while behind a newspaper.

Other transformations occur in the early films. For instance, over the course of the film, *Sleep* gradually transitions from lyrical abstraction into the grotesque. Through the harsh lighting and shadows that gradually envelop the subject's eyes, the performer's face in *Blow Job* turns into a human skull, an image that Warhol would mine in his later paintings, which, like *Sleep,* are portraits of death. The curator Henry Geldzahler regresses into infantilism during his face-off with the camera in his extended screen test. *Shoulder* (1964), a short film of the Judson dancer Lucinda Childs, focuses not on her face, but on her shoulder and breast. After a little over two minutes of the camera's intense scrutiny, her shoulder muscles invariably twitch as she attempts to hold a pose, causing a transformation to occur: her shoulder tenses, the striped material of her tank top ripples, her breast flattens, and shadows are cast on her arm and chest, thus altering the original composition.

While there is definitely a conceptual outrageousness in Warhol's early films, they also exhibit a great sense of humor. They are what Hollywood would term "high concepts," ideas so clearly articulated that this no doubt partially accounts for the fact that some scholars have discussed the films without even bothering to see them. Rather than being boring, Warhol films can be surprisingly entertaining. Only two of the early silent films, *Empire* and *Sleep,* are marathon endurance tests. One of the myths, perpetuated by Warhol, involves the notion that his work is only about surface. He insisted: "If you want to know all about Andy Warhol, just look at the surface: of my paintings and films and me, and there I am. There's nothing behind it."[2] This has led Patrick De Haas to

comment: "The world means nothing: there is thus no need to interpret it but possibly to scan it with the gaze, like 'a kind of mental Braille,' to render it in the manner in which a mirror sends back a reflection. There is also no need to interpret Warhol's images. They have no depth (whether spatial, semantic, or psychological)."[3]

Warhol's images in the early films, however, are not surfaces bereft of meaning, but instead display remarkable depth. In addition, the films have decidedly narrative overtones.[4] Marshall Deutelbaum, for instance, has argued persuasively that the Lumière films were not straightforward recordings of happenings but rather structured events, even if they were mundane events.[5] Since many of Warhol's early films involve some type of visual transformation, they play with expectations, such as the continually changing size of the mushroom in *Eat*. In *Kiss*, there's a clear setup, so that when the camera zooms back in the fourth kiss, we're taken by surprise that we've actually been watching two men kissing rather than the heterosexual couple we expected as a result of the previous positioning in the frame. Other films show a sense of narrative development. Freddy Herko, for example, gradually undresses and briefly exposes himself toward the end of *Haircut (No. 1)*. *Sleep* moves from sleep to the notion of death and physical decay. In *Blow Job*, there is a literal climax, followed by the post-sexual smoking of a cigarette. *Couch* also employs a number of skits. By the end of his portrait, Henry Geldzahler has become completely deflated. *Empire* moves from dusk to night, from an emphasis on the positive space of the building to the negative space surrounding it.

The popular reception of Warhol's early cinema has been another matter altogether. *Empire*, Warhol's extended depiction of the New York City skyscraper, and *Sleep*, his portrait of the sleeping poet John Giorno, are considered to be two of his most infamous films, even though very few people have viewed them in their entirety. They sound incredibly boring. Watching an animate figure asleep for five hours and twenty minutes or an inanimate object for slightly over eight hours suggests a Duchampian gesture, and mere mention of the titles invariably elicits laughter. Gerard Malanga, Warhol's main assistant, writes: "*Empire* was a seven-hour [sic] movie where nothing happened except how the audience reacted."[6]

Jonas Mekas has indicated that early screenings of both *Sleep* and *Empire* provoked hostile reactions from audiences. Mekas quotes a letter from Mike Getz, the manager of the Cinema Theatre, indicating that *Sleep* nearly provoked a riot when it was shown in Los Angeles. He

writes about the premiere of *Empire* at the Film-Makers' Cinematheque in New York City: "Ten minutes after the film started, a crowd of thirty or forty people stormed out of the theatre into the lobby, surrounded the box office, Bob Brown, and myself, and threatened to beat us up and destroy the theatre unless their money was returned."[7] Part of the mythology surrounding Warhol's early work is that not even he could stand to watch his own films—a notion propagated by the artist himself. In *POPism,* for instance, he discusses a screening of *Sleep:*

> When someone found out before the screening exactly what it was going to be and said he wouldn't sit through it all for anything, Jonas [Mekas] got a piece of rope and tied him to a chair to make an example out of him. I guess Jonas realized it was me he should have tied down instead, because he couldn't get over it when I got up and left after a few minutes, myself.[8]

This anecdote reinforces the idea that these two early epic works were conceived as deliberate attempts to test the tolerance and endurance of audiences.

Yet a different picture emerges from Ronald Tavel, one of Warhol's later collaborators, who insists that Warhol's own films actually were not boring to him: "They really weren't; he would sit and watch them for endless hours with one leg crossed over the other and his face in his hands and his elbows on his knees, with absolute fascination and he was puzzled why the public wasn't equally fascinated."[9] Upon seeing only a handful of people at a screening of *Empire,* Warhol found it hard to believe that audiences might find some Hollywood blockbuster more entertaining. Tavel adds: "So we should not think that these films were not interesting to him or that he didn't want them to be interesting. As with any visual artist, the entire visual world was fascinating to him, and he did behave rather traditionally in that sense."[10]

If for Eisenstein the basis of cinema was the shot and for Peter Kubelka it was the frame, for Warhol it was the camera roll, which was determined less by the filmmaker than by the mass production of the manufacturer of the film stock he used, namely Kodak. The size of the reel, of course, varied depending on the capacity of the camera he had at his disposal, whether it was a Bolex, which accepted 100-foot spools, or the Auricon camera, which allowed him to use 1200-foot rolls. The early films, such as *Sleep, Blow Job, Eat, Kiss, Haircut (No. 1),* and most of the silent *Screen Tests* (including *Ann Buchanan), Shoulder, Mario Banana # 1,* and *Mario Banana # 2,* used 100-foot rolls, whereas *Empire, Henry Geldzahler,* and the sound films, starting with *Harlot,*

all used the larger 1200-foot rolls. The new reels are even announced in certain Warhol films, such as *Kitchen*. In *Horse*, the different reels are emphasized by the inclusion of a middle reel, which alters the film's temporality. In some sense Warhol let manufacturing determine how he constructed and conceived of his films. As Rainer Crone suggests: "Obeying the machine in order to make use of it—this is Warhol's aesthetic principle."[11]

SLEEP

Most descriptions of Warhol's first film create the impression that it consists of a continuous single take of a man sleeping. This turns out to be one of the many misconceptions about the film. *Sleep* is actually composed of twenty-two different shots—some handheld, and others looped and repeated numerous times. There are seven separate shots in the first reel, four in the second, only one in each of the third and fourth reels, and nine in the final reel, which turns out to have the most complex editing structure.[12] Warhol extends time through the repetition of images, yet he also slows down time from 24 to 16 frames per second, which creates a curious and paradoxical effect. In addition, the subject's facial features continually change, serving as an indicator that the film was shot over an extended period of time rather than in one session.[13] Instead of a single, continuous take, *Sleep* turns out to be a carefully edited, achronological, serial piece.

Both Callie Angell and Branden Joseph relate the use of repetition in *Sleep* to Erik Satie's *Vexations* and to Cagean aesthetics.[14] Warhol was very up front about the fact that he reprinted a number of shots and, in fact, entire 100-foot rolls over and over again in *Sleep*. Warhol discusses bringing a number of his films to an open screening at the Gramercy Arts Theater, near the Film-Makers' Coop: "I brought in some newsreel-type dance films I'd made, too, and then I decided, oh, why not bring in *Sleep*, which I'd actually faked by looping footage, so although it was hours of a person sleeping, I hadn't actually shot that much."[15]

Like Willard Maas's early avant-garde classic, *Geography of the Body* (1943), *Sleep* turns the human body into an alien landscape; Warhol's careful compositions continually fragment the male figure.[16] At times, the image is so abstract that it merely becomes an unrecognizable interplay of light and shadow, or merely a clump of human hair. We eventually see the face of the sleeping figure of John Giorno, with whom Warhol was involved in an intimate relationship at the time. We notice

certain curious elements of Giorno's face, such as the low positioning of his ear on his head. From a low-angle shot of his reclining body we become aware of the ring of black hair from his upper chest that seems about to swallow his chin. In addition, Giorno's facial features are highly sculpted, like a wooden mannequin; his eyebrows appear unusually wide; his rear end, cutting horizontally through the composition, has a distinctly feminine pear shape.

The act of sleeping is a private or personal phenomenon. It is generally an activity better performed in the dark, but light is a prerequisite for the proper exposure of film. When someone stares at a sleeping person, it is often enough to cause the person to awaken; perhaps that's why Warhol chose to make a film about it. There is, of course, something outrageous in expecting a viewer to watch someone sleeping for such a long time. For one thing, it goes against the classical notion of an active protagonist. How can human downtime prove to be interesting subject matter for a movie? In this respect, Warhol has inverted conventional thinking.

When I viewed the film for the first time, a middle-aged woman happened to wander into the sparsely attended screening. After several minutes, she turned and asked loudly, "Was he ever awake?" Shortly afterward, she got up and left the theater. In some ways, it's not such an unreasonable reaction. Yet, as the film goes on, it doesn't really seem to be about sleep. The experience of viewing the sleeping figure of Giorno is very much like watching a very sick person, or someone near death, in a hospital room. In some shots, which are repeated, there's a strong sense of stillness. If Giorno is asleep, Warhol's film innocently seems to ask, where has he gone? Not every shot, however, is peaceful and serene; there is a repeated shot that shows Giorno breathing heavily through his mouth, perhaps snoring, before his whole body jerks spastically into another position on the bed.

During the shots where Giorno seems unnaturally still, there are times when we even wonder whether the subject might have died. As the image repeats itself, we watch not only Giorno's face, which appears lifeless at certain times, but also his throat for any sign of movement or confirmation that he's still breathing. With *Sleep,* Warhol raises a philosophical question about the connection between the physical body and the notion of personhood. Some commentators have suggested that *Sleep* is an erotic meditation on the human body, but the effect turns out to be exactly the opposite.[17] In the course of the film, we gradually come to see the human figure, not in aesthetic or sexual terms, but as a mass of flesh that seems incapable of engendering any such physical desire.

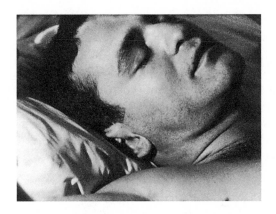

FIGURE 2. John Giorno; *Sleep*, 1963 (16mm film, b/w, silent, 5 hours and 21 minutes @ 16 fps. Film still courtesy of The Andy Warhol Museum)

Reels 3 and 4 involve the greatest amount of repetition. Each of them contains a repeated loop of a shot lasting for a continuous 100-foot roll. This section is the most challenging, causing even a sympathetic viewer to wonder whether Warhol might have run out of either footage or ideas. As often happens in a Warhol film, however, a viewer's patience is rewarded in the final reel, where, through a buildup of extreme black-and-white contrast, shots of Giorno's body transform into images of physical decay. In one notable shot, light appears to reflect off Giorno's eyelids so that the image transforms into one of horror. The images and compositions become more grotesque and surreal. *Sleep* mirrors the world later documented by the photographer Peter Hujar, who would capture the utterly eerie image of Warhol superstar Candy Darling on her deathbed.[18] According to Giorno, Warhol's biggest fear was dying in his sleep, which makes the connection between sleep and death even more explicit.[19]

HAIRCUT (NO. 1)

Haircut (No. 1) suggests the influence of dance on Warhol, who in 1962 created seven "Dance Diagram Paintings" and one drawing based on dance steps.[20] Three of the performers in the film were associated with the avant-garde Judson Dance Theater—Freddy Herko, Billy Name (Linich), and choreographer James Waring. While *Haircut (No. 1)* deals with the action of a single haircut, it really functions more as a highly conceptual dance piece in which bodies define visual space, and the shots combine to engage the viewer in a perceptual game as the film slowly transforms into an intricately choreographed striptease and peepshow.

Haircut (No. 1) is perhaps the most formally complex of Warhol's

early silent films. There are three different versions of *Haircut (No. 1)*; the one discussed in Stephen Koch's *Stargazer* is the version analyzed here. The film consists of ten carefully composed shots, taken from six different angles, shot with six 100-foot rolls of black-and-white film. The first shot shows deep space that divides into three different planes of action, much like the later planar composition of *Vinyl*.

A shirtless man—the outline of his penis can be seen through his light-colored pants—stands on the left in the foreground. The man, in fact, is Freddy Herko, the Judson dancer, who looks directly at the viewer as he hovers at the side of the frame.[21] Billy Name, dressed in black, eats something in the middle ground, while John Daley, in a white shirt, sits barely visible in the background. Daley delineates the space by walking diagonally behind Herko, and then into the foreground to get a pack of cigarettes before retreating back to his original place. Herko turns and walks slowly into the background—it's more like a dance than a casual walk. He stops and turns toward the camera. A barber chair is visible on the left.

The second shot shows a medium close-up of Billy Name giving Daley a haircut. His back is to the wall. The third shot—wider and from a slightly different angle—calls attention to the framing of the previous one, in which Herko is notably absent, which suggests a concern for offscreen space. We see Herko, now wearing a small cowboy hat, on the left, as he smokes a pipe of marijuana. He has an open magazine on his lap. The light still flares behind Daley. Name moves in front of Herko, obliterating him at one point. Daley smokes a cigarette, while Herko lights his pipe and refills it, and Name steps in front of Herko to move back to the other side. We are thus forced to watch three different activities in the left, middle, and right of the frame, while the light creates a circular halo right in the middle. The following shot is more spatially confusing. The three figures are stacked in a closer shot. Daley, in the foreground, looks screen left. Name, in the middle, cuts Daley's hair. In the background, Herko smokes the pipe and peers around at Name, who at times obscures Herko as he cuts Daley's hair.

In the fifth shot, Daley's chair is turned in a different direction, raising the question of whether it has the ability to swivel. Name sits on the chair, cutting Daley's hair, while Herko, whose bare legs suggest that he might be naked, is positioned between them. Name moves in front of Daley now. We watch as Herko removes seeds from his marijuana, while Name nearly disappears from the right-hand side of the frame. Herko starts to smoke his pipe again as the scene ends. In the sixth shot,

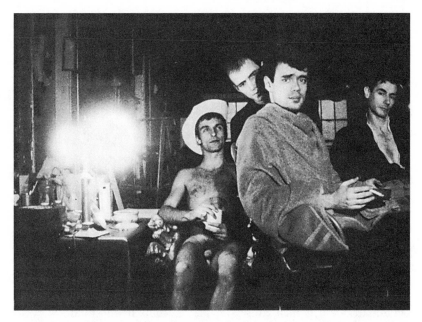

FIGURE 3. Freddy Herko (left), Billy Name, John Daley, and James Waring; *Haircut (No. 1)*, 1963 (16mm film, b/w, silent, 27 minutes @ 16 fps. Film still courtesy of The Andy Warhol Museum)

the three men, and a fourth, James Waring, stare directly at the camera. Herko sits screen left, Name stands behind Daley, and Waring is to their right. The halo of the light is on the extreme left. As Herko drinks from a cup, his left leg is crossed to cover his crotch. When he switches legs, his penis is briefly exposed. This is followed by three handheld close-up shots of Daley, Herko, and Waring. The tenth and final shot returns to a wider shot of the four of them, with Waring at times nearly out of the frame. They all rub their eyes as if waking from a dream.

KISS

Kiss consists of thirteen different couples kissing. The film makes us realize that there are a wide variety of ways to kiss, and how personal and idiosyncratic kisses really are. We often see kisses in Hollywood movies or on television, but they tend to be highly stylized. Hollywood kisses seem to erase questions, while these messier ones tend to raise them. For instance, we become quite aware of the element of performance in each kiss. Some actors seem to be actively engaged in the act of

kissing, while others clearly are not. The kisses reveal the personalities of the performers, or at least something about the situation. Are these people being asked to kiss friends, foes, lovers, or strangers?

Kiss makes us aware of the framing—the lighting and exposure—and how these factors influence what we see and how we read the image. We realize that kisses are a form of portraiture as well. In Emile de Antonio's *Painters Painting* (1972), Willem de Kooning talks about the mouth being an interesting part of the body. The early Warhol silent films are heavily oral, as are a number of *Screen Tests,* such as one that focuses on Lou Reed's mouth as he smokes a cigarette; mouths also appear in certain Warhol paintings, such as *Marilyn Monroe's Lips* (1962).

As with the various portraits Warhol painted, the identifiability of the performers in *Kiss* gives an added dimension. The first kiss shows Naomi Levine and the French art critic Pierre Restany, but their kiss ends abruptly and prematurely after nearly a minute. The second one shows Naomi Levine (left) and Gerard Malanga (right). There appears to be a window behind Levine, as Malanga aggressively attempts to devour her chin, which causes Levine to smile at one point. He also paws Levine like an animal, puts his tongue in her mouth, and rubs his chin on her. These first two kisses appear within the first roll; otherwise the remaining kisses last for an entire 100-foot roll of film.

After three successive kisses in which the woman is on the left-hand side of the frame and the man on the right, in the fourth kiss, the viewer assumes that the person on the left is a woman. The kiss itself—two bodies, naked from the waist up, moving back and forth in the frame—suggests the idea of kissing being a form of dance. After some time, the camera zooms back to reveal that the person on the left is actually John Palmer. The shot invites the viewer to focus on the breast area of the person on the left, as if inviting the viewer to confirm the expected: the female breast. But we see male rather than female breasts. The wider shot also reveals that the two of them—Palmer and Andrew Meyer—are kissing on a couch, as the two bodies writhe in front of a painting of Jackie Kennedy in the background. The zoom back provides a decidedly narrative element, as we will see in other early films. In the fifth kiss, which features Baby Jane Holzer (left) and a handsome young man (right), their mouths appear to be stuck together. They suck at each other's lips, at times looking like two fish kissing in a tank.

In the sixth, Mark Lancaster, the taller man on the left, seems to be leaning on the shorter Gerard Malanga, nearly pushing him out of the frame—their kiss can be viewed almost as a physical or psychological

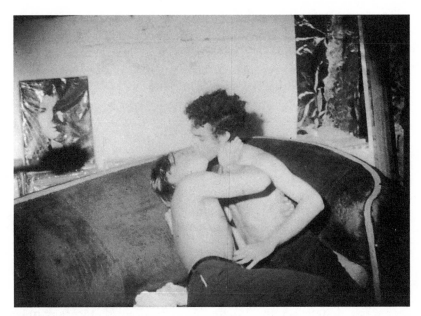

FIGURE 4. John Palmer and Andrew Meyer; *Kiss,* 1963–64 (16mm film, b/w, silent, 54 minutes @ 16 fps. Film still courtesy of The Andy Warhol Museum)

battle—before Malanga finally pushes back. The tension that we sense in their interaction stems from the dynamics of their personal relationship, suggesting that a kiss had the potential to become a mini-psychodrama or that it tells a story. Lancaster told an interviewer: "I think he [Warhol] knew that Gerry [Malanga] didn't like me and that I was wary of him. So his wanting us to kiss could be interpreted in several ways."[22] The two engage in a French kiss, which Lancaster suggests was almost a necessity to fill up the required time. He remarks about Malanga: "He was sexy, in a way, but not my 'type,' though I spent a good deal of time that summer trying to figure that out and experiment with 'types.'"[23]

The seventh kiss, which involves the same setup as the second, features a more sensuous kiss between Naomi Levine and Ed Sanders of the Fugs. The ninth also depicts Levine, but this time she appears underneath Rufus Collins, the African American performer from The Living Theatre. The interracial kiss might have seemed shocking at the time, but Warhol would top this in *Couch.* In the eleventh kiss, the assemblage artist Marisol kisses the painter Harold Stevenson, dressed in a striped shirt and tie. Stevenson initially kisses with his eyes closed, but at several points, he opens them, as if the length of the camera roll is

much longer than he bargained for. The thirteenth and final kiss is an extreme close-up that turns out to be the most abstract of the reel. In this one, the man's large nose appears about to poke out the woman's eye; otherwise, the interest here involves the formal interplay between light and shadow.

BLOW JOB

Blow Job (1964) uses its provocative title, taboo subject matter, and Warhol's already established reputation for making films based on a certain literalness to poke fun at prevailing censorship laws. Koch has referred to *Blow Job* as "a piece of pornographic wit."[24] Warhol's humor involves his decision to frame the action so that instead of focusing on the sex act, he concentrates on the reaction shot of a handsome young man being fellated for forty-one minutes. He thus withholds what would be considered the pornographic activity—the act of fellatio—while managing to create it in the viewer's mind. This is the film's conceptual brilliance. As a result, despite its rather formal simplicity, *Blow Job* turns out to be one of Warhol's most richly evocative and resonant films.[25]

Koch writes: "The recipient looks like a once fresh-faced, foursquare Eagle Scout, a veteran of countless archery contests and cookouts."[26] Koch also identifies him as a "hustler."[27] Yet Koch's characterization of the actor seems to represent his own fantasy, as nothing in the film suggests the backstory he creates for this character. As it turns out, the performer, DeVerne Bookwalter, was a former art major and Shakespearean actor who later played bit roles in television and film.[28] There is nothing in Bookwalter's *Screen Test* to suggest how perfect he would be as the then anonymous performer in what, on the basis of its sheer title alone, would become one of Warhol's most famous films. Clad in a black leather jacket and set against a background of a brick wall, recalling Genet, Bookwalter bears an uncanny resemblance to James Dean—high cheekbones and deeply inset eyes—that would turn him into an iconic gay image of masculine desire.

Because *Blow Job* does not focus on the sexual act itself, but on a reaction shot of the recipient, there's no way of knowing for certain whether the act is actually occurring offscreen. It could be a hoax. By focusing on the face of Bookwalter, the film engages the viewer's perceptual capacities in trying to determine the authenticity of the film's premise. The film forces the attentive viewer to seek out the small visual cues to verify that an oral sex act is indeed taking place beneath the frame.

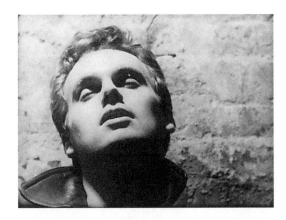

FIGURE 5. *Blow Job,* 1964 (16mm film, b/w, silent, 41 minutes @ 16 fps. Film still courtesy of The Andy Warhol Museum)

Those cues reveal the traces of a structure to what is occurring. Douglas Crimp rightly suggests that *Blow Job* "'narrates' a sexual act, and that as such it has a beginning, middle, and end, and even a coda."[29]

In the beginning of *Blow Job,* the subject keeps his head down. Because of the lighting, shadows cover his face, especially his eyes, preventing us from seeing him. It's only when he raises his head that we see his expression, which, as Koestenbaum notes, recalls Falconetti in Dreyer's *The Passion of Joan of Arc* (1928).[30] The performer's responses suggest the same sense of religious ecstasy, as his eyes roll and dart offscreen. At times, he seems very uncomfortable. He often looks toward the camera. His face also bears a pained expression, suggesting a kind of fluctuation between agony and ecstasy. On some level, however, Bookwalter seems to become too elated, almost as if he's receiving a surfeit of pleasure, which makes one at least question what is actually occurring in the offscreen space, to which we have neither visual nor aural access. Part of Warhol's brilliance in *Blow Job* is how he reverses the importance between onscreen and offscreen space in such a profound way. For Warhol, as Koch suggests, the power of sex does not reside in the physical act, but in the imagination: "Pornography is always about imagined sex. That is to say, it is about our own imaginations, about ourselves."[31]

As Bookwalter continues to be fellated, his head tips back more and more, especially as he appears to achieve an orgasm. Toward the end of the film, there is a moment when shadows completely cover over his eyes in such a way that his face transforms into a human skull, suggesting the strong Gothic overtones that permeate Warhol's body of work, from his early "Death and Disaster" series to his later 1976 "Skull" paintings. Like sleep or death, orgasm offers a release from the constric-

tions of the physical body. Afterward, Bookwalter smokes a cigarette, thus receiving his own oral gratification. When he smokes, shadows cover his entire face except for his nose, making him appear like a devilish figure. It's the type of image one associates with Kenneth Anger's *Scorpio Rising* (1964).

EAT

Like Warhol's other early films, *Eat* (1964) is often described as being a simple recording of a mundane activity, namely a film in which fellow Pop artist Robert Indiana eats a mushroom. But just as *Sleep* is a carefully edited construction rather than a continuous recording of John Giorno sleeping, so Warhol's decision to splice the various 100-foot rolls of *Eat* out of order has a disorienting effect. For one thing, *Eat* confounds our sense of the object he is eating and of the film's temporality, because the mushroom, almost as if by magic, keeps changing in size. Even though the choice of the subject of eating might appear to be a bit odd, Indiana was a logical choice as a performer for it, since he incorporated eating in a number of his works, such as his painting *USA 666* (1964) and the flashing "Eat" sign he created for the New York World's Fair, which, like Warhol's mural of mug shots, *Thirteen Most Wanted Men*, wound up being censored.[32]

Eat very much depends on the formal elements of its mise-en-scène: the quality of light that streams in from the window of Indiana's Lower Manhattan loft on the right side of the frame, the plant in the background, and the detailed patterning on the wood of the rocking chair, as well as its movement within the frame. The costuming—Indiana's bulky sweater and the texture of the shirt, and especially the goofy hat he wears—becomes a critical element in creating a sense of character. The cat adds unexpected visual interest as well, especially when he decides to pose for his own screen test by staring back at the camera for an extended period of time.

In discussing the notion of cinematic presence in Warhol's work, Stephen Koch quotes Ondine: "Your brain seems to be apparent when you're on camera. It seems as if—when you look at yourself on the screen—it seems as if your brain is working. Like, to me, I can tell what people are thinking by what they look like on the screen."[33] This point seems especially relevant in *Eat* because the viewer has a sense of Robert Indiana's thought processes as he eats a single mushroom over the course of the film.

Whereas some of the performers in *Kiss* appear uptight and frantic,

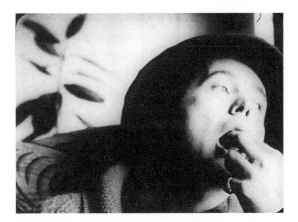

FIGURE 6.
Robert Indiana; *Eat,*
1964 (16mm film,
b/w, silent, 39 minutes
@ 16 fps. Film still
courtesy of The Andy
Warhol Museum)

Indiana seems remarkably relaxed and serene; the passage of time in front of the camera does not seem to disconcert him. In the various Warhol *Screen Tests,* the issue of time becomes a crucial and distinguishing element. How can the subject fill up the time? For Warhol, time essentially is determined by the length of the film that is running through the camera, even though he ultimately projects it at a slower speed. Many of the subjects of the Warhol portraits, such as Henry Geldzahler, would become uncomfortable in an effort to deal with the temporal element, but Indiana has no difficulty performing throughout the process. Other screen portraits, such as *Mario Banana # 1* and *Mario Banana # 2* (both 1964), which inaugurate Warhol's interest in transvestites, seem theatrical by comparison. Mario Montez exaggerates the sexual connotations of the banana, even in the more abstract black-and-white second version, whereas Indiana eats the phallic mushroom casually.

EMPIRE

Just as *Sleep* is not really a film about a man sleeping, but rather a meditation on death, so *Empire* (1964) turns out to be a celestial, or cosmic, film. In the midst of the conversational banter during the single night of production on July 25 and 26, 1964, Warhol described the film: "It's like Flash Gordon riding into space."[34] Though artistic intention is always a slippery subject for Warhol, this statement represents the best high-concept pitch that could possibly be made for the film; to my own surprise, the experience of watching *Empire* most closely resembles exactly that—a journey into outer space.

At the time Andy Warhol's *Empire* was shot, the 102-story art deco structure in midtown Manhattan was the tallest building in the world. Rising to a height of 1,454 feet, the building is a quintessential American icon, defining the ambition and size of New York City, as well as its skyline. As Warhol liked to point out, the Empire State Building was a star.[35] Malanga writes: "The Empire State Building was already a star of sorts when it was featured in *King Kong,* but Andy wanted to make the building an even bigger star!"[36] A museum exhibition photograph shows Edie Sedgwick and Warhol posing in front of the skyscraper; Andy holds one hand high in the air, while his other one holds Edie's as she strikes a balletic pose. The photo caption reads: "In 1965 Andy Warhol poses with two of his superstars: Edie Sedgwick and the Empire State Building, the main protagonist in his film *Empire.*"[37]

Yet like a glamorous Hollywood movie star, the building also has a dark side, exerting a gravitational pull on desperate people who want to put an end to their lives. Over thirty people have committed suicide by leaping to their deaths from the skyscraper since it was opened to the public in 1931, linking it indirectly to Warhol's pieces on people leaping to their deaths from buildings, such as *A Woman's Suicide* (1962), *Suicide (Fallen Body), Bellevue 1,* and *Suicide (Silver Jumping Man)* (all 1963), as well as Warhol's notorious "Death and Disaster" series.[38]

Given the highly conceptual basis of *Empire,* one might expect the film to have been shot during the day rather than from around sunset into the very dead of night. That part at first seems counterintuitive, but the floodlights at the tower of the building had recently been added in honor of the 1964 World's Fair, turning the building into a dazzling nighttime spectacle.[39] This no doubt affected Warhol's decision to shoot the building at night. According to Warhol, the idea for the film can be attributed to John Palmer, whose mother "donated money to get the film out of the lab."[40]

MoMA Highlights, which documents the museum's collection, describes *Empire* as follows: "*Empire* consists of a number of one-hundred-foot rolls of film, each separated from the next by a flash of light. Each segment of film constitutes a piece of time. Warhol's clear delineation of the individual segments of film can be likened to the serial repetition of images in his silkscreen paintings, which also acknowledge their process and materials."[41] This is simply inaccurate. If *Empire* had been shot in 100-foot spools, the cameraperson would have been changing film every two minutes and forty-five seconds throughout a very long night. Nor are the flashes (or flares of light) that appear throughout the film the

result of splicing short rolls together. Gerard Malanga, who was there during filming, indicates:

> Both *Sleep* and *Empire* are in black-and-white, no sound, shot at night, and the camera never moves. The only major difference between the two films is that *Sleep* was shot with the Bolex using 100-foot/three-minute film rolls, and *Empire* was shot with a rented Auricon equipped to shoot 1,200 feet of film for thirty-five minutes non-stop.[42]

There are other fundamental differences between the two films as well. As already indicated, the camera in *Sleep* is not stationary. *Sleep* was shot over a period of time and heavily edited, whereas *Empire* was filmed continuously during a single night.

To be precise, *Empire* was shot in 16mm black-and-white in ten 1200-foot magazine loads, or thirty-three-minute takes at 24 fps, but it was projected at 16 fps, which extended the running time of the film to slightly over eight hours. It was shot from the forty-fourth floor of the Time-Life Building, located on Avenue of the Americas, between Fiftieth and Fifty-first Streets. The film was shot by Jonas Mekas. According to Malanga, "John and Jonas took turns loading and threading the film every 35 minutes."[43] Others present included Henry Romney, who worked for the Rockefeller Foundation and allowed Warhol to shoot the film from the office of the Foundation. (Romney appeared in Warhol's *Screen Tests* as well as *Soap Opera*.)

As the film begins, the Empire State Building stands almost directly in the center of an overexposed frame on an overcast day. Two smaller buildings are visible on the left; one is the Metropolitan Life Insurance Company Tower, which has a light on top that will later blink the time of day. At seven hundred feet, or less than half the size of the Empire State Building, the Met Life tower was heralded as the tallest building in the world from 1909 until 1913, when it was supplanted by the Chrysler Building. The details of the grid-like pattern of the windows of the Empire State Building gradually become more pronounced as the sky darkens.

The skyline to the right gradually becomes faintly visible. The Empire State Building moves from flat, two-dimensional space to three-dimensional space as its volume becomes revealed. The light on the top of the Met Life tower turns on. The grain in the shot becomes more pronounced as the natural light fades. The light on top of the Empire State Building glows; a light also appears in one of the office windows. There are additional pinpoints of light on the left-hand side of the screen, in-

cluding one window in the Met Life building. When the Empire State Building floodlights come on, the effect is dramatic; light begins from the top and moves down the tower, creating a slightly delayed effect.

As the light fades to blackness in the second reel, the image occasionally appears to become solarized. This results from a change in light, where flashes that last for a couple of seconds obliterate the image. What appear to be bubbly processing stains also create tension between the surface and depth of the image. The night takes on a lonely, eerie quality. The Empire State Building begins to seem like a giant star or space station in a vast solar system or galaxy, where other planets and stars appear tiny or as mere pinpoints of light set against the dark black sky.

The white star-like specks (most likely the result of dust and dirt on the camera original) proliferate at the opening of the third reel. Similar flashing or solarization also occurs, along with other strange, inexplicable effects. These include several shots of rain containing processing splotches, printed sprocket holes moving horizontally across the frame almost as a superimposition, and a couple of seconds where the images turn completely white. The repeated effect of this is to create the equivalent of solarization, so that the lighted tower of the Empire State Building appears to implode on itself—like what happens to certain stars. Throughout the third reel, the tiny white specks on the film make the image look like a galaxy—a night sky filled with stars. In the fifth reel, we can see the reflection of someone (probably Jonas Mekas) fiddling with the camera. We see the frame of the window and a reflection of the interior of the room in which Warhol and his crew are filming. During this reel, the light on the Met Life building turns off.

One of the most startling effects, however, occurs in the sixth reel, when round white dots of light that vary in size and intensity twinkle or flicker like stars around the building. They appear intermittently for approximately eighty frames and as little as two frames apart. The image washes out completely for approximately sixty frames, and then less so for another thirty frames. In addition, there is a single flash-frame, which causes the image to flicker. The light inside the Rockefeller Foundation room has been turned on at the start of the seventh reel. We see the camera and someone reflected in the window, and shortly after this Andy Warhol prominently crosses the frame from screen right to screen left.

In the eighth reel, we see a reflection of someone, but only for a brief moment. At times, it appears as if the moving image, as occurs in *Sleep*, has somehow managed to achieve stasis. The light on the top of the nee-

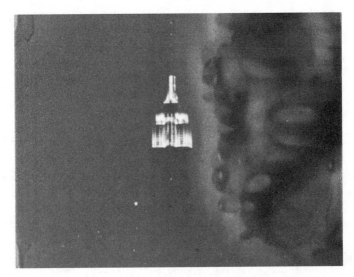

FIGURE 7. *Empire*, 1964 (16mm film, b/w, silent, 8 hours and 5 minutes @ 16 fps. Film still courtesy of The Andy Warhol Museum)

dle of the Empire State Building blinks on and off. The floodlights suddenly turn off in the ninth reel, leaving four small lights on the needle, five or six at the base of the tower, and a larger sized light atop the Met Life tower. We see light flares and an increase of grain. The aerial light atop the Met Life tower goes off; it later blinks (indicating the time) and then remains on. The various points of light set against the black background create a sense of depth.

John Palmer can be seen briefly at the beginning of the final reel. The image first brightens and then darkens, so that only faint points of light remain. The light on the Met Life building blinks off and on. The image is so dark that we're nearly watching a black screen, suggesting a view of the solar system. The tiny points of light are reminiscent of what happens when an image becomes obliterated by contrast, as in the second half of my own film, *Print Generation* (1973–74). The points of light give only the suggestion of the image we've seen previously, so the film becomes about memory—trying to remember the previous skyline from a series of dots of light. The images gradually become darker; the lights on the needle of the Empire State Building nearly disappear, along with the overall image. The arrangement of the lights suggests a star constellation. The light on top blinks again. There's a long stretch of near-blackness. After more flashing, the film ends in darkness.

Warhol's *Empire* shares an affinity with Vija Celmins's series of paintings, drawings, and prints of starry night skies, which derive from a photographic source. In a catalogue on Celmins's work, Briony Fer writes of the "Night Sky" drawings: "The associations of a night sky filled with showers of stars only increase this sense of there being something unyielding in infinity. Celmins' sense of the infinite is absolutely not transcendental or sublime but material and concrete."[44] The same might be said of Warhol's *Empire,* which starts with a fixation on a "star" and ends up defining a cosmos, thanks to the transformative power of the photochemical and mechanical process of black-and-white film. Or, as Paul Arthur aptly describes *Empire:* "It looks by turns graphic, fluid, solid and a negative x-ray of itself; a piece of flickering wallpaper and a moment by moment contest between an image, an image twice-removed by cultural standing, and a material surface."[45]

There are a number of technical factors that account for the transformative qualities of *Empire.* For instance, the recurring light alterations could have been the result of natural changes in the light as the sun sets, although this seems unlikely. In addition, as Gerard Malanga attests, Warhol could have played with the aperture of the camera, which might explain the initial overexposure. The choice of black-and-white film stock—negative or reversal—as well as the speed of the film would also have significant bearing. Finally, there are issues connected to the film laboratory where *Empire* was processed. These include possible lab procedures, the handling of the original stock, and the quality control of the lab itself.[46] Scholars disagree about these matters, but my own speculation is that the film was shot with Kodak 4-X Negative 7224 black-and-white stock, with the lens aperture wide open the whole time, and then pushed one-and-a-half stops in the lab. This would account for the overexposure at the beginning and the near-darkness at the end.

This discussion might seem a small quibble about minor technical matters, but in the case of *Empire,* these technical aspects completely engage our perception of the film. Even Angell's long entry on *Empire,* which focuses on the temporal aspects of the film, did not prepare me for the actual experience of viewing *Empire* in its entirety. She suggests:

> For most of the film's duration, . . . the glowing, free-floating shape of the lighted tower is the sole claim to the viewer's attention, its unwavering presence suggesting at various times (to this viewer at least) a rocket ship, a hypodermic needle, a heavenly cathedral, or a broad paintbrush that has been dipped in white paint and placed on the surface of a dark gray canvas.[47]

It's interesting that Angell echoes Warhol's offhand comment during production that suggested a rocket taking off into space. I believe the distinction is an important one. *Empire* is less about the trope of the spaceship than about what happens after the rocket ship blasts off—it is less about the launching pad than the actual journey into space. And how Warhol was able to intuit that remains another of the many intriguing mysteries of the film.

Warhol's early films are often contrasted with those of Stan Brakhage. The position was first raised by Sitney in *Visionary Film*, but was perhaps best summarized by A. L. Rees in *A History of Experimental Film and Video* twenty-five years later. Rees writes: "Significantly, [Warhol] rejected the lyric and expressive modes, notably those of the arch-romantic Brakhage, and adopted a deliberate attitude of cool distance towards his subject-matter."[48] What's ultimately so surprising about Warhol's *Empire* is that there is a strange hallucinatory quality to the viewer's perceptual experience, thus making it Warhol's most Brakhage-like film, especially in its visionary or eidetic aspects. There is a major difference, of course, because Brakhage's visual effects were conscious and deliberate, whereas Warhol's were strictly fortuitous—the results of the film being mishandled during processing and printing in a lab. The main point of raising this issue, however, is to insist on the fact that Warhol's film work resists easy classification. Even the heavily edited and serial *Sleep* and *Empire* are not as similar to each other as most critics would have us believe.

HENRY GELDZAHLER

Most of the *Screen Tests* consist of a single 100-foot roll of 16mm film. Some are longer, such as *Henry Geldzahler* (1964), which was shot with two 1200-foot rolls left over from *Empire* and has a running time of ninety-nine minutes when projected at slower speed.[49] There is a strong conceptual aspect to *Henry Geldzahler*, Warhol's portrait of the then twenty-nine-year-old curator of the Metropolitan Museum of Art, namely that the film lasts roughly as long as it takes Geldzahler to smoke a cigar. According to Geldzahler, he received no direction whatsoever from Warhol, and as a result he attempted to go through a repertoire of facial expressions, presumably based on various art historical portraits.

As Angell points out, Warhol's composition recalls Picasso's portrait of Gertrude Stein, a painting owned by the Met, while the symbiotic rela-

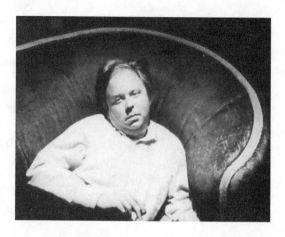

FIGURE 8.
Henry Geldzahler, 1964
(16mm film, b/w, silent,
99 minutes @ 16 fps.
Film still courtesy of The
Andy Warhol Museum)

tionship between Warhol and Geldzahler parallels that which existed between the Spanish artist and his American patron.[50] The fixed composition serves to define and limit Geldzahler's movements within the frame. The number of props has been minimized: couch, cigar, sunglasses, ashtray, and a white handkerchief, which Geldzahler takes out of his pocket. Warhol places the camera at a high angle, looking down at his subject, which puts Geldzahler, slumped on a small portion of the couch, at a distinct psychological disadvantage. He begins his portrait full of swagger and confidence. At one point, he sneezes, referencing Fred Ott's sneeze in early cinema. He takes out his handkerchief and deliberately puts it to his nose, but when he then uses it to wipe sweat from his forehead, Geldzahler appears to become ruffled.

Koestenbaum talks about a game of seduction between Warhol and Geldzahler, but various accounts indicate that Warhol wasn't there for most of the filming.[51] Whereas Robert Indiana seems positively blissful in *Eat,* Geldzahler gets more and more uncomfortable as time goes by. Indiana's portrait is composed of 100-foot rolls of film, but Geldzahler's consists of two longer rolls that each last thirty-three minutes. Geldzahler seems to be responding not to Warhol, but to the blank, unrelenting stare of the camera. In this sense, the film begins to feel like a psychoanalytic session, complete with requisite couch. Henry tries various approaches. He attempts to be coy and seductive; he preens and plays games with the cigar or with his hands. He strikes different poses, appears to sing to himself, flirts some more, and changes position. He smokes the phallic cigar in various ways. The sunglasses, which he presumably wears as a mask or defense, do not completely shield his eyes.

As the film progresses, Geldzahler seems to be regressing. The child-like quality of his features becomes more and more emphasized. The shadows that appear under his pudgy neck make it appear as if his head has been collaged onto his body in a manner similar to the way the shadows in *Blow Job* turn the bony features of the James Dean–like performer into a skull or the way the shadows transform Giorno's face in *Sleep*. Once Henry lies down, he eventually seems like a baby in a huge bassinet, and the cigar could easily be read as a rattle. Unlike Indiana, who remains composed, Geldzahler clearly loses the battle with the camera.

ELVIS AT FERUS

Warhol exhibited his infamous *Campbell's Soup Cans* in his first show at the Ferus Gallery in Los Angeles in 1962. The following year, he took his 16mm Bolex camera along to document his silver silk-screen paintings of Elvis at a second solo gallery show, which also featured paintings of Liz Taylor in the back gallery space. Through the silk-screening process, many of the images of Elvis are superimposed over each other to varying degrees.

Elvis at Ferus (1963) begins with a shot outside of the Ferus Gallery with Irving Blum, the gallery director, standing in front of an Elvis painting in the window. Blum moves to the center, opens and displays an art magazine to the camera in a wide shot, and then exits the frame. The handheld camera jiggles unsteadily and then frames Blum in close-up from the side. Blum turns toward the camera and speaks, even though it's a silent film. Warhol does an in-camera cut from Blum's face to a close-up of Elvis, suggesting a similarity between the look in their eyes. Warhol creates a pixilated effect through short bursts of different shots. He focuses on the doorway to the gallery. The camera moves down the Elvis painting and then up as we see two more figures. To our surprise—Warhol fools us into thinking we're still outside—the camera pans to show many figures of Elvis and continues to show Elvis canvasses covering other walls inside the gallery. At times Warhol pans the camera fast, but he slowly tilts down and back up the silk-screen paintings, as if massaging the life-size images of Elvis dressed as a cowboy—his legs spread wide, holster around his waist, and shirt open at the top—who points a gun as if he's about to shoot at the viewer.

The image of Elvis was apparently appropriated from a production still from a Hollywood Western entitled *Flaming Star* (1960), directed

by Don Siegel for Twentieth Century-Fox.[52] Warhol's choice of a well-known star, use of multiple images, and black silk-screened images on silver painted canvasses allude directly to the movies. While *Elvis at Ferus* provides documentation for the gallery installation of Warhol's Elvis paintings, it contradicts many of the common assumptions about Warhol's early silent films. *Elvis at Ferus* highlights his use of a handheld, mobile camera. Warhol employs pixilation, or animated live-action. He uses tilts and pans, which give life to the static serial images, suggesting that the repetition and superimpositions of his silk-screen technique in many ways reflect his aspirations to create motion from static images—something that Warhol quickly understood was easy to achieve with a movie camera.

TARZAN AND JANE REGAINED, SORT OF . . .

Tarzan and Jane Regained, Sort Of . . . (1963) is a genre film inspired by Warhol's visit to Los Angeles, where he met various celebrities and attended the opening of his show of Elvis paintings at the Ferus Gallery in 1963. The film was shot silent, but edited by the poet, actor, and filmmaker Taylor Mead, who also added a sound track consisting of pop songs and the sound track of an instructional movie, as well as his own ad-libbed remarks, some of which provide editorial commentary about what we are viewing.

After his performance in Ron Rice's *The Flower Thief* (1960), Taylor Mead was widely considered the first underground film star. He accompanied Warhol, Gerard Malanga, and Wynn Chamberlain on a three-day, cross-country car trip to Los Angeles. The filmmaker Naomi Levine flew out to L.A., ostensibly to raise money for the Film-Makers' Coop, but more likely because she had a crush on Warhol and didn't want to be left out. Warhol refers to her in *POPism* as his "first female superstar."[53] He explains that "we decided to shoot a silent Tarzan movie around the bathtub in our suite at the Beverly Hills Hotel—with Taylor as Tarzan and Naomi as Jane."[54]

Mead's body was the exact opposite of that of Tarzan, who was played by the Olympic swimmer Johnny Weissmuller in the first twelve Tarzan movies. Rather than being muscular like Weissmuller, Mead was skinny and elastic—very much like the ninety-seven-pound weakling displayed in muscle ads in kids' comic books of the period. Warhol must have seen the comic potential of deconstructing one of the popular images of masculinity simply by casting Taylor Mead as an unlikely

Tarzan. Warhol creates additional irony by having Mead play opposite a voluptuous Jane.

As an attempt at making a genre film, Warhol's *Tarzan and Jane Regained, Sort Of . . .* has a distinct amateur quality. The film's similarities to Rice's work no doubt stem from Mead's influence, even if he ridicules the results through his good-natured but critical commentary. Yet the film is important for several reasons. It demonstrates Warhol's interest in narrative, in a performance-oriented cinema, in the abdication of authorial control, and in the debunking of Hollywood's conceptions of masculinity. *Tarzan and Jane Regained, Sort Of . . .* is also concerned with transformation. In Warhol's imagination, Mead can play Tarzan, well-known Los Angeles locations can replace the jungle, dogs and cats can substitute for wild animals, a hotel swimming pool can be a river, a doll can substitute for a person in a heroic rescue, actors can refuse to follow scripts, stunts can be obvious, sexual subtext can be made overt, and Jane can somehow turn into a dog.

In the film, Warhol employs a home-movie or amateur aesthetic with lots of quirky camera movements, pixilated sequences, and repeated jump cuts that disrupt conventional continuity. He also combines black-and-white with color footage. There is a sense that Taylor Mead and the other performers have been left to improvise for the camera, so the actors, especially Mead, are often controlling the action instead of Warhol directing it. There's no attempt at naturalism; the artifice of the production is continually emphasized.

Tarzan, for instance, plays on gymnastic rings to suggest his ape-like skills, and Jane, or "Jane Levine," as she's referred to in Mead's commentary, is introduced eight minutes into the film and immediately disrobes on the beach. She then swims naked in the hotel pool, in color, to the sounds of Dionne Warwick's "You'll Never Get to Heaven (If You Break My Heart)." Jane floats on her back, and her large breasts extend above the water in the black-and-white sequence that follows. The film cuts from Tarzan lying in the sand to Irving Blum and a woman at an art opening. There is another cut to Tarzan flexing his muscles atop monkey bars, and to him pounding his breasts with his fists in a bathtub full of soap bubbles to the sounds of the Orlons' "South Street." Jane and Tarzan take turns washing each other. Mead mockingly comments: "This is the bathtub scene. It's endless . . . [laughing] One of Andy Warhol's greatest scenes." After Tarzan and Jane later cavort around the Watts Tower (in color footage), there is a cut to Tarzan lying with a dog. He lifts the dog's ear. On the sound track, Mead explains: "Jane

FIGURE 9. Taylor Mead (center) and Naomi Levine; *Tarzan and Jane Regained, Sort Of...*, 1963 (16mm film, b/w and color, sound, 80 minutes. Film still courtesy of The Andy Warhol Museum)

Levine has been changed into a dog by the forces of evil. Whereupon he still loves her, however. However, her ears have become rather large. But she is still beautiful. Tarzan rolls her over in the clover. And it's the same old affair."

Dennis Hopper makes a cameo appearance in which he compares muscles with Tarzan. Over a shot of Warhol, Mead mockingly says on the sound track, "The great director Andy Warhol." Tarzan looks up, and the camera pans up a tree. Mead continues, "Tarzan refuses to follow the script." Warhol gestures to the tree and hands Tarzan a crumpled piece of paper that represents the script. Tarzan rips it up and Warhol beats Tarzan's bare buttocks with a palm leaf. Hopper, presumably as Mead's stuntman, climbs up high and then swings down. He lips synchs, "I quit."

Tarzan rescues a large doll floating in the water. After he gets sprayed by a water hose, he fights to get the hose away from the villain (fellow Pop artist Claes Oldenburg) and chases him down the block. Tarzan beats his fists against his chest in victory. At the beach in Venice, Tarzan's simulated attempt to swim in grass is intercut with a shot of a large tur-

tle eating lettuce. In blue-tinted shots, Jane and Tarzan first walk down and then up the steps. Tarzan's loin cloth covers only his genital area, but his backside is bare. As he walks behind Jane, Tarzan twice lifts up Jane's dress, revealing her naked rear end. Jane gets attacked by a man with a rifle. All three of them fall on the ground. The song "Too Fat Polka (She's Too Fat for Me)" plays on the sound track. As Tarzan and Jane paw each other, Mead suggests on the sound track, "This should be the end right in here," but it continues. After another attack, Jane is left sprawled on the ground, but Tarzan comes by and revives her. We then see her at an A & W restaurant, where Tarzan suddenly appears next to her. The camera frames them in a handheld two-shot before it zooms in on Tarzan.

TAYLOR MEAD'S ASS

In the first feature film in which he acted, *The Flower Thief*, Taylor Mead's pants fall down as he climbs over a fence, exposing his naked rear end to the camera. Occurring early in the film, it's a sight gag reminiscent of silent cinema—one that Mead would subsequently repeat a number of times. In *Tarzan and Jane Regained, Sort Of . . .* , Mead's loin cloth covers his front, but leaves his backside exposed. As Tarzan and Jane dance in the shower, the camera emphasizes their buttocks. When Tarzan refuses to follow the script in the scene with Dennis Hopper, Warhol spanks Tarzan's naked rear end. *Taylor Mead's Ass* (1964) was made in direct response to a letter of complaint by filmmaker Peter Emanuel Goldman in the *Village Voice* that he was tired of Jonas Mekas praising "films focusing on Taylor Mead's ass for two hours."[55] Since no such film actually existed, Warhol and Mead playfully set about creating a film devoted to this premise.

Mead creates a variety of skits involving his naked backside throughout the film. He engages in a dance number, a striptease act, and a magic show—all rolled into one. The effect of *Taylor Mead's Ass* is erotic, scatological, and comedic. Throughout the film, Mead's ass is shown to be remarkably pliant. Light and shadow alter its shape through the angle of his body and his proximity to the light source, and Mead deliberately contracts and expands his sphincter muscles to create similar effects. At times he shakes his rear end so fast that it almost creates a blur, suggesting an animated effect. Mead also uses his hands and assorted objects, such as a triangular mirror, to distort its form. He even employs his hands and plastic spoons to turn his buttocks into a drum. Mead vacu-

ums it, rakes it with a fork, and stabs it repeatedly with a utensil. He creates an elaborate dance with toilet paper and gaffer's tape.

Besides an extended section where Mead uses a motorcycle or patrolman's hat as a prop in a sexy dance that suggests a striptease, much of the film could be described as a bad magic show, where the artifice is apparent. At around nineteen minutes, Mead simulates placing various items into the shadowed crack of his buttocks: one- and ten-dollar bills, a *Life* magazine with the Beatles on the cover, a copy of *Time*, a male porno magazine, a program from the New York Film Festival. He also places various books, which range from Hemingway's *A Moveable Feast* to Susanne Langer's *Philosophy in a New Key*. The film contains a number of references to popular culture, including Mead's placement of a box of Tide detergent.

As befits its subject, *Taylor Mead's Ass* emphasizes scatological elements. Mead manipulates a long wooden stick to suggest he's defecating, and then lets round balls drop from his butt. He maneuvers a long-stemmed rose in a similar manner, and later makes it appear as if the long nozzle of a vacuum cleaner is emanating from his rear end. He also uses a fork and spoon suggestively. If Mead plays with the notion that his anus is a receptacle, he later uses a pair of needle-nosed pliers to remove various items: a plastic spoon, a Fritos wrapper, a book of his poems, and other assorted objects.

Even though *Taylor Mead's Ass* was initially filmed as a joke, it demonstrates Warhol's interest in depicting the human body, which was already evident in *Sleep*. The comedic aspects of the film were undoubtedly contributed by Mead. While it lacks the formal rigor of *Sleep, Kiss, Blow Job, Empire, Eat,* and *Henry Geldzahler,* it is linked to those films in its emphasis on transformation. Warhol doesn't merely show us Taylor Mead's ass for seventy-six minutes; he turns it into a theatrical spectacle.

COUCH

Throughout the 1960s, Warhol continually tried to push the limits of what might be permissible under prevailing censorship laws. Warhol's *Lonesome Cowboys* and *Blue Movie* would later be banned, but, interestingly, he kept his sexually explicit home movie *Couch* (1964) private rather than public by mostly showing it within the confines of the Factory. *Couch* explores the various activities that can occur on a single piece of living room furniture, but it also explores the issues of transformation and narrative as much as any Warhol film.

It begins with a shot of the filmmaker and poet Piero Heliczer sleeping on the couch without a shirt, while Gerard Malanga, in a black leather jacket, hovers above him on the headrest, and Warhol's *Flowers* can be seen in the background. In the second shot, Naomi Levine strikes naked pinup poses on the couch, as a dapper male motorcyclist with sunglasses tinkers with his motorcycle, thus presenting contrasting sexual stereotypes of femininity and masculinity derived from popular culture. Despite Levine's blatant attempts to seduce the man, he's clearly more interested in his mechanical machine than in her extremely large breasts.

The third scene pays tribute to the beat classic *Pull My Daisy* (1959) and features the poet Gregory Corso sitting on the couch with a book, as well as Allen Ginsberg squatting on the floor and then moving about, and Jack Kerouac and Peter Orlovsky. Rolls 4, 6, and 7 depict men and women eating bananas on the couch. In the fourth, Joe LeSueur, John Palmer, and Gerard Malanga eat bananas, while Ivy Nicholson hangs upside down. The sixth features Baby Jane Holzer, Naomi Levine, Amy Taubin, and Gerard Malanga, while the seventh has the same performers as the fourth roll.

The first half of *Couch* seems like a home movie, in which the participants largely sit around and mug for the camera, but the sexual subtext of the earlier scenes rises to the surface with the eighth shot. It begins with Gerard Malanga, naked, kneeling on top of the fully clothed Ondine as they make out on the couch. Two other men come out; one (Walter Dainwood) sits down, while the other, who is shirtless (Binghamton Birdie), pours beer on Malanga and then puts a leather belt around his neck.[56] Dainwood uses a triangular piece of a mirror to observe the action behind him, and then shatters it. As Malanga and Ondine embrace passionately on the couch, we get a type of vaudeville skit as another man starts vacuum cleaning them as well as the broken pieces of mirror on the floor. Malanga eventually sprawls on top of Ondine, who fondles his buttocks as they make out. The man removes the vacuum cleaner from the shot and passes back and forth through the frame, carrying a suitcase, then variously sized buckets and objects, creating a series of visual distractions to Malanga and Ondine, as Dainwood, wearing sunglasses, leans against the couch.

In the ninth shot, Malanga, still naked, and Ondine, still clothed, lie together on the couch. Dainwood sits and smokes a cigarette on the right-hand side of the screen. He starts to take off his clothes as Ondine

lowers his own shorts in the background. Birdie brings out a chair and does a handstand on it, as Ondine straddles Malanga and Dainwood removes his clothes and carefully folds his pants. Dainwood gets up and removes his dark bikini underwear so that he's naked, then sits down, as Ondine positions Gerard's legs over his shoulders. Birdie and the other man come out and dance in front of Ondine and Malanga, who now has an erection. Dainwood, still naked, gets up and dances close to the camera, creating a dark silhouette, blocking us from seeing the sexual activity in the background, before sitting down again.

The tenth shot uses a similar strategy by having Dainwood, now clothed, partially obscure Ondine playing with Malanga's penis throughout the scene. Because Dainwood picks up broken pieces of mirror from the floor, this shot suggests that the ninth and tenth rolls might be spliced out of sequence. The suspected temporal shift becomes confirmed in the eleventh shot. Ondine lies on the couch, while Gerard Malanga and Binghamton Birdie initially sit. Malanga begins to strip, gets up, removes his belt, and gives it to Ondine, who whips him very lightly a couple of times. Once naked, Malanga straddles Ondine. Birdie dances over and interacts with them briefly, while someone sits down on the right side of the frame. As Birdie walks screen right, he bends down and peers into the camera before exiting the frame. Dainwood is then revealed to be the person on the couch. Birdie comes behind the couch and participates in the action with Ondine and Malanga. Ondine leans over and picks up a bottle of beer. He hands it to Birdie, who empties the contents on them. The shot ends with splice marks and flashes of overexposed frames of the very first shot.

The twelfth shot features a threesome involving Rufus Collins, Kate Heliczer, and Gerard Malanga. As Heliczer lies on top of Collins on the couch, Malanga appears to stimulate Heliczer's anus orally and then have anal intercourse with her for the remainder of the shot. The thirteenth shot shows Ondine, wearing sunglasses, sitting on the couch, stroking someone's clothed crotch, while a woman sits and smokes in the foreground on the left, obscuring the person's identity. While we might assume it to be Malanga, the person wears light trousers rather than the dark jeans Malanga had on earlier, raising the possibility it could be Heliczer. Ondine talks to someone outside the frame, while the woman continues to smoke. Ondine undoes the person's zipper, takes a hit of a joint, pulls down the person's pants, and begins performing oral sex on him. Ondine comes around to the front of the couch and continues to fellate the obscured figure until the reel runs out.

FIGURE 10. Ondine and Gerard Malanga on couch, and Walter Dainwood; *Couch,* 1964 (16mm film, b/w, silent, 58 minutes @ 16 fps. Film still courtesy of The Andy Warhol Museum)

Formally, *Couch* reiterates strategies of staging action in both foreground and background used previously in *Haircut (No. 1)*. The activity in the foreground distracts the viewer from the sexual activity in the background, but, like the act of Herko opening and closing his legs, Warhol understood the eye's natural inclination to be drawn to sexual images, so that the comic skits, dancing, gymnastics, or cigarette smoking only provide temporary distractions. He also teases the viewer by obscuring certain elements, such as the nature of the sexual activity or the identity of the person.

The film also plays with time in a manner similar to *Eat* by splicing the rolls out of sequence, which only becomes obvious in the scenes involving Malanga and Ondine. *Couch* disrupts the logic of narrative sequence in shots 8 to 11. Warhol also incorporates other narrative elements, such as the comedic skits and activities that occur in the foreground of shots 8 and 9. In addition, the film is structured so that the first half creates a sexual subtext—Levine's attempt at seduction and the overt symbolism of the banana eating—that sets up the viewer for the sexual acts that occur in the second half.

SOAP OPERA

Soap Opera (1964) combines elements from both *Kiss* and *Couch*. The film is partially silent, but contains sound as a result of the inclusion of a number of TV commercials by Lester Persky, a strategy that links it more closely to Pop art. When asked how he felt about the interruption of television by commercials, Warhol responded: "I like them cutting in every few minutes because it really makes everything more entertaining. I can't figure out what's happening in those shows anyway. They're so abstract."[57]

Soap Opera involves a series of narrative episodes interrupted by commercials, or it might be better described as a series of product commercials interrupted by melodramatic scenes, since it begins with one of a chef advertising a rotisserie broiler. In the first episode, which is stylistically reminiscent of early silent cinema, Gerard Malanga and another man, both dressed in jackets and ties, smoke cigarettes in a small garden area. They appear to be rival suitors, who eye each other warily. The scene employs a conventional shot sequence that is unusual for an early Warhol film. A woman comes out of the house and hands the man a letter. He opens the envelope and reads the missive. After the man looks over at Malanga, we see a close-up of the letter, followed by a reaction shot of his face. As he starts to move out of the frame, the woman and Malanga sit in the chairs.

Baby Jane Holzer comes out, leans over, and begins kissing Malanga. In close-up they rub noses and touch lips. Holzer stands up and maneuvers Malanga into the house. We return to a close-up of the first woman. A bearded man, Sam Green, exits from the house, sits next to her, and tries to kiss her. In a close-up, they slowly touch noses. The camera moves to frame Green before shifting to a wider shot of the two of them sitting in the garden. This is followed by a commercial for Glamorene rug cleaner. We then get a shot of Holzer lying on a couch and Malanga, now shirtless, holding her foot, while she pets a cat. When Malanga starts to put on his shirt, Holzer moves forward and the camera zooms in and then back out. The two appear to be arguing. Two other women enter the frame and physically attack Holzer, while the camera frantically zooms in and out on the action. Holzer eventually flees the frame as the two women discuss the situation using very theatrical gestures.

The TV commercials not only create temporal gaps in the narrative, as evidenced by the one for Glamorene, but they also provide metaphoric commentary on the action. In the most outrageous commercial,

FIGURE 11. *Soap Opera (aka The Lester Persky Story)*, 1964 (16mm film, b/w, sound and silent, 47 minutes. Film still courtesy of The Andy Warhol Museum)

which Warhol shows twice, a fashion model "scientifically" proves that a single shampoo and hair setting can survive a grueling seven-day experiment aimed at destroying the waviness of her hair. At one point, she employs "a terrible torture test"—a steam and hurricane wind tunnel—in the studio. She pulls a switch that emits a gush of steam that obliterates her image, and moments later, an enormous burst of wind that envelops her. The model then brushes her hair and the waviness magically returns. The commercial provides a humorous commentary on subsequent scenes involving Baby Jane Holzer, the fashion model and superstar known for her enormous mane of hair.

The commercials, on the whole, prove far more entertaining than the various couples who kiss, argue on the phone, slap each other in the face (Ivy Nicholson repeatedly slaps Sam Green), ignore the other's advances, or engage in multiple flirtations and infidelities. In one for a deodorant, a daughter comes to the aid of her mother, who is stressed out over a surprise anniversary party. Another for muscular dystrophy ends with Jerry Lewis and the poster child shooting at each other with toy guns. A Morse-Whitney cordless carving knife connects to the next scene, in which a man in the foreground fondles his crotch while women

dance in the background and a dancing sailor eventually appears on the right side of the screen. The sexual connotations of the masturbatory activity are reinforced by an erotically charged Pillsbury commercial for cake frosting.

Following this, there is a scene in which Holzer is unable to seduce Sam Green away from his newspaper. While the bearded Green covers his face with the paper, he transforms (via in-camera editing) into another man, which only becomes obvious once Holzer comes over and tries to kiss him, allowing us to see his face.[58] After this scene, there is a commercial for a "Wonda-scope," a small, plastic, multipurpose device that serves as an all-in-one microscope, telescope, magnifying glass, and compass. It even includes a polished mirror that "helps you look your best at all times." In an overexposed shot that follows this, a naked woman gyrates sexily in front of a large oval mirror. The film ends with a reaction shot of Gerard Malanga, who gapes at her.

By incorporating actual television commercials into the film, *Soap Opera* mimics Warhol's fascination with images derived from popular culture, which he featured in his paintings and sculptures. Not only do Lester Persky's commercials reflect some of the same anxieties depicted in the narrative segments, but they highlight the fact that television soap operas serve as a pretext to sell products. It's not surprising that a Pop artist would invert their relationship, or that Warhol would find Persky's commercials far more entertaining than the melodramatic situations he depicts in *Soap Opera*.

Although Warhol's early films are generally thought to be concerned with mundane events, a much different picture of the so-called minimal films emerges once films such as *Couch; Tarzan and Jane Regained, Sort Of . . . ;* and *Soap Opera* are taken into consideration. The narrative aspects of *Sleep, Kiss, Blow Job, Eat, Empire,* and *Henry Geldzahler* may have seemed less obvious to critics and commentators initially, but upon closer analysis, they exhibit the same structural organization that Deutelbaum finds in the Lumière films. He writes: "As these descriptions of the brief Lumière films illustrate, there is little reason to continue to regard them as naïve photographic renderings of natural events which happened to occur before the camera. Even the slightest of the slight events discussed here reveals an attempt to impart a shape to the action depicted."[59]

Films such as *Tarzan and Jane Regained, Sort Of . . . ; Couch;* and *Soap Opera* serve to make Warhol's interest in narrative more apparent.

Tarzan and Jane Regained, Sort Of . . . has an episodic structure, *Soap Opera* employs melodramatic sequences mixed in with commercials, and *Couch* contains narrative sequences of sexual acts involving Gerard Malanga and Ondine, even if they are presented out of order. Taken as a whole, the early films explore a broad range of narrative possibilities. Warhol's films involve physical transformation, such as the erasure of the Empire State Building in *Empire*, psychological transformation, as in the case of *Henry Geldzahler*, and even stylistic/technical transformation, such as his choice of framing in *Blow Job* or the use of reprinting to increase the amount of grain and contrast in *Sleep*.

Even though narrative has become something of a bogeyman in the history of avant-garde cinema, Warhol's interest in it intensified once he decided to move into synchronous sound filmmaking. It was hardly a coincidence that he engaged Ronald Tavel to write a series of scenarios for him. Tavel would profoundly affect the direction of Warhol's work by making his concern with issues of narrative and transformation even more pronounced.

Scenarios by Ronald Tavel

We Have Your Number

Warhol made a number of radical shifts in his artistic practice through-
out his career, including renouncing painting for filmmaking at the height
of his success as a Pop artist. While developing a style that many crit-
ics associated with a fixed camera and minimalism, Warhol confounded
some of his avant-garde film admirers by abruptly shifting into mak-
ing theatrical narrative sound films with then-unknown writer Ronald
Tavel. Most critics and scholars still find it difficult to reconcile the two
sensibilities, as if, according to Tavel, the Theatre of the Ridiculous, with
which he was later associated, "represent[ed] a different life-energy from
Warhol's."[1] He adds: "It's really crazy, like denying his [Warhol's] con-
nection with rock'n'roll, what he did for the Velvets. To say that he had
no connection with hysteria, flamboyance, largeness, garishness, is not
true; it also denies him his later color period in which he makes the point
of stepping forward as a colorist."[2]

There is little question that the brilliant playwright Ronald Tavel ex-
erted a profound creative influence on Andy Warhol through the films he
scripted, most notably *Screen Test # 1*, *Screen Test # 2*, *The Life of Juanita
Castro*, *Horse*, *Vinyl*, *Kitchen*, *Space*, and *Hedy*. Warhol's other major
collaborators, Chuck Wein and Paul Morrissey, also helped to shape the
direction of Warhol's subsequent work, as did many of the superstars—
Mario Montez, Gerard Malanga, Edie Sedgwick, Mary Woronov, Nico,
Ondine, Viva, and so forth—whose personalities were used to create ve-
hicles to display their natural talents. Steven Watson writes:

The artifacts of the Factory collaborations demand models of authorship that do not fit conventional monographic discourse, interpreting the artist as a solitary genius. The Factory group process of creation is inevitably flattened: whatever was created in Warhol's presence became "an Andy Warhol." One of Warhol's greatest "works" was, in fact, psychological: the creation of a physical/social place where people "performed themselves." They determined how they would present themselves to the camera or to the tape recorder; Andy Warhol framed them and pushed the button. The Silver Factory was a "social sculpture," in which Warhol broadened the concept of authorship. In an arena where everything was possible and self-determination was the rule, who could be credited as the author?[3]

Even at a recent symposium on Warhol's work, part of the exhibition "Andy Warhol: Other Voices, Other Rooms" at the Wexner Center for the Arts, the issue of authorship caused lively debate.[4] The question arose as to why art historians still find it necessary to attribute authorship solely to Warhol given the collaborative nature of his artistic practice.

The answer is bound up with the notion of "branding." In his book on the economics of the art world, *The $12 Million Stuffed Shark: The Curious Economics of Contemporary Art*, Don Thompson defines the term: "Branding is the end result of the experiences a company creates with its customers and the media over a long period of time—and of the clever marketing and public relations that go into creating and reinforcing those experiences."[5] Thompson discusses how branding works within the art world by citing the careers of artists such as Damien Hirst, Jeff Koons, and Warhol.

Damien Hirst's art works, including his spot paintings, for instance, are all done by assistants. As Thompson explains, someone named Rachel does the best job of painting the spots. In fact, Hirst recommends that collectors really want to own one of the paintings executed by her because she's so much better at painting spots than everyone else, including him.[6] Does that make Rachel the true author of Hirst's spot paintings? Hirst comments, "I like the idea of a factory to produce work, which separates the work from the ideas, but I wouldn't like a factory to produce the ideas."[7] Warhol wasn't so fussy. He took ideas wherever he could get them, including those that came from other people. Yet Warhol decided which ideas he ultimately chose to brand.

The films that Warhol made from Tavel's scenarios are, for the most part, very much stamped with the writer's personality. Andrew Sarris, in his review of *The Life of Juanita Castro*, writes: "The creative force behind 'Juanita Castro' is not so much Warhol, actually, as Ronnie Tavel, who wrote the script, and acted the key role of the stage manager, and

very good he is in both capacities."[8] What might Sarris say about a film such as *Horse,* in which Warhol can be seen talking on the telephone? Yet in the Tavel-inspired films, Warhol was not really an absence. He made a number of stunning decisions that contributed to the success of the films. For example, it was his idea to make a synchronous sound film like *Harlot,* but have the improvised sound track be completely unrelated to the visuals. It was Warhol's inspiration for Tavel to create an inquisition of his current boyfriend, Philip Fagan, in *Screen Test # 1.* When that didn't turn out, Warhol came up with the idea of remaking the film using Mario Montez. Not only did Warhol propose *The Life of Juanita Castro,* but, to everyone's surprise, he chose Marie Menken to play the lead role. In addition, Warhol's last-minute decision to change the camera angle turned out to be a determining factor in the success of the film.

In *Horse,* it was Warhol's idea to rent a horse and bring it into the Factory. In addition, the middle section, where the horse and trainer interact with the rest of the Factory in a single wide shot, makes the other scripted sections work far more effectively, especially because Warhol chose to show the reel out of sequence. He also decided to buy the rights to Anthony Burgess's acclaimed novella, *A Clockwork Orange,* in order to make *Vinyl.* Tavel didn't much care for the book; it was Warhol who perceived its relevance. Warhol also decided to add Edie Sedgwick to the composition at the last minute by having her sit on a silver-painted trunk on the right side of the frame. Cast as an extra, Edie stole the show. It was Warhol who persuaded Tavel to write a film for Edie, entitled *Kitchen.* He not only chose the location, but also gave Tavel specific instructions for a screenplay. Tavel didn't disguise his dislike of Edie, but *Kitchen* proved that Warhol was absolutely right in recognizing that she had the screen presence to become a major superstar.

Not much has been written about *Space,* but the film's use of chance operations relates much more to Warhol's interests than Tavel's. Despite the film's conceptual basis, the casting of folk singer Eric Andersen as well as Edie and her Cambridge friends would hardly seem to represent Tavel's choices. Given what transpires in the course of the chaotic film, it is no wonder that Tavel wound up fleeing from the set. Tavel also wrote the scenario for *Hedy,* in which Warhol's much criticized mobile camerawork (rather than the tabloid story of Hedy Lamarr) turns out to account for the film's interest. Without Warhol, these films would not have existed.

HARLOT

Tavel explains in an interview: "In the fall of 1964, Andy had just finished a block of silent films and he wanted to move into sound. Since he thought abstractly, his first thought was to have a voice that had nothing to do with what was on-screen, so that it would force interpretations."[9] Warhol's initial move into synch sound, *Harlot*, features Mario Montez, the transvestite performer from Jack Smith's *Flaming Creatures* (1963), and Tavel, who was known by Warhol to be a talented writer. Although *Harlot*, in which Montez suggestively eats a number of bananas while reclining on a couch, was shot with a synch-sound Auricon camera, Warhol chose to eschew the use of onscreen dialogue altogether. The tableau-like composition also includes Gerard Malanga, dressed in a tuxedo, Philip Fagan, who for the most part glowers at the camera, and Carol Koshinskie, the star's supposed lesbian lover, who also stares directly into the camera while holding a white cat. There is very little action otherwise. Malanga puffs on a cigarette and blows smoke at Montez in the first reel. In the second, Malanga and Montez engage in an extended and passionate kiss, and Malanga performs a brief skit in which he offers cigarettes to Fagan, who lets them drop from his mouth. At the end, Fagan dumps his drink on Koshinskie's head, and she in turn showers him with a can of Pabst Blue Ribbon beer. Music from *Swan Lake* builds dramatically at the end, while shouts from the offscreen voices of "Bad Banana" and "Eat Me" repeat on the sound track.

As in *Blow Job* and *Haircut (No. 1)*, Warhol exploits the relationship between onscreen and offscreen space. Instead of recording the actual performers, Warhol mikes the offscreen, improvised banter of Tavel, Billy Name, and Harry Fainlight, whose comments have only tangential bearing on the main action, which involves Montez's simulation of fellatio and sexual intercourse with the bananas. Billy Name, in particular, occasionally subverts the flow of the verbal interactions between Tavel and the poet Fainlight with Beat expressions and inflections reminiscent of Kerouac's verbal riff on the sound track of Robert Frank and Alfred Leslie's *Pull My Daisy*.

In "The Banana Diary," Tavel writes: "Jean Harlow is a transvestite, as are Mae West and Marilyn Monroe, in the sense that their feminineness is so exaggerated that it becomes a commentary on womanhood rather than the real thing or representation of realness."[10] Montez's over-the-top rendition of the actress Jean Harlow clearly demonstrates

Warhol's ambivalent relationship to Hollywood's emphasis on glamour as a strategy for providing audiences with vehicles to display its stars. In *Harlot,* Warhol deconstructs such notions through camp portrayal, the extended temporal duration of very limited actions, a decidedly juvenile obsession with the phallic nature of bananas, and what occurs through the disjunction between image and sound.

SCREEN TEST # 1

Screen Test # 1 (1965) is a portrait of Philip Fagan, who appeared in *Harlot* and was Warhol's lover at the time.[11] According to Tavel, Warhol gave him explicit instructions for writing the script: "Go home and devise an inquisition, basically. Sit and ask him questions which will make him perform in some way before the camera. . . . And the questions should be in such a way that they will elicit, you know, things from his face because that's what I'm more interested in rather than in what he says in response."[12] In other words, Warhol specifically asks Tavel to manipulate Fagan in order to provoke certain emotional responses. While this doesn't make for a very dynamic film, this screen test is as psychologically revealing of Fagan as *Henry Geldzahler* was of its subject. Instead of serving as a star vehicle, *Screen Test # 1* turned out to be Warhol's instrument for revenge against Fagan, who, according to Tavel, turned out to be unwilling to have sex with him.[13]

Shot in medium close-up, Philip Fagan stares directly at the camera. He's dressed in a black tee shirt and lit by a key light positioned screen left, so that the other side of his face has more shadows. For roughly four and a half minutes, nothing happens except that Fagan occasionally blinks. Tavel, who plays the role of the "Tester," instructs Fagan to relax, but, as he continues to direct him, Fagan clearly becomes more self-conscious, as evidenced by the quivering of his lips, facial tics, movement of his Adam's apple, and other gestures and facial responses, including when he suddenly breaks into an uncomfortable grin.

Tavel asks Fagan to smile like the Mona Lisa in profile, and then to give a full-face smile. After indicating a preference for the profile shot, Tavel suddenly asks Fagan, "Have you ever seen the Indians scouting with their hands over brow?" Fagan smiles and responds, "Only in the movies." Tavel then directs him to play an Indian. The role playing appears to have been nothing more than a setup; Tavel suddenly gets very personal: "Now I want you to think about your family. Concentrate. You're thinking about your mother." In response, Fagan scrunches his face. He

tries to smile, but his lip quivers again. Tavel probes whether he wants to tell us anything about his mother, his father and brother, while Fagan stares ahead unresponsively.

Tavel then asks Fagan about his shoplifting of a pair of red panties. After originally denying it, Fagan, in response to Tavel's probing, admits he stole the red panties for his "girlfriend's Christmas present." Tavel later suggests, "Maybe you didn't intend to give those panties to your girlfriend?" When Fagan hesitates, Tavel interjects, "Louder?" Fagan sheepishly replies, "Well, what difference does it make?" Tavel has Fagan face forward and repeat the line, "I'd like to kiss her when she bows." After various line readings, Tavel asks, "Where would you like to kiss her when she bows?" Fagan answers, "On her foot." After several more line readings, Fagan asks Tavel to move on to something else. Tavel gets Fagan to pose with his hand raised in the gesture of a supplicant and say, "Oh Lord, I commend this spirit into thy hands." He then wants Fagan to use this same gesture in repeating the line, "I'd like to kiss her when she bows." Fagan is reluctant, but Tavel insists that this is an important part of the screen test. Fagan does it, but he drops his hand afterward and appears frustrated. Tavel then connects the red panties to wanting to kiss the woman when she bows. He asks Fagan again where he would like to kiss her. When Fagan again indicates her foot, Tavel responds, "I think you should have shoplifted a pair of shoes."

Tavel has Fagan give a look of innocence and inquires about the ways he's good and bad, which makes Fagan uncomfortable. He closes his eyes and answers evasively, "I'm bad in the ways that I'm not good." Tavel indicates that he believed Fagan's performance when he closed his eyes. Tavel probes Fagan about his reactions to going to jail, asking him whom he intends to call when he gets out. Fagan responds, "Andy Warhol," as he breaks into a big grin. Tavel asks him, "What if you called your brother and told him what happened?"

In the first reel, it's clear that Fagan fails to engage imaginatively with Tavel's questions, which we suspect have deep personal implications. Fagan seems to be completely inhibited, and his face registers discomfort throughout. As a psychodrama, Fagan's silence, blockage, and lack of spontaneity actually reveal a great deal about his character. Eric Bentley describes what would happen in an actual psychodrama: "When the protagonist, at a psychodramatic session, is found to be reluctant, silent, overdefensive, another person is asked to play his double and to come forward with exactly those responses which the protagonist is holding

back."[14] While there's no double to assist Fagan here, it is noteworthy that Tavel describes Fagan's screen test in purely psychoanalytic terms:

> In the first reel, Philip is reminded of an unpleasant incident that puzzled him, his shoplifting of a pair of red panties he'd convinced himself he intended as a gift to a girl. The memory is interlaced with painful misgivings concerning his father, then brother, for his convoluted relations with them actually caused the shoplifting. He evidently conjures up for himself on screen a forceful and incestuous image of the insteps of both these men. Then he quietly struggles as he relives his guilty transference of them to the girl—which guilt had sought assuagement in his being caught shoplifting.[15]

Thus, the shoplifting of the red panties suggests unfinished business related to a traumatic event in Fagan's past life, which the screen test forces him to re-experience as a psychodrama.

As the second reel begins, Tavel asks Fagan to recite lines that appear to be from a poem, which begins, "There will be a competition for his heart." Fagan initially looks offscreen and starts to laugh. When Tavel asks him to repeat the line "Ah—the hurdles, the leaps—his own phrase," Fagan responds that it's too difficult. Tavel improvises additional lines, but Fagan insists, "Too hard." He closes his eyes; his lip quivers. When Tavel prods him with more lines, he says, "Not again, go on." Fagan smiles, but it's clear he's become rattled by the personal content of the poem. After Tavel continues to repeat the poem, Fagan insists, "No more."

The reference to a poet who will write beautiful poems is Gerard Malanga, Fagan's perceived rival for Warhol's attention at the Factory.[16] Tavel has set about exploiting Fagan's jealousy. Once Fagan realizes that the screen test has become a setup, he refuses to repeat lines that make him uncomfortable. His sense of frustration and betrayal becomes palpable. There's a line that refers to his own physical beauty: "I will give him my face. Can anyone here deny that I have a beautiful face?" Right after this, Tavel asks Fagan to repeat, "And I will give him my nipples and soul." Fagan makes a face and finally responds, "It sounds better when you read it." Tavel repeats the line, but Fagan just stares at the camera. After Tavel gives him another line and says, "Try that," Fagan counters weakly, "You read it. It sounds better when you read it." Tavel asks him, "Do you feel it at all?" Fagan admits he feels blocked by responding, "I can't say it." Fagan looks down rather than at the camera.

Tavel references the movie *White Cargo* (1942), which starred Hedy Lamarr in the role of Tondelayo. Tavel says, "I am Tondelayo with a

FIGURE 12.
Philip Fagan; *Screen Test
1, 1965* (16mm film,
b/w, sound, 66 minutes.
Film still courtesy of The
Andy Warhol Museum)

facelift. When I had my facelift performed, they made me look like I was fourteen-years-old, so now I can't appear in public until I get a little older." Fagan bursts out laughing in response. Tavel later asks to see his tattoo. Fagan continues to peer offscreen and make faces as Tavel ridicules the tattoo by intoning, "It seems to be death on wings." Fagan stares in the direction of the camera. Tavel says, "Mr. Fagan, will you zipper up your fly, please? We can't have people taking screen tests with their flies open." Fagan looks screen left and makes a face. Tavel then imitates a sexy female. He is so funny that he makes Fagan laugh, but otherwise Fagan has shut down almost completely. As Tavel improvises and repeats words that he hopes will conjure up associations, Fagan merely positions his body at a forty-five-degree angle and stares straight ahead. Tavel ends by thanking Fagan. He says, "Don't call us; we'll call you. We have your number." Tavel repeats the last line and emphasizes, "We have your number."

Tavel makes fun of Fagan throughout the screen test. Fagan is aware of this, of course, but he does not have the verbal dexterity to counter the clever spider's web of words that Tavel weaves to ensnare him; his only response is to stare silently ahead. It was actually Fagan's idea to employ Tavel to write star vehicles for him, but, as *Screen Test # 1* attests, Fagan seemed to be deluded about his own talents as a potential superstar.[17] As a psychodrama, *Screen Test # 1* is fascinating, precisely because Fagan lacks spontaneity—he is so inhibited and blocked in his feelings. He's certainly no match for Tavel, who demonstrates his talent as a performer through imaginative and spontaneous improvisation, whereas Fagan's only defense is to play possum.

The film is absolutely brutal in how it deflates and ridicules Fagan. The sense of betrayal he experiences during the screen test is so patently obvious that, as we watch it, we doubt his relationship with Warhol could have survived such public humiliation. Fagan was also the subject of *Six Months*, an extended daily photographic portrait that dealt with the physical transformation of the human face over time.[18] Scheduled for six months, it was terminated on February 9, the same day that Warhol and Tavel decided to reshoot the screen test utilizing Mario Montez rather than Fagan.[19] *Screen Test # 2* marked the end of Warhol's relationship, both personally and professionally, with Fagan. There couldn't be a more striking contrast between the inhibited and stoic Fagan and Mario Montez, the flamboyant transvestite performer.

SCREEN TEST # 2

After the failure to puncture Philip Fagan's protective armor in *Screen Test # 1*, Warhol realized that the concept would work better with Mario Montez. Tavel quotes Warhol as saying: "So, we're going to do the same thing because I love this idea of *Screen Test*, and it has to work, and the problem here has been the subject. So, we'll get Mario Montez, who thinks of himself as a star. All of these things. He thinks he is, and he wants to be, and he is. And, then, that's how we'll pull this off, using the same technique."[20] At the time Warhol made *Screen Test # 2*, Mario Montez had an underground reputation as Jack Smith's reincarnation of the B-movie actress Maria Montez, but was nevertheless anxious to become a famous film star. For Mario Montez, the clock was ticking. Montez later told Tavel that he only had "five years of beauty left" as a performer.[21] Although there are similarities between the two screen tests, Tavel wrote them specifically for each subject. Even though Tavel decided to exploit Montez's deepest vulnerabilities in the scenario for *Screen Test # 2*, Montez proves, in many ways, to be a willing rather than unwitting victim. Montez's performance indicates that he grasped the humor and outrageousness of Tavel's shenanigans. Like most actors in Warhol films, Montez was more than willing to play along, but, like so many others, he wound up being subjected to far more ridicule and abuse than he bargained for.

Warhol understood only too well that mass culture had created an insatiable desire in people to be famous and glamourous. Just as Warhol was able to emphasize the more garish aspects of constructed beauty (hair, eye shadow, eyebrows, and lipstick) in his iconic Marilyn Monroe

series, such as *Gold Marilyn Monroe* (1962), the film portrait of Montez, shot in a soft-focus medium close-up, highlights the exaggerated aspects of femaleness of this transvestite performer. In *The Philosophy of Andy Warhol*, Warhol writes:

> Among other things, drag queens are living testimony to the way women used to want to be, the way some people still want them to be, and the way some women still actually want to be. Drags are ambulatory archives of ideal moviestar womanhood. They perform a documentary service, usually consecrating their lives to keeping the glittering alternative alive and available for (not-too-close) inspection.[22]

In *Screen Test # 2*, however, Montez ends up being subjected to close scrutiny, as we watch the performer's illusions of glamour slowly disintegrate under the sadistic direction of Tavel.[23]

Tavel, who again remains offscreen, structures *Screen Test # 2* like a con game by employing various strategies to entrap his victim. As the screen test director, he begins with flattery and reassurance: "Now Miss Montez, just relax. Relax completely. You're a lady of leisure, a grande dame. You have nothing to worry about. Relax. That's it. You feel comfortable?" With the final question, Tavel expresses concern for the actor. At times, his personal questions to Montez regarding his feelings suggest that Tavel is playing the role of psychoanalyst. Tavel also mimics being a hypnotist in the scene where he lulls him to sleep in the tower, before inducing Montez to have a hysterical reaction to the hunchback.

Throughout the "audition," Tavel controls the pace and tempo carefully, so that Montez hardly ever has time to reflect or offer resistance. Whenever Montez tries to question Tavel, as in the scene where he's supposed to seduce the holy priest, Tavel cuts him off and demands that he follow his orders, dangling the promise of stardom as incentive. Tavel's tactic of asking Montez to repeat a line or gesture implies criticism of the actor's performance. Other times, he faintly praises him or suggests that he's doing quite well. Tavel even goes so far as to indicate that it's already obvious that Montez merits the role and that they'll make a fortune. Yet this is only to induce Montez to lower his guard temporarily; what follows turns out to be even more degrading than Tavel's demand that Montez seduce the priest.

The most fundamental exploitation of Montez involves having him simulate oral and anal sexual acts by getting him to lip-synch the word "diarrhea," to play a female geek, to salivate, and to act out Tavel's version of "spin the bottle." The effect of sexual simulation between the off-

screen groans of Tavel and the onscreen gestures of Montez has obvious implications in terms of spectatorship. Montez fulfills Tavel's sexual fantasies during the audition, making obvious the viewer's own libidinal investment in the sexualized images on the screen, especially Hollywood's dependence on fetishized images of glamour.

In the final scene, where Tavel demands that Montez stare straight at the camera and give "the real cockteaser look," he implicates the viewer in the process by saying, "And let's have a lot of cocks up at erection right there, from row 1 to row Z." Tavel also plays on the perverse nature of Hollywood screen tests. After Montez balks at exposing himself, Tavel tells Montez, "Miss Montez, you've been in this business long enough to know that the furthering of your career often depends on just such a gesture. Taking it out and putting it in. That sums up the movie business." The humor, of course, in Tavel's description of the purpose of the casting couch is grounded in gender reversal.

Tavel creates clear associations between the notion of freaks and the transvestite performer. For instance, he describes a "female geek" as a carnival term for someone who bites off the heads of chickens. Tavel also announces to Montez that the studio is considering him for a role in their remake of *The Hunchback of Notre Dame*. While Montez balks at playing the hunchback, he clearly relishes the thought of playing Esmeralda, the fourteen-year-old gypsy, no doubt because of the association with Maria Montez, who starred in *Gypsy Wildcat* (1944). The audition scenes in the second reel, where Tavel induces Montez to wear a veil, also reference Maria Montez, who played Arabian princesses in such films as *Arabian Nights* (1942) and *Ali Baba and the Forty Thieves* (1944).

Tavel also uses *The Hunchback of Notre Dame* to introduce both the priest and hunchback as two of Montez's three possible lovers. Although the religious Montez seems wary of seducing a holy priest with his beauty, it's clear from his performance that he has a great deal of empathy for the ugly hunchback. Tavel exploits Montez's religious beliefs by having him dump hair dye into the holy water font at church. Tavel goes even further by having Montez address God and say the line, "Oh Lord, I commend this spirit into thy hands." In doing so, Tavel gets the performer to test fate because Montez, by Warhol's own account, justified "going into costume" (his euphemism for drag) by the logic that "even though God surely didn't *like* him for going into drag, that still, if He really hated him, He would have struck him dead."[24]

Tavel clearly exploits Montez's vulnerabilities, including having a Latino performer mimic his Spanish accent (another play on Maria

FIGURE 13.
Mario Montez; *Screen Test*
2, 1965 (16mm film, b/w,
sound, 66 minutes. Film
still courtesy of The Andy
Warhol Museum)

Montez, who had to relearn a Spanish accent for her Hollywood roles),
but the most degrading request by far is his command that Montez
remove his veil, lift up his skirt, unzip his fly, and expose himself.

As Montez reluctantly follows the director's instructions, Tavel insists
that he look down and asks, "Are you proud of it?" Montez makes a
face. He tells him, "Now just zipper your fly halfway up, and leave it
sticking out." Tavel insists that Montez look at his penis, but he coun-
ters, "I have, many times." While this action occurs offscreen rather than
on-camera, it clearly aims to humiliate the performer by destroying his
own pretense of being a woman rather than a man. In truth, Tavel's
screen test of Mario Montez reveals him to be an amateur, somewhat
awkward performer, especially when compared to Tavel's own spirited
rendition of the director. Although Tavel is quite energetic and witty, the
viewer is able to see through his insincerity almost immediately, whereas
we're never quite sure what to make of Montez. Is he acting, or isn't he?

Despite all the abuse he is subjected to in *Screen Test # 2*, Montez
manages to maintain a certain dignity, and his sincerity and good-natured
humor win us over, so that by the end we're completely on his side. Like
his namesake, Mario Montez embodies Jack Smith's conception of a
star, namely that the performer's personality would become manifest to
the viewer. Smith writes: "In my movies I know that I prefer non actor
stars to 'convincing' actor-stars—only a personality that exposes itself—
if through moldiness (human slips can convince me—in movies) and I
was very convinced by Maria Montez in her particular case of her great
beauty and integrity."[25] This also became the definition of the Warhol
superstar. For Warhol, the notion of acting is intrinsically phony, and
Hollywood epitomized it to the hilt.

Douglas Crimp discusses *Screen Test # 2* as a film in which the viewer experiences intense shame—the identification with, yet separation from, another human being's humiliation—which he views as a requisite stage in the formation of gay identity.[26] Yet the Warholian twist is that Montez's screen test ends up being as much a portrait of his offscreen tormentor, who was later to have ethical regrets about his sadistic role in the film, especially because Montez actually believed that this was a real audition and that he was going to be cast in the role of Esmeralda.[27] Tavel told an interviewer: "My God! And it's bringing out the worst in me because: who debases himself more—the person who debases someone else? I felt humiliated in this way."[28]

Yet there is still a power differential between the two roles. The person behind the camera, namely Tavel in the role of the Tester or director, exerts power over the person in front of the camera, Montez, whose image he obviously controls. This represents the inherent vulnerability of a performer. In a film, it is the actor who looms large on the screen, whereas the director usually remains hidden. Amy Taubin points out: "For all its seeming passivity, Warhol's camera is a weapon. Before its impassive gaze, the sexual masquerade eventually crumbled, revealing raw narcissistic wounds and pathological insecurities as great as Warhol's own (and that seemed even greater when magnified by the projector)."[29] Ironically, while *Screen Test # 1* is generally deemed a failure and *Screen Test # 2* is touted a success, the results turn out to be virtually identical. Taubin aptly puts it: "The would-be superstars flocked to the factory to have their narcissistic investment in their own sexuality confirmed; the camera left them in shreds."[30]

THE LIFE OF JUANITA CASTRO

Mario Montez was not so intent on becoming a famous star that he couldn't refuse a role that met with his disapproval. Tavel indicates that Montez was the initial choice to play Juanita Castro in the next Warhol and Tavel collaboration, *The Life of Juanita Castro* (1965), but Montez turned down the part because he was opposed to doing anything that dealt with either religion or politics.[31] Although not an actor, Marie Menken accepted the role provided that she was allowed to drink beer on the set. Menken, a painter and avant-garde filmmaker, was married to the poet and filmmaker Willard Maas, who was gay and reportedly the off-camera actor in *Blow Job*.[32] Menken and Maas, who were known for their celebrity parties, had a difficult life together. The cou-

ple lost a child and tortured each other over it for the rest of their lives.[33] In Martina Kudláček's documentary *Notes on Marie Menken* (2006), Kenneth Anger and Gerard Malanga insist that the two were the model for the couple in Edward Albee's *Who's Afraid of Virginia Woolf?* (1962) after Albee had occasion to observe their constant fighting. Both Menken and Maas were serious alcoholics by the time *The Life of Juanita Castro* was shot.

Watson suggests that the film turned out to be a rather ingenious solution to the problem of performers having to learn their lines, something that was neither the style nor inclination of those associated with Warhol's Factory.[34] Tavel indicates otherwise: "I read their lines and screen directions to the performers not because they would not have learned them themselves or rehearsed—during the first half of that year the chances are they would have—but because there was no more intention to have the participants 'act' as acting normally is understood, than there was to move the camera."[35]

The Life of Juanita Castro becomes an initial read-through of the script, but the twist is similar to that of *Screen Test # 2* in the sense that the rehearsal becomes the actual film. The actors sit in a kind of bleacher arrangement. Juanita sits prominently in a wicker chair front center. Fidel appears screen right, while Che is positioned on her left. Tavel, who chews gum, drinks, and smokes throughout the production, can be viewed in the back, prompting the various lines and giving directions. The performers all play to an imaginary camera, while the actual camera is placed off to the side because Warhol believed this arrangement yielded a more dynamic angle compositionally.[36]

The cast of *The Life of Juanita Castro* includes Marie Menken, Tavel, Elektrah, and future superstar Ultra Violet, who sits in the foreground but does not have a speaking part. In a reversal of films being made from plays, the scenario was shot as a film prior to being performed at the Theatre of the Ridiculous. According to the scenario, both the parts of the director and Juanita were supposed to be played by men, so that Menken, a large, imposing woman with manly features, represents a rather mean-spirited casting choice on Warhol's part. The others (including Fidel, Che, and Raúl) are performed by women. The portrayal of Ernesto "Che" Guevara (the handsome revolutionary whose face would become an iconic image of the Left following his murder by the CIA two years later) subverts his romanticized image, while Fidel's supposed virility, which would become a target for various CIA plots to undermine him, becomes a source of parody.

The Life of Juanita Castro makes no effort to create cinematic illu-sionism. In this sense, the film is as Brechtian in distancing us from the diegesis as any post-1968 Godard film. The performers repeat lines fed by Tavel. For the most part they play to an imaginary camera rather than to each other. This strategy of non-interaction with the other per-formers makes Menken terribly uncomfortable. Throughout the film, she looks to her left and right in a vain effort to respond to the other performers, who stare straight ahead at the imaginary camera. Since the camera position remains fixed, when Tavel instructs Fidel to come for-ward for a close-up, Fidel ends up out of the frame.

Such strategies call attention to the construction of traditional Holly-wood films, where scenes are usually shot first in a master shot, while the cut-in shots, such as close-ups, are shot separately. Here, what would be deemed dramatically important by virtue of being shot in close-up is precisely what we are prevented from seeing. Later, for instance, Tavel has Juanita stand up after discovering that the G-2 men are after her. Tavel hands down a pistol and Juanita points it at the camera, but, of course, we never see this dramatic moment because it occurs offscreen. As is typical of early Warhol narratives, there is very little use of cos-tuming, except for Menken, who wears a long black dress, and Fidel, Che, and Ultra Violet, who wear fashionable dresses. The film also uses a minimum of props, such as Juanita's fan and gun, Fidel's cigar and cord (to choke Juanita), and Che's handkerchief. There is no attempt to create any type of tropical Cuban setting within the cluttered frame.

The Life of Juanita Castro is based on Juana Castro's article, enti-tled "My Brother is a Tyrant and He Must Go," which appeared in the August 28, 1964, issue of *Life* magazine.[37] This political film is staged as a portrait of the Castro family. While the various members smile throughout the film, sibling rivalry and various tensions smolder under-neath. Tavel actually incorporated the idea of the family portrait and its underlying subtext directly from the *Life* article, which features a photograph of the Castro clan during a family feud at the wedding party for Fidel's sister, Enma. The tension stems from her decision to be married at a cathedral despite Fidel's disapproval. The caption reads: "Though everybody was angry, the Castro family—excluding the bride-groom—composed themselves long enough to pose for this picture."[38] Like Juana's exposé in *Life*, cold war politics quickly become reduced to a family squabble, with underlying tensions among the siblings stem-ming from childhood experiences. Rather than offering political analy-sis, Juana Castro's article merely provides family gossip. Tavel embel-

FIGURE 14. Marie Menken in wicker chair and Ronald Tavel, back row; *The Life of Juanita Castro,* 1965 (16mm film, b/w, sound, 66 minutes. Film still courtesy of The Andy Warhol Museum)

lishes on the article in several respects. He adds Che as a character. He also creates a romantic triangle and sexualizes the relationships between Juanita, Che, and Raúl (who, despite contributing to gay rights abuses in Cuba, was rumored to be gay).

The film begins with Fidel (Mercedes Ospina) smoking a cigar and blowing smoke at Juanita. Fidel tells her, "I discover you apathetic." Juanita responds, "I am not apathetic." In this exchange, Tavel actually changes Fidel's line "I find you apathetic" to broken English, something he does more and more as the film progresses. He also accidentally misreads the script. In the *Life* article and Tavel's own scenario, Juanita's response is supposed to be "I am apathetic"—she's apathetic about the revolution—rather than the reverse. Tavel also switches from English to Spanish, which momentarily confuses Menken because she's not fluent in Spanish. This in turn causes her to butcher the line. Tavel orders Che to put his arm around Juanita. When she complains about the revolution, Fidel shouts, "Silencio," to which she replies, "Shut up, yourself. You always were a spoiled brat."

Juanita accuses Fidel of not caring for the poor peasants. After Tavel

demands that Menken become emotional, she suddenly bellows at the impassive Fidel, "You never really cared for the poor starving peasants." Tavel asks Juanita to think about the poor peasants, and she responds, "I think." He then asks her to become very sad and cry about the fate of the poor peasants. Menken attempts to cry, and the rest of the family cries with her, but their tears, like Juanita's, are totally exaggerated and contrived. Tavel commands them to stop and pose for the portrait. Fidel then complains about the "guajiros" on his father's farm. Although the reference is unclear in the film, Juana Castro indicates in the *Life* article that Fidel always complained that the guajiros on the family farm were overpaid. To Juana, Fidel was the most pampered of all the Castro children, and thus his complaint about the workers becomes evidence that his commitment to communism remains insincere. Fidel then proceeds to give the type of long speech for which he was famous. Nearly three minutes later, Fidel returns to his seat but continues his torrent of words, causing Juanita to fan herself more furiously. For awhile, she seems to become annoyed as Fidel rambles on, but she also appears bemused when the speech lasts for another six minutes.

Fidel's long-winded speech changes the dynamics of the film. In the second reel, the focus shifts from character to performer, as tension develops between Menken and her role. As it begins, Menken, clutching a can of beer, frowns as Fidel continues with the speech. After a minute or so, Tavel prompts Menken, who interrupts, "I want very much to disagree with you at this moment. I do not want to have this regime in this area. You may like it, but I do not . . ." As Menken objects, Fidel tries to outshout her. Menken continues, "You are giving these people something not to live for. But I will not have it! I will not have it!" Fidel's speech intensifies, but Menken bellows, "Never mind! Never mind! You've done good things for some people, but you're not doing good things now." Menken takes another slug from her can of beer. Tavel leans over and says something to her. Menken waves him off dismissively, but she then follows his direction and more or less falls asleep.

Menken gradually becomes more rebellious in playing her part. She's drunker, for one thing, and she keeps ad-libbing, altering her lines, and making snide asides. Rather than mimicking Tavel's inflections, the gulf between Menken and her role grows wider with each passing line. Tavel tells her to say, "Mira, Chico, I am getting pretty sick and tired of all of this!" Menken proceeds to break the line into three parts. She belts out the fact that she's "sick and tired" and then overemphasizes the word "all" in the final phrase. The film inadvertently turns into a power

struggle between the director and his inebriated performer when Tavel asks Juanita to stand up. After she stands, Menken knocks something over and exclaims loudly, "All right!" As Tavel describes scenes entailing Juanita's involvement with the Cuban underground following the Bay of Pigs invasion, Menken has difficulty repeating the lines. She mangles place names such as "Playa Girón" and "Teatro Blanquita" and the line "When I get theres, a soldata revolucionario stops me." Menken turns "soldata revolucionario" into something indecipherable and "stops me" to "greets me." When Tavel corrects her, she remarks, "Oh, *stops* me, not *greets* me. All right, so he stops me." Tavel continues, "Get out of my way, I scream, or I keel you." Despite Tavel's impassioned attempts to get her to say "I keel you," Menken persists in saying "I hear you."

The real breakdown occurs over Tavel's next line: "He says I hope a tree fall on your coche and crush you to death." Menken is still standing at this point, so she is only partially visible, but her silence and hand gestures indicate her confusion. She stammers: "Now look, give me that line again. I don't get this crush-you-to-death routine." Tavel says, "He say I hope a tree . . . ," but Menken interrupts, "I say he said . . ." Tavel responds, "Yes, I said he say" and proceeds to repeat the line. After Menken finally says it, she asks Tavel whether this is correct. He answers, "Correct, gracias."

Much of the fascination of *The Life of Juanita Castro* lies in the unexpected battle that develops between Tavel and his performer, whose rebellious reactions create the film's dramatic tension. In terms of performance, Menken's character remains in a constant state of flux. There's no way to predict what she will do or say at any given moment and as a result, the film seems to have the potential to fall apart completely. Even though Tavel has once again stacked the deck, Menken proves much less docile than Mario Montez in *Screen Test # 2*. She may be an atrocious actress in conventional terms, but as Juanita, Menken manages to capture the contrarian personality of Fidel's sister. Her eccentric and buoyant personality erupts continually through the deliberate artifice Tavel constructs. Menken proves to be a truly subversive force in the film, rebelling against the constrictions Tavel imposes, just as Juana led a personal revolt against her brother once he became a dictator.

HORSE

Warhol and Tavel were interested in pushing conventional boundaries by exploring subjects that hadn't been depicted in film previously.

Transvestitism and sadomasochism, which had been largely limited to gay subculture, both fit the bill because, according to Tavel, "they were novel, but also theatrical . . . all image and display."[39] *Horse* (1965) anticipates the later *Lonesome Cowboys* and *Vinyl,* the film that immediately followed it. In fact, seeing *Horse* makes one view *Vinyl* in an entirely new light. It includes two of the same performers—Larry Latreille and real-life sadist Tosh Carillo—only *Horse* reverses their respective roles as sadist and masochist.

Moreover, amyl nitrate (poppers) figures prominently in both films. In *Vinyl,* Carillo and Malanga use drugs onscreen, while in *Horse* the performers have apparently taken them prior to filming. According to Tavel, the actors were so high during the shooting that they were fearless.[40] Carillo, for instance, gets kicked by the horse while trying to molest it, and the fight scenes get out of hand. On some level, *Horse* explores Tavel's notion of the director as a sadist who has the power to make actors do his bidding, an idea that seems to have evolved directly out of *Screen Test #2* and *The Life of Juanita Castro.* It's almost as if Tavel is conducting his own type of Milgram experiment on obedience to authority figures.[41] He told Patrick Smith that "what I *really* wanted to say was how easily would a group of people under pressure be moved to sadistic acts: to genuinely inhuman acts toward each other and perhaps the horse—under pressure. And I had this *very* consciously in mind."[42]

The genesis of the film came from Warhol discovering that a horse could be rented for an entire day from the nearby Dawn Animal Agency, which still operates on Forty-seventh Street in Manhattan. The presence of a horse in the Factory suggested that Warhol could make a Western.[43] Tavel told an interviewer:

> To make it work, I incorporated very traditional literary themes, as you would find in a Hollywood movie that understood itself as some kind of literature, which is to say deconstruct the myth of the West, the hero of the Western and introduce subjects like cowboy bestiality and cowboy homosexuality. But I knew that these literary things were only to get us from the beginning of the film to the end, but which we used to allow the unexpected to happen.[44]

Tavel intended *Horse* to be a "genuine" Western. Since there are no women, Tavel conceived of the cowboys not as the familiar figures of the Hollywood genre, but as "celibate, asexuals and homosexuals" who are turned on by their horses.[45] In *Horse,* Tavel literalizes the notion of the Western being a "horse opera" by having a camp opera, Florence

Foster Jenkins's rendition of the *Faust Travesty*, represent culture and civilization.

If Warhol could designate superstars capriciously, he could also bring a horse into the Factory and declare the ensuing film a "Western." There's a deliberate incongruity between the Factory (urban) and the horse (rural). Pop art, which is referenced by the opening image, really wasn't so much about nature, except through its commodification, as in the "Marlboro Man," but Westerns, because of their mythological importance, remain a staple of American popular culture. If we think of American art in terms of nature and urbanization, as did the PBS documentary *Imagining America: Icons of 20th Century Art* (2005), Warhol clearly makes a statement through their ironic juxtaposition.

There are four major characters in the narrative—Kid (Latreille), Tex (Dan Cassidy), Mex (Carillo), Sheriff (Battcock)—as well as the trainer (Leonard Brook) and the horse (Mighty Byrd). Costuming is minimal: Kid wears a vest and neckerchief; the Sheriff dresses in jeans and jacket, checkered shirt, and white cowboy hat; Tex wears boots; Mex has on a denim outfit with a striped tie. The horse's trainer is easily the most natural performer, along with the rented horse. The credits are interspersed throughout the first reel, and, whether by accident or design, Battcock is mentioned twice.

Although Tavel had written a ten-page script, the actors in *Horse* seem not to have had access to it before shooting. Instead, Tavel relies on large cue cards to prompt the actors during the actual filming. Because the performers don't know their lines or actions, they seem to exist in a curious state of tension, which lies somewhere between reality and fiction, between just being themselves and becoming performers at a moment's notice. As a consequence, the actors often appear apprehensive and bewildered.

Like *The Life of Juanita Castro*, *Horse* exhibits many reflexive elements. For instance, the performers continually look toward the camera to read their cue sheets. Misreading the cue card intended for Kid, the Sheriff, addressing himself, says, "Tex, Mex, Sheriff, it's my horse!" The performers laugh, as Battcock readily admits, "I screwed up this time." Such mistakes, which disrupt the consistency of the diegesis, add considerable humor. Not only does the boom microphone poke into the frame conspicuously from frame left, but cue cards or a shoulder occasionally intrude from the right foreground.

Tavel himself often whispers or yells directions, especially when he's forced to stop the out-of-control fighting. In addition, he walks across

the set and passes directly in front of the camera a number of times, and even gets involved in the action. Since *Horse* is staged in the entrance of the Factory, everyday activities continually intrude on the narrative: people inadvertently walk onto the set from the elevator or stairwell, talk on the telephone, eat and drink. We see Andy, Gerard Malanga, Ondine, Edie Sedgwick, and Chuck Wein. Some children come into the Factory as well, perhaps because they heard that there was going to be a real horse. A couple rushes out abruptly during the violent, sadomasochistic segment involving the Sheriff in the third reel.

Horse consists of three continuous-take reels. The opening image shows an extraneous pop advertisement in which the frame divides horizontally in half. The upper portion is white with a vertical line on the left side. The lower portion is black, on which we see part of a can or jar with the letters "xie" and the words: "Tasty as a bowl of."[46] As the film proper begins, Kid sits on top of a black horse. The Sheriff announces that one of the guys is a murderer while looking around, indicating some confusion as to whom he's actually addressing. He orders Kid to leave town, but Kid responds, "Go to hell." He recites, "I'm the kid from Laramie/Hang me on that yonder tree/I come ridin' off the plain/out of the wind/out of the rain/A-seeking just one friend/But friend, this here's the end." The Factory's phone rings and Warhol enters the frame to take the call. After the cowboys, including the Sheriff, feel up the horse, Kid and the others claim to be onanists, except for Mex, reinforcing his status as an outcast.

As Mex takes a roll of white paper towels and dispenses "land deeds," Tavel suddenly whispers, "Beat him up." The other three men attack Mex viciously, before Tavel yells, "Break!" With prodding, Mex, still out of breath, comes forward and repeats Tavel's curses in Spanish. Mex gets on the horse and humps it, causing the others to pull him off and pummel him again. When it becomes particularly brutal, Gerard Malanga yells, "Resume original positions!" The cowboys all profess to love the horse, but when Mex does as well, they drag him off the horse and start beating him, ignoring Tavel's direction to "feel him up." He yells, "Feel him up; don't beat him up! Sexy! Feel him . . . all his parts." Tavel orders them to take off Mex's tie and shirt. As they rip Mex's clothes off, he tells Kid to get on the horse.

The second reel, which begins with a wide shot that includes both the horse and trainer, was obviously shot after the third because we see Carillo and Battcock leave together. This causes a temporal discontinuity similar to the reordering of camera rolls in *Eat* and *Couch*. This

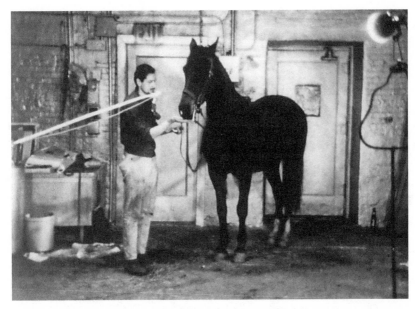

FIGURE 15. Trainer and horse; *Horse,* 1965 (16mm film, b/w, sound, 100 minutes. Film still courtesy of The Andy Warhol Museum)

reel, which disrupts the Western narrative, has more of a documentary quality than the other two. We see the shadow of the boom, and then the actual microphone, as it sidles in from the left side of the frame, as if the sound person is miking the horse for an interview, a possible reference to the popular 1960s television show *Mister Ed,* which starred a talking horse.[47]

Mighty Byrd spurns the trainer's offers of hay and granulated sugar. Just as the horse finally takes a lick of the sugar, the elevator door opens behind them, and Edie, Ondine, and Chuck Wein enter and disappear offscreen. Larry Latreille strolls in from the foreground, gets the horse to lick his hand, and tries to mike the horse and provoke it to make sounds. When Edie and Chuck Wein come forward, Latreille whispers that the horse is telling him dirty jokes. Edie offers part of her sandwich to Latreille, then to the horse, and finally to the trainer. Edie, Chuck, and eventually the trainer leave; only Latreille remains. Flirtatiously, he says, "Bye, Sheriff," as Battcock and Carillo exit together. When the phone rings again, Edie answers it and gets Gerard Malanga, who leaves it off the hook. The trainer invites in a woman who has come up the stairs.

Reel 3 picks up where the first reel ended, with Kid, now smoking,

atop the horse, and the Sheriff and Tex still torturing Mex. After some prompting, the Sheriff reaches into his coat pocket for a tiny pistol, but Kid "shoots" him in the shoulder. Kid dismounts and proclaims, "Milk for everyone!" Mex passes out glasses of milk, which they spill all over themselves in a sexual metaphor for ejaculation. Tex asks, "Hey, what is this, anyhow?" The Sheriff responds, "This is a horse opera, Tex." As opera music plays, Mex begins to dance and mime to the *Faust Travesty* as the Sheriff gropes him. At one point, the Sheriff succeeds in pulling Mex down, but he recovers and finishes the song as Kid and Tex turn their sexual attention to the horse, declaring their love.

In order to settle the dispute over the object of their desires, the Sheriff and cowboys play a game of strip poker. After Mex loses, Tavel instructs Kid and Mex to remove their pants "very, very slow." Someone asks, "Everybody?" Tavel says, "No, no, just the two." As the game continues, Tavel orders Mex to serve milk. He pours a glass for Kid; when the Sheriff refuses it, Mex pours the remaining contents of the carton on Kid. After the Sheriff loses the game, Tavel yells, "Rush at the Sheriff!" The men go after him and beat him viciously. They tie him to the horse, and then Mex and Kid whip him with belts as the Sheriff screams in real agony.

Meanwhile, Tex and Mex continue to strip the Sheriff and scuffle over his wristwatch. The fighting gets so out of hand that Tavel, like a referee at a wrestling match, has to yell "Break!" As the opera music resumes, Mex, wearing only a jockstrap, tries to mime to it and the Sheriff again tries to grope him. With the trainer's help, Kid mounts the horse and lies on it in a sexually suggestive position. Carrying the script, Tavel crosses in front of the camera and enters from the left side of the frame. He turns offscreen and says, "Billy [Name], play it again." After a false start, the opera begins. Tavel kneels in front of Mex and shows him how to mime the proper movements, while his hands begin to caress Mex's legs as the reel runs out.

Tavel was fascinated by his ability to incite the performers to such an intense level of violence in *Horse*. Yet there are a number of other factors that might explain what occurs on set. Because none of the performers had access to the script beforehand, they had no conception of their roles. As a result, they were dependent on the cue cards and off-screen stage directions by Tavel, who serves as an active cheerleader in provoking the actors to attack each other with such abandon. The fact that the performers were high on amyl nitrate and playing macho cowboys in a Western no doubt affected their responses as well. In the film,

the actors are very much following the orders of the director, much like soldiers following their commanding officer in combat.

In nearly every interview, Tavel insisted that *Horse* was his favorite collaboration with Warhol, yet it remains one of the least seen or written about of the Tavel-scripted films.[48] One reason for this is that *Horse* has been overshadowed by their next film, *Vinyl,* which deals with similar themes and features Edie Sedgwick more prominently, even though she doesn't have any dialogue.

VINYL

Vinyl (1965) is based on Anthony Burgess's *A Clockwork Orange* (1962). Tavel's loose adaptation of the book was originally intended to star Gerard Malanga, the young poet who not only assisted Warhol with silk screening but also helped to run the day-to-day operations of the Factory. Edie Sedgwick, however, was inserted into the film by Warhol at the last minute and wound up stealing the spotlight. The odd thing about Edie's performance is that she doesn't have a speaking part—she sits on a trunk for most of the film—yet she becomes the major focal point of the film. Edie shows genuine compassion for the abused victims, especially Malanga, which is why the viewer tends to watch her every response. In many ways, *Vinyl* represents the usual Warhol setup: create jealousy between performers, give them different instructions, and watch what happens, while including an actual sadist in the mix in the form of Tosh Carillo.[49]

The film was initially called *Leather,* which fit its sadomasochistic theme, but it was changed to *Vinyl* because it sounded more modern.[50] Warhol reportedly purchased the rights to the Burgess novel for $3,000.[51] This was an unusual gesture; Warhol typically kept production in-house because it was so much cheaper. Warhol originally asked Malanga to adapt Burgess's book. After he declined, Warhol turned to Tavel.[52] The screenwriter, who had been called upon to produce scripts one after the other, was having trouble coming up with new ideas. Warhol thought that it might be easier for him to adapt existing material rather than having to create something from scratch.[53]

Tavel actually found the novel somewhat boring and gave up reading it halfway through.[54] In his scenario, he focused on its sadomasochistic elements and turned it into a ridiculous farce. In contrast, Warhol very much liked the book. It is clear what attracted him to *A Clockwork Orange:* its graphic violence and sadomasochism, its focus on youth cul-

ture, its theme of turning human beings into machines, and most importantly, its homosexual overtones. As a follow-up to *Horse, Vinyl* depicts the world of sadomasochism—something that, in the years prior to Stonewall, was hidden in private quarters or in the clandestine back rooms of gay leather bars.

Vinyl begins with a shot of Malanga's face. He bends down and disappears out of frame. He comes up again and looks screen right. As he continues to turn his head left and right, it becomes apparent that he's lifting barbells. The camera slowly zooms out to reveal Victor (Malanga), who wears a black leather jacket, surrounded by six other people. Dressed in fashionable black dress and leopard belt, Edie sits on a trunk and smokes a cigarette on the right side of the frame. Victor proceeds to lift weights with his eyes closed. A voice intones: "Andy Warhol's *Vinyl.*" As Victor stands up, Scum (Ondine) asks, "What are we gonna do, Victor?" He answers, "We'll do whatever comes along, Scum. We'll do whatever comes along, Scum baby." Victor lights a joint and hands it to Scum. In the novel, Victor and his pals accost an intellectual who is carrying books as he walks home. The adolescent-looking Pub (Larry Latreille) is a far cry from the character described in the novel. He comes in carrying magazines, which look like a pile of *Playboys*. After Victor and Scum rip up his magazines, he responds, "You two boys should be home in bed." Victor asks, "What does this here page say, pray you tell?" Pub responds, "It says Man is a creature capable of individuality and multiple direction. And that to try to mechanize him is to . . ."

Recurrent phrases in Burgess's novel include "the old in and out" and "ultra-violence." In *Vinyl,* Victor grabs a chain and says, "Let's have a little of the old up-yours." He and Scum grab Pub and begin to tie him with the chain, as Edie watches. Victor returns to the foreground. Brandishing a chain, he announces: "OK, OK, I am a J.D. So what? I like to bust things up and carve people up and I dig the old up-yours with plenty of violence so it's real tasty." Victor dances to "Nowhere to Run" by Martha and the Vandellas. Edie moves her arms and sways to the music, while the sadistic doctor (Tosh Carillo) tortures Pub in the background with a candle, and the cop (J.D. McDermott), dressed in a suit, periodically breaks into mad laughter. After Victor and Scum get into a physical fight over Scum's lack of appreciation of the music (Alex's love of Beethoven in the novel has changed to Victor's love of rock and roll), the cop arrests Victor and spits in his face. He tells Victor he's bad, but they can make him good, and he's later turned over to the sadistic doctor for reprogramming. In the novel, while in prison, Alex

FIGURE 16.
Gerard Malanga; *Vinyl*,
1965 (16mm film, b/w,
sound, 67 minutes. Film
still courtesy of The
Andy Warhol Museum)

is subjected to a behavioral experiment called Ludovico's Technique, in which he's shown images of rape and violence that cause him to become ill. In *Vinyl*, this aspect is less clearly presented, largely because the narrative elements of the novel have become subsumed by the elaborate spectacle of Victor being tortured by the doctor, who covers his head with a leather mask and burns him with candles. Throughout most of the film, Pub is also sadistically abused by the doctor and a torturer (Jacques Potin), as well as Scum, in the background.

Because the film is staged in various planes of action, the viewer is often forced to choose what part of the frame to watch. There's the torture of Pub in the background on the right. A reflective disco ball can be seen in the left background. There's the sadistic abuse of Victor in the left foreground (like Edie, he is sometimes cut off by the framing). And, of course, there's Edie, who winds up being as interesting as anything else that happens in the film. Warhol intuitively understood the fundamental aspect of film acting, namely that it involves not line delivery, but reacting. Edie's reactions turn out to be what most holds our interest, even more than the sadomasochistic spectacle.

To understand Edie's importance to *Vinyl*, one has only to try to imagine the film without her. One of the great moments occurs when she responds to the music of Martha and the Vandellas and dances to its rhythms with Malanga. Because she's forced to sit, Edie dances almost solely with arm movements; in the later closer shot, her hand darts rhythmically into the frame from the right. This response to the music shows her natural spontaneity. Edie nervously or unconsciously starts to move to the music of the Rolling Stones in a later torture scene, but she hesitates because it seems inappropriate for her to dance in such a con-

FIGURE 17. Gerard Malanga and Edie Sedgwick dancing; *Vinyl*, 1965 (16mm film, b/w, sound, 67 minutes. Film still courtesy of The Andy Warhol Museum)

text. She also laughs at times when things are funny and occasionally looks to people offscreen for direction. At one point during the cop's monologue, she gets up from the trunk and briefly leaves the frame. Edie appears uneasy when the doctor hands her an instrument of torture (a lighted candle) to hold. At the end of the film, the leather-clad torturer (Potin) snuggles up and tries to slow dance with her, causing Edie to become noticeably uncomfortable.

Malanga resented the fact that Edie was added to the film because *Vinyl* was conceived as an all-male production, and he didn't think she fit the concept.[55] Warhol's brilliance was in using her as a compositional element. By placing her on the right side of the frame, she adds visual interest and functions much like Ultra Violet in *The Life of Juanita Castro*. Edie, however, turns out to contribute much more to the film. Her reactions, especially when Victor shouts in agony while being tortured, serve as a kind of moral compass. Because Edie didn't know the story or what would happen, she was able to react to events without preconceived ideas, spontaneously, which was her real talent as a performer.

In *Vinyl*, the "real" manages to intrude on the overly theatrical. When Victor, for instance, rips Scum's shirt, Ondine appears to become genu-

inely incensed. Ondine beats up Malanga, just as Carillo and Potin torture people in the film. Ondine also cuts off Latreille's pants, causing the young man to resist by kicking him. Carillo gives Malanga amyl nitrate as the film transforms into a dance party, and the two of them wind up in a wobbly, extended embrace before Malanga collapses to his knees in a drugged state. The film ends with Carillo taking a pair of scissors to Malanga's long hair and starting to cut it off.

Vinyl contains the usual Warhol manipulations. Tavel wanted to rehearse the actors, but Warhol reportedly sabotaged that plan through such tactics as sending Malanga on extended errands so that he didn't have time to rehearse his lines.[56] As a result, Malanga's performance has a stilted quality. Warhol also cast the verbally sharp Ondine as the dim-witted character, and Tavel lists Edie in the spoken credits as an "extra." When this is announced, she registers a momentary reaction. Edie does function as an extra because she doesn't have a speaking part, but the irony (and Warhol's ingenuity), of course, is in creating a situation where—because of her screen presence—Edie is secretly the star.

KITCHEN

After Edie managed to steal the limelight in *Vinyl*, Warhol conceived of *Kitchen* (1965) as a star vehicle for her. He had met Edie at a party for Tennessee Williams thrown by Lester Persky and thought she was extremely beautiful. It's unclear whether Edie knew much about Warhol at the time, but she soon became a kind of beautiful double to Andy. Gary Indiana observes: "They didn't look alike, but dressed alike, wore the same hair color, and shared the quality of ambiguity, unreadableness. Edie completed Andy Warhol in a new way, which made them a new type of power couple: together, they spelled a runic inscription that was all presence, all absence."[57]

Warhol approached Ronald Tavel about creating a script for Edie. Tavel inquired whether Warhol wanted a plot, but what he really wanted was a "situation."[58] Warhol chose the location: a clean white kitchen, indicating that he conceived of the film in aesthetic, formal, or even painterly terms. The emphasis on white suggests an empty canvas to be filled. Indeed, Warhol fills the space of *Kitchen* with various objects—furniture and appliances and products—as well as performers, who will be given the same status or equivalent weight as "talking objects" within his fixed camera composition. *Kitchen* looks like it was shot on a set, but it was actually shot on location in Buddy Wirtschafter's loft.

The film begins with an out-of-focus shot as a hand tries to cover the lens. We then see an empty set: a table and chair, a bottle on the table, a box of "Trend" detergent. There's also a hair in the gate, a technical defect that becomes an important compositional element in the first reel, calling attention to the camera as a recording instrument. After Edie's voice announces the credits, she promptly sneezes twice (sneezing will become one of Edie's trademarks, as she demonstrates in *Outer and Inner Space*). In *Kitchen,* sneezes become physical actions that interrupt and punctuate the main actors' performances. They, in effect, break or disrupt the continuity of the narrative. Edie then mentions the various props that will appear in the film. This adds a "game" aspect by causing the viewer to look closely at the cluttered composition for these objects or the appearance of these objects throughout the film.

Edie continues with a physical description of the set, which consists of words written by Tavel for the director and performers:

> The set is a clean, white kitchen. A kitchen table and chairs. One wall of the kitchen is in frame and a calendar is on that wall, which is not actually a calendar but a copy of the scenario. Several articles are on the table and hidden between them is another copy of the scenario. There is also a large book on the table, or two or three books and copies of the scenario are hidden in the book. When the actors forget their lines [she sneezes], they should pretend to be reading the book, or can get up and go over to the calendar on the wall and read until they reach the place they want, as if they were tearing off that date.

In doing so, she telegraphs to viewers that the actors have not really memorized their lines.

Edie, carrying a large black handbag and wearing a striped boatneck shirt and black tights, comes from the back of the kitchen. She sits on a chair and takes out a large mirror. Rene Ricard putters in the background with his back to us, presumably washing dishes. Ricard functions as a kind of on-camera prop master in the film. Such crew members, it should be pointed out, usually perform their duties between takes rather than during them. Ricard goes into the back and gets what appear to be pages of the script and places them on the table. Edie clumsily knocks the mirror over and takes out a cigarette. As we become aware that nothing is happening, Edie makes furtive glances over at the camera. Our focus shifts between foreground and background. Ricard runs the water and we hear other sounds of dishes, while Edie starts to primp in front of the mirror and apply mascara.

A photographer enters and takes Edie's picture, then walks out of

the frame. This is an obvious reference to production stills, which are needed to market a film. Production stills are usually not recorded while the production is in progress, but are instead taken before or after a scene has been shot. Here Warhol privileges the role of production stills by having the photographer make intermittent entrances and exits as a part of his mise-en-scène. At times, he nearly collides with Edie in his attempts to get candid pictures. From the rear left, a shirtless man named Mikie (pronounced "Mickey" and played by Roger Trudeau) comes out and kisses Edie's neck and back. The photographer runs out again and snaps a picture. Edie and Mikie both sneeze. Edie makes more furtive glances and then begins to comb her hair, while they stare at each other. There's an awkward tension, as if they are both waiting for the other to say or do something. Mikie says, "Little basket," as if to prompt Edie. She asks, "What did you say, dear?" After he repeats it, Edie says, "I know you said litter basket, but what am I supposed to do about it?" Mikie answers, "Rummage around in them." Edie acknowledges that she does rummage around in litter baskets by remarking, "That's how I found you."

The actual story is a domestic melodrama that quickly lapses into an absurd Ionesco-like farce. Mikie admits to having a homosexual affair in a public shower with a man named Joe. Edie, whose character is named Jo, asks, "Which Joe," initiating a basic confusion involving characters having the same name. Mikie answers, "The other Joe." After the two of them repeat phrases involving the words "how tender," Edie shouts at Mikie to "shut up!" He becomes angry and strangles Edie— in fact, he chokes her so forcefully that Edie appears shocked. Mikie yells, "Oh mother, mother, please forgive me." After some discussion about going to the beach, Edie suddenly becomes distraught and says, "Then I've failed you as a mother and as a lover." The story is confused both because two sets of characters have the same names (Jo/Joe) and because Edie's character shifts between being Mikie's lover and being his mother.

Mikie talks about always wanting to wear hand-me-down clothes. This leads to a long, rather absurd monologue. Because "clothes are personality," Mikie claims that the previous owner's personality can influence his own identity. As a result, he tries to choose the used clothes of someone with a similar personality, which can, in turn, help him to understand himself. Mikie's monologue gives Edie a chance to do what she does best—simply make mundane activities fascinating through the sheer force of her personality. For instance, she gets up and puts on the

FIGURE 18. Roger Trudeau and Edie Sedgwick; *Kitchen*, 1965 (16mm film, b/w, sound, 66 minutes. Film still courtesy of The Andy Warhol Museum)

malted machine, which makes Mikie's monologue nearly impossible to hear. She primps in front of the mirror, smokes a cigarette, and smiles to people offscreen, thereby acknowledging the absurdity of the situation. At the end of the first reel, Mikie asks Jo questions, but she refuses to answer him.

In reel 2, we see Ronald Tavel on set with a copy of the script. The crew and cast attempt to reestablish continuity between the first and second reels by turning on the malted machine again. A male voice offscreen announces the credits, including special directions: "The part of Joe should be played for high camp at all times. The part of Mikey should be played as a dumb blonde—broad—unless the lines specifically urge otherwise. Jo and Mikie should keep their characters from reel 1, which is to say, very changeable from one moment to the next."

Finally, the other Joe (played by Donald Lyons), carrying a mattress, enters and announces, "Good friends should lie together!" Lyons plays his part as camp, while his companion, a woman named Mikey (Elektrah), acts like a dumb blonde (although Elektrah has dark hair). Since Edie's hair is blonde, this direction seems to be aimed at her. While serving coffee to her guests, Edie deliberately spills the hot coffee on

Mikie, disrupting the set. She then asks whether she can get everyone some layer cake. When Joe talks about everyone having their own layer, Edie becomes upset. After Mikie comments on her attractiveness, Edie yells at Joe, "How can a two-headed girl look attractive?" When he responds that her two heads are attractive, Edie becomes so enraged that she violently pushes his chair backwards. She shouts at Mikey, "Do you dig sleeping with cripples?" Moments later, Edie exclaims that she can't figure out what her part is in this movie.

Edie's line gets at the heart of what's going on here: she has become confused about her role in the film. Warhol used the filming of the script almost as a pretense to get at what he's most interested in, namely the personalities of his performers. In *Kitchen,* Tavel claimed that he was interested in eliminating not only plot, as per Warhol's wishes, but also character:

> I worked on getting rid of characters. Andy had said, "Get rid of plot." Of course, Samuel Beckett had done that in the Fifties, but he had retained his characters. So I thought what I could introduce was to get rid of character. That's why the characters' names in *Kitchen* are interchangeable. Everyone has the same name, so nobody knows who anyone is.[59]

Contrary to Tavel's assertion, all the characters in *Kitchen* don't have interchangeable names; rather, two sets of characters have identical names. In addition, such a strategy does not eliminate the notion of character, but rather merely confuses it, as evidenced by Jo's bewilderment that Mikey happens to be Elektrah's name, as well as her lover/son's name. Mikey and Joe voice similar concerns later in the film.

Joe comments that he never saw a movie where there were so many "excitable people," which causes Mikey to keep repeating the phrase. Mikey then delivers a long monologue about rape, in which she blames the victim, who majored in journalism, for "going around with a bum like that." As this long monologue goes on, Edie ad-libs, does a little dance, and keeps looking offscreen. At one point, she says, "Good friends should always lie together." Joe snaps, "Stop stealing my lines." He eventually gets up and mauls Mikie while saying "I love you, Mikie." Now it's Mikey's turn to get upset. She responds, "I'm Mikey," acknowledging her confusion over the names. Joe likewise wonders aloud how he's supposed to know with whom to have sex.

Meanwhile, Edie decides to roast some marshmallows. In the background, she touches the marshmallow and burns herself—an action that Tavel wrote into the script. She offers Mikie a marshmallow, and he gets

burned as well. He picks her up, lays her across the table, and chokes her. Joe says, "Really, that's your mother, isn't it?" Edie sneezes as she's being choked, but then pretends to die. Joe announces, "She croaked," and adds, "Matricide on a mattress." Edie nevertheless sneezes again, even though she's supposed to be dead. Joe tries to bite her like a vampire. Edie suddenly starts talking as if the film is over, but the camera keeps recording. Edie acknowledges that she did, in fact, burn herself, along with Trudeau. The actors try to deal with Edie's injury. Edie eventually asks, "When was it over?" Donald Lyons, no longer in character, replies, "Out of time."

Kitchen inaugurates strategies related to Warhol's notion of the superstar. Warhol wasn't at all interested in performers interpreting a part. This led him to encourage Tavel to create situations in the film where Edie becomes distracted from playing her role as Jo. The delayed beginning of the film, when nothing happens, the deliberate boredom created by the long and repetitious monologues by Mikie and Mikey, the excessively violent manner in which Trudeau chokes her, the scene in which Edie burns herself, and the camera continuing to roll for another six minutes after the narrative ends all become occasions to make Edie, as Henry Geldzahler put it, "more Edie."[60] It's in these instances, when Edie's unconscious actions and reactions fill up dead screen time, that her magnetic personality manages to radiate through the silly contrivances of an otherwise absurd plot.

SPACE

Space (1965) features the folk singer Eric Andersen, as well as Edie and a number of her Cambridge friends as they engage in what at the time might have been derogatorily termed a "hootenanny." Consistent with the Factory crowd's distaste for folk music and its associations with Bob Dylan, there's a strong element of parody in the film. It is clear that Tavel considered the result a kind of exposé of the puerile shenanigans of a bunch of insufferable rich kids. In his extensive notes on the film, Tavel emphasizes the abstract and conceptual basis of *Space*. He indicates that the film is organized in a visual pattern that mimics the number "eight":

> The figure "8" is linearly the most complete and complex of the digits, and visually the most interesting; and the symbol of infinity, etc. Pursuant, there would be eight characters (or readers) in this movie, seated in bridge chairs arranged to delineate an "8." Each would hold a single page of dialogue with

eight speeches typed out on it, some of them but a single line, others several sentences, still others exponents of these. All would appear to be abstract or so pulled from their contexts as to be coextensive with abstraction.[61]

Tavel admits that he deliberately chose to employ the *I Ching,* or the equivalent of Cagean chance operations, to counteract the rigid patterning of the initial structure. Much of the randomness derives from the fact that sound recordist, Kristy Keating (called the MC in the script), at least theoretically could determine who would speak at various times, while the camera was in the hands of Warhol himself.

Space begins with two establishing shots of Eric Andersen sitting with his guitar on a busy set, while Edie appears on the left side of the screen. This is followed by a spatially ambiguous image of Edie and her reflection in a mirror as her microphone levels are being checked by the sound person, Buddy Wirtschafter. Wearing long earrings and rosary beads around her neck, Edie asks whether she has to speak louder, as we hear Tavel's voice offscreen. Donald Lyons bobs his head into the frame and talks into the microphone. As Tavel speaks, the camera moves to a position behind his head and then pans over to frame Eric Andersen, who smokes a cigarette and strums a guitar while he awaits the start of the film.

The camera slowly zooms back as Tavel, framed on the bottom screen left, counts down, but not consecutively, which causes Andersen to grin. It's a familiar planar composition also used in *The Life of Juanita Castro* and *Vinyl.* Ed Hennessy, in white shirt and pants and a dark bow tie, sits behind Andersen. His body is positioned to look screen left. A male figure, his head cut off by the framing and dressed only in his underwear (Roger Trudeau), stands in the background along with a man in a striped shirt. As Tavel introduces the actors, the camera pans over to Dorothy Dean, who sits on the couch, and eventually over to Edie when her name is mentioned, and on to Trudeau, whom Tavel describes as "completely stoned and almost completely naked." The camera attempts to pan over to the various other cast members when they are introduced, but Warhol sometimes frames the wrong person, thus creating confusion.

The MC moves from character to character as they recite snippets from the written script. After a long pause on Trudeau and Hennessy, who do not speak, the MC leans seductively over Eric Andersen as the singer talks about Marilyn Monroe. The sound (determined by Keating's microphone) and the visuals (determined by Warhol's camera) at times create disjunctions between what we are hearing and seeing. Keating

and the camera, however, arrive together on Edie, who flubs being able to say the "Hail Mary." She looks plaintively to Lyons for coaching, but he merely answers, "This is a sad time for all Americans." The two continue interacting, but the sound person moves out of the frame, so Edie and Lyons are reduced to pantomime.

Andersen sings a song, which turns out to be his lines from the script: "Rudolph Valentino was called the most perfect man in the world. But he wasn't a man. He was a woman." The film veers out of control when Hennessy manages to provoke a food fight among the participants. Keating nevertheless interviews the good-natured Andersen, who continues to follow the script. The camera eventually finds its way over to Edie, who's talking with Lyons, but the voices we hear are those of other people. Edie tries to recite prayers during the rest of the reel, but she doesn't appear to know the words.

The chaos continues in the second reel as the assembled cast sings several songs, such as "Michael, Row Your Boat Ashore," "Blues in the Bottle," and "The Battle Hymn of the Republic." Someone suggests "Hey Mr. Tambourine" ["Mr. Tambourine Man"] and later "It Ain't Me Babe," but Andersen, apparently responding to the overt references to Dylan, judiciously avoids them. After they all sing "Puff the Magic Dragon," Andersen gets them to read several snippets from the script, but Edie asks, "What does it all mean?" Andersen then sings the lines, "I wish I didn't cut off my hair." At one point he shows them the script and they all shout "Wow!" Edie, however, repeats the word mockingly. She picks up the script and insists to everyone, "It's all script . . . And it means something. It means definitely something important." After burping, she reads, "Sometimes I think creative people should never die." She hands it back to Andersen and concludes, "I think it's useless." Andersen stares at the camera and covers his face with the script in embarrassment. Hennessy says, "What's this thing about space? Cut the crap . . . Edie, what's this about space?" She responds, "I can't be intellectual at this point." Edie and Hennessy then dance to Andersen's rendition of "I Hear You Knocking," after which she insists, "Let's have some rock and roll." Andersen eventually picks his guitar up and leaves.

The screenplay for *Space* is highly unusual for Tavel because it's not very theatrical, narrative-driven, or humorous. Neither does it depend on the elements of psychodrama found in *Screen Test # 1* and *Screen Test # 2*, *The Life of Juanita Castro*, *Horse*, or *Vinyl*. Instead, it is spare and highly conceptual. Despite Tavel's expressed formal intentions, the structural element involving the number 8 is not realized in the film.

While it's true that various performers are originally staggered in such a pattern on the set, neither the microphone nor the camera movement attempts to mimic this configuration throughout the film, or if they do, it's not readily apparent. Tavel suggests that an investigation of spatial elements represented a logical progression from the temporal elements that had been foregrounded in earlier productions. He discusses the ideas and references behind the unorthodox script, including the use of the *I Ching*, which Tavel indicates "would be called into play here to dictate its overall flow via physical movement and progression via the compass: the fact, or space, of the film."[62]

Such considerations are impossible to discern because the conceptual structure of *Space* becomes arbitrary and quickly falls apart. As in *Harlot*, Warhol ultimately seems more interested in the discrepancy between image and sound, especially because his mobile camera often chooses not to focus on the action as defined by the sound person and her microphone, thereby undermining the very function of synchronous sound. Rather than the sound and image being in synch, with sound serving to support the picture, Warhol has reversed the usual roles for the sound person and camera operator so that they function in an autonomous rather than unified manner. It is an interesting idea, at least conceptually, because it forces the viewer to struggle to connect the source of the sound with the image at any given point in the film. In synch-sound filming, such a relationship normally would be taken for granted.

Indeed, *Space* is as much about offscreen space as about what is being framed by the camera. Warhol is also concerned with staging bodies within a fluctuating planar composition. There is also a subversive element to the film, which has to do with the performers' complete disregard for the formal conceit of Tavel's script. The film could be viewed as contemptuous of Bob Dylan, and by extension, folk singers in general, in that Eric Andersen is prevented from performing for the camera; he's often rendered as a bystander rather than the "main character" of the film.

The simmering battle between Tavel and Edie reached its apogee in *Space*. Edie doesn't hide her disdain as she makes dismissive comments about the script throughout the film. Tavel claims that he never pressed Andy to explain the meaning of what he was doing, so he became annoyed that Edie didn't understand that, like most artists, he was attempting to work intuitively. According to Tavel, Edie would react to his scenarios by questioning their meaning: "She would object right away and say, 'I don't know what that means, to say it doesn't mean anything.'"[63] Edie's

objections about *Space* are clearly directed at Tavel. He indicates that the issue finally came to a head in this film: "The end really came when Edie tore up the script of a movie called *Space,* saying she wasn't going to memorize anything. She started to read a few of her lines: 'What is all this about? How stupid!' and tore it up, right in front of everybody. That's when I walked out. That may have been the last time I saw her."[64]

HEDY

Hedy (1966) is part of Warhol's Hollywood trilogy—a series of biopics on screen actresses—which also includes *Lupe* and *More Milk Yvette.* The Viennese actress Hedy Lamarr, like Lupe Velez, was better known for her beauty than for her acting talent. The scandalous aspects of Lamarr's career undoubtedly made her an attractive subject to Warhol and Tavel: her nude swim scene in *Ecstasy* (1933), her promiscuity, numerous marriages, and arrest for shoplifting a pair of shoes while carrying $14,000 in checks. Although the film might seem highly scripted, Tavel's scenario was actually conceived to allow for a great deal of improvisation. The courtroom scene, for instance, was improvised by Tavel's brother, Harvey. *Hedy* also features an impressive cast: Mario Montez, Gerard Malanga, Mary Woronov, Ingrid Superstar, and Jack Smith. It also includes a live musical score by The Velvet Underground.

Hedy is composed of four main scenes, each of which concludes with a character having to drink hemlock, an idea inspired by Hedy Lamarr's portrayal of Tondelayo, a jungle beauty who served spiked cocktails in *White Cargo.* This formal structure also recalls Greek tragedy. The narcissistic Hedy is so convinced of her own physical beauty that it blinds her to her personal flaws, causing her to remain in a state of denial to the bitter end. *Hedy* seems quite different from other Warhol films. In its handling of screen space, it is one of the most illusionistic. Although the entire film was shot in a large furniture storage warehouse located on the top floor of the Factory, Warhol's camerawork, especially in the transitions between scenes, attempts to create the impression that the four scenes—the operating room, the department store, Hedy's apartment, and the courtroom—take place in entirely different locations.

The opening shot, an extreme close-up of a magnifying glass on Hedy's (Mario Montez) upside-down face, enlarges her nose and quivering eyelash and lips as she lies on a table while having a facelift. Along with the voices of the German surgeons, the shot suggests the beginning of a horror film, a point underscored by a reference by one of the doctors

FIGURE 19. Mario Montez; *Hedy*, 1966 (16mm film, b/w, sound, 66 minutes. Film still courtesy of The Andy Warhol Museum)

to *Bride of Frankenstein* (1935). After the operation, Hedy sings "I Feel Pretty" from *West Side Story* (1957), but the camera remains on the operating table rather than on her. After her realization that she's been turned into a fourteen-year-old girl, Hedy insists on being referred to as Mrs. Lamarr. She tells the doctors, "You fools, don't you know that I've been married five times, and that it cost me a half million dollars to shed my last husband. How could I forget something like that so easily?" She then serves the doctors two goblets of hemlock soda. They drink the hemlock and die, but this is barely visible because the camera focuses on Hedy instead.

In the department store, the camera frames Hedy's cigarette as she argues with a salesgirl (Ingrid Superstar) over her refusal to let her charge items because she's only a girl. Hedy exclaims: "How dare you! Don't you know who I am? I am Hedy Mrs. Lamarr." She then attempts to distract the salesgirl while her husbands walk off with large pieces of furniture. Hedy also steals a shoe and a banana, but she gets caught by the store detective (Mary Woronov, in one of her best roles) and whisked away. After Gerard Malanga sings "I can't get no kicks from champagne," he and the other husbands drink from a goblet. The store

detective drags Hedy back and then heads over to the salesgirl, who also drinks hemlock. When Ingrid Superstar appears confused, Tavel enters the frame and forces her to drink the liquid. Ingrid's death becomes so prolonged that Tavel and Woronov attempt to maneuver her offscreen. Tavel finally leans over Ingrid, places his body over hers, and dies as well. Woronov strolls over, pulls him off her, and disappears. She leaves with Hedy, but returns in order to search her handbag.

Reel 2 begins with a static shot of a large, semicircular, fan-shaped piece of furniture and music by the Velvets. After nearly a half-minute, Hedy rushes in from screen right, followed by the store detective, who discovers a cache of stolen goods in her apartment. Hedy changes into more suitable clothes before being booked, while the detective observes her. Warhol's use of zooms and a mobile camera abstractly captures a number of details, including Hedy fixing her dress and primping in front of a hand mirror held by Woronov. The most striking camerawork, however, involves the continuous zooming in and out once Hedy puts on her long left glove, with some assistance by the detective. She puts her arm on Woronov, who leans into her, and the two embrace passionately. The detective, however, responds, "Miss Hedy Lamarr. Sorry, we have to go to court now." Hedy vamps to the camera; she then tries to poison the detective, who doesn't fall for the ploy. Woronov remarks, "I may be dirt, but I'm smart dirt." Hedy improvises her response: "You're a very smart private flatfoot."

We hear sounds of a gavel pounding over blackness, which creates a sound bridge to the scene of the courtroom. As the judge (Harvey Tavel) calls Husband No. 1 to the witness stand, Gerard Malanga, blurry and out of focus, sits down in the foreground; this shot also shows Hedy's legs in patterned stockings. The judge leads the various witnesses (her five husbands and the store detective) to say derogatory or incriminating things about Hedy, all the while assuming her guilt on the basis of flaws in her character. As he approaches Hedy to inquire about her emotional problems, the camera tilts up to the ceiling, and, as the Velvets briefly start playing again, tilts down to the various witnesses, who sit impassively, then zooms up to reframe a wider shot that includes Hedy. The judge finds Hedy guilty and gives her hemlock to drink. As Hedy removes her dress, the judge forces the goblet to her mouth. In her death throes, Hedy lies back. The camera zooms out, the music blares once again, and the reel ends, as Jack Smith, now in the role of the doctor, suddenly proclaims, "She was tragic and noble."

Tavel has offered conflicting opinions regarding the effect of Warhol's

cinematography on *Hedy*. In *Stargazer*, Koch quotes Tavel as praising Warhol as a master, even though he felt it came close to destroying his script:

> Because I'd never seen that sort of thing before: As the action would move toward its most dramatic, move toward its point, its shattering, unbearable thing, the camera eye would move away, the camera eye would become bored with the action, with the story, with the problem of the star, kleptomania and so forth, and would begin to explore the ceiling of the Factory.[65]

In the introduction to the script, however, Tavel cites Warhol's cinematography as one of the film's drawbacks: "Altogether the most talent-crammed feature delivered by the Factory, if HEDY has any major weakness it is Andy's cinematography which, true to form, wanders aimlessly through much of the furniture missing the fare."[66] Koch himself reinforces this notion:

> The inattentive camera is one of Warhol's most pronounced stylistic habits. That camera *will not* give the spectacle before it its full concern. One senses the constant tug of its refusal to submit to the domination of the scene and its idea, its interest; that camera is like a restless child who keeps looking away, staring around the room, not giving in to that dominating experience that is everyone else's concern.[67]

Similarly, Wayne Koestenbaum suggests that in Warhol's sound films, "when the camera budges, it erratically disregards the action; it digresses, ignores the star."[68] Koestenbaum even uses the same metaphor: "Warhol's camera, like an inattentive schoolchild, wanders away from the lesson."[69] Koch speculates on the implications of this strategy:

> The camera will not give in; will not say to the spectacle, "yes, you have me, I am absorbed." On the contrary, the camera's wandering inattention is a subtle, passive method of guarding its own autonomy and even primacy: It utterly withholds itself from the threat of transparency that hovers over it; it refuses the illusion of nonexistence and willingness.[70]

Yet, on closer analysis, Warhol's camerawork turns out to be a great deal more complicated than Tavel, Koch, and Koestenbaum suggest.

The camera movement fluctuates between being divorced from the narrative and helping to interpret it. At Hedy's apartment, for instance, the camera plays a functional role in covering the action by zooming out to reframe the actress as she rises from the chair. The camera also appears to respond to the music of the Velvets' live sound track at various times. For example, in the scene where the store detective helps Hedy put on her long gloves and arm bracelet, the zooming synchro-

nizes with the musical chords. Some of the camera movements repeat themselves, suggesting a formal patterning. In the scene with the bracelet, the camera also interprets the narrative, its rapid zooming in and out creating a sexual tension within the scene as Hedy attempts to seduce the detective with her beauty. The jittery image created by the quick zooming also creates a sense of drama in setting up Hedy's lines, where she plays to the audience in wondering aloud about her husbands and why they aren't there to protect her.

In the largely improvised courtroom scene, the camera also serves a functional and interpretive role. For instance, the camera zooms back to allow us to see more of the action, so that we see Jack Smith, the various witnesses, or even the judge. The camera also interprets the action. When the judge questions Hedy about stealing a pair of shoes, the camera tilts down to focus on her feet, one of which moves nervously backward and forward. The staccato zooms at the end of the film as Hedy undresses, along with the sound, create a highly dramatic sense of Hedy's impending doom, especially by reframing the shot to feature the goblet of hemlock more prominently. The camera does not appear disinterested at all, or, to quote Koch again, like "a very inattentive dog, constantly distracted by the fly on the ceiling."[71] Rather, Warhol's camerawork suggests that there are more creative possibilities for camera movement within a scene than either Tavel or Koch might admit.

Regardless, it is hardly the camerawork that's at fault for not absorbing viewers in the spectacle. Let's imagine, for a moment, that *Hedy* was shot in the classical Hollywood style. Would traditional camerawork allow viewers to succumb any more easily? It is doubtful. For one thing, *Hedy,* as Koch admits, is highly theatrical. The film is clearly staged in a location that gives the semblance of a stage set, even if Warhol's camera transitions, like the fading of the lights between scenes in a staged play, disguise the fact that it's occurring in a single location. The casting choice of having Hedy played by a transvestite, Mario Montez, also creates an inherent ironic distance. Furthermore, Gerard Malanga plays two roles. In his role as one of Hedy's husbands and co-conspirators in crime, he drinks hemlock and dies, only to reappear in the courtroom scene with her other dead husbands. Jack Smith also switches roles. He appears in the first scene involving Hedy's disastrous surgery. Throughout the trial, he functions as a "Friend of the Court," presumably because Hedy is underage, but Smith doesn't speak until the very end, when he suddenly transforms into the attending physician. In fact, virtually everything about the production—from the mise-en-scène to the improvised

musical score by the Velvets to Tavel's impromptu appearance during the salesgirl's death—works toward an effect not very dissimilar to what Warhol achieves with his camerawork.

Tavel, Koch, and Koestenbaum assume the primacy of story in their arguments about Warhol's camerawork in *Hedy.* My position, however, is closer to that of Douglas Crimp, who, in discussing the films Warhol made with Tavel, observes: "Whereas typically script, cinematic technique, and performance are concerted to focus our interest on relationships and their storyline development, here they consistently move us beyond them. Indeed, they are the means for the complete dissolution of relationships and stories as we know them."[72]

To his credit, Ronald Tavel wrote many of Warhol's best works: *Screen Test # 2, The Life of Juanita Castro, Vinyl, Kitchen,* and *Hedy,* as well as sections of *The Chelsea Girls.* He proved to be the right collaborator at the right time once Warhol decided to make synch-sound films. The writer grasped Warhol's basic aesthetic concerns, even if they clashed over the ways Warhol would subvert Tavel's scenarios. Whether by design or not, this also became part of the dynamic of the films, as we clearly saw in *Horse, Vinyl, Kitchen, Space,* and *Hedy,* which led to the writer's frustration with Warhol. Tavel indicates:

> I had a general dissatisfaction with the way he was making the movies from my scripts. You can allow for all these calculated errors and so forth, but when he deliberately shot the films badly, out of focus or paying no attention or exercising no control over what was an increasing army of uncontrollable actors, who had less talent, less looks, and were less serious—just there to be part of this glamorous scene—I had a lot of difficulty working with them. And he was not exercising his power of getting them in line, which he had done in the beginning.[73]

The dissatisfaction grew even greater once Edie Sedgwick came into the picture because the two of them soon began to clash.

The image that stands out from the Tavel period is that of Edie sitting on a silver trunk on the side of the frame as Gerard Malanga and Larry Latreille are being tortured in the foreground and background of *Vinyl.* The tension between the sadomasochistic spectacle and a beautiful superstar who has no dialogue encapsulates the battle that was to develop between Tavel and Edie. Tavel did not share Warhol's infatuation with her. He later told an interviewer: "This was a woman who could not learn lines. Plus, that attitude of hers . . . Did you ever see her in a movie where she projected anything but annoyance at having to

be in it? How can you work with that—an actress who is annoyed and cannot be bothered learning lines, and even when she tried, she was too drugged up to remember anything?"[74]

Given the conflict that developed between the writer and Warhol's favorite superstar, which came to a head in *Space,* it is not surprising that Tavel's role would be usurped by someone who better appreciated what Edie brought to the films. By the time Tavel made *Hedy* in February of 1966, he had already been replaced by a new Warhol collaborator, Edie's friend Chuck Wein, who made a number of films for the artist, mostly featuring her.

Films Made with Chuck Wein

Mind Games

Following the two scripts he wrote for *The Chelsea Girls* in 1966, Ronald Tavel stopped writing scenarios for Warhol films. He has offered various explanations:

> One of the immediate ones was that he [Warhol] was not paying me and I needed money. Another is that my theatrical career was taking off, which he was responsible for in suggesting that I stage some of the scripts and make myself a playwright and have the credit. And theatrical producers at the time wanted me to disassociate myself from him because his name was box-office poison and told me I should not mention having done movies with him.[1]

Tavel felt that the Factory's atmosphere was changing for the worse. In his view, hard-core drug users and socialites looking for thrills started hanging out there, and Warhol was not trying to control things. As Tavel put it, "He was just letting chaos reign, and becoming more and more distracted with childish social climbing and being seen every night at parties or hanging out with less serious people."[2]

Different factions were developing within the Factory. For instance, Paul Morrissey was extremely critical of what he considered the non-professional nature of Warhol's film productions. He had no respect for modern art and no appreciation for the avant-garde tradition of film-making as represented by what he saw at the Film-Makers' Cinema-theque. Morrissey was more interested in narrative and in pushing War-hol in a more commercial direction. Tavel, of course, was also interested

in narrative, but Morrissey thought that Warhol should be making more conventional films that would play in regular movie theaters rather than at small, avant-garde showcases.

The other faction growing more prominent at the Factory revolved around Edie Sedgwick, the troubled socialite who had already appeared in two films for which Tavel had written scenarios. Edie was as an "extra" in *Vinyl*, but upstaged the film's "star," Gerard Malanga. Warhol then had Tavel write *Kitchen* as a star vehicle for her, but Edie helped to sabotage *Space* and refused to participate in another Tavel scenario, *Shower*, at least partially at the instigation of her unofficial promoter, Chuck Wein. Wein, like Morrissey, was highly critical of Tavel's work and harbored his own ambitions to become involved in filmmaking. Additional complications soon arose when Edie became infatuated with Bob Dylan, whose people were suggesting that they also had an interest in producing movies. Edie's eventual involvement with Dylan would create a bitter conflict between the Warhol and Dylan camps. It would also have a profound effect on the direction of Warhol's filmmaking by inaugurating a period in which Chuck Wein shaped his films, which, for the most part, featured Edie.

In Edie Sedgwick, Warhol found his greatest superstar. Edie appeared in some of Warhol's very best films during this period: *Poor Little Rich Girl, Vinyl, Kitchen, Face, Restaurant,* and *Outer and Inner Space.* Warhol was fascinated by Hollywood glamour, especially "stars" who had the ability to carry entire motion pictures by their ineffable screen presence alone. He believed that the magic of cinema involves the transformation that occurs between a performer and her or his image. Warhol writes: "The great stars are the ones who are doing something you can watch every second, even if it's just a movement inside their eye."[3] Edie not only had intrinsic beauty, but, as *Poor Little Rich Girl* proves, she managed to be fascinating even when out of focus for half of the film.

Not everyone shares this belief in Edie's unique talent and ability. Tavel, for instance, recognized her star potential but ultimately had no use for her because he felt she had a bad attitude and was uninterested in learning his lines. Steven Koch also makes disparaging remarks about Edie, even though he acknowledges that she was one of the few Warhol performers who justified the status of superstar during this period. It wasn't, he writes, because

> Sedgwick was particularly gifted as an actress or performer—not like Ingrid Superstar or Ondine. And to say that Sedgwick had the qualities of a star in the old Hollywoodian sense—that she was a presence who was ideal when

herself—seems like a desecration, too, seems to invite the same inflated fantastic comparisons that did so much of the Factory in.[4]

Warhol replaced Edie with Ingrid Superstar in order to spite her for her traitorous involvement with Dylan, but Ingrid had absolutely none of the star qualities that make Edie so mesmerizing to watch.[5]

Warhol describes the films he made with Edie: "All the movies with Edie were so innocent when I think back on them, they had more of a pajama-party atmosphere than anything else."[6] Although "pajama party," in some strange way, might describe *Beauty # 2*, Warhol's comment disguises what's really going on in the films. George Hickenlooper's melodramatic biopic on Edie, *Factory Girl* (2006), captures some of the subtext. In one scene, Warhol manipulates Chuck Wein into exploiting his relationship with Edie so that she will continue to make films for him. The carrot that Warhol dangles is an offer to let Wein direct the films. As Warhol (Guy Pearce) and Wein (Jimmy Fallon) converse about Edie (Sienna Miller) while Wein is being fitted for a new suit, Warhol tells him, "Well, it's just such a pity that she should get all the attention when you're the one who found her." Warhol questions Edie's desire to make films and feigns that he might be disappointed in the results. Wein responds, "I can have her say anything you want. She trusts *me* more than anyone."

Chuck Wein's role in Warhol's films was often behind the scenes, even though, like Tavel, he can be heard offscreen in three of the collaborations, namely *Poor Little Rich Girl, Face,* and *Beauty # 2*. As the allusions to him in the film make clear, Wein was a strong presence in the filming of *Restaurant,* but he turns out to be an enigmatic absence in *Afternoon.* Callie Angell describes Chuck Wein's role as "offering Warhol film ideas and directorial assistance, accompanying Sedgwick to film shoots, and also acting as Sedgwick's offscreen friend and/or interrogator, engaging her in conversation and giving her something to react to while Warhol filmed her."[7]

POOR LITTLE RICH GIRL

Poor Little Rich Girl (1965) represents a switch in collaborators—from Ronald Tavel to Chuck Wein—as well as a movement away from the theatrical and melodramatic toward a greater sense of realism. The film also serves as another star vehicle for Edie Sedgwick, about whom Warhol claimed, "If she'd needed a script, she wouldn't have been right

for the part."[8] The credits, which are read by Wein at the end, employ pseudonyms: Mazda Isalon (Edie) and scenario by Hal Larson (Chuck Wein).[9] The film clearly references the Shirley Temple film *Poor Little Rich Girl* (1936), in which Temple runs away from a rich family to join a vaudeville group, a situation that mimics Edie's own flight from her wealthy, upper-class family to the Factory.

Callie Angell describes the Edie Sedgwick films as "basically extended portraits" and further suggests: "In fact, they can be regarded almost as documentaries—straightforward, unscripted filmings of Edie simply being 'herself,' in scenes taken from her real life."[10] Jonas Mekas claims that *Poor Little Rich Girl*, "in which Andy Warhol records seventy minutes of Edith Sedgwick's life, surpasses everything that the cinéma vérité has done till now; and by that I mean film-makers such as Leacock, Rouch, Maysles, Reichenbach. It is a piece that is beautiful, sad, unrehearsed, and says about the life of the rich girl today more than ten volumes of books could say."[11]

Although Edie, on some level, does play herself rather than a fictional character, such a description seems misleading when applied to *Poor Little Rich Girl*. For one thing, the abstraction of the first reel undercuts conventional cinematic codes of realism. In addition, the film is less a documentary slice of life than a construction, which involves a narrative setup, much like *Screen Test # 2* or *The Life of Juanita Castro*. Edie becomes so stoned in *Poor Little Rich Girl* that she has difficulty even being able to follow the conversation with the offscreen Chuck Wein, who uses the masquerade of friendship to poke fun at Edie's insecurities, even though Edie mostly remains oblivious to the import of his subtle manipulation.

Despite its latent psychodramatic underpinning, which remains a strong subtext in the work, *Poor Little Rich Girl* rests on distinctly formal elements. Warhol creatively plays not only with focus but also with expressive camera movements and zooming. One of his boldest strategic moves is that the entire first reel, or virtually half the film, is deliberately out of focus. Due to a technical problem involving the lens, Warhol initially shot both reels out of focus. He then reshot the film and selected a reel from each. Angell asserts: "This is one of the few instances in which Warhol reshot a particular film in order to obtain a desired result."[12] The soft focus becomes part of the film's stylization. Not only does the first reel recall impressionist painting, but it also reminds a contemporary viewer of paintings by Gerhard Richter and the blurry-photograph school of painting that he embodies. At several points in *Poor*

FIGURE 20. Edie Sedgwick;
Poor Little Rich Girl, 1965
(16mm film, b/w, sound, 66
minutes. Film still courtesy of
The Andy Warhol Museum)

Little Rich Girl sharp focus is achieved, but this only occurs for fleeting moments.

The film opens with a blurred close-up of Edie's face as she sleeps. As Wein announces the film's title, Edie responds, as if annoyed, "Fuck you!" Throughout the first reel, Edie talks to a friend by phone, orders orange juice and coffee, and smokes cigarettes. After roughly ten minutes, she plays the "Best Hits" of the Everly Brothers, which recalls Kenneth Anger's use of pop tunes in *Scorpio Rising,* as well as Warhol's use of pop music in *Tarzan and Jane Regained, Sort Of . . .* and *Vinyl.* As Edie moves around the apartment, the camera zooms in and out, fragmenting various parts of her body as it attempts to keep her within the frame, and sometimes moves into darkness. After about thirteen minutes, Edie strips to her bra and panties. She reclines on the bed and begins to do leg exercises, so that the abstraction becomes a sexual tease, especially when the camera zooms in closer to her genital area. The soft focus serves as a screen or buffer between Edie and the viewer, a technique that Warhol used to add an erotic dimension to films such as *Haircut (No. 1)* and *Couch.* Edie will also subsequently disappear into blackness, which has a similar effect.

In stark contrast to the dreamlike abstraction of the first reel, the second is in sharp focus. Indeed, it comes as a rude shock to see grainy, high-contrast, black-and-white images of Edie in only her bra and underwear and black nylon stockings, as well as to stare directly at her navel, while the Searchers song "What Have They Done to the Rain" blares on the sound track. The film provides us with a sudden sense of erotic intimacy with a very attractive movie star—as if we've been allowed entry into her private dressing room. The camera zooms out. Edie peers around and then lights a pipe full of marijuana. She suddenly calls out to Wein,

FIGURE 21. Edie Sedgwick;
Poor Little Rich Girl, 1965
(16mm film, b/w, sound, 66
minutes. Film still courtesy of
The Andy Warhol Museum)

"Chuck, are you going to wake up?" They converse about how long he's been asleep. Edie informs him that the phone is broken. She claims that she was going to call Lester [Persky] in order "to apologize for nothing." The camera frames her in close-up as she continues to smoke, while Chuck declines her offer to share in getting high.

Edie asks whether he had any funny dreams. Chuck talks about having a dream about the "bomb" song, or, as he puts it, "miles and miles of people dressed in striped shirts looking like the Kingston Trio, singing 'What Have They Done to the Rain.'" Because Edie has been playing the song, she seems momentarily confused by his reference to it being a dream. Edie, in turn, discusses a dream of her own in which she had to "walk down thousands and thousands of white marble stairs . . . and nothing but a very, very blue sky." She alludes to the fact that this was after her accident.[13] Chuck asks her whether she's been eating while he's been asleep— a veiled reference to her well-known eating disorder (bulimia).

The phone (which Edie had announced earlier was broken) rings six minutes into the second reel. Since the film appears unscripted, a question immediately arises: Is the phone call a setup? Did someone really just call, or did Wein and Warhol arrange it? Because Edie's very stoned, she doesn't recognize the caller at first. She then says: "Oh, hi, how are you?" As she converses, Edie makes a multitude of expressive faces at Chuck, who announces that he's going to put on some music. After he asks whether the music will bother her, he puts on "Everybody Loves a Lover" very loudly, so that Edie has trouble focusing on the phone call. While Edie makes plans to meet the caller the next day, Chuck keeps yelling "Edie!" In a reference to the movie itself, she tells the person on the phone that she has to shoot "this first scene," thus referencing the

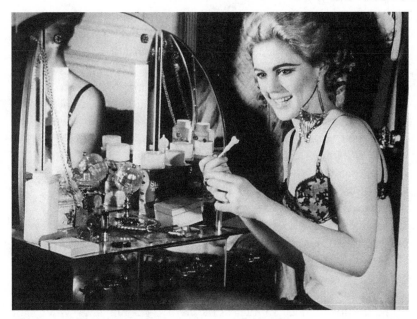

FIGURE 22. Edie Sedgwick at vanity table; *Poor Little Rich Girl*, 1965 (16mm film, b/w, sound, 66 minutes. Film still courtesy of The Andy Warhol Museum)

fact that she is actually performing in a movie at the moment. When Chuck presses her about the caller, she acknowledges that the guy wants to see her. He asks for more details, but Edie has trouble remembering. Although she's short on details, Edie talks about a planned trip around the world where she and the caller would party continuously. As Edie, still in her bra and panties, walks over to the vanity table, Chuck puts on the Shirelles' "Tonight's the Night"—a song with strong sexual connotations. Chuck continues to question her while Edie puts on makeup, dances briefly to the music, and then reaches for the pipe.

The phone call serves as the inciting incident or catalyst in the second reel. As Edie sits at the vanity table, the camera framing emphasizes her attractive legs. Edie asks, "What am I going to do?" Playing the role of close confidant, Chuck gets her to talk about her family, her bulimia, and her newly dyed hair. The discussion about her looks prompts Edie to smoke more marijuana, and the camera tilts suggestively down and up her body. Chuck also puts on different versions of the song "It Ain't Me Babe," first a version by Bob Dylan and then one by Joan Baez, as a mockery of Edie's involvement with the Dylan crowd.[14]

Chuck gets Edie to try on clothes. When he questions whether she

has put a dress on backwards, Edie rejects the item. Chuck also mentions her cleavage, but Edie responds, "Don't make fun of me." Edie doesn't feel like trying on clothes, but she puts on a skimpy leopard belt (Wein jokingly refers to it as a "leopard chastity belt") and long black boots. Chuck then gets Edie to model her leopard fur coat. As Edie puts it on, she remarks that it's "the most beautiful coat in the world," to which Chuck counters, "Introducing the most beautiful coat in the world." The camera zooms in on Edie, revealing a large scar below her left breast. Chuck criticizes the buttons by suggesting they look like "two-way radios." Suddenly insecure, Edie asks, "You don't like them?" Chuck puts on opera and gets her to talk about the coat, which, as it turns out, she received as a gift from an admirer. As she removes the leopard belt, Edie offers what amounts to a sound bite: "I think everyone should wear fur this summer." Edie then puts on a long dress and a pendant that contains a $100 bill, which she claims she stole from her mother. Chuck cynically suggests that he believes everything she tells him. Edie puts on perfume, and he asks her to call Donald [Lyons]. While she does, Chuck announces the credits. The film ends with a shot of Edie on the phone.

Poor Little Rich Girl is a subtle portrait of Edie that relies on understanding the context of Chuck's remarks to grasp the ways he's manipulating her. He has a distinct advantage because Edie's very high, and so she seems not to pick up on what he is actually doing. He knows how to play on her personal insecurities as Tavel was able to do with Philip Fagan in *Screen Test # 1* and Mario Montez in *Screen Test # 2*. The template is there already. The film might appear to be improvised, but there's a structure to what Wein is doing, especially with the phone call, the suggestive choice of songs, and having Edie try on clothes, which prompts her to react to even the slightest hint of criticism. Warhol's use of the probing camera makes the invasions of her personal space even more discomfiting, as if we don't have any right to be intruding on her privacy.

RESTAURANT

Restaurant (1965) is notable for inaugurating Warhol's use of a technique that became known as the "strobe cut," in which a flash of light is created between frames when the Auricon sound camera is turned on and off. The traditional purpose of the flash of light was to indi-

cate to the editor where one shot ended and the next began; Warhol's innovation was to use this as a form of obvious in-camera editing. Rainer Crone discusses the strobe cut as a Brechtian device "to interrupt the depiction of a person or the reproduction of a conversation or an action."[15] Yet, as we will see, once Warhol began to use the technique with great frequency, in *Bufferin* (1966) and the later sexploitation films, it functions more like a purely stylistic device, similar to the way Warhol incorporated the smearing that occurred during the silkscreening process into his paintings.[16]

Restaurant begins with a photographer shooting inside a dimly lit, empty restaurant. This is followed by a strobe cut to a wide shot of people inside the restaurant, which features a large Romanesque statue in the foreground. Other elements reinforce the impression that it's an Italian restaurant. A second strobe cut shows a close-up of a table: a bottle of Chianti, a Cinzano ashtray, a plate, a bottle, napkins, and a drink. As the shot continues, we hear Edie's name being mentioned. At one point a waiter obscures Warhol's "still-life" composition, a shadow passes, a hand intrudes from the left, and the waiter reappears. After three minutes, shadows and then bodies move in front of the camera to sounds of shrieks as Edie enters. At nearly four minutes, we see her plunk her purse on the table and hear Ondine arrive. Edie says, "Oh, this is Ondine; oh my goodness." After greeting friends, she says, "You must be Ondine" and adds, "Ondine just got back from the Panama Canal." Although we can't see the people sitting at the table, various activities occur, such as a hand, presumably Edie's, taking the drink and placing her purse on the table. We hear fragments of dinner banter. Edie asks, "Is this what you consider rock and roll, Ed?" He answers, "Ask Chuckles. He put it on."

After ten minutes, the camera zooms in slightly and then slowly zooms out, revealing someone with a striped tie on the right. More and more, arms start to intrude into the composition. Edie says, "Somebody, tell me where Chuck went?" The references to Chuckles and Chuck suggest that Wein is also there, but presumably involved with the filming. Edie announces to everyone that Ondine's "a genius." By twelve minutes, Edie is completely visible in the foreground on the right, and Ed Hood is revealed to be the person with the striped tie. Dorothy Dean sits between him and Ed Hennessy. Donald Lyons becomes visible in the left foreground. At one point, he leans across the table to talk with Edie, while another woman can be seen next to her. As the zoom gets

wider, we see Edie's attractive crossed legs. Edie remarks that she thought Ondine (whose real name was Robert Olivo) would love her friends. At around sixteen minutes, we finally see that Ondine is seated between Lyons and Hennessy, as the waiter moves around the table, taking dinner orders. A minute later, Ondine switches seats with the woman who was sitting next to Edie. By now the entire table is visible.

While *Restaurant* is unscripted, the suggestion that the Edie films are somehow "documentary, unfiltered slices of [her] life" is misleading.[17] As in other Warhol sound narratives, there is a fictional element, an effort to create dramatic tension by inserting an explosive personality, Ondine, into a situation involving the Cambridge crowd.[18] It sets up class differences that will fuel the interactions throughout the film's thirty-three minutes. When Ondine changes places, the viewer can see that he's dressed casually in shorts, tee shirt, and sandals, which separates him from the formal dress of virtually everyone else at the restaurant.

Ondine and Dorothy Dean, the only person of color at the table, spar verbally throughout the dinner, as Ondine openly insults Edie's friends. Ondine even makes an offensive racial remark, also calling her a pest and a drunk.[19] In response, she calls him a pig and a junkie. Others at the table wonder aloud what Ondine's doing there, but Edie characterizes him as a "genius" and claims he's "marvelous," without bothering to provide any reasons why. Only the woman he trades places with defends him by saying she thinks he's "divine." Without this underlying dramatic tension, *Restaurant* would not be nearly as interesting. Edie had only recently met Warhol and would not have known Ondine very well. Their greeting reinforces this, as Edie suggests the contradictory notions that they are just meeting for the first time and also that they are dear friends. Their alliance as the two stars of the film remains an essential part of the fiction. At several points, Ondine threatens to leave the restaurant because of poor service and his dislike of Edie's friends, but he nevertheless stays until the end.

Another source of tension in the film is the poor service in the restaurant, despite evidence to the contrary. When Ondine complains that the restaurant is a "joke" and that they haven't gotten their food, Edie tries to appease him by shouting that they've been there for "at least an hour." She even appeals to Chuck Wein to solve the problem. But, despite the complaints by everyone that they've been waiting an hour for their food, it's really only been ten minutes since the waiter has taken their order, which suggests another fictional element. After Edie indicates that Ondine has been calling people "pigs," another person

wonders why she has brought Ondine back, suggesting that he's left, an event we never actually see.

At one point Edie is asked for her autograph, as if she's a well-known movie star. While she clearly looks like one, this seems to be a staged contrivance. In *Restaurant,* Edie is playing the role of a movie star out on the town with her friends. The first two shots—the photographer snapping photos in an empty restaurant and the wider shot showing the layout—have clear narrative functions. The first shows the empty set, while the second serves as an establishing shot. This suggests that rather than a documentary slice of life, *Restaurant* is actually a fictional event staged for the camera.

The camera movement in *Restaurant* certainly reinforces the film's narrative aspects. The still-life composition creates a tension between the on- and offscreen space similar to that in *Harlot* and *The Life of Juanita Castro.* The slow zoom out that begins at ten minutes gradually reveals the identities of the various diners. Prior to this, we attempt to guess who is dressed in the striped tie or where people are positioned. For instance, we're pretty sure where Edie is sitting, but it turns out to be surprising where Ondine ends up. Once the camera has zoomed out, we can see him change places. This shot also allows us to see how Ondine is dressed, so his walk in front of the camera to sit next to Edie seems to be planned rather than spontaneous. In terms of the framing, it makes more sense to have the two main characters next to each other, and indeed the camera will frame them in such a way that the two will at various times become more prominent. The arrival of the dish of Osso Bucco also occurs in a wide shot, allowing the viewer to watch Donald Lyons grab the plate with the eggplant. The zoom in closer allows us to see him give the eggplant to the waiter, Alfredo, who drops it back on the plate.

The camerawork thus serves a narrative function by allowing us to view important aspects of the action. The panning left and right is not arbitrary. For instance, it pans back to Edie just in time for her to shout about how long they've been waiting for the food. It also zooms out in order to introduce the new couple. The camera also pans to the other table as Ondine and Dorothy Dean get into a verbal spat, so that we get what amounts to a reaction shot of the man, who smokes a cigarette and laughs. In the zoom out, we witness Ondine putting chains on the woman next to him.

These actions suggest that the camerawork in *Restaurant* is not divorced from narrative concerns. At the same time, it follows a conceptual logic—the two strobe cuts, the extended still-life shot of the table,

the zoom out and back in, as well as the pans and tilts both left and right. The camera movements add to the tension, obscuring some parts of the action. By doing so, it heightens our awareness of what is occurring outside the space of the frame by creating an interesting juxtaposition between sound and image.

AFTERNOON

Warhol's films implicitly contained a significant risk of failure. His narratives depended heavily on the improvised performances of his actors in continuous, extended rolls of film as opposed to trying to construct the film in the editing room afterward. Warhol wrote: "I never liked the idea of picking out certain scenes and pieces of time and putting them together, because then it ends up being different from what really happened—it's just not like life, it seems so corny. What I liked was chunks of time all together, every real moment."[20] Tavel made clear that such moments need some sort of catalyst; otherwise the films will fall flat. Despite Warhol's offscreen exhortations to the performers, *Afternoon* fails to develop any sort of compelling dramatic conflict. Yet the film is fascinating for how it lays bare the essential mechanism behind Warhol's narratives.

Besides Edie and Ondine, *Afternoon* features three of Edie's Cambridge friends: Donald Lyons, Arthur Loeb, and Dorothy Dean. They sit around for an afternoon, drinking, taking drugs, listening to music, watching television, talking on the telephone, singing songs, and chatting with each other. They even address Warhol, who is operating the camera. We also hear Warhol directing the performers, refuting the widely held myth that he wasn't involved in his own productions. Warhol asks Ondine to make a face for the camera. He then insists, "Another face . . . more, more, more, more faces, more . . . more faces." Warhol later asks Arthur Loeb and each of the other actors to smile for the camera. Edie asks Warhol if she can pick on Ondine, to which he replies, "You can pick on whoever you want."

They discuss politics in the third reel. When the subject of Lyndon Johnson comes up, Edie says, "Oh, I hate Johnson. Johnson is both a pig farmer and a basset hound . . . it's too unbelievable." Ondine responds, "He's not good enough for a basset hound." Dorothy Dean chimes in that he's "still better than Nixon." When politics fails to generate the necessary tension, Warhol begins to talk to the performers from offscreen:

Warhol: Come on. Camp it up, Ondine.

Edie: Oh, camp it up yourself.

Ondine: If you think I can camp it up after two reels, you're mad. In this blistering heat? You're insane.

Edie: This is . . . I mean, what do you want? The end of a . . . like everybody's got to be campy?

Warhol: Then don't camp it up, Edie.

Edie: We could just really have a really bad argument right now instead of camping it up.

Warhol: Come, on, camp it up, Edie.

Ondine: That's camping it up.

Donald: You distinguish?

Arthur: Stop injecting [sic].

Edie: You don't think . . . no I'm just being . . . I think, camp it up like, okay, maybe it amounts to the same thing . . . it doesn't matter . . . you argue or . . .

Dean: It depends what you mean by "bad arguing."

Ondine: Bad aroma.

Edie: I mean, we could really argue about any single . . .

Dean: You mean ferocious, ferocious argument or a . . .

Edie: Yeah, people could say . . . people would say what they thought . . .

Warhol soon tries to provoke a response from Ondine by asking, "Did she [Edie] call Ondine 'Nellie'?"

Dorothy Dean and Arthur Loeb (who were, in actuality, very close friends) get into a row that has racial and anti-Semitic overtones, providing one sure way to provoke a bad argument.[21] As Ondine talks on the phone, Warhol directs Dorothy Dean to insert herself next to him. He also gets Donald Lyons to sit between Edie and Arthur, so that they are now framed like a family portrait, with Ondine on the left side of the frame. Given the enmity that existed between Dean and Ondine in *Restaurant,* Warhol gives her an instruction. Dean leans over and kisses Ondine on the cheek. He slaps her in irritation. As Dean's body jerks back, her cigarette burns Edie's leg.

Warhol encourages Ondine, "Make a scene with Dorothy. Treat her like you treated her the other night . . ."[22] As Dorothy bends over to put out her cigarette in an ashtray, Ondine shoves her rear end. When

Ondine threatens to leave, Edie shouts, "Camp it up! Camp it up! . . . That's the whole point . . . just a laugh, just a joke . . . it doesn't mean a goddamn thing. That's your answer to the whole problem—camp it up!" Warhol answers, "Yeah, Edie." Warhol eventually asks Edie to sit more in the middle and Edie slaps Ondine's buttocks on the way over. A male actor not in the frame yells to Warhol, "Give us more directions like fight and love, and hate and . . . cuddle." Edie shouts, "No, we already had a fight . . . No more fights!" Loeb quietly tells Edie, "There is no drama without conflict." Dorothy Dean eventually gets them to play "Virginia Woolf," a game in which "one attacks one another's shortcomings."

Despite the efforts of the cast, *Afternoon* fails to achieve the same level of dramatic combustion as Warhol's other films. Nor does it have the conceptual framework and formal rigor of his best works. The inclusion of Ondine always has the potential to create dramatic tension. He threatens to leave the set and deliberately annoys the others by playing a Maria Callas record very loudly. Antagonism develops between him and Arthur Loeb that takes the form of snide remarks and a brief physical exchange, which is partially fueled by their class differences. With an African American woman (Dorothy Dean) and a Jewish homosexual man (Arthur Loeb), some friction between them also results in racist and anti-Semitic comments.

Ondine will later make an anti-Semitic remark about Arthur as well, but these are all cheap shots—weak-hearted attempts at what even the film terms "bad arguing." The most revelatory aspect of *Afternoon* involves the chance to hear Warhol's offscreen directions to his performers and his various attempts to rile them. The essential conflict of *Afternoon* turns out not to be among the five performers onscreen, but between the actors and their offscreen director, who, as in the game of "Virginia Woolf," seems painfully aware of their shortcomings, as well as his own, on this hot summer afternoon in Edie's apartment.

FACE

The close-up is often used for dramatic emphasis in narrative films, but Warhol made entire films using only this shot, often as a form of portraiture. Warhol's many silent *Screen Tests* provide examples of his predilection for this particular framing, as do some of his other films, such as *Blow Job*, *Henry Geldzahler*, and *Outer and Inner Space*. The Hungarian film theorist Béla Balázs wrote extensively about the power

of the close-up and, in particular, about the depiction of the human face:

> Facial expression is the most subjective manifestation of man, more subjective even than speech, for vocabulary and grammar are subject to more or less universally valid rules and conventions, while the play of features, as has already been said, is a manifestation not governed by objective canons, even though it is largely a matter of imitation. This most subjective and individual of human manifestations is rendered objective in the close-up.[23]

In *Face* (1965), Warhol filmed a close-up of Edie's face for the entire sixty-six minutes, demonstrating that his most famous superstar had the ability to command an audience's attention while merely playing music, applying makeup and accessories, smoking marijuana, talking on the phone with a friend, and conversing with Chuck Wein, who, as usual, remains an elusive figure off-camera.

Face alludes to trips to Paris, London, and Tangier. In May, Edie and Wein accompanied Warhol and Gerard Malanga to Paris, where the Pop artist had a show of flower paintings at Ileana Sonnabend's gallery.[24] It was here that Warhol reportedly announced his decision to give up painting in order to concentrate on film. Warhol explains: "I told the French press, 'I only want to make movies now,' but when I read the papers the next day, they said that I was 'going to devote my life to the cinema.' The French have their way with English—I loved it."[25]

Warhol also discusses the group's spontaneous decision to take a detour to Tangier before returning home. He describes an incident in which, as the plane was about to take off for New York, "Chuck leaped up and said, 'Wait a minute, I'll be right back.' He ran down the steps of the plane and disappeared. We took off. All the way across the Atlantic, I wondered if there was something he knew that we didn't, like, say, that there was a bomb on the plane or drugs in our baggage."[26] As might be expected, Chuck's erratic behavior had an unnerving effect on the rest of the group, especially Edie. Warhol comments: "Chuck came in on the next flight. I realized he might have bolted just because he'd gotten one of those cosmic flashes that our plane was going to crash. He was from Harvard, after all, which was early LSD country. I never did find out for sure, though."[27]

This particular incident, as well as Edie and Chuck's travel experiences more generally, provide important backstory for *Face*, along with the superstar's well-known obsession with lipstick and makeup. According to Tony Scherman and David Dalton, "Edie's dalliances with lipstick

and makeup were similarly epic. Chronically late, she could easily spend three hours doing her face to the exasperation of anyone who happened to be waiting for her to show up. Her belated arrivals at parties and openings, hours after she was expected, created a sense of drama and seemed the sign of a true diva."[28]

Face begins with a profile close-up of Edie. We hear the spoken credits, which indicate the film's original title, *Isn't It Pretty to Think So,* and that it is "by Chuck Wein for Andy Warhol." As her name is read, Edie turns toward the camera. She puts on music. We hear the Righteous Brothers singing "You've Lost That Lovin' Feelin'," which became a number 1 hit single in 1965.[29] Edie lights a cigarette, puts a piece of gum into her mouth, combs and brushes her hair, and exhales a steady stream of smoke. She also applies makeup to her cheeks and nose. The song ends, but she decides to play it again. Edie looks around the frame, drinks what appears to be orange juice in a goblet, and eventually puts a pill in her mouth and washes it down. She then applies lipstick.

Roughly two-thirds of the way through the first reel, the music switches from pop songs to what sounds like music from a Fellini film. Edie wets a marijuana cigarette with her lips. She looks offscreen and asks Chuck whether he's going to wake up, and begins to smoke the joint. Chuck talks about having things to do, causing Edie to mutter to herself. Suddenly anxious, she asks, "How am I ever going to get ready?" Chuck indicates that they're going by plane, not boat, so that automatically limits what she can bring. Edie answers, "I just have so many things. That's the trouble." When Wein indicates that she doesn't have to be ready until Thursday, Edie responds indignantly, "Now? Thursday! How can I possibly get ready? There's no chance!" Chuck then counsels Edie, who's worried that her mother might have her committed to a mental hospital. She rants, "They have no grounds," especially because, legally, she's over twenty-one. Chuck suggests that she tell her mother that the doctor said, "Insanity runs in the family and it's all hereditary."

As the second reel begins, Chuck tells her that he didn't purposely miss the plane in Tangier. Edie replies, "How come this once you did something perfectly idiotic?" He suggests that he was at the duty-free store, but his explanation remains unclear. It becomes obvious that Edie proved difficult on the trip. Chuck suggests, "So now you're going to stay in New York and you won't give us any trouble." Edie answers, "I give you trouble all the time . . . I mean I'm always screaming and yelling. What do you mean?" After the phone rings and she answers it,

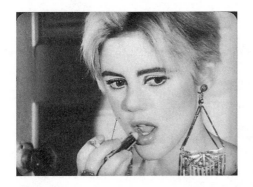

FIGURE 23. Edie Sedgwick; *Face,* 1965 (16mm film, b/w, sound, 66 minutes. Film still courtesy of The Andy Warhol Museum)

she insists to a friend named Sandy, "I didn't have any more tantrums than anyone else." Chuck counters, "Lies, lies, lies." Edie talks about their hotel being in proximity to the Louvre, commenting, "It was like a block away and we never went." Instead, according to Edie, they went to discotheques, dirty bars, and strip clubs.

Chuck provides his own running commentary throughout her phone conversation. Edie, for instance, frowns when she describes a friend quitting his job, but Chuck explains, "He worked in an international law firm . . . and never saw the light of day." Edie deepens her voice and tells Sandy knowingly, "Chuck, always distorting anyway. Get that!" Chuck keeps talking in the background, but he finally tells Edie, "Stop boring her. Get off the phone!" Edie stares at him and responds, "What? Who are you telling that to? Are you talking to me that way?" She continues, "I'm boring her? Is that what you said?" Chuck answers, "Well, she's obviously trying to get off the phone." After she hangs up, he suggests that Edie should do musical comedy and compares her favorably to Judy Holliday, Barbara Streisand, and Judy Garland. She asks, "Who said that?" He answers, "I'm saying it."

The issue of Chuck missing the plane appears to be a sore point in their relationship because he returns to it again. They talk about Chuck getting stopped by customs agents. Chuck indicates their group looked rather conspicuous, especially Edie, who had leopard and mink coats on her arm, while wearing leotards and "earrings that interfere with cleavage." In response to his dig at her lack of cleavage—something he also alludes to in *Poor Little Rich Girl*—Edie yells, "Oh, we're going to get on a bad subject." She talks about two members of their group being searched at the airport and getting taken away, leaving her sitting on a suitcase. When Chuck discusses having his jacket pockets searched, Edie admits they were worried the police would find drugs on him.

As they talk, Edie gets more stoned. At one point she becomes confused by the conversation and asks Chuck, "Are you saying what you mean?" They continue to talk about being searched while traveling. Chuck fantasizes about eventually going "anywhere in the world because we'll own it." Edie remarks, "We better!" Somewhat dramatically, she adds, "Oh, everything could be so marvelous!" Chuck responds, quoting the final line from Hemingway's *The Sun Also Rises* (1926), "Isn't it pretty to think so." He repeats the phrase five times, and the sixth time merely says, "Isn't it pretty . . ." After a long pause, he asks, "What were we talking about?" Edie laughs nervously and exclaims, "Everybody's out of it." The camera continues to roll and we hear stifled coughs offscreen, as Edie smokes a filtered cigarette and gives a variety of confused looks to the camera before laughing as her head moves nearly out of the frame and the film ends.

Warhol claimed: "I only wanted to find great people and let them be themselves and talk about what they usually talked about and I'd film them for a certain length of time and that would be the movie."[30] Like other Wein films featuring Edie, *Face* could be understood in relation to this concept, but once again, it fails to account for the formal choices Warhol makes: the decision to shoot black-and-white film stock, his use of a fixed camera, the close framing, the careful attention to lighting, and the film's overall structure.

Edie initially plays pop songs, mostly from English bands, while primping for the camera. The songs do not seem arbitrary, but carefully chosen for their lyrics. *Poor Little Rich Girl*, which *Face* resembles, used the Everly Brothers on the sound track. Chuck is supposedly asleep when both films begin, a contrivance that allows Edie to wake him up at opportune moments. In *Face*, this also coincides with a change in music, from rock to a mélange of different music—ranging from movie sound tracks and Dixieland jazz to classical—that plays for much of the rest of the film. As in *Poor Little Rich Girl*, Edie gets increasingly high during the course of *Face*, and also receives a phone call from a friend, which lasts nearly eight minutes. This appears to be planned rather than a coincidence.

If this were simply a recording of a segment of Edie's life (in this case, shot in a continuous close-up), as Warhol would have us believe, it wouldn't be nearly as interesting. The concept behind the film, as was true of all the Wein films involving her, was to set up Edie for something unexpected. In this case, Chuck plays a "mind game" on Edie while she's high, thereby toying with her sense of reality, which is the aspect of the film that relates it to psychodrama.

Face might be the best vehicle for displaying what made Edie the great-

est Warhol superstar, namely her presence on camera. Her radiant facial features have visual impact, which is precisely the quality that attracted Warhol to her. As Bibbe Hansen, who appeared in several Warhol films, puts it: "Looking back at me looking at it then—we're getting very Proustian here—she had the most amazing and wonderful quality to live in the film frame. To live there, to breathe, to inhabit it."[31] While Edie manages to inhabit an extremely tight frame, it is the final three minutes of *Face* that prove most riveting. Warhol claimed: "All my films are artificial" because "I don't know where the artificial stops and the real starts."[32] The major interest in *Face* is how the film explores this boundary.

BEAUTY # 2

Hickenlooper's biopic *Factory Girl* restages a fragment of *Beauty # 2*; this occurs shortly after the previously described scene in which Warhol and Wein discuss how to manipulate Edie. In this fragment, Wein brings up Edie's father, Fuzzy, and her brothers (one of whom, Minty, was gay), and raises the issue of incest. He gets Edie to kiss Gino Piserchio, the attractive pickup with whom she's lying on the bed, but his actions border on rape. The fictional Wein says, "Gino, she likes it when you get rough. She likes those tough men. Strong men are what turn you on, isn't that right, baby cakes? Not like your brother, Minty. Your father wasn't so keen on him, was he? Who was he keen on . . . you?" This causes the fictional Edie to hurl an ashtray at him. Throughout the scene we're given reaction shots of both Warhol and Wein—something we never see in *Beauty # 2*—as Edie physically struggles against the aggressive Gino. Anyone who has seen Warhol's *Beauty # 2* realizes that this re-creation of the film is an utter fabrication—a rewrite to satisfy the kind of facile psychology that motivates the typical biopic by reinforcing the notion that Edie was a tragic victim.

Beauty # 2 is far more subtle. Warhol writes: "We filmed a lot of movies over at Edie's place on 63rd Street near Madison. Things like the *Beauty* series that was just Edie with a series of beautiful boys, sort of romping around her apartment, talking to each other—the idea was to have her old boyfriends there while she interviewed new ones."[33] In *Beauty # 2*, Edie and the good-looking Gino Piserchio aren't exactly romping around the apartment, but rather confined to a bed, along with a dog named "Horse." The name of the dog is significant because Edie was obsessed with horses, which provided the subject matter for her own artwork. Chuck Wein plays the former boyfriend, who remains

offscreen and controls the flow and tempo of the conversation. Such a situation automatically involves unresolved emotions and resentments between the ex-lovers as well as a natural built-in animosity between Wein and his replacement, Gino, especially when the new lover and Edie are encouraged "to get to know one another."

Warhol's fixed-camera composition is important to the success of *Beauty # 2*. The camera frames the length of the bed, which is placed in a receding diagonal position, so that it creates a sense of depth. We see a slight side view of Edie, who is positioned at a perpendicular angle and wears a skimpy black bra and panties. Gino sits at the head of the bed, so he remains at a perpendicular angle to her, but facing the camera. Horse lies between them. The high-contrast lighting overexposes the foreground as a result of the placement of the key light, while the back area of the frame remains largely in shadow.

According to Tavel, Warhol thought of film in abstract terms. For *Kitchen,* he told Tavel he wanted "white," while for *The Chelsea Girls,* he told him: "I want two energies . . . I want black and white, at the same time."[34] It's clear that Warhol conceived of *Beauty # 2* in terms of geometry. The film begins with lines: "This is not just another pretty face, but *Beauty # 2: Gino Piserchio.* As the first angle of the triangle: Edith Sedgwick." This calls attention to the framing, which creates a triangle involving Edie, Gino, and the invisible Chuck Wein. In addition, a romantic triangle, which is what we have here, is often used as a device for creating conflict in narrative films. Warhol once claimed: "The best atmosphere I can think of is film, because it's three-dimensional physically and two-dimensional emotionally."[35]

The naturalistic conversation of *Beauty # 2* is somewhat difficult for most viewers to follow, especially because of the poor sound quality and the fact that we don't have a context for many of the personal remarks, nor do we always know what's fictional and what's not, precisely because *Beauty # 2* deftly explores the boundaries between the two. For instance, the three of them begin by discussing Horse, the dog that Wein claims they found outside a discotheque called "Arthur." This appears to be a deliberate contrivance given Edie's personal connection to horses, but the mention of the specific discotheque also serves as a veiled reference to Bob Dylan, because that's where Edie used to run into him.[36] In addition, it's doubtful that they would include a stray Doberman in the production or happen to know that he is eight years old. Even Edie jokes about the dog's ability to discuss his age with Wein. She asks him, "Why won't he talk to me?"

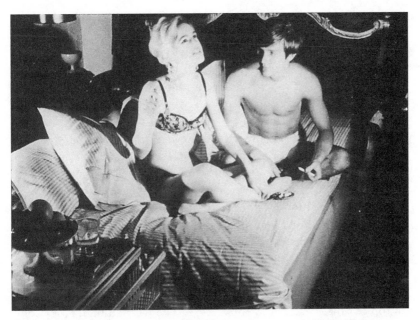

FIGURE 24. Edie Sedgwick and Gino Piserchio; *Beauty # 2*, 1965 (16mm film, b/w, sound, 66 minutes. Film still courtesy of The Andy Warhol Museum)

After six minutes have passed, Gino takes off his pants—another contrivance—so that he's now in only his white jockey shorts. Edie quotes a line from *Kitchen:* "I said, 'good friends should lie together.'" Gino responds with the German word "immer" (always). This confuses Edie, who earlier became perplexed when Wein made reference to a Leica camera. Wein later brings up "hustlers," but then asks, "What's a hustler?" When Wein asks them if he's really a hustler, he adds, "I've outhustled myself. Look where I am," alluding to his present role in the production. Wein later accuses Edie of not listening to him. She replies, "I listened to you. Like Billy Graham on the morning TV show."

When Edie accuses Wein of not loving dogs, he turns it back on her by suggesting that she only pretends to love horses. He says, "You used to tell me how you beat your horse all the time . . . the one you loved so much." Wein is unearthing a childhood experience from when Edie was younger than nine. Edie admits that she did beat her old horse, but claims that she loved the new one. After she mentions getting the dog drunk, Wein seizes the opportunity to say, "That's why you beat Horse. You were trying to get after your brother or some closely related male?" When the two of them later bicker, Edie admits, "I'm just looking for

something to lash out at." Wein has a cruel response. He tells her, "Your mirror's over there. Why don't you start there?" Wein plans to read John Lennon's new book, *A Spaniard in the Works*—another obvious contrivance—and wants Edie and Gino to start to become more intimate. We hear someone whisper off-camera that there's only one minute left in the reel. This persuades them to postpone initiating any romantic activity.

The second reel begins with Wein reading passages from Lennon's book, which consists of a series of nonsense stories. He stops reading the story and notices Edie and Gino making out. Wein suggests that if he were a voyeur, he'd be very deprived on the basis of what he's just witnessed. After they make out again, he says mockingly, "If you're not enjoying it, why don't you just stop?" Gino answers, "Because you're enjoying it." As Edie and Wein continue to quarrel, Gino begins to kiss Edie again. We hear someone whisper some directions to him, "Gino, not too much." Gino backs off, suggesting again that we're not really witnessing a documentary, but a highly contrived fiction. As Gino moves on top of Edie, Wein finally says, "Oh, do better than that, Edie. Come on. The boy's not here for the fun of it." Edie sits up, picks up the glass ashtray, pretends to throw it, and then does, but she doesn't fling it at Wein out of genuine anger, as it's usually described.

Wein compares their kissing to a scene in the film *Mondo Cane* (1962) where young girls give artificial respiration to dying swimmers. In response, Edie jerks her head from her embrace with Gino. She asks him, "What do you mean?" Her question actually gets Wein to raise his voice. As in a bad marriage, they keep coming back to the same issues, namely that Wein tells Edie what to do. He continues to go for Edie's weak spots. He suggests, "If you were only older, Gino, then you could be her daddy and she could . . ." Edie responds angrily, "I wish you'd shut up!" Wein continues to belittle their feeble attempts at intimacy. He tells her, "Why don't you just give up altogether? You can't feel anything for him. You can't feel anything for me . . ." Wein suggests that she can take pills, and he and Gino can leave. He says, "How does that sound, Edie? I'll wake you up tomorrow. We'll find another doctor." Edie and Gino act as if he's talking about a psychiatrist, but he's not. Edie asks him, "If it's not heads, what are you talking about?" As the film runs out, Wein drops a major bomb, when he answers, "Oh fertility, pregnancy, abortion . . ."

Koch characterizes *Beauty # 2* as "an almost ideal example of Warhol's technique of the period and one of the strongest films from any period of his career."[37] Yet *Beauty # 2*, despite having all the necessary

ingredients, doesn't completely capitalize on the inherent dramatic conflict of its romantic triangle, even though Edie throws an ashtray. For one thing, Edie seems distracted throughout, whether because she's been drinking martinis or because the chemistry with Gino never quite develops. Like a fish out of water, he merely flails on the bed under the spotlight of the camera. For all his good looks, Gino appears to be a flop in bed, in the sense that he fails to turn Edie on.[38]

Wein openly belittles Edie throughout *Beauty # 2*. He criticizes her vanity, her promiscuity, and, most pointedly, her performance in bed with Gino. He also takes cheap shots at her, such as bringing up her abuse of a horse as a child, hinting at incest with her father, implying that she might need to have an abortion. This last issue, of course, is what might have turned *Beauty # 2* into the equivalent of a true psychodrama. Wein, however, waits too long to bring up this sensitive and potentially explosive issue and the reel runs out, so we never get a chance to see Edie's reaction.

What is the difference between Tavel's scenarios for *Screen Test # 1* and *Screen Test # 2* and Wein's *Poor Little Rich Girl, Face,* and *Beauty # 2?* In these films, both Tavel and Wein approach their subjects with inside information. Through Warhol, Tavel was well aware of Philip Fagan's vulnerabilities, just as he knew that Mario Montez wanted desperately to become a star but for religious reasons was uncomfortable about being a transvestite. Tavel approaches the subjects as if they're on the witness stand in court and plays the role of a clever prosecutor armed with incriminating evidence. He also stages the two films as psychoanalytic encounters, in which he skillfully probes the psyches of his subjects. Wein, on the other hand, was Edie's close friend and confidant, so he uses his personal relationship and intimate knowledge of Edie to force her to reveal painful and traumatic experiences—at least partially because she implicitly trusts him.

Tavel is a great actor and skilled director. He is often so hilarious and imaginative in his repartee that even Philip Fagan, despite his obvious discomfort in *Screen Test # 1,* has to laugh at some of Tavel's antics. *Screen Test # 2* is also wickedly funny. Both of Tavel's films are highly theatrical and carefully scripted in advance. As a result, their structure is more obvious. He makes us aware of the artifice he's employing throughout—there's a farcical element to what he's doing—which is why Mario Montez isn't really a complete victim, even when Tavel insists that he drop his pants and expose himself, giving the lie to the pretense that he's a woman.

Wein clearly borrows some of the same techniques of psychodrama that Tavel had exploited earlier, but he doesn't have the same wit or verbal dexterity. Wein's films are more naturalistic and unscripted, even though they are planned and structured. Tavel has a flamboyant personality, whereas Wein exhibits very little affect in his offscreen role. He's dry and matter-of-fact in his probing. In *Poor Little Rich Girl* and *Face*, it's not an accident that Edie smokes marijuana excessively, or that she's drinking a martini in *Beauty # 2*. Her drinking and drug use make it easier for Wein to manipulate her. He can slip numerous Dylan references into *Poor Little Rich Girl* without them registering. In *Face*, he can set Edie up a certain way and then undercut her by employing a surprise mind game, so that we can witness the results. In *Beauty # 2*, Wein, in the role of spurned lover, is much more overtly antagonistic. He dredges up highly sensitive material involving Edie's family and uses the romantic triangle as an excuse to bring up the issue of abortion.

Wein converses with Edie as an intimate friend—only he has a hidden agenda. In a sense, he is willing to betray their relationship for the sake of making an interesting film and advancing his own career. In his next film, *My Hustler*, he hoped to use the device of a romantic triangle once again, only this time with someone to whom Edie was very much attracted.

MY HUSTLER

As a college student who attended the initial theatrical screening of *My Hustler* (1965), which played on a program with the black-and-white short *Mario Banana # 2*, I can attest to the seediness of the viewing experience at the Hudson. After I passed through what seemed like a stained and filthy white cloth sheet that separated the actual theater from the lobby, my most vivid memory of seeing my first Warhol films involves the beams of light that periodically emanated from the flashlight of a manic usher patrolling the aisles. These were aimed at viewers' crotches in order to insure that no one was masturbating. As far as I can remember, the audience was entirely male, and it was more likely the suggestive title rather than the Warhol name that drew most of them to the midtown theater. Yet, for all the flashlight action at the Hudson, *My Hustler* actually contains very little nudity.

Although *My Hustler* was another collaborative venture between Warhol and Wein, it turned out to be an Edie film without Edie, who declined to participate, most likely because she did not find it particu-

larly flattering to be portrayed as a "fag hag." Yet despite Edie's absence, she remains very much a presence in the film. *My Hustler* was shot on Fire Island over Labor Day weekend and financed by Dorothy Dean, who put up the $500 (in today's currency, about $3,500) to shoot it.[39] It features many of Edie's Cambridge friends, such as Ed Hood, Genevieve Charbin (her roommate), and Dorothy Dean, as well as Paul America (Paul Johnson), who later became Edie's boyfriend. The fact that Edie was already attracted to the good-looking Paul America apparently provided Wein with the idea for the film. *My Hustler* also includes Joe Campbell, the former partner of Harvey Milk, in the role of an aging hustler, and J. D. McDermott, who played the cop in *Vinyl* and has a cameo role as Ed Hood's house servant.

My Hustler, at the time it was made, certainly seemed to explore new cinematic territory, especially in terms of gay subculture. Warhol films had already dealt with both transvestites and sadomasochism, so the male hustler must have seemed like a logical choice in terms of racy subject matter. Moreover, John Rechy's *City of Night* (1963) had been published two years earlier. Written from the perspective of a male hustler, the autobiographical novel explored the psychology of its narrator while detailing the major cruising scenes in various American cities, such as Times Square, Pershing Square in Los Angeles, and Hollywood Boulevard.

There was no written script for *My Hustler,* which was largely improvised by the performers. The premise involves Ed Hood's discovery of a new service called "Dial-a-Hustler," which involves using the telephone to eliminate the need for public cruising. The opportunity to avoid such exposure would have been welcome given that cruising and male prostitution were dangerous and risky practices in terms of both the law and the prevailing cultural climate for gays at the time. *My Hustler* begins with a zoom toward a beach house on Fire Island, and then a further zoom in as Ed Hood, dressed in a striped beach robe with a cloth napkin wrapped around his neck, chastises his house servant, Kali. When the zoom finally ends, the framing cuts off Kali's head, so that we are denied his reaction to the scolding and instructions he receives from Ed:

> What are you doing out of uniform? When I hired you I hired you for purposes of servitude, and if this is what you call service or servitude, it's not a very good idea. You're totally out of uniform. I placed an ad saying I wanted a servant who understood discipline. By discipline I suggested boots, some knowledge of belts and leather, and you turn up in this garb. It's obvious that you haven't the least idea what kind of servitude that I had in mind. You

know what you were hired for? Never mind, it doesn't matter. Take a look around there and you will see a blond boy. Look out there. You see him? Now you're hired not only for servitude and discipline, but as my body-guard. And that means that you have to take care of that boy too. Take care of him in every way that he requires, and he may require some very special ways. If he wants anything, you're to get it immediately. If, on the other hand, he presents any difficulties, you're to help me in taking care of him. You follow what I'm saying? All right then, get me some ice in this drink.

The camera moves slightly toward screen right, disrupting the framing, before it pans back to the left, past Ed and Kali, across a row of houses, and picks up a tall, blond-haired young man, Paul America, as he heads in the direction of the beach.

As we watch Paul in a telephoto shot, Ed explains that he may have made a mistake in hiring Kali, but that he was attracted to his name because it's the "Assyrian goddess of destruction." Paul finds a spot in the sand, takes off his shirt, and applies suntan lotion. As he sits down, the camera zooms in closer as he lies on one arm, so that his crotch prominently faces us. Ed's commentary—"that's all they do, sun and preen"—creates a disjunction between the main action and the off-screen sound track in a manner similar to what occurs in *Harlot* and *Space*. As Paul reads a magazine, the camera initially tilts up and then swish pans back to Ed on the porch, as his neighbor, Genevieve, in a dark bathing suit with white trim, walks directly in front of the camera and sits beside him.

Tension immediately develops between Ed and Genevieve over Paul, as they stare at him on the beach. Ed says to her, "Incidentally, what does it remind you of? The Leaning Tower of Pisa? Or the Empire State Building? Or a big fat sausage? How do you like them? Big and fat, or long and tall?" As the two argue over Ed's fears that she will try to steal his trick, the camera zooms back to a wider shot that includes the fence. Ed complains to Genevieve, "And what would you do? You will get him [Paul] all hot and bothered and frustrated, and then you drop him . . . You appeal to their sense of masculinity and wanting to prove them-selves, you know, heterosexual, or whatever you call it. And then you don't carry through." The camera zooms back in on Paul, who whittles a piece of wood with a knife. Ed disdainfully calls Genevieve a "fag hag."

In the corner of the frame, someone comes over and talks with Paul. Ed shouts, "There's someone down there with him." The phone rings. The camera pans left to show a dark-haired, older man (Joe Campbell) in a hooded plaid jacket, with a Pan Am World Airways duffel bag next

to him. As Genevieve calls to him, Joe takes off his jacket and sits behind Paul. The camera zooms out as Joe walks toward the beach house. The zoom stops on the wide shot showing the fence in the foreground, as Joe passes the camera. Ed exclaims, "Oh my God. I know him. It's the Sugar Plum Fairy, Genevieve. It's Sugar Plum!"

The camera then pans slowly right and back to the beach house, and zooms in to frame Joe, Ed, and Genevieve in a three-shot. Ed raves about the Dial-a-Hustler service, which leads the two men to insult each other.

> *Joe:* Well some people have to use the telephone, other people use their inge-nuity, you know. That's the way it goes.
>
> *Ed Hood:* You're a tired aging old hustler yourself . . . I don't doubt it.
>
> *Joe:* Tired old aging hustler? At least I had something to hustle once. That's more than I can say for some people, you know.
>
> *Ed Hood:* What do you mean? Just because you have . . .
>
> *Joe:* In order to have lost something, you had to have it to begin with.
>
> *Ed Hood (overlapping):* . . . one of the longest sausages in the meat market. I suppose that remains to you.

Once Genevieve returns, there's a strobe cut (not an edited cut, as Koch indicates) to Paul lying on the beach.[40] On the sound track, the three continue to banter. After Joe inquires whether Ed might have an extra bedroom, Ed replies with a sexual pun: "There is no room for you in the inn. There's plenty of room in your end, but there's no room in my inn."

As the three continue to bicker, the camera zooms out to the wide shot with the fence and then back in again on Paul, as the bottom torso and legs of a couple making out intrude at the top of the frame. The camera zooms out again and then in to reframe Paul and the couple in a wider shot. This is followed by a second strobe cut back to the other three at the beach house. Joe claims to be an old friend of Paul's and indicates that they've arranged to meet there. Ed makes a bet with Joe and Genevieve over which one of them will get to have Paul. The camera pans left and zooms out before framing Paul on the beach again. The camera tilts up to show the ocean waves and then back down again. Someone passes in front of the camera. Shortly afterward, Genevieve appears on the left side of the frame and begins talking to Paul.

The two men discuss the allure of women. Joe comments to Ed, "The more of a man he is, the more you'll want him." The camera quickly swish pans back to Ed and Joe, who discuss hustling. Ed asks, "So where is it going to get you?" Joe answers, "Well, let's not think of where it's

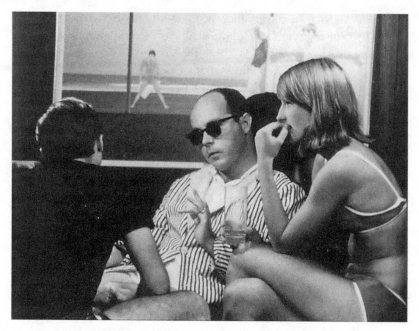

FIGURE 25. Joe Campbell, Ed Hood (center), and Genevieve Charbin; *My Hustler,* 1965 (16mm film, b/w, sound, 67 minutes. Film still courtesy of The Andy Warhol Museum)

going to get me so much as where has it gotten me. It's gotten me on your beach, and it's gotten me with your friend before you had him." The camera wobbles and then swish pans back to the beach. Moments later, Paul and Genevieve get up, and the camera zooms out to a wider shot as they head toward the ocean. The two frolic in the waves, as Joe hints to Ed that Paul has an extremely large penis. The first reel ends as Paul and Genevieve run from the water toward us.

The second reel depicts Joe's attempt to seduce Paul as they change out of their bathing suits and shower in a cramped bathroom. The two stand around, in proximity, taking turns preening in front of the mirror. They display their bodies not only to each other, but, of course, to the viewer, who becomes implicated in the ensuing sexual tease. The scene turns into a standoff between the two hustlers—one a young novice, the other experienced and starting to lose his prized looks—as they appear unable to acknowledge their sexual desire for one another. Even though they both have sex with men for money (and, if we are to believe Joe, have already had sex together once), they don't necessarily consider themselves to be gay, so both are engaged in some form of denial. When

FIGURE 26. Joe Campbell (left) and Paul America; *My Hustler*, 1965 (16mm film, b/w, sound, 67 minutes. Film still courtesy of The Andy Warhol Museum)

Paul's towel nearly slips off, Joe remarks, "I've seen it before." He talks about inhibited kids in school locker rooms "running around with towels on and everything, afraid somebody's going to see their ass, like it's something special." Right after this, Paul turns his bare ass toward Joe and changes into his pants.

The scene is about power relations between the two men. It also seems to involve the distinction between active and passive sexual participation. Joe makes a play for Paul by making flattering remarks about his body and athleticism, massaging his back and shoulders, and offering to share tricks with his younger counterpart. Joe obviously expects something in return, but Paul, who pees into the toilet as an obvious come-on, merely plays dumb. He asks Joe about hustling, but he refuses to acknowledge the subtext of the scene, so that we end up witnessing a standoff between the two men. Joe starts to lose patience: "Well look, either you want to hustle or you don't want to hustle. I don't see why we're playing all these games, you know, either you're interested or you're not. Either you want to make a couple of fifty bucks every week, or three or four times a week, or you don't, you know."

Shortly after this, he towels off Paul's back and then applies lotion sen-

suously to his body. Just as Paul appears to submit, Genevieve, Ed Hood, and Dorothy Dean interrupt and attempt to proposition Paul by promising him various things: money, travel, beautiful rich girls, cars, famous people, and education. Dorothy Dean, who hasn't been even introduced as a character—which makes her appearance somewhat puzzling—gets the final word when she asks, "Why be tied down to these old faggots?"

Koch calls *My Hustler* "a piece of psychological realism," but that doesn't take into account the role playing that occurs.[41] Yet there are aspects of the film that suggest that it had potential to develop beyond the tension of its subtext, which centers on Paul America being the object of everyone's desire, male and female alike. Ondine, for instance, describes Paul America as, in reality, being "everybody's lover."[42] In his short *Screen Test: Paul America* (1965) he is lit by a key light from screen left without any fill light from the right, thus placing half of his face in dark shadow. Whereas someone like Ann Buchanan is intensely fixated in her *Screen Test,* Paul America appears distracted. He stares at the camera, chews gum, smirks and smiles, and moves his head and eyes in various directions—all in an effort to appear casually seductive. Because everyone desires him in *My Hustler,* the battle for his affections might have been stronger had Edie rather than Charbin been cast in the female role. The scene in the bathroom with Joe Campbell demonstrates the power politics between hustler and john, between fading looks and young beauty. Because it's improvised, there is a sense of unpredictability to the scene, which ends as an open question.

Chuck Wein added another element of uncertainty to *My Hustler* to give it more dramatic tension and the potential for psychodrama. He reportedly slipped LSD into either the food or drink; Paul America later claimed to be tripping while performing in the film. In a profile in the *New York Times,* he is quoted as saying: "I was completely unaware of what 'My Hustler' was all about. They didn't *tell* me. I was on LSD the whole time, and I thought I was just going through some practice motions."[43] Warhol comments:

> Years later I read an interview with Paul America in *The New York Times* where he stated that he'd been on LSD all during the shooting. I didn't know that, specifically, at the time, but what I did know was that there was a *lot* of it out there that weekend. We were with the Cambridge kids again, and they were slipping it into everything. I made sure I only drank tap water, and I only ate candy bars where I could tell if the seal had been broken. Believe me, I knew these people well enough to know that if you spent a weekend with them, you'd get a dose of acid if you weren't careful.[44]

Paul America was not a complete innocent when it came to drugs. In a video portrait of him entitled *Paul Johnson* (1965), Paul is high on drugs and talks about them for much of the video while playing with a switchblade knife.

In comparison to Ronald Tavel, Chuck Wein has not received much credit for his brief role as a major Warhol collaborator. Tavel went on to have a successful career as a playwright with the Playhouse of the Ridiculous (aka Theatre of the Ridiculous). He was also careful to provide details of his contributions to Warhol films through extensive interviews, commentary, and even a Web site. Wein, on the other hand, kept a low profile. He was involved in the early stages of *Ciao! Manhattan* and directed *Rainbow Bridge* (1972), a film that documented Jimi Hendrix's last concert. Because Wein didn't discuss and document his role in the Warhol productions, we know a great deal less about the extent of his contributions. He broke with the artist in fall of 1965, following a disagreement about a feature project called *Jane Heir* or *Jane Eyre Bare*.[45]

Although Wein borrowed strategies from Tavel, it would be unfair to portray him merely as an opportunistic imitator; the films on which he collaborated with Warhol exhibit a very different sensibility. Several of them, most notably *Poor Little Rich Girl, Restaurant,* and *My Hustler,* rank as some of Warhol's most impressive films. If Tavel dismissed Edie as difficult, Wein found a way to harness her talents, even if he appears to have exploited her in the process, and the Wein-inspired films will forever be associated with her presence. Yet the film in which Edie did not appear, *My Hustler,* would later influence another important phase of Warhol's career, namely the sexploitation films.[46]

During the same period that Warhol collaborated with Tavel and Wein, he also made a series of sound portraits. Even though they have been largely neglected in many accounts of Warhol's career, the sound portraits, which document such figures as John Palmer and Ivy Nicholson, Paul Swan, Gerard Malanga, Mario Montez, and even Andy's mother, Julia Warhola, merit consideration as an important category of films in their own right.

The Sound Portraits

Doing Ourselves

Although portraiture accounted for a significant portion of Warhol's practice in a variety of media—drawing, painting, prints, photography, film, video, and television—critics had a mixed response to his continued fascination with the human subject. This became heightened when Warhol began doing commissioned portraits of the rich and famous in order to provide a steady stream of income for his numerous other projects. Nicholas Baume, for instance, points out: "It is as a face painter for hire that critics saw Warhol as cheapening his avant-garde credentials and offending the morals of the 'serious' art world."[1]

It is tempting to see many of Warhol's films as portraits, even when they contain narrative elements, such as *Beauty # 2, My Hustler, The Chelsea Girls,* or *Bike Boy.* Even *Restaurant,* a film that initially appears to be a still life, transforms into a portrait. In some ways, the *Screen Tests,* in their deceptive simplicity, provide the most accessible window into Warhol's cinematic achievement. Warhol produced the silent *Screen Tests* between 1964 and 1966. During 1965 and 1966, however, he also made a series of sound portraits. Perhaps because some of these films don't fit neatly into traditional categories, the sound portraits tend to be among the least well known of Warhol's films.

Warhol often did *Screen Tests* of various people who visited the Factory, including celebrities such as Bob Dylan, Salvador Dalí, Cass Elliot, Susan Sontag, Dennis Hopper, and Allen Ginsberg. Many of the people who sat for silent portraits, or *Screen Tests,* wound up partici-

pating in other films that Warhol made, but for others it was a one-time affair. As such, the *Screen Tests* document the Factory as a social space that drew both the famous and those aspiring to become so. Although Warhol often shot multiple *Screen Tests* of certain individuals, the sound portraits were usually longer and more complex. Warhol was so prolific that if a subject or idea interested him, he would make a film of it, whether it was something he happened upon in a newspaper, in a magazine, or on television. But he also found his greatest inspiration from the people who surrounded him. They are not conventional portraits in a documentary sense, but are instead tied to broader conceptual frameworks. The sound portraits, while clearly serving as a form of portraiture, contain strategies that Warhol employed in his narrative experiments. Baume suggests: "Warhol's interest in people—to which his lifelong pursuit of portraiture attests—was not a search for inner truths, but an endless fascination with the theatre of living."[2]

JOHN AND IVY

John Palmer provided Warhol with the idea for one of his most famous films, *Empire*, for which he is credited as co-director. Palmer appears in *Kiss* and several other Warhol films. He was also married to the fashion model Ivy Nicholson, who performed in a number of *Screen Tests*, as well as *I, a Man; Since;* and *The Loves of Ondine;* her scenes, though, are marred by conflicts with the other performers.

John and Ivy was shot in their East Village apartment and consists of a fixed-camera, continuous take of a cluttered kitchen divided by a large post in the foreground. The unusual composition creates interplay between deep space on the right, the flat beam, and the shallow space on the left-hand side of the frame. Palmer, dressed in a suit and tie, moves in an out of the frame, as does Nicholson. Rock-and-roll songs and other information, such as the temperature (29 degrees Fahrenheit with the threat of snow), can be heard on WABC radio, which serves as the film's sound track. Ivy brushes her teeth; their two young boys wander in, and one of them cries. Ivy pulls up her long boots and starts to dance. John kisses and embraces her. As John drinks a beverage, Ivy dances and sings to The Beatles' "Love Me Do" while also reading a children's book.

As the two hang out in the kitchen, Ivy becomes angry about being filmed and snaps at John, "I'm not getting involved with a camera." John expresses his love for the song "Tell Her No," by the English rock

FIGURE 27. John Palmer and Ivy Nicholson; *John and Ivy*, 1965 (16mm film, b/w, sound, 33 minutes. Film still courtesy of The Andy Warhol Museum)

band the Zombies. Ivy eventually gets up from her seated position on the left side of the frame and dances into the larger space. John talks about the movie and the "hang-ups of meeting another person," and indicates, "We've just met the camera." We hear the news on the radio about a winter bus accident in Pennsylvania, mixed in with a commercial for Mennen Skin Bracer.

Someone switches stations on the radio. Ivy smokes and we hear a commercial jingle for Winston cigarettes: "Winston tastes good like a cigarette should." As Ivy circles from the right side of the frame around the post, she says, "I wish we loved one another the way we love ourselves," which underscores the tension between them. Ivy reaches out the open window and grabs enough snow to make a snowball. She puts it on her lips, stuffs it down her sweater, and rubs her knees and thighs with it, claiming to be "cooling off." John embraces her in a bear hug and the two descend below the frame. He gets up and begins to unbutton his shirt, but Ivy dances to "Come See about Me" by the Supremes. John grabs her and again wrestles her down beneath the frame, as one of the kids wanders in from the left side of the room. The film ends when Ivy goes to the window and throws snowballs, presum-

ably at John, as we hear the song "No Arms Can Ever Hold You" on the radio.

John and Ivy presents a bleak portrait of an attractive young couple who are living in cramped quarters. Through his divided composition, Warhol makes the small space of the kitchen appear even more confining. The tenement apartment is dark and claustrophobic. We're made aware of the passage of time by the radio, which regularly announces the hour. The songs provide ironic commentary on the domestic situation we are witnessing, as they combine with commercials, news, and the chaotic sounds of the couple's young children. John and Ivy's more fashionable clothes contrast sharply with the depressing interior of the tenement apartment. Palmer clearly wants to make something happen through his sexual advances, but the kids are a distraction, and Ivy doesn't appear willing to respond. Instead she prefers to dance by herself to the pop songs on the radio. Whether by intention or not, Warhol's portrait of a nuclear family is fraught with an undercurrent of tension, some of which results from the couple's clear awareness that they are performing for the camera.

PAUL SWAN

Paul Swan was a self-taught dancer who was strongly influenced by ideas of beauty derived from classical Greece. He was particularly enamored with Greek myth and played Zeus in Gregory Markopoulos's *The Illiac Passion* (1964–67), where he first met Andy Warhol and Gerard Malanga, who also had parts in the film.[3] Originally from Nebraska, where he grew up on a farm, Swan had aspirations to be an actor. He landed a role in Cecil B. DeMille's *The Ten Commandments* (1923), but after getting into a disagreement with the director over having a limited time to train inexperienced dancers, his Hollywood career ended.[4] Swan eventually gravitated to Paris, where he began painting, reciting poetry, and dancing in vaudeville. Swan continued to put on public shows of his work in Paris and New York for nearly fifty years.

In his eponymous color film, Swan introduces himself as "the most famous unknown person in New York." After his first performed poem, Paul is requested to get ready for his next piece. A bit confused at having to change costumes onscreen, he says, "Well, I hate to do a striptease." As he struggles to change, Swan curses and then remarks, "They can't hear me, I hope." He complains, "It takes too long. It spoils it. I can't do it." Swan questions the need for the camera to record continuously by sug-

gesting the possibility of editing: "You can cut that all out, can't you?" He then performs a second piece. Dressed in a green costume, Swan informs us: "This is the 'Elements': earth, fire, water, and air—the movements seen and unseen in nature."

Throughout his sound portrait, Swan, who was in his early eighties at the time, struggles to raise his body from kneeling positions, change his elaborate costumes, and even put on his shoes. After disappearing off stage, he comes back out and, perplexed, asks, "Change here?" Two of Swan's pieces are about death. In his "Prelude," for instance, he warns: "Lest we forget amid harsh laughter that somewhere Death still stalks his ghastly way toward those we love." As Swan tries to change costumes again off-camera, he comments, "This takes too long. You can cut it down, can't you?" As he continues to fuss with his costume, he remarks, "The audience has all gone home, waiting. I'm sure of that." Swan's costume for this piece is so elaborate and involves so much additional jewelry that it takes him a very long time to get ready. He announces that he will be doing "The Nightingale and the Rose" and "The Temple Bells Are Ringing." But, by the time Swan is ready to begin and calls for the music, the first reel runs out, truncating his performance.

The second reel begins with Swan dancing in a large cape and then without it. After he disappears offstage, the camera continues to record the empty stage and his cape lying in a heap on the floor. The camera zooms out as Paul tries to change privately, but we hear a voice tell him: "Paul, they want you to hurry because . . ." Someone walks across the stage toward where Paul is changing into another costume behind a black folding screen. We hear a male voice explain: "See, they want you to fix yourself out in front of them because they still have the movie camera going." Paul, irritated, responds, "Oh, I don't care." Although he wears a black thong, the naked cheeks of his rear end start to stick out from behind the screen, as we hear laughter. The camera attempts to zoom in on Swan's buttocks, but ends up on the empty chair on stage, missing the action. Paul tells them: "I'm doing the best I can, gentlemen." As he struggles to find something backstage, someone yells, "Paul, don't wear any slippers!" When nothing appears to be happening, the camera zooms back out, revealing the stage, occupied by a single empty chair.

The person who disappeared behind the screen puts the chair backstage and walks off, as Paul asks, "Should we do the whole thing?" Swan also wonders aloud whether one of the crew members might have taken his shoes, indicating that he's been looking for them the whole time. Paul announces the title of the next number: "Musical Lines on

the Canvas of Space." After he dances, he moves off stage. He returns to do a French country dance. At one point the camera zooms in and out slightly, creating an odd spatial effect; the image seems to shimmer. As Swan dances, the fast camera movements create abstract patterns. Afterward, he's asked to come out and give a speech because the film is nearly over, but Paul responds, "I don't know what to say," and recites a series of poems instead. They again badger him to give a speech. Paul finally relents and discusses the fact that he's never been in jail, but suggests that "we'd all be in jail, really, if the truth were known." He concludes: "Now that sounds like a terrible way to introduce oneself. I only want to do it to show that whatever I do, it's a sincere expression of one kind or another."

No one would dispute the sincerity of Swan's anachronistic dances and poems, which provide a striking time capsule of a bygone era. Callie Angell insists that Warhol was not making fun of Paul Swan in this sound portrait.[5] While Warhol, as she suggests, no doubt appreciated Swan's eccentricities as camp, there's actually something very unkind about the way he's treated.[6] Warhol inverts the relationship between the actual performance and its preparation in that Swan spends more time getting ready for his pieces than actually performing them. Just as Swan begins one of his numbers at the end of the first reel, the film runs out. We also watch as he clumsily struggles to get into his extravagant costumes. For Warhol to insist that Swan change in front of the camera is certainly embarrassing for the aged performer. And, in the second reel, there's every indication that someone involved in the production has hidden his shoes, which causes the enormous delay that results in the camera filming an empty stage.

For Warhol to have presented Swan's dances as simply camp would not have been nearly enough; he's once again actively looking to create his brand of dramatic conflict. In Swan's portrait, Warhol finds ways to throw Paul off guard, frustrate him, and then to record the results. It should be noted that at the time the film was made, Swan was not only hard of hearing but also beginning to suffer from dementia. Emily Leider writes in the foreword to Swan's biography: "Swan could not be honest with himself about his own aging and changing appearance. . . . In his later decades he not only wore makeup daily but stuffed his pants with socks to make himself appear better endowed. He bathed in olive oil and darkened his hair."[7]

When Swan performed, he wore flamboyant costumes as well as a great deal of jewelry and makeup, so that, as Warhol must have recog-

nized, he looked like the equivalent of a drag queen or an aging movie star still holding on to false notions of glamour. Paul Swan might still have believed he was "the most beautiful man in the world," even if his body betrayed him at every turn. As Janis and Richard Londraville observe:

> There are, then, two characters in *Paul Swan:* Paul Swan the old man and the memory of Paul Swan as Adonis. Swan unknowingly creates the tension in the film as these two characters battle with every lunge, every arm extension, each costume change. Just as we are often shocked by a snapshot of ourselves revealing flaws we ordinarily decide not to see, Swan's dance is a ghostly echo of the grace and beauty that once was. What at first appears as "more Gloria Swanson than Rudolph Nureyev," a spectacle for us to deride or pity, becomes a study in the capacity of the human to ignore the burdens of time.[8]

Paul Swan might be hilarious, but it's also tragic. Afterward Swan, "exhibiting signs of senility and paranoia, had forgotten who Warhol was and did not even remember being filmed."[9]

Morrissey writes: "What makes this film so interesting is its combination of extreme theatrical artifice (the Paul Swan recital) and the total lack of any artifice in the intervals of the costume changes."[10] This relates to Warhol's notion of performance. The empty stage with an abandoned costume serves as an apt metaphor for Warhol's inversion of acting and non-acting. His real interest is not in the dances, but in the moments where Swan struggles to get into costume or vainly attempts to find his shoes or fails to appear on stage to perform.

CAMP

The seven *Screen Tests* that Warhol made of Susan Sontag indicate that he found her fascinating (or at least wanted to court her). Her influential 1964 essay in the *Partisan Review,* "Notes on Camp," attempted to provide an understanding of an aesthetic sensibility that was very much in vogue at the time. Sontag writes: "Indeed the essence of Camp is its love of the unnatural: of artifice and exaggeration. And Camp is esoteric—something of a private code, a badge of identity even, among small urban cliques."[11] Although Warhol wasn't mentioned in Sontag's article, he was very much attuned to the camp sensibility. She writes: "To perceive Camp in objects and persons is to understand Being-as-Playing-a-Role. It is the farthest extension, in sensibility, of the metaphor of life as theater."[12] In *Afternoon,* Warhol attempts to rile his actors, especially

Edie, by suggesting that they "camp it up" for the camera. Even though camp, according to Sontag, was by nature a "naïve" or "unintentional" sensibility, Warhol chose to celebrate it as simply the latest trend by conducting an avant-garde variety show entitled *Camp* (1965).

Camp begins with an extreme wide shot in which Warhol's famous cow imagery can be seen in the background. The various performers sit and stand in the Factory, waiting for the production to begin, as the crew members make final adjustments. Three minutes pass before we hear any sound; Paul Swan, dressed in a knight (or gladiator) costume and holding a wooden sword, makes his way from screen left across the set to the music of a Vivaldi oratorio. Swan's highly stylized, interpretive dance is obviously camp. As soon as he finishes, Gerard Malanga, dressed in a tuxedo and playing the role of impresario, immediately asks Swan to repeat it. Malanga claps insincerely, which produces boisterous applause from the rest of the assembled group. Swan repeats the dance, but at one point collapses on the floor; it's unclear whether the aged dancer has become winded and disoriented or whether his action is part of the performance. Baby Jane Holzer very sweetly comes to his aid. As Swan recovers, everyone claps. Swan suggests to Holzer, a tall, gum-chewing fashion model, that they do an "impromptu." He takes her hands and the two of them dance in a series of spinning moves. She bows, returns to her seat, and reclines on a couch. The camera focuses on Swan, who appears to be confused, but he and Holzer dance again, which culminates in the elderly performer giving her a kiss.

Mario Montez, under the name Inez Martinez, sings the song "If I Could Shimmy like My Sister Kate" and then does a Latin dance. The camera zooms in and out in time with the melody, causing the space of the frame to expand and contract at a dizzying rate. Next up is Mar-Mar, who appears to be a deliberate bore. He carries a trophy, pretends to give a political speech, wears a funny hat and round sunglasses, has a stuffed animal attached to his waist, plays "God Bless America" on a toy musical instrument, and performs yo-yo tricks. The assembled cast members lose interest so quickly that they forget they also are performing in a film. Jack Smith and Tally Brown, for instance, vamp for the camera. Their antics turn out to be far more interesting than Mar-Mar. The next female performer sings and dances but also fails to hold anyone's attention.

The second reel begins with music from the song "The 'In' Crowd," which fades in and out while Malanga reads a poem entitled "Camp," based on a gay-themed poem by John Wieners, which he dedicates to

FIGURE 28. Paul Swan (foreground), Baby Jane Holzer, Gerard Malanga, and Tally Brown (background); *Camp,* 1965 (16mm film, b/w, sound, 66 minutes. Film still courtesy of The Andy Warhol Museum)

English poet Harry Fainlight. He then introduces the singer and actress Tally Brown, who announces: "This picture's called *Camp.* I don't happen to believe in the existence of camp. So I'm going to do things for you that are absolutely serious, as I believe, indeed, everyone before me has done. I don't think anybody's 'camping.' I think we're all doing ourselves." Brown then belts out an imitation of the Peruvian soprano Yma Sumac. In introducing Jack Smith, Brown deliberately alludes to their previous work together in Warhol's *Batman Dracula* (1964). Warhol's failure to complete *Batman Dracula* was a major sore point for Smith, who held a number of grudges against him. As Ronald Tavel points out, Smith and Kenneth Anger viewed Warhol "as a Johnny-Come-Lately and as a thief," an assessment Tavel did not agree with.[13]

Jack Smith had a troubled life. A militant anarchist, the intensely political Smith railed against capitalism in the guise of "Landlordism" and "Lobsterism"—his own colorful vocabulary for "exploitation"—as the source of much of his own and society's ills. Smith was a modern-day Proudhon who couldn't fathom either paying rent or collecting art; to him both were merely different forms of theft. Smith vented against

people and institutions for not supporting him in his artistic endeavors, believing that "real art" was destined to get "mutilated" within capitalist culture. He became famous for making one of the most notorious underground films of the 1960s, *Flaming Creatures* (1963)—a baroque, gender-bending orgy of naked and costumed bodies that became a test case for prevailing censorship laws. The experience had a traumatic effect on Smith and his career. The reception of *Flaming Creatures* became a rationalization for his "never making any masterpieces again" or finishing any of his later films.[14]

Warhol viewed avant-garde films at the Film-Makers' Cinematheque prior to making his own, and borrowed a great deal from Jack Smith, including the notion of superstars and his conception of performance. Warhol never denied his admiration for Smith's work. In Mary Jordan's documentary *Jack Smith and the Destruction of Atlantis* (2006), Warhol indicates that Smith was "the only person I would ever copy," adding, "I just think he makes the best movies." In the documentary, Smith's resentment of Warhol's use of Mario Montez, who had earlier worked with Smith, is apparent. Like an overly protective parent, Smith laments "slowly watching Mario's brain being eaten away."

The schism between Smith and Warhol was highly personal, but also represents the difference between a baroque and a pop sensibility. Smith had a trash aesthetic. His art was about making something beautiful out of nothing. By contrast, Warhol used techniques of mass production in his art, which enabled him to become an extremely prolific artist. Smith takes a swipe at Warhol in Jordan's film when he suggests that "manufacturing and making art" are two entirely different endeavors. Warhol obviously didn't think so. Smith insists, "I want to be un-commercial film personified." Warhol, on the other hand, always had commercial aspirations and constantly foregrounded the fact that art was a business. As Tavel put it, Smith thought of Warhol less as an artist than as "someone who had gone in[to] publicity."[15]

The friction between the two becomes manifest in *Camp*. Smith obviously relishes having the spotlight. His sense of pacing is impeccable as he finally asks, "Should I open the closet now, Andy?" Smith keeps pressing the issue, which appears to cause a crisis on set. He finally takes the initiative and walks screen right to open it, forcing the crew members to scramble after him. Once Smith stands in front of the closet, he demands the microphone, which Tally Brown sets up for him.

Holding the key to the closet, Smith directs the light. He discards the microphone, then changes his mind and has a crew member retrieve it.

FIGURE 29. Jack Smith; *Camp*, 1965 (16mm film, b/w, sound, 66 minutes. Film still courtesy of The Andy Warhol Museum)

He says, "Translucite Plastic." After he opens the cupboard door, the camera zooms in and out; Smith first looks pained and then laughs maniacally. Smith insists, "Bring the camera forward." He asks, "Is there a zoom on that?" Someone offscreen responds, "You're in it when you zoom." Smith dances out of the frame to the music of "The 'In' Crowd." After a short consultation, he dances back. He tries to get Tosh Carillo to help him move the glass cupboard closer in order to get it in close-up. Barely visible inside is a Batman comic, a veiled reference to why Smith has commandeered the set and turned Warhol's variety show into chaos. As in *Paul Swan*, Warhol deliberately chose to include Jack Smith, knowing full well that he would add the unpredictable and dramatic elements the film needed to transcend its title.

THE CLOSET

Barbara Rubin suggested the idea for *The Closet* (1966), which was originally intended to be part of *The Chelsea Girls* but ultimately wasn't incorporated into the film.[16] It features Randy Bourscheidt, a shy and boyishly handsome young man who seems nervous to find himself in a

Warhol film, playing opposite Nico. Edie might have been Warhol's greatest star, but Nico, who fronted as lead singer for The Velvet Underground, was the most stunningly beautiful. In *Swimming Underground*, Mary Woronov describes Nico: "She was so beautiful she expected everyone to want to fuck her, even the furniture, which groaned out loud when she walked into the room. I had seen chairs creep across the carpet in the hopes that she might sit down on them."[17] Nico indeed had a number of romantic relationships with high-profile stars such as Bob Dylan, Brian Jones, Lou Reed, Jackson Browne, Jim Morrison, and the French actor Alain Delon, with whom she had a child, Ari, who appears in a number of Warhol films.

For the first eight minutes, the camera focuses on the door of the closet, as we hear the two of them inside discussing Bourscheidt's need to relax and the fact that snakes shed their skins. The door finally opens to reveal the two performers inside a closet full of mostly ties. Nico asks, "Do you actually know where we are now?" He answers, "No," but then indicates, "New York, I think." The camera zooms, tilts, and pans while Bourscheidt demonstrates how to put on a tie. At one point the camera pans to the left so that it frames the wall, then pans back again to show Nico in close-up. Bourscheidt jokes about strangling her, but Nico indicates she has a switchblade to defend herself. He responds innocently, "Do you really?"

Bourscheidt asks Nico whether she's still bored, but she denies having been bored, especially since being in the closet. Nico asks him what he does with himself. Bourscheidt answers that he doesn't do too much—he goes to school in the mornings and has a few friends, but not very many. When she alludes to Bourscheidt now wanting to become an actor, he downplays the notion, indicating he's much too uptight. Bourscheidt discusses being in a musical in high school, and his father telling him afterward that he was very stiff. Nico indicates that when you think about acting, you become self-conscious, and then it becomes "disastrous." She continues, "You should ignore the fact that you're acting at all." Nico stares directly at Bourscheidt. There's an extremely long and awkward pause, as when talk has run out, and there's sexual tension. As Nico asks him what he thinks about the "underground," she touches his hair. He seems to become even more uncomfortable and embarrassed.

Nico moves her chair closer. She talks about the proverbial Good Samaritan, which seems to confuse Bourscheidt. The camera tilts down to focus on Nico's boots. She touches his frayed knit sweater with her hand and, after a long pause, asks, "What do you keep looking at your

watch for?" She suddenly states the subtext of the scene by inquiring, "Are you afraid of me?" Bourscheidt laughs uncomfortably. Nico adds, "I'm not trying to embarrass you." She asks him whether he sees a similarity between them. All he can muster to say in response is that her hair is much longer. She responds, "Not really." He touches her hair and laughs nervously. Nico says, "But that's not the essential thing." Clearly unable to broach the issue of gender, he asks, "Our faces?"

The premise of *The Closet* is pretty clear by the end of the first reel. As in *John and Ivy*, Warhol has limited his performers to a confined space. By placing Nico and a younger man, who might be gay, in such close proximity, the tension of the film is palpable, as she flirts and he fails to reciprocate. Warhol deliberately puts Bourscheidt on the spot; the young man appears to be intimidated by the older woman, even though she's being very sweet to him. In a quiet way, the scene mirrors what happens in other Warhol films that create expectations between performers, such as Viva and Joe Spencer in *Bike Boy* or Viva and Tom Hompertz in *Lonesome Cowboys*.

In many ways, the most interesting aspect of *The Closet* is the way Warhol's camerawork emphasizes the negative space surrounding the two subjects. When Nico suggests the closet is floating on a cloud, Boursheidt emphasizes that the closet has walls that define the space. Warhol's camerawork makes the relationship between positive and negative space very clear. Yet the interaction between the two subjects in *The Closet* remains at the level of subtext, largely because Bourscheidt is too young, shy, and nervous to engage with Nico, especially when she flirts with him within such a confined space.

As psychodrama, Bourscheidt's inability to respond bears strong resemblance to the dynamic of Philip Fagan's *Screen Test # 1*. Here Warhol explores "being in the closet" quite literally. He is interested in unmasking the secret of this handsome young man under the scrutiny of the camera within a contrived situation.[18] And he uses space as the formal quality to depict this visually.

EATING TOO FAST

The little-known *Eating Too Fast* (1966), which features art critic Gregory Battcock, could be thought of as a screen test with sound or, in Angell's estimation, a "remake of *Blow Job*."[19] Battcock is framed in close-up. A strong key light shines from screen left, while the other side of his face is bathed in shadow. This has the effect of emphasizing the

movement of his left eye. The background is divided in half. Black paper offsets the bright side of his face, while a wall provides contrast to the side of his face that is in shadow. We hear the sounds of street traffic and dogs barking, as if there's a window just offscreen. Occasionally smoke appears to rise up from beneath the frame. Battcock coughs and takes a sip from a wineglass. We hear the sound of someone below the frame, making sounds as if eating, as Battcock's eye shifts down and then straight at the camera. It takes some time for the viewer to realize that Battock is being fellated.

Late in the first reel, the phone rings. Battcock answers: "Hello? Yes, who's this? Bob? Hi! No, you're not waking me up. I'm not asleep. Oh, I've been calling you for days, but your line was busy." At one point, he learns that Bob's grandmother has died, but Battcock simply wants to know, "Did you get any money?" As he says, "God, that's too bad," the camera tilts down to reveal the guy who is fellating him. Battcock says to him, "Bob's grandmother died . . . finally." The man responds cheerfully, "Oh, too bad," as the image turns to white and the first reel ends. The second reel begins with Battcock still on the phone. He tells Bob to come over in a half-hour, then says, "Yes, okay, in thirty-five minutes . . . exactly thirty-five minutes." This is nearly how long it will take in real time to get through the second reel. After about ten minutes, Battcock begins to eat an apple. He briefly gets a coughing attack. As the camera tilts down, the person says, "You shouldn't eat so fast." Battcock knocks over the phone. Later, the other person coughs. We hear heavy rhythmic breathing as the camera frames the back of his head and then tilts up to Battcock's impassive face.

Despite the sense of the present that moving images convey, it's hard to watch Warhol's *Screen Tests* and sound portraits without thinking of the lives of the various subjects, especially those who died early, such as Edie, Nico, Paul America, Freddy Herko, Eric Emerson, Ingrid Superstar, Gregory Battcock, and so forth. One of the first art critics to write in depth about Warhol's films, Battcock was found murdered in 1980 on the tenth-floor balcony of his condominium in Puerto Rico. According to David Bourdon, "The forty-three-year-old bon vivant, noted for his risky habit of picking up rough trade, had been stabbed 102 times."[20]

In *Eating Too Fast*, a blow job is depicted as a casual, rather mundane event. Even though death is mentioned in *Eating Too Fast*, it has no import. No one seems to care that Bob's grandmother has died, only whether she left him any money. On this summer day, Battcock's momentary choking on an apple represents the only threat to his mor-

tality, while the connection between sex and death, which is made so explicit in *Blow Job,* appears to be the farthest thing from the art critic's mind.

BUFFERIN

Bufferin is a sound portrait of Gerard Malanga, Warhol's paid studio assistant at the Factory from 1963 to 1967. He not only worked with Andy on the screen prints and sculptures, but also assisted in the making of numerous films, even starring in films such as *Soap Opera, Couch, Vinyl, Hedy, Since,* and *The Chelsea Girls.* Malanga also danced with Mary Woronov as part of The Exploding Plastic Inevitable, the intermedia event. Although Malanga and Warhol had a conflicted personal relationship, he proved to be a great networker, bringing Warhol to various avant-garde events and serving as a kind of talent scout. According to Scherman and Dalton, "He had a sharp eye for talent and looks: many of the people who entered Warhol's mid-sixties orbit—the filmmaker Paul Morrissey, the film scenarist Ron Tavel, the actress Mary Woronov, and many others—were brought there by Malanga."[21] He was also responsible for hooking Warhol up with Nico.

We have seen that Warhol used the strobe cut in earlier films, but *Bufferin* is considered the first to use this in-camera editing technique extensively. In *Bufferin,* Malanga reads from poems and his diary, but all the names have been uniformly altered to the pain reliever to conceal the identities of those mentioned. The film begins with a close-up of Gerard's chiseled features. A key light illuminates the left side of his face into a slightly overexposed warm golden glow, while the right side lies in shadow. The first poem has to do with an Italian woman named Bufferin (Benedetta Barzini), with whom Malanga was passionately in love at the time. After he finishes the first poem, Ronna Page, who will provide commentary on Malanga's text throughout the film, suggests that it sounds like a dream. Malanga responds that Barzini actually functions as the third person in the film. After discussing Barzini again, Malanga mentions Bufferin being banned from the Dom (an East Village nightclub) for stealing Bufferin's painting. In this instance, Malanga is alluding to Rene Ricard, who had a role in *Kitchen* and developed a contentious relationship with Warhol over a painting that wound up missing from the Factory.[22]

What's fascinating about *Bufferin* is that by substituting the generic product name, the references become totally fluid, shifting across gender

boundaries and creating rather fascinating juxtapositions in the process. As a result, the viewer is forced to listen carefully to the clues to decipher the context of Malanga's gossipy revelations about various people. In a diary entry from September 29, he reveals being in a taxi accident at Forty-seventh Street and Park Avenue with three Bufferins. In one from September 30, Malanga alludes to Warhol's show at the Institute of Contemporary Art in Boston and expresses contempt for allowing "such superficial fringe to get directly involved with public appearances." He then briefly returns to the issue of Ricard being banned from the Factory over the paintings. When he talks about needing to get a check from Warhol, Page asks, "Who pays you, Bufferin?" Malanga answers, "No, Aspirin." He then adds, as if inserting a commercial, "Everyone should have their Bufferin."

Malanga says, "I wonder what would happen if Bufferin and I went on a mescaline trip together?" He talks about buying a black tee shirt to wear in the assassination movie, presumably *Since,* where he, along with Ronnie Cutrone, would play a combination of Lee Harvey Oswald and Jack Ruby. Malanga at times makes mistakes and mentions the actual person's name, such as Rene or Andy. Several jokes are made about Andy really being "Aspirin." At roughly twenty minutes, we suddenly get repeated strobe cuts. Malanga talks about dancing with the Velvets and how he's really dancing for Barzini. We also get shots of Ronna Page, who tries her best to contribute, but Malanga is so fixated on Barzini that he doesn't really allow her much room to comment. Page smokes a cigarette, as does Malanga, who is revealed to be a hopeless romantic. He discloses the fact that on October 23, Bufferin said she loved him. Page says breathlessly in response, "Oh, wow! That's beautiful." The strobe cuts accelerate. Toward the end, a light suddenly fills in the right side of Malanga's face. Bufferin asks him whether they would have children. He says, "Yes," as the film ends.

In the multilayered *Bufferin,* Malanga reads actual poems and diaries in which the well-known consumer product Bufferin replaces the names of actual participants. Ronna Page provides her rapt commentary, but Warhol exercises his own filter over the material by choosing to turn the camera on and off, almost like someone bored by a friend's hopeless romantic obsession. Malanga's love-struck prose, with its surfeit of feeling, must have seemed to Warhol like a record needle stuck in the same groove. It's no wonder that he can only suggest a pain reliever.

What becomes clear, however, is that despite the coding, Warhol, Barzini, and Malanga form a competitive triangle. Malanga says, "I sense

that Bufferin [Warhol] is going to do something chemically destructive between Bufferin [Barzini] and me. Bufferin [Warhol] should learn not to interfere in other people's private lives." One senses animosity in the subtext of Malanga's diary entries about Warhol, which is reinforced by various biographers. Bockris comments: "Andy did not like it when his associates fell in love because it took their attention away from him."[23] Indeed, Malanga's infatuation was affecting his work for Warhol because his dancing, which he referred to as an "interpretative-visual happening," was an essential part of The Exploding Plastic Inevitable tour.[24] In a diary entry dated October 30, 1966, Malanga writes:

> We were to do a show this evening in a small town outside of Boston. The first show was in the late afternoon. Benedetta became extremely nervous and said she couldn't stay for the second show and that she had to get back to New York. I decided it would be foolish of me to stay behind with Andy and The Velvets and instead decided, along with Rene and John (Wieners, poet) to go to New York with Benedetta. We immediately left after the end of the first show. Andy was quite annoyed with me, but even more annoyed with Benedetta for acting as an unconscious influence.[25]

Warhol made several silent *Screen Tests* of Barzini.[26] It's also clear that Malanga thought she should star in Warhol films, or the two should appear together, but the above entry might explain why Warhol never cast her. Malanga was subsequently irked by the minor role he was given in Warhol's new film, *Since.*[27]

One senses from clues in Malanga's text that Barzini, who had become a top New York model, represents a kind of fantasy (or "dream," as Page puts it), and that *Bufferin* unwittingly exposes the vulnerability of the young poet's romantic obsession. Malanga, who announced plans to marry Barzini, describes the abrupt end to their relationship in a diary entry dated November 7, following his return from a four-day tour with The Exploding Plastic Inevitable:

> We drive to a small bar on Seventy-third Street, Third Avenue. Wine is brought to the table. "She explains that she cannot love me. I am speechless and in a state of shock" is what I have typed here. It's very cut-and-dried. It all sounds rehearsed, as if she spent double time seeing her analyst. It's as if a bomb went off at the table and I no longer exist, or I'm just plain dreamin', unable to get back through to the other side, as if observing all this at a short distance. My pride prevents me from making an attempt to be persuasive or argumentative. I've lost all sense of speech, but more than that I've lost my magic and power. In a matter of a few minutes the happiest man on earth is reduced to unfathomable unhappiness.[28]

Malanga nevertheless continued to obsess over her, and she became the subject of both his poems and a film. He followed her to Italy, where his film *In Search of the Miraculous* (1967) screened at the Bergamo Film Festival.

Malanga wound up stranded in Europe without the financial means to return. After begging Warhol to rescue him, he resorted to passing off a screen print he had made of Che Guevara as a work by Warhol. Scherman and Dalton write about Malanga: "Too blind to see that even before this charade Warhol had been hardly well-disposed toward him, was in fact tired of him, ready to dump him, he worked assiduously on his 'Warhols,' building a trap for himself."[29] The incident profoundly affected his subsequent relationship with Warhol. Fate would not be any kinder to Barzini. She left New York after four years to pursue an acting career in Italy, where she met the director Roberto Faenza, whom she married in 1969. He left her on the very night that she gave birth to twins.[30]

SINCE

Warhol commented about the assassination of John F. Kennedy in 1963: "What bothered me was the way the television and radio were programming everybody to feel so sad. It seemed like no matter how hard you tried, you couldn't get away from the thing."[31] The Kennedys had captured the imagination of the public and become a modern American myth. Warhol would turn Jackie Kennedy into an iconic image of national grief in the numerous silk screens that he made of her. Douglas Fogle also reminds us, "As television broadcasts would endlessly show footage from the 8mm film taken of the Kennedy assassination by Abraham Zapruder, Jackie herself would become the unwitting star of her very own film."[32] Another avant-garde filmmaker, Bruce Conner, would make a film of Kennedy's assassination, *Report* (1967), so it makes sense that Warhol would shoot his own film about this traumatic event, which had so transfixed the nation that people could not leave their television sets for several days.

Since, Warhol's version of the Kennedy assassination, is one of his most anarchic films. It's almost as if the death of the president becomes directly related to the sense of chaos that seems to exist among the participants on the set. Like *Tarzan and Jane Regained, Sort Of . . .* , *Since* seems so heavily reliant on improvisation that it appears at times to lack

any clear sense of direction (even though there's evidence in the actual film of at least some type of written treatment). In *Since,* Warhol inadvertently plays Abraham Zapruder by filming the media events that the actors stage for the camera. The film features Ondine in the lead role as Lyndon B. Johnson. Other cast members include Ingrid Superstar (Lady Bird Johnson), Mary Woronov (John F. Kennedy), Susan Bottomly (Jackie Kennedy), and Richard Rheem (Texas governor John Connally). Gerard Malanga and Ronnie Cutrone, an artist and one-time Warhol assistant, play a combination of Lee Harvey Oswald and Jack Ruby. There is no attempt at realism. A large, crumpled sheet of red construction paper becomes blood. A banana substitutes for a gun. The couch in the Factory serves as a car. Rather than evoking sadness, *Since* is actually quite comedic.

Warhol's camera moves around the set in seemingly unmotivated fashion. Each assassination attempt results in some type of incomplete coverage—the shaky camera movement often misses the important action, but invariably ends up focusing on the blood. Large inflatable Baby Ruth candy bars create their own commercials within the film. Indeed, *Since* and *Soap Opera* might be viewed as the Warhol films that relate most directly to Pop art. It's probably not a coincidence that both deal with Warhol's fascination with television. In *The Philosophy of Andy Warhol,* Warhol comments, "Right when I was being shot and ever since, I knew that I was watching television. The channels switch, but it's all television."[33] As we view Ondine in close-up at the opening of *Since,* a male voice offscreen articulates the conceptual framework of the film, which will follow the model of the "Oswald display on television." He continues: "First it happened, then it was played back in tape, and then it was played back in slow motion . . . Except that we don't have to maintain the stiff character portrayals—like one individual can assume another role, assuming that he has assumed that role by choice originally." The commentator also states that we're not in Dallas. Ondine seems surprised and immediately contradicts this by saying, "It's marvelous being in Dallas with the President."

The participants appear to be confused about the events. They are unable, for instance, to cite the proper street on which the motorcade is traveling or to supply the name of the book depository. Ondine indicates that Ingrid Superstar is the First Lady. He initially seems to think he's the president, but then is informed that he's actually the vice president, Lyndon B. Johnson. Ondine announces that he has to hire the assassins, suggesting one of the common conspiracy theories surround-

ing the event: LBJ's desire to be president at all costs. Gerard Malanga and Cutrone come out together as a pair of assassins. The group tries to set the stage for the assassination, but Ondine still doesn't know the right street name. He says in response, "I don't know. I didn't even see it." Mary Woronov, as JFK, suddenly waves the large sheet of crumpled red construction paper to indicate that she's been shot. As Ondine begins to speak, Malanga comes out and shoots Woronov with a banana, causing Ondine to exclaim, "A little late!" Ondine is handed a speech to read to the American people. It ends with the line, "I ask for your help and God's."

The actors restage the assassination, as if they are replaying videotape on television. Ondine says, "Well, I'm so excited to be back in Dallas, my old home." Gerard Malanga runs in from the back and shoots Woronov. The camera zooms in on the paper blood. Ingrid Superstar naively asks, "Who got shot?" She plays with Richard Rheem's hair. Susan Bottomly, as Jackie Kennedy, tries to exit over the top of the couch, which serves as the vehicle in the motorcade. She is then asked to do it again in slow motion. The sound drops out. This time Cutrone shoots Woronov with the banana in an attempted simulation of slow motion. The camera once again zooms in on the paper blood.

Ondine tells Ingrid that she's supposed to be the First Lady. He becomes slightly testy that she's not taking her role seriously. Ondine says, "I am the new President and I don't like it one bit." When the War on Poverty is brought up, Ingrid remarks, "I think we should omit poverty and paranoia." As Warhol's camera moves around the set, Ingrid comments that the shotgun microphone recording their voices reminds her of the assassination. A guy in a red shirt substitutes for JFK and dies in a pool of blood, with a card indicating the date: Friday, November 22. References are made to *You Are There,* the popular TV news program that featured Walter Cronkite. Someone announces that they are on the way to the hospital, but Ondine, referring to the president, simply says, "He's dead."

Malanga and Cutrone, who eats a banana, are escorted by Secret Service agents through a passageway. Malanga pretends to be shot, but is told that they have to do it again. He asks, "What was wrong with it?" He's told, "It wasn't a traumatic situation. It wouldn't shock the world for four days." This time the two actors are separated. Cutrone, as Oswald, is escorted by agents and then shot with a banana by Malanga, who has now transformed into Jack Ruby. The murder is restaged. This time Cutrone screams loudly and groans as he falls to his knees. Report-

ers attempt to interview him, but he demands that they pick him up. Malanga (Ruby) is frisked and taken away. Cutrone smokes a cigarette, while an offscreen voice reveals that they are calling this the "slow motion version," but that they'll also have to do the "regular rapid-motion version." As Cutrone comes back, we see a large inflatable Baby Ruth bar— a reminder of the ultimate fate of another mythic American hero.

The second reel begins with the cast waving to the public. Ondine says, "There's Neiman Marcus." Susan Bottomly, in true Jackie Kennedy fashion, responds, "Oh, hi," in one of the funnier moments in the film. As the presidential party members discuss putting the top down on the convertible they are supposed to be driving in, Oswald rushes in and shoots Woronov, as the camera wildly zooms in and out on the red construction paper and ends up instead on Ivy Nicholson's red stockings. The camera returns to the crumpled red paper, the focus becomes soft, and it finds Ondine, who addresses Ingrid by her real name, then calls her Lady Bird as a shotgun microphone pokes into the frame. Ondine compliments Bottomly by calling her "the loveliest first lady we've ever had, outside of Abigail Van Buren," an example of his considerable wit. (Martin Van Buren was an American president, but Ondine is referencing the writer of the "Dear Abby" newspaper advice column.) A message is delivered, which turns out to be an inflatable Baby Ruth bar. The camera moves around the action so fast that the screen becomes a colorful abstraction as Ondine explains that JFK has been shot. He later exclaims, "Oh, I don't even care to be President with this group. Who wants to fill your shoes, Jack?" In this case, whether he's aware of it or not, he's addressing a dead person.

Ondine becomes frustrated, mostly because the other characters aren't very imaginative in their repartee, especially Ingrid Superstar. He complains that they are "absolutely boring." The only person he praises is the "close-mouthed" Jack Kennedy (his pal, Mary Woronov), who he claims "may have been the most interesting person here." At one point Ondine turns his back to the camera in protest. He then addresses his fellow performers: "We all have to try to cohesively keep attention away from Jack and play some kind of a vague scene. I hate to be the announcer of this, but I really think that we're all lacking in character. I have mine, sketchy as it is—I'm still trying to maintain it." After insulting others on the set, Ondine yells, "What the hell is the matter with you people?"

Ondine then gets into a spat with the temperamental Ivy Nicholson, but suddenly Malanga and Ronnie Cutrone run in and drop two giant inflatable Baby Ruth bars on the cast. The camera loses focus, preventing

PLATE 1. (top) *Paul Swan*, 1965 (16mm film, color, sound, 66 minutes. Film still courtesy of The Andy Warhol Museum)

PLATE 2. (bottom) *Since*, 1966 (16mm film, color, sound, 67 minutes. Film still courtesy of The Andy Warhol Museum)

PLATE 3. (top) Edie Sedgwick; *Lupe,* 1965 (16mm film, color, sound, 72 minutes; 36 minutes in double screen. Film still courtesy of The Andy Warhol Museum)

PLATE 4. (bottom) Edie Sedgwick; *Lupe,* 1965 (16mm film, color, sound, 72 minutes; 36 minutes in double screen. Film still courtesy of The Andy Warhol Museum)

PLATE 5. (top) Cast (left screen) and Eric Emerson (right screen); *The Chelsea Girls,* 1966 (16mm film, b/w and color, sound, 204 minutes in double screen. Film still courtesy of The Andy Warhol Museum)

PLATE 6. (bottom) Nico (left screen) and Ondine (right screen); *The Chelsea Girls,* 1966 (16mm film, b/w and color, sound, 204 minutes in double screen. Film still courtesy of The Andy Warhol Museum)

PLATE 7. (top) Nico; *The Chelsea Girls,* 1966 (16mm film, b/w and color, sound, 204 minutes in double screen. Film still courtesy of The Andy Warhol Museum)

PLATE 8. (bottom) Valerie Solanas and Tom Baker; *I, A Man,* 1967–68 (16mm film, color, sound, 95 minutes. Film still courtesy of The Andy Warhol Museum)

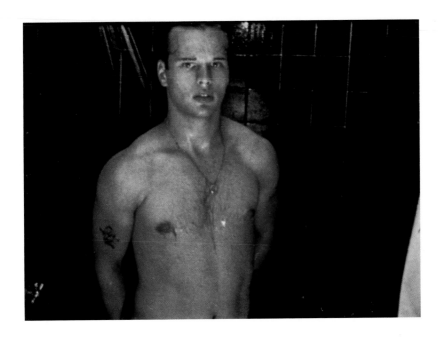

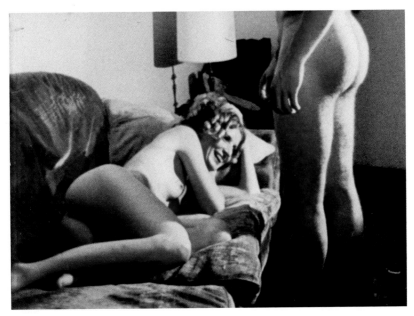

PLATE 9. (top) Joe Spencer; *Bike Boy*, 1967–68 (16mm film, color, sound, 109 minutes. Film still courtesy of The Andy Warhol Museum)

PLATE 10. (bottom) Viva and Joe Spencer; *Bike Boy*, 1967–68 (16mm film, color, sound, 109 minutes. Film still courtesy of The Andy Warhol Museum)

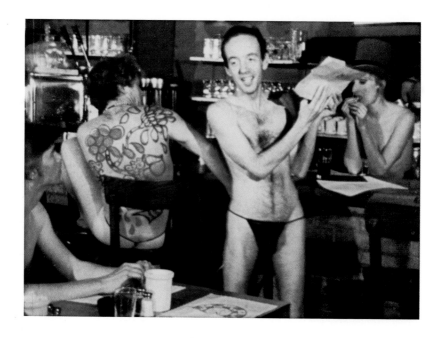

PLATE 11. (top) Julian Burroughs, Louis Waldon, Taylor Mead (standing), and Viva; *The Nude Restaurant*, 1967 (16mm film, color, sound, 100 minutes. Film still courtesy of The Andy Warhol Museum)

PLATE 12. (bottom) Viva roughed up by cowboys; *Lonesome Cowboys*, 1967–68 (16mm film, color, sound, 109 minutes. Film still courtesy of The Andy Warhol Museum)

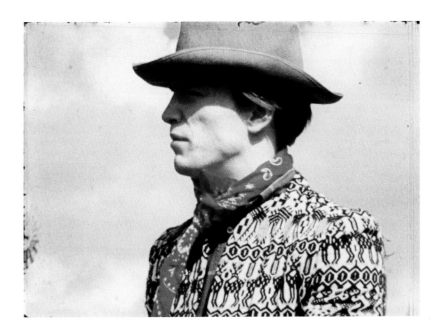

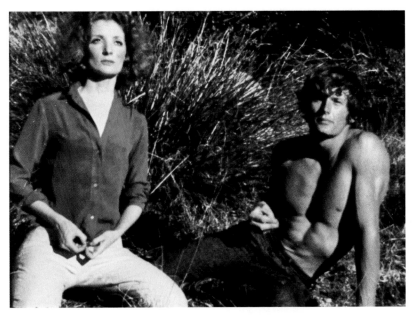

PLATE 13. (top) Joe Dallesandro; *Lonesome Cowboys*, 1967–68 (16mm film, color, sound, 109 minutes. Film still courtesy of The Andy Warhol Museum)

PLATE 14. (bottom) Viva and Tom Hompertz; *Lonesome Cowboys*, 1967–68 (16mm film, color, sound, 109 minutes. Film still courtesy of The Andy Warhol Museum)

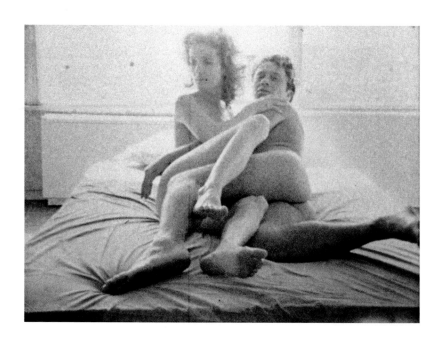

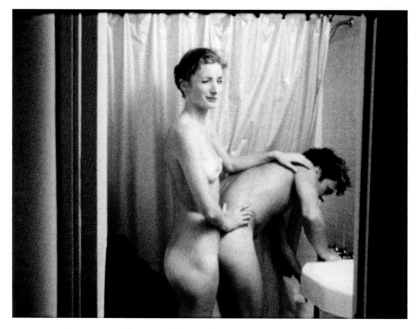

PLATE 15. (top) Viva and Louis Waldon; *Blue Movie*, 1968 (16mm film, color, sound, 133 minutes. Film still courtesy of The Andy Warhol Museum)

PLATE 16. (bottom) Viva and Louis Waldon; *Blue Movie*, 1968 (16mm film, color, sound, 133 minutes. Film still courtesy of The Andy Warhol Museum)

Credits for all images: ©2012 The Andy Warhol Museum, Pittsburgh, PA, a museum of Carnegie Institute. All rights reserved.

us from seeing the action. As Ondine starts to talk again, Malanga and Cutrone run back in and beat the cast with the Baby Ruth bars. Ondine comments: "This is the most fantastic Baby Ruth commercial in history." Someone announces that Lee Harvey Oswald is being transferred from prison. Warhol's camera pans to the left, creating a completely abstract moving image, reminiscent of Brakhage. We see Malanga and Cutrone practicing with whips. They congratulate Ondine for becoming president, and he in turn praises their good work. Malanga asks, "Where are the escorts?" Ondine responds, "You mean the Secret Service?" Cutrone (Oswald) pretends to be brought in, and Malanga (Ruby) shoots him, but not on the wrist, as they had planned. They enact a press conference. Ondine, imitating Edward R. Murrow, says, "All right boys, thank you once again and good night." Malanga walks around the set and cracks his whip. When Ondine returns, Malanga asks him, "Do you have anything to get high with?" We see the inflatable Baby Ruth bar on the floor when the camera zooms out. Cutrone kicks the candy bar in the air several times before the film ends.

It is almost as if by trying to stage the Kennedy assassination as a television event, Warhol is showing the inability of a theatrical presentation to be convincing or to hold our interest, because it's incapable of employing the very techniques—repetition, slow motion, images of real celebrities in moments of tragedy—that kept viewers glued to their television sets, even though what they were watching was as minimal as anything Warhol had done in his own films. *Since* is ultimately about the artifice of live theater and the fact that it relies so heavily on suspension of disbelief. In theater, an action is always different, whereas Warhol was fascinated with mechanical reproduction, with television's ability to reproduce or replay the same exact image over and over again. On the other hand, Warhol allows for imaginative transformation to take place. Not only are objects mutable, but characters can change identities, gender roles, and move between the living and dead. Throughout *Since*, the recording apparatus, as well as the lights, become an intricate part of the action. Warhol stages the assassination of JFK not as a historical event, but, largely due to the impact of television, as the media spectacle it truly was.

MRS. WARHOL

Andy's mother, Julia Warhola, played a major role in her son's life. Of her three children, Andy was the youngest and shared her love of draw-

ing and the arts. Julia was the first person to recognize Andy's talent, even though he wasn't a particularly good student in school. The money his father left after his death would be spent on sending Andy to the Carnegie Institute of Technology. How Andy, the product of poor immigrant parents, became one of the most famous and important artists of our time, remains, on some level, a mystery. Yet, as Gary Indiana explains, Andy held a unique position within the dynamic of the family:

> Andy was the family's moody, tyrannical centerpiece. The child had panic attacks and was prone to hysteria. He shaped weaknesses into weapons for rejecting anyone he didn't like and avoiding anything he didn't want to do. He manifested the estrangement and neediness of the gifted child, cursed and blessed with qualities foreign, magical, and possibly frightening to those around him. The misery of such a child, "kidnapped" into a Depression-era, uneducated family is immeasurable. Regardless of the family's primal bonds of love, its inability to comprehend him and his inability to understand himself inevitably nurtured a degree of resentment and produced from the child sadistically impossible demands and intolerable behavior.[34]

Julia, who was a significant influence on Andy's becoming an artist, unexpectedly came to live with him in New York City in 1952. Warhol thought her stay would be temporary.[35] He assumed Julia would quickly tire of the big city, but she instead stayed until 1971, when she returned to Pittsburgh, where she died a year later at the age of eighty.

As the various biographies of Warhol indicate, Julia helped Andy with his commercial artwork, and she often signed it for him because she had good penmanship. They also collaborated on two books about cats. Julia became the subject of his artwork as well. Andy did a posthumous series of portraits of Julia in 1974. He also made three diary videos of her, including *Julia Warhola in Bed* (1970–72), in which she talks to Andy before falling asleep. Warhol continues to record his sleeping mother, thus referencing *Sleep*.[36] Warhol also made a sound portrait of her, *Mrs. Warhol* (1966). There were various superstars, such as Naomi Levine and Ivy Nicholson, who developed crushes on Warhol. Nicholson even began to think of herself as Mrs. Andy Warhol. Yet, as the film's incestuous title makes clear, Andy actually lived with his mother, and the two even shared a bedroom when she first moved in with him in New York City.[37] Julia even titled one of their early collaborative books *Holy Cats by Andy Warhols' mother [sic]*, thus subsuming her identity into his.[38]

Included in *Mrs. Warhol* is Warhol's lover at the time, Richard Rheem, who also lived with Andy and Julia for part of 1966 and was the subject of one of the more fascinating *Screen Tests*.[39] *Mrs. Warhol* is a rather

unusual sound portrait. It's a fantasy of Andy's mother as an aging homicidal movie star, in which Richard (she calls him "Rich" and "Richie" throughout the film) plays the latest of her many husbands. It begins with Julia in her kitchen as she makes eggs for Richard, who pretends to be fearful that she might poison him like she did her previous husbands. Julia looks very much like an Eastern European peasant. She's short and very difficult to understand due to her heavy accent. She wears glasses, a hairnet, and is dressed in a red and yellow flowered blouse and a blue checkered skirt. Richard wears a green shirt and rust-colored pants with a thick belt. A red-striped table cloth gives the composition more visual interest. Shot in color, the film has a slightly bluish cast.

The dialogue in *Mrs. Warhol* is improvised around a central idea reminiscent of *Hedy*, namely that Julia, an aging Hollywood star, has murdered her previous six husbands. When Julia adds spices to the eggs, Richard questions whether she's adding poison. She initially acts shocked that he's saying such things, but she plays along and even laughs at the joke. He tells her, "You're laughing because you know I'm going to die from it." Julia suggests that he is flattering her because he's after her money. She then threatens to get rid of him because he keeps growing bigger and bigger. He responds that it's because she's feeding him too much. Richard tries to get Julia to kiss him, but she refuses and insists, "I kiss nobody."

The second reel, which is even more bluish in tone, takes place in a different room. Warhol uses assorted fabrics to give the mise-en-scène more visual interest. The camera frames Julia in close-up as she talks to Richard about her previous residence, priests marrying, and the fact that her nephew is studying to be a priest. Julia teaches Richard, now dressed in a long-sleeve blue flowered shirt, how to iron underwear. After he persuades her to iron his tee shirt as well, he is briefly naked from the waist up, but she doesn't look at his body and concentrates instead on her ironing. After Richard puts his shirt back on, Julia calls him a "good boy" and suggests that these skills will be useful for his future wife (she's apparently in denial about his relationship with Andy).

Julia talks about all three of her sons being "good boys." She's proud of the fact that Andy bought her a fur coat. Richard gets her to model a fur hat, which she claims was given to her by a lover, and even tries it on himself—perhaps a veiled reference to Edie in *Poor Little Rich Girl*. He asks her to sing, but Julia suggests that she sounds like a rooster. Richard indicates that he's heard her sing along with a record. She claims that she was given the record player by a movie star in California. Julia sug-

gests it's too much trouble to get the record player out. Richard wants her to sing without it and also asks her to dance, as the reel ends.

Mrs. Warhol provides an odd portrait of Andy's mother, who comes across as an intriguing character. Andy and Julia had a co-dependent relationship. As Gary Indiana suggests, "Over the twenty years that Andy and Julia lived together in Manhattan, their relationship was a mixture of mutual support and antagonism. They seem to have kept one another amused and infuriated."[40] Discussing his mother's visit to him in the hospital after he was shot by Valerie Solanas in 1968, Warhol writes:

> My mother visited me with my two brothers from Pennsylvania and my nephew Paulie, who was studying to be a priest. Paulie stayed on with my mother after the other relatives left, because she didn't speak much English and was sort of batty by then. She couldn't be left alone, certainly, since she had a habit of letting anybody into the house who rang the bell and said they knew me. Any reporter could have gone right up there to talk to her and, if nobody was there to stop her, she'd take them on a complete tour, play my tapes for them, arrange a marriage with me if it was a girl, or with one of my nieces if it was a man—I mean, any embarrassing thing could happen if my mother became a hostess.[41]

In *Mrs. Warhol,* Julia seems to be most comfortable when she's making eggs or ironing clothes. She likes Richard Rheem a great deal and treats him like her own son instead of her fictional husband. Julia was often extremely critical of Andy and reportedly made him feel like he was "the ugliest person in the world."[42] Warhol must have been fascinated by watching and recording his own handsome lover transform during the course of the film into a surrogate, good-looking Andy in his mother's eyes.

ARI AND MARIO

Children don't appear very often in Warhol films, but, Nico's young son, Ari, the offspring of Alain Delon (who denied paternity), appears in several of them, including the sound portrait *Ari and Mario.* Mario Montez thought of himself as a glamorous female star, but in *Ari and Mario,* he is cast in the unlikely role of Ari's babysitter. Warhol obviously saw humor in the incongruity of placing Montez in a domestic situation. Montez good-naturedly attempts to relate to Ari while the child is temporarily in his care, but what's not so obvious is that Ari's utter lack of response to Montez is less a reaction to his being a drag queen than to issues of language. As we know from Susanne Ofteringer's compelling documentary

Nico Icon (1995), Ari was initially raised by Delon's parents and would have spoken French rather than English. Indeed, both Nico and Tally Brown speak French to him during the course of the film.[43]

The film begins with a close-up of Ari shaking his head as his mother runs her hands through his long blond hair. Nico asks him, "Why not? You can't always stay the same, Ari." She continues, "So what are you going to do while I go away? What games are you going to play?" Nico calls Irene (Montez), who comes in wearing a blue evening gown, blond wig, heavy rouge, and gaudy jewelry. Irene indicates the film's premise when she says, "I guess I'll have to babysit for you today, don't I?" Nico suggests that Irene looks like a fortune-teller—and indeed Montez could easily pass for the kind you might find at a carnival. When Irene sees Ari, she says, "Oh, is he adorable!" Ari runs around and immediately hides in the hall, causing Irene to question whether he's playing a game of hide-and-seek with her. Tally Brown, wearing a fur hat, turns up with Ari, saying she found him at the next landing, implying that Montez is already failing to keep an eye on the rambunctious child.

Throughout *Ari and Mario,* we hear directions being whispered to the participants from offscreen. Ari begins making noises and gestures with his hands at the camera, as if he's a crocodile. He uses his hands to enlarge his mouth and stick out his tongue, and then walks toward the camera and out of the frame. Brown comments, "He's a funny child." Irene concurs. Brown asks Ari whether he knows that Christmas is coming but doesn't get a response. As we hear whispering offscreen and Ari positions himself close to the camera, Brown suggests reading to him and indicates that he likes books in about "four languages." She tries to get Ari to sing, and, speaking in French, alludes to the fact that his mother is a singer before excusing herself and leaving.

Alone with Irene, Ari wants his mother. Irene tries to interest him in a game of cowboys and Indians, using a child's black cowboy hat as incentive. She originally offers to play the Indian, but he wants her to be a cowboy. After Ari gets a rifle and a pistol, Irene decides they need a target. After she later fails to interest Ari in a Hans Christian Andersen book, she tries to entertain him by performing a dance about an Indian with a tambourine. As she spins around and bangs loudly on the tambourine, Ari pulls an orange striped curtain over himself to block her out. As she tries to pull back the curtain, he whines. After Irene distracts him with another crocodile sighting, she gets Ari to shoot it in the closet.

The second reel begins with Ari sitting on the kitchen sink and shooting at Irene, who pretends to be wounded in very dramatic fashion. After

he continues to shoot her, she asks him to stop and complains, "I can't stand it anymore!" Nico eventually arrives home and gives Ari an apple as a present. When she asks him for a kiss, he immediately jumps down and gives her one. Ari mumbles something about "pee pee" to Nico. Irene asks, "What did he say?" Nico answers that he has to go to the bathroom. They eventually close the door to give him some privacy, but the hidden sound person mikes the loud sound of Ari peeing and then flushing the toilet. Irene later buttons up his fly. Irene tries to discourage Ari from being a cowboy by claiming they don't make any money.

Nico makes a surprising revelation after Ari finds a battery for a hearing aid on the floor. Irene asks, "Who's hard of hearing?" Nico admits it fell out of her ear. Irene asks in disbelief, "You have a hearing aid?" Nico laughs about her disability. She did, of course, have hearing problems, which is why the Velvets often complained about her singing off-key. From offscreen, Andy tries to incite Ari by insisting that there are no crocodiles in the closet and hurling Ari's teddy bear and toys at him. Nico comments, "It's raining toys." Andy yells at Ari, "You are a crocodile . . . Ari is a crocodile!" Nico tells Ari to say, "You're a crocodile yourself, Andy." She complains, "Ari, you don't love me anymore." She also tells him that his teddy bear is crying, a remark that Andy repeats. Irene tells a story about a crazy person buying guns on Forty-second Street and shooting two people in Bryant Park. Nico mentions seeing Roger Corman's *Bucket of Blood* (1959) on TV, blurring the distinction between an actual event and one that's fictional.

Ari threatens to hit Irene with his rifle. It's clear that Andy is encouraging Ari to misbehave, much like he tried to rile the actors in *Afternoon,* as he insists, "More, more, more." As Nico sits on the floor with a red poinsettia, she suggests to Ari that he's getting boring. She then reverses herself and tells him, "You're a very nice cowboy." Irene looks pained and then, suddenly feeling maternal, says, "He didn't finish his apple." Warhol understood only too well that a well-behaved child makes for a boring film.[44] While Ari doesn't really misbehave in *Ari and Mario,* it's clear from all the offscreen whispering that Andy secretly wishes the young cowboy would create more mischief than he does, even though it's safe to assume that Montez probably has had enough of his domestic role as babysitter, one that is very far removed from the world of glamour for which he yearned.

The sound portraits still needed the same sort of catalyst to spark the dramatic tension that we find in Warhol's other films. In *John and Ivy,*

for instance, the subtext involves John Palmer's desire to have sex with Ivy Nicholson, who refuses to cooperate and rebels against participating in the film. In *Paul Swan,* Warhol minimizes Swan's actual performances, instead emphasizing the long delays getting into costume, thereby frustrating the aged dancer. In *Camp,* the underlying personal friction between Jack Smith and Warhol takes the form of a power struggle in which Smith tries to commandeer the film through his own directions. The suspense resides in whether Smith will force Warhol to move the camera and open the glass cupboard in order to reveal the source of their personal rift. *The Closet* explores the sexual tension between a handsome young man and an older female superstar who are confined within the small space of the closet.

Bufferin is a coded psychodrama involving Gerard Malanga's romantic involvement with a beautiful fashion model and Warhol's disapproval of the relationship. In *Mrs. Warhol,* a highly convoluted Oedipal fantasy, Andy's mother, Julia Warhola, is cast as an aging Hollywood serial killer who is married to his then boyfriend, Richard Rheem. In *Ari and Mario,* Warhol actively encourages Nico's son, Ari, to misbehave while being baby-sat by a good-natured Mario Montez. Warhol subtly uses the glamour-obsessed transvestite performer to depict the more mundane side of being a woman.

Although less known or written about, a number of the sound portraits—*Paul Swan, Camp, Bufferin,* and *Since*—deserve a great deal more critical attention than they have received until now. During this same period, Warhol actually made other sound portraits, including a number of biopics, such as *Lupe* and *More Milk Yvette.* When he was given video equipment to test, Warhol decided to shoot *Outer and Inner Space,* a double-screen sound portrait of his favorite superstar, Edie. He also became involved with The Velvet Underground. While seemingly unrelated, these two developments converged to provide the direction for another major phase of Warhol's film career, namely, intermedia, or what became known as "expanded cinema."

Expanded Cinema

Come Blow Your Mind

Jackie Hatfield writes: "Not without ambiguities, expanded cinema as a term generally describes synaesthetic cinematic spectacle (spectacle meaning exhibition, rather than simply an issue of projection or scale), whereby the notions of conventional filmic language (for example, dramaturgy, narrative, structure, technology) are either extended or interrogated outside the *single*-screen space."[1] Intermedia, or expanded cinema, dates back to Abel Gance in the 1920s. Kenneth Anger presented a three-screen version of *Inauguration of the Pleasure Dome* (1954) in 1958, the Eames Brothers made a number of works that utilized more than one screen, and Barbara Rubin created *Christmas on Earth* (1963), a sexually graphic double-screen film that utilized colored filters.[2] A number of artists—Robert Whitman, Stan VanDerBeek, Ed Emshwiller, and Angus MacLise, among others—incorporated other art forms to create intermedia events that expanded the standard notion of cinema as moving images projected on a single screen. Although it was an international phenomenon, occurring in a number of countries simultaneously, "expanded cinema" gained prominence in the United States in late 1965, largely as a result of the New Cinema Festival at the Film-Makers' Cinematheque. Jonas Mekas staged the series and then praised it effusively as an exciting new development in his influential movie columns for the *Village Voice*.[3]

Warhol had already created the double-screen film *Outer and Inner Space* in the late summer of 1965, but the artist soon began to see new

possibilities for creating expanded cinema. Later that year, Warhol and other members of the Factory became enamored with a rock group called The Velvet Underground, whose sensibility shared a strong affinity with that reflected in Warhol's films. The group consisted of Lou Reed, John Cale, Sterling Morrison, and Maureen Tucker; they were brought to the attention of the Warhol crowd by the filmmaker Barbara Rubin, who is credited with introducing the element of live performance into Warhol's work through her Up-Tight series.[4] According to Warhol, Rubin persuaded Gerard Malanga and Paul Morrissey to help her shoot a movie of the band at the Café Bizarre in the West Village, where they were playing. Warhol writes about the Velvets: "We talked to them a little bit that same night while Barbara and her crew went through the audience pushing the blinding sun gun lights and the cameras in people's faces and asking, 'Are you uptight? Are you uptight?' until they reacted, and then she would hold the cameras and lights on them while they got madder or cringed more or ran away or whatever."[5]

Morrissey had been approached about the possibility of Warhol becoming involved in a huge new discotheque that would be opening in Long Island. He thought the intense volume of The Velvet Underground would be perfect for such a large space. Warhol indicates that they had also been looking for a band for Nico to front. Gerard Malanga had met the German-born fashion model, actress, and singer (whose real name was Christa Päffgen) in London, and she had recently turned up at the Factory with a record that had been produced in Europe.[6] With Edie balking at the prospect of appearing in new films, the focus began to shift to Nico as the next major superstar. Morrissey thought the Velvets lacked the necessary charisma to be successful, and he saw the potential of having the beautiful and mysterious Nico as their lead singer. Morrissey describes his reaction:

> I felt that the one thing the Velvets didn't have was a solo singer, because I just didn't think that Lou had the personality to stand in front of the group and sing. The group needed something beautiful to counteract the kind of screeching ugliness they were trying to sell, and the combination of a really beautiful girl standing in front of all this decadence was what was needed.[7]

The members of The Velvet Underground took themselves very seriously as musicians and were hardly enthusiastic about being reduced to being a backup band for a pretty face. Morrissey, however, managed to convince them of the benefits of letting Warhol manage them on the condition that Nico would be their singer.

When Warhol was invited to speak at the New York Society for Clinical Psychiatry at Delmonico's Hotel on January 13, he initially decided to show two of his films—*Harlot* and *Henry Geldzahler*—but after watching The Velvet Underground in action, he thought they might provoke even more of a reaction.[8] The psychiatrists' banquet turned into an Up-Tight event. It featured piercing music by the Velvets, "wailing" by Nico, Edie's expressive dancing, and Gerard Malanga performing a dance with a whip, while Barbara Rubin and Jonas Mekas accosted the psychiatrists and their spouses with lights and cameras and asked them provocative sexual questions. A similar multimedia event, billed as "Andy Warhol Up-Tight," was later staged for a week (February 8–13, 1966) at the Film-Makers' Cinematheque, which had recently moved to Forty-first Street. Besides a live music performance by The Velvet Underground and Nico, there were films by Warhol (*Lupe, More Milk Yvette,* and *The Velvet Underground*), dancing by Gerard Malanga and Edie Sedgwick, lights by Danny Williams, slide projections by Warhol and Morrissey, and photographs by Billy Linich (Name) and Nat Finkelstein. In addition, Barbara Rubin once again harassed audience members in an attempt to make them "uptight."[9] Rubin was, in effect, attempting to engage the spectators in her own form of psychodrama. Bockris and Malanga describe the response: "For the most part the audience sat there too stunned to think or react. The music was supersonic and very loud. The Velvets turned their amps up as high as they could go. The effect vibrated all through the audience. To some it seemed like a whole prison ward had escaped. Others speak of it today as hypnotic and timeless."[10]

Edie participated in the Up-Tight shows at the psychiatrists' convention and the Film-Makers' Cinematheque. In late February, however, she made a final break with Warhol and the Factory, ostensibly over money. Edie also perceived that there was no longer a major place for her because the new emphasis on intermedia had shifted the center of attention to The Velvet Underground and Nico. In the end, she abandoned Warhol to pursue career opportunities with Bob Dylan, with whom she was smitten. She was already gone by the time the multimedia events were showcased on college campuses, such as Rutgers in New Jersey and the University of Michigan in Ann Arbor.[11] When the much-planned launching of The Velvet Underground at the Long Island discotheque fell through at the last minute, Morrissey rented the cavernous Dom on St. Mark's Place for the month of April and began staging the multimedia performances there.

Andy Warhol's major foray into expanded cinema, The Exploding

Plastic Inevitable (EPI), reflected a constellation of factors. It fit in with Warhol's involvement with The Velvet Underground, as well as his insatiable interest in anything new and different, especially if it related to drugs, youth culture, or the club scene. It was also connected to Warhol's desire to present his films within a different context.[12] The intent was to provide audiences with a more immersive experience that resulted from bombarding the senses by combining a number of different art forms. In addition, Paul Morrissey, who was exerting a big influence on Warhol, turned out to have the entrepreneurial and managerial skills required to stage such a complex venture. Warhol's expanded cinema phase lasted a year and a half—mainly 1966 and 1967—during which, in addition to the EPI, he created a number of major multiple-screen films, including *The Velvet Underground and Nico* (1966), *The Chelsea Girls* (1966), and **** (*Four Stars*) (1967), a twenty-five hour film that was screened just once.

The EPI became a powerful and intense mixed-media event that consisted of music, multiple-screen projections of film, a stroboscopic light show, dance, and theater. Branden W. Joseph describes a typical performance:

> At the height of its development, the Exploding Plastic Inevitable included three to five film projectors, often showing different reels of the same film simultaneously; a similar number of slide projectors, movable by hand so that their images swept the auditorium; four variable-speed strobe lights; three moving spots with an assortment of colored gels; several pistol lights; a mirror ball hung from the ceiling and another on the floor; as many as three loudspeakers blaring different pop records at once; one to two sets by the Velvet Underground and Nico; and the dancing of Gerard Malanga and Mary Woronov or Ingrid Superstar, complete with props and lights that projected their shadows high onto the wall.[13]

Warhol's *Village Voice* ad for the Dom shows, which were initially billed as "The Erupting Plastic Inevitable," announced, "Come Blow Your Mind," thus targeting young people who were attuned to references to mind-altering experiences as a result of the proliferation of psychotropic drugs, which were hitting college campuses around this time.[14] Warhol suggests that The Exploding Plastic Inevitable, as it finally became known, provided yet another venue for him to reach several distinct audiences:

> So now, with one thing and another, we were reaching people in all parts of town, all different types of people: the ones who saw the movies would get curious about the gallery show, and the kids dancing at the Dom would want to see the movies; the groups were getting all mixed up with each other—

dance, music, art, fashion, movies. It was fun to see the Museum of Modern Art people next to the teeny-boppers next to the amphetamine queens next to the fashion editors.[15]

Warhol's interest in extending his "brand" across multiple platforms shows how savvy he was when it came to applying business principles to the making of art. At the time of the EPI show at the Dom, Warhol was also staging two other major events in different media: *My Hustler* was playing at the Film-Makers' Cinematheque, and the *Silver Cloud* sculptures and *Cow Wallpaper* were being shown at the Leo Castelli Gallery. This strategy would later pay even bigger dividends when *The Chelsea Girls* became a sensation, resulting in his first success in breaking into the mainstream with his films.

OUTER AND INNER SPACE

In art and film, Warhol seemed very much attuned to how media and changes in technology were affecting American life in the 1960s. He appreciated the importance of mechanical and electronic reproduction, which is why he turned from painting to silk screening and still photography, and then to film, the tape recorder, video, and eventually television. He understood that we were moving from an industrial age to an information age dominated by images and media. Warhol intuitively grasped how mass media's emphasis on glamour and celebrity was affecting the very foundations of our personal world, especially individual identity. The Warhol film that deals most squarely with this issue is *Outer and Inner Space,* a work that was virtually ignored at the time it was made (August 1965), even though it was directly related to his previous work in painting and silk screening.[16] It's also the film that propelled him in the direction of expanded cinema.

Norelco, aware of Warhol's interest in new technologies, gave him their latest video recording equipment to experiment with in the hope that he would promote it to his rich friends.[17] Warhol approached the medium of video with the same innate curiosity with which he experimented with the formal parameters of film. He was interested in exploring not only its strengths, but also its weaknesses. This led him to take advantage of the instability of the video image by deliberately manipulating it to the point of abstraction. Warhol's understanding of the implications of electronic recording was remarkably sophisticated and advanced. As usual, when confronted with a new situation, Warhol

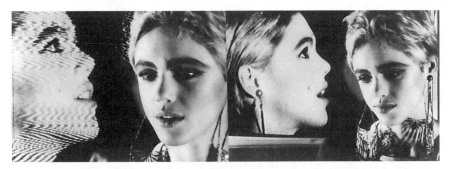

FIGURE 30. Edie Sedgwick; *Outer and Inner Space*, 1965 (16mm film, b/w, sound, 66 minutes; 33 minutes in double screen. Film still courtesy of The Andy Warhol Museum)

turned to what he knew best: portraiture. The resulting piece became a double-screen portrait of his reigning superstar, Edie Sedgwick.

In *Outer and Inner Space,* Warhol deconstructs the "celebrity interview," exposing its scripted, artificial, and vacuous nature. Through the relationship between image and sound, Warhol explores the discrepancy between outer and inner space on a number of different levels. There is the space within the film frame as well as the offscreen space to which Edie addresses her comments. There's the space both inside and outside the video monitor as well as the space between the two screens that comprise the double-screen projection. And, of course, the title suggests the confusion between image and identity. As Reva Wolf writes: "The idea that image and reality are not the same thing—yet are so deeply intertwined that they are not necessarily distinguishable from one another—came to be articulated in a wide range of theoretical and historical writings of this same period, the late 1950s and early 1960s."[18] Edgar Morin, Erving Goffman, and Daniel J. Boorstin are among the theorists and historians to whom Wolf is alluding in this passage.[19]

Outer and Inner Space begins with a close-up of Edie, who wears large earrings and a great deal of eyeliner, on the left, in front of wavy electronic lines, while a wide shot on the right allows the viewer to see that she's positioned in front of a TV monitor. Another profile shot of Edie with her head canted slightly upward appears first on the left screen and then on the right, so that Edie, who smokes a cigarette, becomes confronted with her own image, much like what occurs during a live recording in a television studio. After about four minutes, Gerard Malanga walks into the frame on the right to adjust the back of the monitor. As Malanga walks behind the monitor, the camera zooms in and he comes

forward on the right. The zoom creates a new sense of scale that approximates the two images on the left-hand screen, only it is not framed quite as closely. At times, electronic glitches occur in the image on the left, increasing the contrast as well as distorting and obliterating Edie's face. The image on the right monitor also flutters at times. At nearly thirteen minutes, the camera on the left screen begins to zoom back until it approximates the wide shot that appeared initially on the right. The two zooms invert the relationship between the two screens, thus helping to structure the piece.

The image on the monitor rolls on the right screen, suggesting multiple or serial frames, recalling Warhol's multipaneled paintings and silk screens. After twenty minutes, Edie complains about the heat from the lights and begins to fan herself, which causes shadows from her moving hand to be reflected on her face. In the wider shot on the right screen, pages of the script appear in the right corner. An arm from off-screen reaches in and adjusts the back of the TV monitor. Edie takes the script and begins to rip up the pages. At twenty-four minutes, loud noises obliterate the sound of Edie's voice, and the image on the monitor of the right screen suddenly loses contrast as flickering light alters Edie's face before returning to normal.

Edie suddenly sneezes, causing her to physically react, as if surprised. Edie comments, "I can do that any time." As a result of the sneeze, which shows on the monitor on the right screen, *Outer and Inner Space* becomes interactive. On the monitor, she asks, "Shall I sneeze again to prove it?" The other Edie suddenly sneezes in response. The Edie on the monitor sneezes, and Edie sneezes once again. She says, "It's so messy." She then lets out a smaller sneeze, but acknowledges, "It doesn't sound real." She does it again. Edie asks, "Again?" She indicates she needs to think about it, which suggests that she's performing the sneeze for the camera. She then coughs a number of times. An arm comes in from the right side, and the image disappears on the monitor on the left screen. Once this happens, Edie positions her head so that it's in the center of the TV monitor. Thirty seconds later, the image of Edie disappears from the monitor on the right screen. Wavy lines appear and then recognizable television images of a woman and a cowboy appear. The contrast increases, and the images disappear by thirty-three minutes. Edie continues to smoke on both screens until the images disappear entirely into whiteness.

The multiplicity of Edie's voices makes the sound track of *Outer and Inner Space* largely indecipherable. From the cacophony of competing

voices, occasional sound bites emerge from Edie's four interviews. As in *Restaurant* and *Poor Little Rich Girl,* Edie plays a glamorous celebrity. Her performance seems to be consciously referencing someone like Julie Christie, the actress who played a ruthless fashion model bent on success in John Schlesinger's *Darling* (1965), a film that appeared the same year. In *Outer and Inner Space,* Edie seemingly offers candid personal insights on a wide variety of topics, punctuating her remarks with various hand gestures and drags from her cigarette. Her responses seem to be a mixture of thoughtful reflection and self-deprecating humor. The transcription of the voice track, however, suggests that much of what Edie says borders on gibberish.[20] She's merely talking for the sake of talking, filling up the allotted time with empty chatter on topics ranging from goldfish and Egyptian culture to the benefits of sports cars. Of course, Warhol himself was the master of the celebrity interview. Wolf points out: "It is as though the *less* serious his answers or his questions were, the *more* serious the ideas left behind for posterity to sort out; and, the more evasive his utterances, the more profound their implications."[21]

By including images within images and utilizing the two zooms to create an interrelationship between the four images on two screens, Warhol creates a virtual hall of mirrors for the performer. When the ghostlike image of herself appears on the video monitor on the left-hand screen in the beginning of the film, Edie reacts to it with surprise, fear, and amusement. Video enabled Warhol to add another layer of reflexivity to his conception of portraiture. Thus, the film itself forces Edie to confront her own self-image as she simultaneously creates a new one for the camera.

Baume relates the psychodramatic aspects of what Warhol was attempting in *Outer and Inner Space* to the instability of individual identity as a result of social performance. He writes:

> Warhol was certainly interested in psychologically charged situations, which he used in many different ways. However, the psychodynamics that his scenarios reveal disrupt the notion of an essential, unified self. The unstable nature of identity is a central theme of *Outer and Inner Space.* Here the self is serialized as Warhol's layering of media and doubling of images multiplies the portrait in time and space. Relations between the "different" Edie Sedgwicks become even more ambiguous as the "live" subject interacts with her videotaped image.[22]

Part of the conceptual brilliance of the piece (and what makes *Outer and Inner Space* Warhol's richest and most complex sound portrait) is that Warhol, through the feedback capabilities of video, was able to achieve this using a single performer.

Outer and Inner Space is considered to be the very first artist video, but, with typical Warholian irony, it's not really a video, but a film of a video. Along with his later *The Chelsea Girls*, *Outer and Inner Space* is one of the two double-screen works that were intended to be shown only in this format. According to J. Hoberman, it premiered at the Film-Makers' Cinematheque on January 27, 1966, as a double-screen projection.[23] Other Warhol films, such as *Lupe*, *More Milk Yvette*, and *The Velvet Underground*, were often shown multiscreen as part of Warhol's venture into expanded cinema, just as many single-screen works were often projected in unorthodox ways—such as on walls, ceilings, and bodies of performers—during Warhol's Up-Tight and Exploding Plastic Inevitable phase.

LUPE

Callie Angell suggests that *Lupe*, which was shot in December of 1965, represents a transitional film, "marking both the end of the Sedgwick films and the beginning of Warhol's experimentations in multiscreen production, a format he would continue to explore in *The Chelsea Girls* (1966) and **** (Four Stars) (1967), as well as in the *Exploding Plastic Inevitable*."[24] The film is a biopic of actress Lupe Velez, the "Mexican Spitfire," who was at one time married to Johnny Weissmuller, the actor who played Tarzan. In the version Kenneth Anger tells in *Hollywood Babylon*, after she became pregnant by a bit actor named Harald Ramond and he refused to marry her, Lupe attempted to stage her own suicide as a type of media event. She concocted a plan to die in bed surrounded by flowers and scented candles. Dressed in a negligee, she proceeded to take an overdose of Seconal, but actually wound up dying with her head in the toilet.[25] Warhol seemed to be fascinated with this image—the ironic juxtaposition of Hollywood glamour and a receptacle for human waste—because it appears at the end of both reels of the current version of the film. *Lupe* was screened in double projection as part of the EPI.[26]

Warhol, who was never much concerned with verisimilitude, cast Edie Sedgwick as Lupe, even though her fair complexion and personality would hardly suggest a "Mexican Spitfire."[27] The film begins with an extended shot of Lupe (Sedgwick) sleeping. Her face is partially reflected in a mirror on the right side of the frame. As Lupe's body moves, the camera zooms out and in to reveal her lying on a bed in a red negligee, along with her reflected image. There are several pillows on the bed,

including two that are red. The color is further accentuated when she takes a cigarette from a red box. The camera zooms in as she lights it. A fur coat lies draped over the bed. She eats a slice of Juicy Fruit gum. When the phone rings, Lupe leaves the frame and returns to the bed with it. As she talks on the phone, the camera tilts up and down to the floor before zooming in on her.

Billy Name, wearing sunglasses and a horizontally striped blue shirt, arrives to give her a haircut. Although Warhol employs a seemingly arbitrary mobile camera, the composition is most interesting when he frames Lupe and Billy in wide shot. Both are reflected in the mirror as he proceeds to cut her hair, so that we have four images of them. He asks her, "Did you settle your agent situation?" This prompts the camera to pan quickly back and forth between the two of them and their reflection in the mirror. With the camera close on her, Lupe whistles a song. As Billy leans over her, he blows hair off her back and tries to get her to stop moving her head abruptly. He later tells Lupe, "Why don't I come back?" Because Lupe has previously talked to Billy about wanting him to dye her hair green, he suggests he'll bring back a variety of hair colors. Lupe insists that he return at five o'clock rather than the next day.

After he leaves, the camera zooms in and out as she continues to apply eyeliner. The scene cuts to an extended roll in which Lupe, now dressed in a blue negligee with green trim, lies with her face in the circle of the toilet seat on the left side of the frame, while her image is reflected in the blue framed mirror on the right. A pink stool can be seen in the right corner of the frame. For a couple of seconds, someone's head pokes into the bottom of the frame on the left side, before the image flares, ending the reel.

Reel 2 begins with a wide shot of an elegant living room. There is a dining table on which sits an ornate floral arrangement and fruit, with a chair in the foreground. The background is dominated by a fireplace with a large mirror above it. Dressed in the blue negligee, Lupe carries a potted plant of yellow flowers and places them on the mantle of the fireplace. She pours herself two glasses of wine, one white and one rosé, plays with a tabby cat, takes pills, listens to the radio, starts to eat a meal, then plucks one of the flowers and dances. The most memorable shot occurs as Warhol's mobile camera aggressively zooms in and out as she sits, suggesting the effects of the pills and alcohol on her. To a musical rendition of "Mack the Knife," the camera moves in circular

patterns around her as well as in vertical motion, creating a sense of vertigo. Lupe picks up her meal and twirls around slowly to the music, raising her plate above her head before returning it to the table. After more dancing and drinking, she picks up the yellow flower and her glass of rosé, moves toward the camera, and disappears from the frame. The second reel also ends with a coda of Lupe's head in the toilet. This time, however, Warhol uses a handheld mobile camera rather than a continuous static shot.

Lupe shows the most attention to color design of any Warhol film, especially the way he uses pinks and reds, shades of blue, and yellows throughout the two reels. Lupe's costumes change from red to blue. Her hair is dyed yellow to match the tiger-striped pillow she lies on in the first reel, in which she eats yellow Juicy Fruit gum. Lupe brings in yellow flowers in the second, drinks straw-colored white wine, and sits in a yellow wicker chair. In the first reel, the camera's vertical tilt highlights the red-colored trim as well as her cigarette case. Billy Name wears a blue striped shirt. In double projection, the colors provide accents across the two different screens so that Billy's shirt, for instance, corresponds to Lupe's light blue negligee. A red vase on the mantle and the rug on the floor, red-colored bottles on the table, and the rose-colored wine in the second reel match the color of her negligee, cigarette case, and the feather she had in her hair in the first reel. The film's final double-screen image, which has a bluish cast, alternates between showing three and four images of Lupe's head in the toilet, which vary due to the camera movement and assorted framings in the second reel. The final shots of Lupe are richly provocative and as haunting as any found in Warhol's films.

Without prior knowledge of Lupe Velez's life, it might be difficult for a viewer to grasp the elements of the story other than her suicide. But Warhol's careful attention to color in both reels, along with their juxtaposition in double screen, suggests that Lupe, who acts very casually in both reels, is choreographing her own color-coordinated buildup to suicide. Bosley Crowther, the film critic for the *New York Times,* wrote: "On one side of the screen, a baby-doll blonde type is primped and powdered by a make-up man, while on the other side the same girl eats a long meal in an elegant dining-room. This one is in color. At the end, both panels are used to show the girl with her head in a toilet."[28] As this slightly inaccurate description indicates, Crowther has not deciphered that the film is a biopic of Lupe Velez. If he knew the biographical details, he would have understood that eating a big meal and drinking, along with swallowing pills, are causally linked to the final image.

Anger indicates that it was eating a big meal after taking Seconal that caused Lupe to vomit profusely, which forced her from the shrine of her bed to her final destination: the bathroom.[29]

MORE MILK YVETTE

Like *Lupe, More Milk Yvette* is a biopic—in this case, of the actress Lana Turner. It premiered as part of the same Andy Warhol Up-Tight event at the Film-Makers' Cinematheque. Anger's *Hollywood Babylon* relates the details on Turner. Recently separated from actor Lex Barker, Lana Turner became involved with an abusive gangster named Johnny Stompanato. One night, as he threatened her physically, Lana's fourteen-year-old daughter, Cheryl Crane, came to her mother's defense and stabbed Stompanato to death. Turner, who had been involved in a series of violent relationships, had to testify at the scandalous murder trial of her daughter. Although the jury took only a short time to rule Stompanato's death a justifiable homicide, Turner was excoriated by the press and public for, among other things, being a bad mother. Her steamy love letters to Stompanato were published, providing additional fodder for the media circus that ensued.[30]

None of this helps to decipher Warhol's enigmatic *More Milk Yvette*, in which Lana is played by Mario Montez. In contrast to *Lupe,* the action takes place entirely on a bare set, without any attempt to create a semblance of realism. The film begins with harmonica playing. In a wide shot, there are three people, including the harmonica player, who bears a strong physical resemblance to Bob Dylan. Lana Turner, who was known as the "Sweater Girl" for her role in *They Won't Forget* (1937), sings that she has to model many sweaters at the studio and that her boyfriend Johnny Stompanato—Lana stomps her foot as she says his name—is waiting for her at home along with her "son" Cheryl. Cheryl is played by a young man (Richard Schmidt, Montez's boyfriend at the time) who leans against a large post and postures in a manner that suggests a juvenile delinquent.[31] Lana calls to her middle-aged maid, Yvette, who enters and removes Lana's sweater. When Lana asks where Johnny is, Yvette answers, "Dead, maybe?" but adds that that's "wishful thinking." Lana then turns to Cheryl and asks why he shot him, expressing her love for Johnny.

Yvette attends to Lana, especially in helping her change in and out of several outfits. Lana asks Yvette for a hamburger, which mother and son ravenously share—more like lovers than family members. Lana asks

Yvette for milk, which she and Cheryl drink from a goblet. The camera tilts from the action up to the ceiling and often moves around the set in a manner similar to *Lupe.* Yvette tries to pour more milk, but Lana indicates they have enough and gives a drink to the harmonica player. While Cheryl smokes a cigarette, Lana calls out, "More milk, Yvette." As in *Horse,* the milk appears to have a symbolic function. After sensuously drinking more milk from the goblet, Lana asks Cheryl once again, "Why did you shoot Johnny? Why? Was he trying to seduce you? Was he? I can't believe that." As the harmonica plays, the camera tilts up to the ceiling and then down several times. Lana asks Yvette for a pear. As the camera zooms in and out, Lana and Cheryl take bites from different sides of the pear in a similar manner to how they ate the hamburger. Lana then has Yvette bring them a bottle of Coca-Cola, an allusion to the discovery of Lana (by Billy Wilkerson, the publisher of the *Hollywood Reporter*) while she was drinking a Coke at a soda fountain as a teenager in Idaho.[32]

We might expect *More Milk Yvette* to deal with Lana Turner's relationship with Cheryl or Johnny Stompanato, or that it will end in his inevitable fatal stabbing (rather than shooting), or that her love letters will come into play, but none of these elements factor in to what actually occurs on the screen. Instead of the scandalous details we might expect in this biopic, Warhol emphasizes Lana's reputation for wearing tight-fitting sweaters. He opts for irony by having the role played by Mario Montez, who spends much time changing into the sweaters, so that we view his flat chest beneath a padded bra.[33] Lana suggests that Cheryl possibly shot Johnny because he tried to seduce him.[34] If Johnny has already been shot by Cheryl, we might also wonder why he turns up in the second reel. He's not portrayed as a gangster or as abusive. Instead it's Lana who bosses Yvette around.

How Dylan might fit into a film about Lana Turner is anybody's guess, but, then again, the film premiered as part of an Up-Tight event. Having a Bob Dylan look-alike wander around playing a harmonica throughout the entire film becomes annoying, especially since he continually intrudes on the main action. The reference to Dylan is made explicit when the musician actually plays a Dylan song, adding a form of social criticism that's as humorous as his inclusion in a biopic about Lana Turner. Warhol made a number of films that spoofed Dylan, the most notable being his subsequent *Imitation of Christ.* Yet, if we could imagine for a second the film playing as a backdrop behind the raw energy of The Velvet Underground and an assaultive, psychedelic multi-

media show, there's a good chance that *More Milk Yvette* still managed to resonate in the parodic way Warhol may have intended.

THE VELVET UNDERGROUND

Warhol recycled a number of his older films for the EPI, thereby giving them new life, but he also shot new ones expressly for this purpose, including the two silent *Screen Tests* of Salvador Dalí and sound portraits that centered on The Velvet Underground. The latter films include *The Velvet Underground, The Velvet Underground and Nico, The Velvet Underground Tarot Cards* (restored, but not yet released as of this writing), and *The Velvet Underground in Boston*. These films not only documented the phenomenon of the band itself but also served as a backdrop for the live multimedia performances.

The rock group took its name from Michael Leigh's paperback *The Velvet Underground,* an exposé of rampant sexual decadence whose suggestive cover features a whip, stiletto leather boot, key, and black mask. According to band member Sterling Morrison, "We had a name at last! And it was adopted by us and deemed appropriate not because of the S & M theme of the book, but because the word 'underground' was suggestive of our involvement with the underground film and art scenes."[35] Yet Warhol's *The Velvet Underground* certainly plays up the book's connections to sadomasochism. It begins with a wide shot of a floor covered with some objects. Someone walks onto the set carrying a bullwhip (only his legs and boots end up in the frame). Gerard Malanga reads a passage that turns out to be lifted from the flyleaf of Leigh's book:

> He may be the man next door . . . she may be the woman who sits beside you in church. Every-day people, leading every-day lives. You know them well. You'd say, *"Impossible!"* if you were told that they also inhabit another world, one so ugly and evil that its existence must be carefully guarded.
>
> This is the "velvet underground," where every possible sexual depravity is practiced. It is a nightmare meeting-place of sadomasochists, the wife/husband swappers and the seekers after unspeakable pornography . . . to mention only a few.
>
> On these pages, the full facts are revealed. You will be astounded by the numbers of participants involved. But most of all, you will be stunned by their identities. You know them so well . . . the man next door . . . the nice lady down the street . . .[36]

When The Velvet Underground is mentioned, a rope and whip snake into the frame.

Lou Reed and Sterling Morrison proceed to tie Moe Tucker to a chair. She sits smiling passively, wearing a leather vest and dark sunglasses. A whip is cracked. Reed uses a light to pretend to interrogate Tucker. He also pretends to masturbate with the long handle of the bullwhip and several times suggestively places it between his legs. Warhol's camera moves around the limited action. At one point, Morrison uses a box as a drum, and Reed dances expressively to the music. Several times the camera tilts up and down over Tucker, ending on the negative space above her. Objects are thrown; we hear the sound of breaking glass. Reed pulverizes shards of the glass with the handle of his whip. A shopping cart appears and Reed sends it back out of the frame. Although there is sound, we can barely hear what the musicians are saying to each other. The second reel, which centers on them eating food, continues in the same vein.

Despite the central image of bondage and the film's sadomasochistic overtones—the dark sunglasses, whips, leather, boots, and broken glass—this sound portrait of The Velvet Underground fails to live up to Malanga's description of their penchant for sexual depravity. Moe Tucker, as even Reed points out in the second reel, hardly looks like she's being tortured. The androgynous drummer (and youngest member of the group) actually looks like "she may be the woman who sits beside you in church," to quote the text read by Malanga.

Moe Tucker was the most unlikely member of the proto–punk band. She was the younger sister of a close friend of Sterling Morrison, which is how she came to be involved. Tucker was deeply conservative, a devout Catholic, and a self-described tomboy from Levittown, Long Island. Tucker, whom Warhol characterized as "very innocent and sweet and shy," later worked for him, transcribing his recorded novel *a: A Novel*.[37] She refused to transcribe any of the dirty words in the text, or even the first letters of any curse words. Her response was, "You know, I don't like that kind of talk, so I don't want to type it."[38] Someone else had to fill in the missing spaces. Tucker left the band in 1971. She had five children and eventually moved to Douglas, Georgia, where she worked for Wal-Mart.[39] She later became an outspoken member of the right-wing political movement known as the Tea Party.

THE VELVET UNDERGROUND AND NICO

It is unclear exactly when *The Velvet Underground and Nico* and *The Velvet Underground* were filmed at the Factory.[40] *The Velvet Under-*

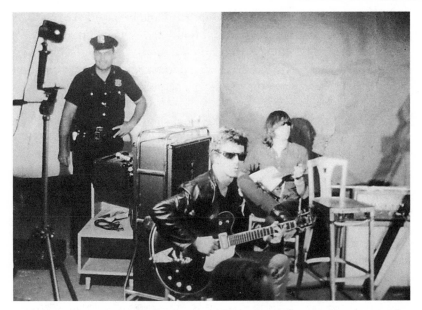

FIGURE 31. Lou Reed (foreground) and Sterling Morrison (background); *The Velvet Underground and Nico,* 1966 (16mm film, b/w, sound, 67 minutes. Film still courtesy of The Andy Warhol Museum)

ground and Nico begins with a close-up of Nico, who holds a maraca. The focus of the camera radically shifts as it zooms in and out, causing the image of her to become abstract. Although Nico is not miked for sound, she bangs the maraca against a tambourine. A zoom out shows her young son Ari in a striped shirt, shorts, and cowboy boots, sitting at her feet, seemingly entranced by the hypnotic wall of sound being created around him. Camera movement and changes in focus help to stylize the playing of the band, as the camera, for instance, fixates on Lou Reed as he plays. The camera zooms in and out in synch with the music, creating a pulsating effect. It then frames Nico and zooms in and out on her in a similar manner. The camera moves to Moe Tucker, the drummer, before it finds Ari swinging a single maraca. It returns to Nico, who plays the tambourine, followed by quick abstract pans of the band. The camera zooms in and out rhythmically to the music.

Ari continues to shake his maraca at the start of the second reel, as the camera responds to the music, which includes opening and closing the aperture, darkening and lightening the image. The camera focuses on Ari, who moves forward and back and smiles as he bangs his maraca. At about forty-five minutes, the camera zooms out to reveal

a police officer, who stands by an amp. The band keeps on playing as he turns down the volume on the amp. Lou Reed smiles in response. We can finally hear Nico as she bangs on the tambourine. Someone says, "It's still too loud." Lou Reed, wearing dark sunglasses, keeps right on playing. John Cale plays the viola. At one point Ari tries to stand up and topples over.

At roughly fifty-four minutes, the band suddenly stops playing. Stephen Shore snaps photos and the musicians disperse. We see Andy talking to the police in the background. A cop says, "No photographs." Andy repeats, "No photographs." The lights go off and the screen goes dark for quite awhile as we perceive figures moving around. The lights come on again. The police at first appear blurry and then come into focus. The camera zooms out into a wide shot. We see Andy, Gerard Malanga, and the others. A police officer yells, "Hey Andy, where do you live?" He gives his address as 1342 Lexington Avenue. Andy consults with Lou. After the camera does a series of quick panning movements, Lou wipes his face with a handkerchief. Malanga sits with Moe Tucker, who slugs a bottle of beer. Nico kisses Malanga good-bye. The band members congregate around Malanga, Warhol, and Nico. Someone says, "The Factory has to go to sleep," at which point Ari comes over to Nico, as the film ends on a shot of her.

Besides the opportunity to observe a hypnotic jam session with Nico and the Velvets, the film doesn't deliver what fans of the band might expect. Unterberger, for instance, writes:

> As amazing as the idea of seeing an hour of this legendary band filmed in its prime by Andy Warhol at the Factory might sound in years to come, actually watching the thing invariably turns out to be a disappointment. The band doesn't play any proper songs, but simply perform an endless, wordless, cacophonous jam.[41]

Warhol appears to have wanted to do more than merely document a performance of the Velvets; for one thing, he intended to use this footage as a projected backdrop to the band playing their music as part of the EPI. As a film, however, *The Velvet Underground and Nico* becomes interesting only when the unanticipated arrival of the police interrupts the music, which causes chaos on the set, long stretches of blackness, and members of the Factory and the police being recorded without anyone acknowledging the presence of the camera. "No pictures," Warhol repeats disingenuously as he maneuvers to capture the entire event on camera.

THE CHELSEA GIRLS

"The period of the underground film," David James observes, "can be reasonably dated from *Pull My Daisy* in 1959 to the run of *The Chelsea Girls* at the Cinema Rendezvous on West 57th Street, New York, in the summer of 1966—the last and the most scandalous of a series of dramatic eruptions of the underground into the attention of the general public."[42] In many ways, Warhol's *The Chelsea Girls* proved to be the right film for the right time. Its subversive depiction of the lives of the fictional inhabitants of the Chelsea Hotel on West Twenty-third Street came to epitomize what had been bubbling under the surface for years. Warhol's double-screen film not only depicts sadomasochism, drug use, violence, and other disturbing behavior, but in its elaborate, aleatory structure it also deconstructed conventional narrative by replacing plot with spectacle on a grand scale.

The Chelsea Girls provides a showcase for many of Warhol's major superstars: Nico, Ondine, Brigid Berlin, Mario Montez, Eric Emerson, Gerard Malanga, Mary Woronov, Ingrid Superstar, Marie Menken, Ed Hood, and Susan Bottomly (aka International Velvet). Only Edie is conspicuously absent. By then, she was associated with the Bob Dylan faction and refused to allow footage of her to be included.[43] Even though parts of the film were recorded at the Factory and other locations, Warhol uses the Chelsea Hotel as a structuring device to link the various smaller narratives that are supposed to be occurring there. But what proves most shocking about *The Chelsea Girls* is how it repeatedly crosses the line from fiction into something that seems frighteningly real. The film's last hour and a half is absolutely riveting; Marie Menken, brandishing a whip, launches into a sadistic tirade at her "son," Gerard Malanga; Eric Emerson does a striptease and improvised monologue while on an LSD trip; and Ondine, after shooting amphetamine, becomes so enraged at Ronna Page, who has called him a phony, that he viciously assaults her. In these three scenes—as Menken rants, Emerson teeters on the brink during a narcissistic exploration of his own body, and Ondine throws an extended tantrum—the film suddenly transforms into an utterly scary psychodrama that surpasses anything Warhol had ever concocted before.

The sheer notoriety of *The Chelsea Girls* belies how little has actually been written about the film. Some of this surely has to do with its length (nearly 3½ hours). Because of the double projection, fluctuations in projector speed, and the variable reflexes of human projectionists, one theatrical screening is never identical to another. Although the projection-

ist was allowed discretion in how to present *The Chelsea Girls* when it was first screened in the 1960s, instructions now accompany the film, indicating a preferred mode of presentation. Despite this, screenings of the film will always vary because of the vicissitudes of projection. Projectionists must respond to a series of sound cues, and the timing of execution necessarily introduces variation. In addition, the complexity of the instructions and having to project two reels at a time makes it easy for a projectionist to make an error. The accompanying instructions indicate that "*The Chelsea Girls* is intended to be slightly different each time it is projected, so timing is approximate."

The standardized version of *The Chelsea Girls* consists of twelve 33-minute reels, shown double-screen, with cues indicating which sound track of a particular reel should be privileged. The reels are slightly staggered—the left screen lags behind the right by approximately five minutes throughout the entire length of the film—so there is a deliberate overlap between them. As the instructions indicate, the film begins on the right screen with reel 1, "Nico in Kitchen," with the sound at normal volume. After five minutes, reel 2, "Father Ondine and Ingrid," begins on the left screen. As the new reel starts, the sound on the reel featuring Nico is reduced to being barely audible, while we hear the sound of Ondine and Ingrid Superstar for the remaining length of the reel. Some reels are intended to be shown completely without sound, such as reel 4, "Boys in Bed," and reel 10, "Colored Lights on Cast," so we never know what is being said by any of the characters, whereas the sound plays all the way through reel 3, "Brigid Holds Court," reel 5, "Hanoi Hannah," reel 9, "Eric Says All," and reel 11, "Pope Ondine." Eight of the reels are in black and white, while four of them are in color.

Watching *The Chelsea Girls* is a cognitive challenge. It seems natural that the viewer's concentration would be directed toward the reels that have sound, even though her or his attention would still be split in trying to absorb two reels at once. Additionally, certain incidents or actions—fleeting nudity, crying, physical violence, color effects, or extreme camera movements—have a tendency to draw a viewer's attention to a reel without sound. The complexity of the structure of *The Chelsea Girls*, however, manages to keep it from ever being predictable. Unlike structural film, which Warhol in some ways influenced, the patterning in *The Chelsea Girls* is not consistent. The sound-image relationships do not follow an obvious pattern, especially in terms of the reels on the left or right side of the screen. In other words, the reels that have sound playing do not alternate in the manner that one might expect. For instance,

Projector #2—Left	Projector #1—Right
Reel #2 FATHER ONDINE AND INGRID Begin only after 5 minutes of reel #1 and continue with sound until beginning of reel #3.	*Reel #1* NICO IN KITCHEN Right projector begins the film with reel #1. Play for five minutes alone with sound, then turn sound down until just audible below reel #2.
Reel #4 BOYS IN BED No sound.	*Reel #3* BRIGID HOLDS COURT Begin with sound as soon as threaded. Cut sound on reel #2.
Reel #6 HANOI HANNAH AND GUESTS No sound until reel #5 goes off. Leave sound on while threading reel #7 and then turn off sound and begin sound on reel #7.	*Reel #5* HANOI HANNAH All sound.
Reel #8 MARIE MENKEN Color. Sound only after sound on reel #7 is turned off. Play until end of reel.	*Reel #7* MARIO SINGS TWO SONGS Sound until female impersonator exits which is approximately the first ten minutes. Then sound off.
Reel #10 COLORED LIGHTS ON CAST Color. No sound.	*Reel #9* ERIC SAYS ALL Color. All sound after end of sound on reel #8
Reel #12 NICO CRYING Color. Turn sound on approx. 20 minutes into Reel #11. After #11 ends, turn projector lamp off on #12, but continue sound as exit music.	*Reel #11* POPE ONDINE All sound.

NOTE: As soon as a reel ends, it should be replaced immediately by the next one scheduled for that projector; in this way, the five minute difference between the two projectors which was established at reel #2 will be maintained throughout the entire film. THE CHELSEA GIRLS is intended to be slightly different each time it is projected, so timing is approximate. All reels are 24 fps.

Critical and historical information was provided by the late Callie Angell, Adjunct Curator of The Andy Warhol Film Project, Whitney Museum of American Art. The instructions are provided by Circulating Film and Video Library, Museum of Modern Art, and accompany the film when rented for screening.

reel 5, "Hanoi Hannah," on the right screen continues to have sound, following reel 3, "Brigid Holds Court." The sound even continues for an additional ten minutes into reel 7, "Mario Sings Two Songs," before it switches to reel 8, "Marie Menken," on the left screen. Reel 9, "Eric Says All," and reel 11, "Pope Ondine," employ sound continuously, but the audio on reel 12, "Nico Crying," begins playing after twenty minutes. Interestingly, the picture is turned off after reel 12, so the film ends with "exit music" by The Velvet Underground.

The Chelsea Girls represented the culmination of Warhol's radical filmic experiments to date. It indulges the Pop artist's fascination with expanded cinema by using the double-screen format on an ambitious scale, while featuring more of his superstars than ever before, along with music by The Velvet Underground. The EPI was performance-based spectacle that depended on a light show, dancing, and prerecorded and live music in addition to cinema. *The Chelsea Girls* translates that interest in spectacle directly into a work of cinema. It represents Warhol's most sophisticated exploration of double-screen projection, surpassing *Outer and Inner Space* and *Lupe*. While its structure might seem arbitrary, some of the relationships between reels appear to be planned, especially in terms of color and sound and image, which no doubt entailed a great deal of early experimentation. Its deployment of psychodrama in the second half is the most sustained use of the strategy in any of Warhol's films.

The Chelsea Girls was largely dismissed by the mainstream press, such as the *New York Times, Time,* and *Variety,* which condemned the film as boring. In decrying its lack of "tension and development," the *Variety* reviewer's description hardly does justice to what occurs:

> Viewers are asked to spend a long, painful evening with various residents, almost all of whom are lesbians and homosexuals. Typical scenes include a blank-looking blond trimming and combing her hair, a lesbian bullying her roommates, another lesbian talking endlessly on the phone, a homosexual eating an orange, a middle-aged homosexual and a girl competing for the attentions of a half-nude male, a girl on LSD confessing to a homosexual priest![44]

In fact, the *Variety* reviewer focuses on the film's most minor elements, such as Rene Ricard eating an orange, and, as far as I know, neither Ingrid Superstar nor Ronna Page confesses to Ondine while on LSD.

Of course, *The Chelsea Girls* received positive responses as well, especially from Jonas Mekas in the *Village Voice.* He compared the film's simultaneity to the work of James Joyce and the breadth of its human

scope to the work of Victor Hugo, while drawing comparisons to Griffith's *The Birth of a Nation* (1915).[45] Mekas zeroes in on what differentiated *The Chelsea Girls* from mainstream film, namely the acting:

> And one of the amazing things about this film is that the people in it are not really actors; or if they are acting, their acting becomes unimportant, it becomes part of their personalities, and there they are, totally real, with their transformed, intensified selves. The screen acting is expanded by an ambiguity between real and unreal. This is part of Warhol's filming technique, and very often it is a painful technique.[46]

The inclusion of so many superstars in a single film indicates that Warhol viewed it as a showcase for the Factory's stable of talent, including several new faces, such as Brigid Berlin, Eric Emerson, Pepper Davis, and Ronna Page.

The real boost to the success and notoriety of *The Chelsea Girls*, however, came from the review in *Newsweek*. Jack Kroll saw it as a reflection of the disaffected younger generation of dropouts. He writes: "In a sense 'The Chelsea Girls' is the testament of that class, the Iliad of the underground."[47] He claims the film "sets the eyes on alert, the teeth on edge and the heart on trial," and he describes the characters as "just as meaningful as Jack Gelber's garrulous junkies, Edward Albee's spiteful comedians, John Updike's poetic suburbanites."[48] Kroll's brief description manages to capture a sense of certain scenes the way *Variety* doesn't:

> So there they are, two helpings at a time—in color and black-and-white—the fat, Lesbian pill popper who lives on the telephone like a junkie Molly Goldberg: the tomato-faced W.C. Fields-like mother ranting against her overcool son while his passive chick sits frozen with intimidation: that same chick in another room, herself now the sadist to *her* passive chicks: a vacantly beautiful blonde endlessly trimming her bangs like the Lady of Shalott waiting for a lanceless Lancelot: a blond-helmeted boy, an Achilles of narcissism, doing an onanistic monologue-and-strip in a colored stroboscopic limbo which makes him look like Man regressing to a primal homunculus.[49]

For Kroll, *The Chelsea Girls* somehow reflects the zeitgeist; he even goes so far as to suggest: "It is as if there had been cameras concealed in the fleshpots of Caligula's Rome."[50]

The Chelsea Girls begins with Nico cutting her bangs in the kitchen, where she preens in front of the mirror, while her young son Ari plays and Eric Emerson asks her questions. Throughout the reel, the three engage in mundane activities in a white kitchen: Nico cuts her bangs, Eric washes dishes, Nico hugs Ari and the two of them play with a ball, Eric gives Ari some Jungle Juice to drink, and Nico reads a paper. All

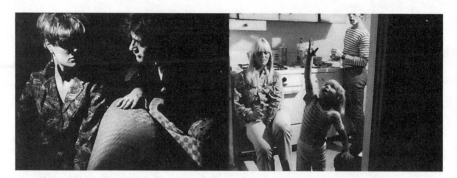

FIGURE 32. Ingrid Superstar, Ondine (left screen), and Nico, Ari, and Eric Emerson (right screen); *The Chelsea Girls,* 1966 (16mm film, b/w and color, sound, 204 minutes in double screen. Film still courtesy of The Andy Warhol Museum)

the time, Eric talks with Nico, even though the sound is barely audible and is overwhelmed by that on the other screen, which features Ondine and Ingrid. The first two reels of the double projection present a striking contrast. The reel on the right, with Nico, Eric, and Ari emphasizes whiteness like *Kitchen,* whereas the one on the left with Ondine and Ingrid features rich blacks.

The domesticity of the first reel is countered by a scene in which Ondine plays a priest hearing confessions. Ingrid Superstar isn't a Catholic, but she's engaged to marry one. Rather than being a passive listener, Ondine aggressively probes whether the couple has had sexual relations before demanding to know if Ingrid is a lesbian. When she denies this, he berates her by insisting that he's seen her at dyke bars, and he gets her to admit that she's gay. Ondine keeps shifting his characterization as well as the situation, as he denies actually being a priest or that they're actually in a Catholic church. Instead he suggests that Ingrid has come for a personal conference, then a job interview for which he deems her unqualified. He recommends bringing her mother, whom he describes as a "nut," to the nearest clinic or slipping LSD into her coffee. The two get into a quarrel during which Ondine spills some of his beer on her and she gives him a shampoo with it. For penance, he concludes: "You should be tied up, put in a bathtub, and pissed on regularly for two hours." Ingrid claims that Ondine is an immoral person, and, as a result, will go to limbo.

The Chelsea Girls presents a Nietzschean view of human relationships in which individuals attempt to exert power and control over others, such as Ondine's attempt to manipulate Ingrid by continually shift-

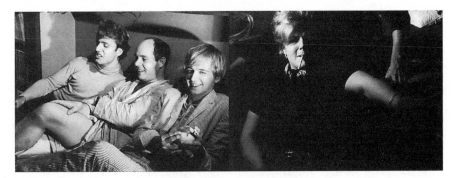

FIGURE 33. Gerard Malanga, Ed Hood, Rene Ricard (left screen), and Brigid Berlin (right screen); *The Chelsea Girls*, 1966 (16mm film, b/w and color, sound, 204 minutes in double screen. Film still courtesy of The Andy Warhol Museum)

ing the nature of their interactions. In the next scene with sound, Brigid Berlin plays a lesbian dope dealer who treats Ingrid as her prisoner. She jabs a hypodermic needle into Ingrid's naked buttocks and later administers a poke to herself through her clothes. As Brigid talks to someone on the phone about a drug deal, she asks Ingrid for her hand mirror, which she violently smashes on the floor. Ingrid tells her, "You really like to destroy people, don't you?" Brigid answers, "Yes, I'd love to destroy *you*." When Ingrid temporarily leaves, she tells the camera, "I would like to go to the bathroom. I have to pee . . . on her . . . and pee and pee and pee and pee and pee." Brigid herself complains to someone off-camera about being told what to say and do in the scene.

In one of her many phone calls, she tries to sell amphetamine, which she describes as being like "snow in the middle of January on the win-dowpane." The person talks about her coming down to make a movie, but she responds, "I hate movies. The underground is not my scene!" She refers to Ingrid as a "trick" and slaps her when she tries to get off the bed. After ridiculing the painkiller Darvon as "kid stuff" and "glorified Excedrin," Brigid proudly announces, "I like people that are up there." On the opposite screen, Ed Hood, in a light striped bathrobe, lies in bed with Patrick Fleming, who's dressed only in his underwear. After Susan Bottomly and Mary Woronov arrive, Woronov climbs on the bed and ties Patrick's hands behind his back with a belt. After he gets free from bondage, Ed pulls down his underwear so that his naked backside is visible. Ed and Mary turn Fleming over so that his penis is briefly exposed. When Patrick has had enough and tries to get away, Mary pulls him by the hair and strong-arms him into submission.

The next pairing involves more sadomasochistic behavior. The fifth reel, a Tavel-scripted segment entitled "Hanoi Hannah," features Mary Woronov, Susan Bottomly, and Ingrid Superstar.[51] Hanoi Hannah was a radio personality, based in Hanoi, whose propaganda radio broadcasts during the Vietnam War were aimed at convincing American GIs of the futility of their military efforts. Tavel's version conflates this historical figure with two characters from *Vinyl*, as Woronov calls Bottomly "Victor" and Ingrid is referred to as "Scum." Warhol's Hannah (Woronov) is a dominatrix who bullies three men, all of whom are played by women. Hannah forces Ingrid to stay under a desk, while she proceeds to assault Bottomly physically.

Hannah announces they're going on the air even though there are no props, such as a microphone. Her broadcast turns out to be about low-priced fresh produce—the pomegranate, blue strawberries, and squash—as Warhol plays with the aperture, so that Hannah's face goes from properly exposed to blackness. She then gives a traffic report from Satellite 7 and informs viewers about a "coming out" party. Hannah then turns it over to Pepper Davis, who plays a GI (despite lacking a uniform). Davis describes Vietnam as a "sticky, lonely country." Instead of sweet-talking the GIs into giving up the cause, Hannah tyrannizes them with visions of unfaithful girlfriends back home. Reel 6, which has no sound, features the same four performers on the opposite reel. Among the actions, Woronov physically attacks Bottomly and pulls her hair, a distraught Pepper Davis shatters a glass object and later cries, and Bottomly dumps a pitcher of water on Ingrid, who responds by violently pushing her through the open window onto the fire escape.

At the halfway point of *The Chelsea Girls,* many viewers might question whether the film lives up to its reputation as Warhol's masterpiece. The similarities between the last two reels, for instance, prove somewhat taxing. Sporadic violence flares briefly among the women like brushfires that are quickly extinguished. Woronov, as Hanoi Hannah, exerts her power not only physically but also psychologically through her efforts at mind control, especially when she forces Davis, as the GI, to repeat her words verbatim. Brigid and Ingrid shoot drugs and gossip about life at the Factory. They do drug deals, talk on the phone, engage in sado-masochistic behavior, and share fantasies of urinating on someone.

It's hard to believe that Woronov is Hanoi Hannah or that Pepper Davis is a GI. And why would someone based in Hanoi be broadcasting from the Chelsea Hotel in the first place? Using the device of the hotel as a structuring element in which "each reel was assigned a fic-

FIGURE 34. Pepper Davis, Mary Woronov, Susan Bottomly, Ingrid Superstar (left screen), and Mary Woronov (right screen); *The Chelsea Girls*, 1966 (16mm film, b/w and color, sound, 204 minutes in double screen. Film still courtesy of The Andy Warhol Museum)

tional Chelsea Hotel room number" doesn't hold up to close scrutiny, especially because the locations and situations undercut the premise.[52] Scherman and Dalton point out: "Characteristically, Andy's hotel conceit was only half thought through. When the same actor is in two scenes at once, or when a scene—say, the choruslike *Their Town,* drenched in Southwestern ambience—couldn't possibly take place in a hotel room, the illusion of peeking through two separate keyholes collapses."[53] That said, logic or realism had never constrained Warhol before, as films like *Horse* and *More Milk Yvette* attest.

The next reel features Ed Hood in his bathrobe and Patrick Fleming in his underwear again, as they smoke cigarettes and Fleming drinks a can of beer. Hood accuses Patrick of betraying his Irish ancestry by "hustling up" a member of the Johnson administration ("the successor to the White House who floated in on tides of blood and bourbon"), which he refers to as the "Johnson menstruation" ("pretty bloody, wouldn't you say?"). Mario Montez, dressed in full drag, plays a female neighbor who visits and sings two Irving Berlin songs: "They Say It's Wonderful" and "I Got the Sun in the Morning." Fleming accuses Hood of being jealous, but he insists he's merely a "property owner." When Montez indicates that he's simply dropped in, Hood says, "Well, now that you've dropped in, how'd you like to be one of those classical dropouts?" Montez answers indignantly, "Well, I wasn't a dropout. I graduated from high school." Hood asks, "In what?" After a short pause, Montez replies, "In the graphic arts." Hood responds, "I graduated in the physical sciences." Patrick seems attracted to Mario, especially his breasts, but Hood wants

no part of him, and Montez acts genuinely put-upon to be in such company. When Mario leaves after approximately ten minutes, Pepper Davis arrives and tries to make Hood jealous by flirting with Patrick, while Ingrid Superstar also pays a visit. Once Montez leaves, however, the audio goes off, and we hear the sound of the reel on the left, which features Marie Menken.

Montez provides a camp musical interlude that provides a perfect segue into the second half of the film, which becomes far more engaging. Reel 8, "Marie Menken" (aka "The Gerard Malanga Story"), which is in color, begins with a close-up of Menken. Wearing a large-brimmed black hat, a black necklace, and black dress, she brandishes a small whip. The camera pans right to Gerard Malanga and over to Mary Woronov; wearing a white blouse, black pants, and a polka-dot tie, she sits on a separate bed in the corner. The camera quickly pans back again. As Menken cracks the whip, the framing becomes wider as it pans back again, revealing that Malanga is wearing a gray cable-knit sweater and blue-and-white striped pants. There's a large crucifix and bullwhip on the wall behind him. The background features colorful hippie-like drawings, including one that shows a hand and what looks like a large penis with the words, "Fuck for peace!" More graffiti is written on the walls, such as the name "Laura." Woronov serves liquor to Menken and Malanga, who claims that Woronov is his servant, which upsets Menken. She asks his girlfriend's name. He answers "Mary," but Woronov sits there silently, refusing to speak; ominous music by The Velvet Underground can be heard in the background for the rest of the reel. As the camera zooms in and out, panning and tilting, Menken insists to Malanga that Mary should not be part of his life. The camera movements become so fast that they create an abstract pattern. Menken asks Malanga, "Isn't that wrong of you to make her a slave?" After Malanga refers to Mary as his wife, Menken panics at the thought of them having children. In fact, she gets so angry that she begins cracking her whip furiously.

As the camera frames a close-up of Mary Woronov, Menken says, "I want to welcome you." Malanga responds, "I want to welcome *you*." His mother snaps, "Not you. I'm talking to Mary." The camera pans back to Menken, who continues, "But you must know what's in store for you. It's not a good thing. This boy's selfish, wrapped up in himself, loathes his mother, loathes his father." Mary tentatively reaches for Gerard's whip, but Menken begins cracking hers, as the camera rapidly zooms in and out. She beats the bed again and again. "My son," she laments, "what a mess I brought into the world." She shouts at Malanga,

"I want you to be great in the world!" As the camera again frames Mary playing with her hair in close-up, Menken tells him, "Oh, good God. I don't know why I even bore you into the world" and laments not having had an abortion. After she brings out colored beads, which Gerard puts around his neck, she suddenly has second thoughts about Mary and wonders: "Maybe she's not such a good daughter?" The camera pans back and forth from Menken to Mary, causing the image to blur.

The next reel shows Eric Emerson, whom Warhol had met at an EPI event at the Dom after he and Paul Morrissey watched him do a spectacular balletic move on the dance floor.[54] According to Warhol, Emerson showed them "his 'trip book,' filled with the poetry and drawings he'd made while he was on LSD."[55] Reel 9, "Eric Says All," is an acid trip that begins with Emerson's face bathed in a red gel with a key light coming from the left side of the frame. He looks at himself in a reflective metal surface, stares ahead, looks around, and closes his eyes. He moves his tongue and sucks on the index finger of his right hand, then his middle finger, feels his neck and face and eye. He looks around and finally begins to speak as we near the six-minute mark of the reel, which occurs slightly after the start of reel 10, "Colored Lights on Cast." After a long pause, Eric says, "I can't see a thing . . . except me. That's all there is to see as far as I'm concerned."

A blue gel mixes with the red as Eric looks into the rectangular piece of shiny metal and shakes his long, Prince Valiant–like hair. He talks about grooving on himself and eating apples, which he compares to vampirism. He says, "Apples you sink your teeth into, like you bite a woman's neck or you bite a man's neck." He continues to free associate, connecting a juicy apple to sweat, "especially if you put salt on it." He tastes his own sweat, and comments, "My sweat tastes nice. I like the taste of my sweat." As he speaks, a strobe light pulses over his body. Emerson talks about being a drop of sweat taken into someone's body:

> I wish I was a piece of sweat or a drop of sweat being licked by someone, dripping down their neck and having a tongue sweep along and pick me up and then taken into the body, completely in. To go that far into someone's body . . . that'd mean you were all them or they were all you, whoever was the controller. I guess they'd be all me because usually I'm the controller. I'm on the top—it's a nice place to be. It's not too hard being on top. Other people think they have you right where they want you, but they don't know.

We can hear someone whispering to him from offscreen, and he looks screen right for the cue.

Emerson then announces he's going to take off his shirt and begins

to undress. A large spotlight, which changes color, shines on him. He sensuously lowers his jeans so that the viewer can see his pubic hair. Emerson turns around and lowers them some more, revealing his buttocks, then more of his bushy pubic hair. While talking about being unable to see what's inside a person, he turns and removes his pants and covers his genitals with his shirt, which he turns into a loincloth. He compares himself to an Indian and to Tarzan "getting ready for the kill, to go after an ape or an animal, a jungle creature."

An intense strobe light causes the image of Emerson's body to flicker, and he continues to talk about people only being able to see what he wants them to see. He discusses showing people a side of him that will make them happy. Eric admits that he has many problems, which are for him alone to contemplate. The strobe light distorts his features. He talks about people calling him "gay" and "queer," but he claims it doesn't upset him anymore.

He admits to having sex with "gentlemen," but he merely considers it having a good or beautiful time. The lights make his body look as if it's on fire. He talks about eventually having to leave people and comments: "I'm the kind of person that lingers in someone's mind. Once they've had me, it's hard to do without." Eric starts to reveal how calculating he can be once he allows people to get close to him by being very endearing, which they love. He cautions, "And then when they love it too much . . ." The reel ends, abruptly severing the rest of his thought.

Eric Emerson, Ingrid Superstar, Pepper Davis, Susan Bottomly, and others perform in reel 10, "Colored Lights on Cast," which was based on *Their Town,* a second script created for *The Chelsea Girls* by Ronald Tavel about an Arizona serial killer named Charles Schmid. Warhol chooses to stage Tavel's scenario as a static reading of the text, so that the reel strongly suggests a radio play that's been transformed into a psychedelic light show. Because the instructions indicate that the segment should be shown without sound—which makes Tavel's script incomprehensible—the reel simply provides a colorful complement to Emerson's monologue on the other screen. Yet the double-screen projection adds an interesting dimension to Eric's solo reel. For instance, while "The Gerard Malanga Story" is still playing on the left, Menken says, "Look at that Mary—beautiful girl." The camera pans over to her and zooms in. On the right screen, the camera likewise zooms in on Eric, who has a bewildered look on his face, creating a serendipitous connection between them. (Eric will later bring up his own gender issues when he claims people often ask whether he's a girl.) Woronov's eyes stare slightly toward

screen right, creating an additional connection. Eric later looks toward the screen with Mary on the left.

Once "Colored Lights on Cast" begins, Eric appears in a smaller blue circle on the left screen, which, because of the positioning of his body, appears to be behind the close-up image of him on the right. His point about only being able to see himself is reinforced by his appearance on the adjoining screen. There's a close framing of Ingrid filmed with an indigo gel. Because the left side of Emerson in the right screen is also indigo, the similarity in color bridges the two screens spatially. When Emerson removes his pants, he faces the left side of the screen, while Pepper Davis faces the right, suggesting that she's watching him across the frame line. Eric then appears to stare at himself from the same screen. Toward the end of his monologue, Eric and two other cast members face the right screen as if they comprise an audience. The cast from *Their Town,* bathed in a blue circle, also appear to watch Ondine shoot up by placing a hypodermic needle into a vein in his wrist. The gels change color and Davis appears to view the activity on the other screen from a smaller circle of blue light before the reel ends.

In reel 11, "Pope Ondine," the low-key lighting and location are identical to those in reel 2. Ondine begins by talking to the crew. After shooting up, he leans on the two abutting couches and addresses Paul Morrissey and Gerard Malanga offscreen. He discusses being Pope and appears to equivocate about whether it's easy or hard, though he complains about it: "Suffice it to say, it's been a horrible gruel all the way. I haven't had one moment's good time." He suggests the Roman Catholic Church has been replaced by Greenwich Village. When he's asked to comment about the Vietnam War, he appears shocked. He replies, "It's a joke. I wouldn't bother with it. Lyndon Johnson is the joke behind it. Forget it." In discussing being Pope, he claims he wants to be true to his flock, which consists of homosexuals, perverts, thieves, criminals, and those people rejected by society. After he demands to hear a confession, a young woman named Ronna Page, who lived with Jonas Mekas at the time, makes an entrance. When she asks whether she can sit in a certain spot, Ondine indicates that she should do it quickly because "the cameras are rolling." He suggests that this represents a new kind of confessional, which he calls "True Confession."

In her confession, Page indicates that she has a deep sexual love for Christ. Ondine immediately responds, "Blow him . . . as simple as that!" He suggests that she go down on his image. When she counters that he's encouraging her to do something that's not "real," Ondine insists

that she should use her mind, which he equates with the soul. When he informs her that his goal is to put her in heaven, she asks, "Where's heaven?" Ondine responds indignantly, "Where is heaven? It's on my shoulder." After Page expresses a desire to remain in the physical world, Ondine tells her to leave. Page isn't finished, however, and ends up confessing, "I think you're a phony."

Ondine calls her one as well and suddenly hurls a glass of water in her face. Instead of leaving, as he demands, Page repeats, "Look at you." Ondine shouts, "Who are you supposed to be, Little Miss Wonder? You're a bore, my dear." As he says this, he suddenly slaps her hard across the face three times, as he rises and stands menacingly over her. He smacks her again and shouts, "You motherfucker! I'm a phony? Well, so are you." He pushes and grabs her from behind and shakes her roughly. As he continues to rant, she tells him, "Stop it. Get your hands off me." Someone takes her hand and leads her away, leaving the screen temporarily black, as Ondine, who has also left, continues to shout after her.

The scene has taken a horrific turn as it rapidly transforms from an improvised confession into a psychotic outburst. The sheer velocity of Ondine's temper and aggression terrified not only the unsuspecting Page, but everyone else on the set. Warhol was apparently so shaken by Ondine's display of violence that he left the room.[56] As Ondine returns to his previous spot on the sofa, he shouts, "I'm sorry but that's a fucking artistic bore—Little Miss Phony!" He screams, "How dare you come onto a set and tell me that I'm a phony on my set!" As he storms off, leaving the set black again, he yells from the background, "I want to smash her face in! That cunt!" After the camera pans in blackness, Ondine returns again and addresses the camera: "Do you know what she had the nerve to do, audience of mine? She came onto my set as a friend [mimicking her in a high voice] who didn't know what to do and said I was a phony. Well, fuck her! And I'll beat her up again, and her husband [Mekas], and anyone else who comes on" Ondine continues to shout and curse at her. He turns to the camera again, "God forgive her, and all like her, who pretend to do good in the name of good, because they are not good. They are lying, phony miseries." He gets up and says, "I really don't want to go on."

The screen is once again black, as Ondine fumes off-camera, claiming Page has "ruined a whole set." As the camera settles on a section of the Factory, someone counsels that everybody should "stop . . . taking advantage of the situation." As the camera follows Ondine into the darkness and we witness the chaos among the various crew members,

Ondine eventually stumbles as he returns to his spot on the sofa, and we see the shotgun microphone and hear laughter. As Ondine catches his breath, he addresses the camera in an attempt to justify his actions. He drinks a bottle of Coke and adds:

> The only other thing I can say is that this may be a historic document. I don't like to hit people. I don't like when people hit me. I think it's ugly and boring. But when I see something as stupid as I just saw, sitting here and pretending, I have to rail out. I have to hit it because it deserves to be put in its place. And its place is below me, beneath me, somewhere where it doesn't want to be a human. It wants to be a little smarter. God forgive them. Me . . . I forgive them. That's all.

Ondine then alludes to Page being "the saint's wife." After suggesting that Brigid Berlin was supposed to play the role but didn't show up, he says, "And let me say one thing. I'm sorry for any physical injury I incurred. Her face is rather red, but that's all. I hope once, I can say to her, honestly, I'm sorry for attacking you. If I can, I'll feel better about it." We hear a woman's voice say, "He had no right to." Ondine shouts at her, "You have no right to, you dumb bitch! Now shut up, or else I'll bring you to court! I'll kill you with your filthy husband! Now shut up!" He yells at her some more. Ondine keeps trying to end the reel, but the camera continues to record him as he chats about whatever comes into his head, talks and arm wrestles with a woman off-camera and plays with his syringe (while the woman laughs excessively) in order to fill up the dead time until the reel mercifully ends.

Nico sits and cries in reel 12. She's lit first by a spot and then by different-colored gels: green, blue, red, and pink. The camera zooms in and out. She plays with what looks like a tape measure and a Sekonic light meter. She puts the light meter to her ear as if it were a transistor radio. Patterns form on her face. Throughout the reel, the combination of her somber mood, the colored gels, varying patterns, and rapid zooms turn her image and background into a psychedelic abstraction. Music from The Velvet Underground, which comes on twenty minutes into the reel and plays beyond it, reinforces the mood. Despite the sense of sadness that permeates this section, the color, lighting effects, and camera movement help to soften the stark brutality of Ondine's tantrum. His scene as Pope is so demonic and ugly that the psychedelic lighting and music that accompany Nico provide a contemplative contrast, suggesting a sad trip rather than a bad one, as if showing the difference between methamphetamine and LSD—two different worlds occupying the two separate halves of the screen.

Stephen Koch's phenomenological analysis of *The Chelsea Girls* addresses, among other issues, the film's temporality.[57] Indeed, time is one of the more complicated aspects of *The Chelsea Girls*, especially its use of unedited, continuous takes for entire reels, which is compounded by having staggered double screens, an overlap between reels, and gaps both between reels and within the frame. The blank spaces within the frame result from Warhol closing the aperture of the camera, thereby turning the image into blackness, as in reel 5, "Hanoi Hannah." There are also several times during "Pope Ondine" when both Ronna Page and Ondine completely leave the frame and the screen goes black. At such points, the viewer is inclined to switch attention to the opposite reel.

Most mainstream reviews, as evidenced by the one in *Variety*, seemed to dismiss the film on narrative grounds: "Warhol has attempted to counter all conventional methods of filmmaking, and the result is an anti-film or, more accurately, a non-film. There is no plot-line."[58] While *The Chelsea Girls* should hardly be judged in conventional narrative terms, it must be said that the incidents and situations in the second half of the film have significantly greater dramatic tension than those in the first. This stems mainly from the film suddenly veering into the realm of psychodrama. For instance, the casting of Menken as a disappointed mother becomes crucial to what occurs in "The Gerard Malanga Story." Although she was quite fond of Malanga and the two were close friends, the premise of the scene, along with the strong alcoholic beverage she drinks, manages to set off something very deep inside Menken in the sense that the improvised fictional scene somehow mixes with autobiographical elements. Even Malanga seems genuinely bemused by the intensity with which she reacts to his enslavement of Mary. The scene takes a bizarre turn when, after Malanga refers to Mary as his wife, Menken becomes distraught over the ramifications of their having children. Of course, the irony of Mary Woronov sitting silently in the corner—her makeup and lipstick providing a mask that hides her contempt—adds a delusionary dimension to the scene. Mary's silence is brilliant; her refusal to speak only fuels the disappointment Menken feels in having given birth to such a terrible son. Her silence forces Menken to speak even more. Koestenbaum astutely points out: "Marie and Mary are doubles, though they don't address each other, and Marie's voluble cruelty, ultimately maternal and solicitous, can't rival Mary's silent spite."[59]

The power of Eric Emerson's scene, "Eric Says All," stems partly from its striking improvisational quality; such a long monologue can't be scripted or faked. The obvious effects of LSD also contribute a sense of

unpredictability. Paul America claimed to have been on LSD during the making of *My Hustler* the year before, but the experience here is much different because Eric has been thrown into a situation where he is exploring himself and his own sense of identity under the camera's scrutiny. He was apparently given little direction other than to improvise and at a certain point to take off his clothes.[60] He stares at the camera and looks around for nearly six minutes before uttering a word, which, though his image is overshadowed by the audio of Marie Menken's reel, makes the viewer uncomfortable in the same way that Mary's continued silence unnerves Menken and causes her to blather even more.

Eric's monologue is so strange, especially the timing of his remarks and the degree of self-revelation, that the viewer can't help but worry about the fragility of his mental state. He talks very slowly throughout the scene. The viewer senses that he is walking on a thin tightrope without any sort of safety net beneath him. His display of narcissism is astounding. Most people would carefully hide the darker sides of themselves, but Eric is like a child who bares his soul for the sake of the camera. In making reference to his desire to be "the controller," Eric is discussing the dynamic of his personal relationships, but also his preferred sexual position. What starts as an expression of hippie self-love gradually turns into something that sounds like calculated malevolence. As his inhibitions break down, Eric talks about being nice to people in order to get them to love him, so that once they do, he will be in a position to ensnare his unsuspecting victims.

The scene with Ondine starts with his shooting amphetamine on camera, after which he chats animatedly with Morrissey and Malanga offscreen, as if doing a casual interview. Most interactions with Ondine, for instance in *Restaurant* or *Afternoon,* involve antagonism and some sort of implicit threat, a quality also present in reel 2, "Father Ondine and Ingrid," which is part of the first pairing in *The Chelsea Girls.* It's not immediately apparent what sets Ondine off in his confessional session with Ronna Page. He seems to take umbrage when she asks him, "Where's heaven?" or indicates she doesn't want to go there. When she tells him she thinks he's a phony, he throws a glass of water in her face and assaults her. Koch offers an intriguing analysis:

> What he called the girl's moralism was, in fact, the violation of a style, a style of life, and one that was being made to function at that moment in its most pristine form. Disastrously for her, she had tried to divert attention—ours, Ondine's, the camera's—from the mode of consciousness in which Ondine and the other important people in the film locate their capacity to live and

act. Trying to be cute for the occasion, she violated the flicker of Ondine's, and the film's, life. Revenge was preternaturally swift.[61]

One has the sense that Ondine wants his scene to be great. Page most certainly threatens the investment he has in his performance (which is bound up with his identity) by being unwilling to engage imaginatively in the improvised situation of confessing to the Pope. As Ondine rages, he accuses her of wrecking his scene and everyone else's work.

In its ambition and structure, *The Chelsea Girls* reflects a competition for the viewer's attention that surely must have been felt by its participants. Against such tough competition, Ondine very much wanted to win. Ronna Page, who wasn't scheduled to be part of his scene, is like a weak understudy for Brigid Berlin—someone he senses is not up to the challenge. He seems to resent that she's only there because of her connection to Mekas. Ondine is high and primed for a grandiose part he relishes—he's playing the Pope, after all—and she threatens to wreck his scene by refusing to follow his lead. Worse yet, she cuts off the repartee by calling him a phony. He senses that she's there to sabotage his scene; he construes it as a personal betrayal. Whatever the motivation for what occurs, this particular scene is terrifying to watch, especially because it goes on for so long and ends with Ondine, with typical self-righteous indignation, blaming the victim and threatening to sue or murder her. Yet it is Ondine who could be arrested and sued because, as the film documents, he engages in an act of physical assault. As pure psychodrama, however, it is the most explosive scene in all of Warhol's films and central to the success of *The Chelsea Girls*.

Both Kroll and Mekas use a reflectionist argument to suggest that *The Chelsea Girls* is a manifestation of the 1960s. Mekas writes:

> The terror and desperation of *The Chelsea Girls* is a holy terror (an expression which, I was told, Warhol himself uses in reference to his work): It's our godless civilization approaching the zero point. It's not homosexuality, it's not lesbianism, it's not heterosexuality: The terror and hardness we see in *The Chelsea Girls* is the same terror and hardness that is burning Vietnam; and it's the essence and blood of our culture, of our ways of living: This is the Great Society.[62]

Mekas was prone to hyperbole, and I'm aware of the pitfalls of making the leap from a work of art to the culture that produced it. But Vietnam actually comes up several times in *The Chelsea Girls*. There is the Hanoi Hannah section of the film, where Woronov tortures a GI and engages in mind control. Ed Hood makes reference to the Walter Jenkins sex scan-

dal, which rocked the Johnson administration, and makes snide comments about the president. Ondine refuses to talk about Vietnam, which he calls a joke, suggesting that "Lyndon Johnson is the joke behind it." While Warhol is often seen as apolitical, politics does find its way into films such as *The Chelsea Girls, Afternoon, Since, The Nude Restaurant,* and *Blue Movie.*

Despite its excessive length and the difficulties of double-screen projection, *The Chelsea Girls* became the first film to rise from an avant-garde showcase to a commercial theater when it moved from the two-hundred-seat Film-Makers' Cinematheque to the six-hundred-seat Cinema Rendezvous in midtown Manhattan on December 1, and eventually to the Regency Theatre and St. Mark's Cinema. The film reportedly grossed $300,000.[63] James Kreul provides the most extensive analysis of the distribution of *The Chelsea Girls* by examining the records of the Film-Makers' Distribution Center (FDC), which handled the distribution in commercial venues both in New York City and around the country.[64] The FDC was a novice distributor, however, and the film was shot in 16mm rather than 35mm, limiting the venues where it could play. *The Chelsea Girls* eventually ran into censorship problems in Boston in late May of 1967, but that only contributed to its notoriety.

THE VELVET UNDERGROUND IN BOSTON

During the spring of 1967, Andy Warhol led an entourage, including Nico, to the Cannes Film Festival (April 27–May 12), where *The Chelsea Girls* was invited to be screened, but, due to a snafu or second thoughts on the part of the festival organizers, the film never actually played.[65] The Velvet Underground had meanwhile accepted a play date at the Boston Tea Party on May 26 and 27, 1967. Nico, who had a solo engagement at the Dom in New York City, decided to pass on playing with the Velvets, and the club was apparently too small for a full-fledged EPI event. Along with Warhol and Morrissey, Nico flew to Boston, but arrived late for the concert. She was barred from participating in the show by the other band members, marking the formal split in the working relationship between Nico and the Velvets. Thus, the last time the Velvet Underground (minus Nico) played together as part of the EPI turned out to be at Steve Paul's The Scene in New York City earlier the same month.[66]

The Velvet Underground in Boston (1967) appears to have been shot from the balcony of the Boston Tea Party concert hall with the synch-sound Auricon camera. It shares the stylistic features of Warhol's other

late films, including a liberal use of quick strobe cuts and frenetic pan-ning and zooming. The film represents a remarkable example of com-posing a film in-camera and captures the raw energy of rock shows in the psychedelic sixties. Quick cuts of colored lights, moving spotlights, a shiny turning disco ball, liquid projection, and rapid changes in shot scale all contribute to the sensory experience of the Velvets' show. There is a close-up of the liquid table in which an overhead projector is manip-ulated into creating an abstract pattern that looks like a large, sunny-side up egg. Sheldon Renan explains: "In this process, known as the 'wet show' process, various dyes and other colored materials are mixed together in water in a shallow glass dish. Their flowing color patterns, which may be controlled in numerous ways, are projected onto a screen or wall."[67] A spotlight and strobe lights pulsate on the band and audi-ence members, creating flickering images.

The band members appear like miniature figures on the stage, shown in wide shot. Their discordant sounds at times make it difficult for con-certgoers to dance rhythmically to the music, but the film records a number of them as they flail away under strobe lights, alternating with quick closer shots of band members playing their instruments. The cam-era focuses on the back of a black man in a white shirt as he dances, intercut with a technician manipulating the liquid projection as he's bathed in blue colored light. The music stops; the disco ball turns. As the music starts up again, the camera focuses on the person operating the liquid table nearby, followed by pans through the space of the club. Lou Reed sways as he plays his guitar.

The crowd dances as the gels change color. Rapid cutting fragments the bodies of the dancers even more. A male dancer with an open shirt and a female dancer have the spotlight. Ed Hood is visible in the back-ground of one shot, in which the couple continues to dance intensely, while audience members around them watch. The spotlight pulses and moves around the crowd in rhythm with the music as it focuses on the band and dancing audience members up front. Strobe cuts alter the shot scale. A woman in an orange-and-green striped dress waves her arms vigorously in a closer shot. The camera focuses on a couple before returning to the woman, who dances in the flickering light. The spot-light moves through the crowd. The camera returns to the woman in the striped dress, with the couple behind her, as the music ends with the sound of feedback. We hear someone announce, "The Velvet . . ." As the audience stands around and some fans start to disperse, there are numerous strobe cuts. Police officers mill about. We recognize some

of the featured dancers as they move through the crowd. Over the next four minutes, we watch as the audience, with prodding from the police, disperses slowly.

The record album *The Velvet Underground & Nico,* with a peel-able banana cover designed by Warhol, had been released in March 1967 (nearly a year after it was originally recorded), but Eric Emerson promptly filed a lawsuit over a photograph of him that originally appeared on the back cover without his permission. His lawsuit affected the momentum of the album, which was rereleased in May with an altered cover. This concert and album release represents the end of Nico's association with The Velvet Underground. In many ways, the other members had never really considered Nico to be part of the band. Yet many critics and fans still consider the debut album to be their best. Unterberger writes:

> In her brief time with the Velvets, Nico contributed a great deal. The three songs on *The Velvet Underground & Nico* that feature her lead vocals— "Femme Fatale," "I'll Be Your Mirror," and "All Tomorrow's Parties"—rank among the group's finest, while her presence undeniably added a great deal of glamour to the band. For better or worse, she also helped the group capture the media's attention, even if the media's tendency after that to single her out above anyone else led to some jealousy and resentment.[68]

Nico played an essential role in The Exploding Plastic Inevitable phase of Warhol's career. Years later, Sterling Morrison would acknowledge: "In fact, 'exploding,' 'plastic,' and 'inevitable' sum it all up from an apocalyptic perspective—the origin of the universe and its contents, the mutability of form, and the inescapable decline, entropy, the end. Against this backdrop, how can a handful of artists, dancers, and musicians hope to fare any better?"[69]

Warhol's association with The Exploding Plastic Inevitable and The Velvet Underground served to invigorate and expand his conception of cinema during this period. Not only did he manage to link his films to rock music, but he also succeeded in creating a new audience for his work: a youth culture that had become turned on to psychedelic drugs. Young people flocked to attend the EPI at the Dom, which reportedly grossed $18,000 during the first week.[70] This made Warhol's foray into expanded cinema profitable from the start. It is hard to fathom that his exploration of multiple-screen projection also led to *The Chelsea Girls* having a successful theatrical run. Having the films play at underground showcases was one thing, but it was another to have Warhol's film written up in the mainstream press. Kroll's ecstatic review in *Newsweek*

changed everything, even if the double-screen film proved challenging to audiences used to standard commercial fare.

Although Warhol followed *The Chelsea Girls* with such small-venue works as *Bufferin, Since, Mrs. Warhol, Ari and Mario,* and *The Velvet Underground in Boston,* his experience with commercial success no doubt confirmed his desire to have his films play more widely. Once The Exploding Plastic Inevitable and his association with The Velvet Underground ended, Warhol moved away from multimedia performance. As was his habit, he once again shifted his focus and managed to catch the next big trend, which involved churning out a series of films for the burgeoning sexploitation market.

The Sexploitation Films

Enticing the Raincoat Crowd

The unanticipated theatrical success of *The Chelsea Girls,* which moved from downtown to uptown, from underground to mainstream, signaled that a number of important cultural changes were taking place in America. For years the underground had been the site of censorship battles, as evidenced by the court cases involving Kenneth Anger's *Scorpio Rising,* Jack Smith's *Flaming Creatures,* and Jean Genet's *Un Chant d'amour* (1950)—the latter case deliberately provoked by Jonas Mekas to challenge the prevailing censorship laws. In 1967, the situation began to change, largely due to the success of films such as *The Chelsea Girls* and Michelangelo Antonioni's portrait of swinging London, *Blow-Up* (1966). In *POPism,* Warhol cites an article by Vincent Canby, the film critic of the *New York Times,* as predicting a relaxation of taboos regarding explicit sexual content.[1] This newfound freedom of expression was even being endorsed by the mainstream Hollywood industry, which began creating subsidiaries to handle such fare. Warhol explains:

> In other words, the studios were making a big show of regulating themselves—setting up and paying for a censorship board to review their clean movies—but when they had a "dirty" one they wanted to get out, they'd just form a new company with a new name and that way they'd be able to stand very aloof from it and moralize all the way to the bank.[2]

Almost overnight, sex films became the rage, as movie theaters and even some regular theaters, such as the Hudson, began converting into sex cinemas in order to screen films imported from Scandinavian countries

with provocative titles such as *Dear John* (1964) and *I, a Woman* (1967). Warhol had dusted off *My Hustler* to play at the Hudson, and, following its successful run, the owner, Maury Maura, was seeking to book additional films. With some prodding from Paul Morrissey, Warhol was happy to oblige him.

P. Adams Sitney contends that *The Chelsea Girls* represented the pinnacle of Warhol's film career, which deteriorated thereafter.[3] Stephen Koch offers a more vituperative critical assessment: "But no, I will stick to the evidence and the relative poverty of critical opinion, to say only that in the works immediately following *The Chelsea Girls* something absolutely grotesque happened to Warhol's two finest gifts: his visual intelligence and his taste. It was simply this: Degradation."[4] Along with other critics and commentators, Koch has suggested that Warhol's move into sexploitation films served as confirmation of Paul Morrissey's ascendancy within the inner circle at the Factory. Yet, it's not fair to blame Morrissey entirely for Warhol's foray into sexploitation, even if he began to exert a stronger influence on what was subsequently produced. Warhol was utterly fascinated by sex—he made *Couch* after all, regularly visited the peep shows on Forty-second Street, loved pornography, and routinely took Polaroid photographs of various men's genitals—so it's hardly surprising that an opportunity to explore pornographic filmmaking would hold a certain attraction for him.[5]

To some ardent admirers of his earlier work, Warhol, under Morrissey's influence, was selling out in order to generate money from his films, which until *The Chelsea Girls* hadn't been the least bit profitable. The sexploitation films are seen as the equivalents of the commissioned portraits he eventually painted for wealthy and famous people. In this account, when offered a chance to become the underground's own Roger Corman, Warhol seized the opportunity to create a number of color films in fairly rapid succession to meet the needs of the sexploitation market. These included such works as *I, a Man; Bike Boy; The Loves of Ondine; Imitation of Christ; The Nude Restaurant; Lonesome Cowboys; San Diego Surf;* and *Blue Movie.*

Regardless of their quality relative to earlier Warhol work, the sexploitation films nevertheless represent a continuation of the strategies Warhol had employed previously rather than a decisive break within his oeuvre. With the exception of *Blue Movie,* the sexploitation films are hardly titillating, and certainly fail to live up to their billing. Despite suggestive titles and premises that sound full of promise, the films must have ultimately frustrated viewers who attended the screenings with

expectations of being sexually stimulated. Warhol's characters are all talk and very little action. For the most part, they enact an elaborate tease, even though *Lonesome Cowboys* (which drew the attention of the FBI during production in Arizona) and *Blue Movie* were busted by the police for being too sexually explicit.

Tom Baker, for instance, never has sex with any of the eight women he attempts to seduce in *I, a Man*. In *Bike Boy*, Joe Spencer, for all his bravado, fails to get an erection with the naked Viva. Nor can Patrick Tilden-Close, high on drugs, meet the sexual demands of Andrea Feldman or Nico in *Imitation of Christ*. *Lonesome Cowboys* starts with an extended sex scene between Viva and Tom Hompertz, but the image is badly underexposed, and their attempts at sexual intercourse remain unconsummated. Only in *Blue Movie* do the performers, Viva and Louis Waldon, actually have sexual intercourse, but the film becomes a commentary on the difficulties human beings have in performing intimate sex acts for the camera. As Warhol understood, the power of the camera's gaze was something that couldn't be ignored or denied: it affects and alters the action that takes place in front of it.

Warhol's intentions, however, were far more subversive than simply depicting sexual activity for the perverse thrills of movie audiences. In these films, Warhol deconstructs the image of the heterosexual stud *(I, a Man)*, the motorcyclist *(Bike Boy)*, the hippie *(The Nude Restaurant)*, the cowboy *(Lonesome Cowboys)*, and the surfer *(San Diego Surf)* as sexually charged gay icons. And whatever their flaws, the sexploitation films, with the possible exception of the unreleased *San Diego Surf*, are not without interest. Most of them create the same psychodramatic tension of Warhol's best work, as in Tom Baker's attempt to seduce Valerie Solanas on the staircase in *I, A Man*, or Joe Spencer's feeble effort to live up to his macho image by making it with Viva in *Bike Boy*. Whatever drug he's on, Patrick Tilden-Close is so high in *Imitation of Christ* that his performance recalls that of Eric Emerson in *The Chelsea Girls;* the fight scenes in *Lonesome Cowboys* become real rather than staged; and we feel the stress of Viva attempting to live up to the premise of *Blue Movie*. In addition, many of these works were conceived to be part of Warhol's magnum opus, the twenty-five-hour * * * * *(Four Stars)*, a film that screened only once.

I, A MAN

Warhol's first effort to make a commercial sexploitation film was *I, a Man* (1967–68), which was supposed to feature Nico and Jim Morrison,

but Morrison backed out at the last minute.[6] Warhol wanted Morrison to have sexual intercourse on-screen in the movie, and the rock musician had agreed to do it, but his manager apparently vetoed the idea. In any event, he was replaced by an actor friend of his named Tom Baker. Bourdon writes: "Just as the film was about to turn, all the performers shied away from actual lovemaking on camera. Baker, in particular, did not want to jeopardize a possible career in Hollywood movies."[7]

In *I, a Man,* Baker attempts to have sex with eight different women: Cynthia May, Stephanie Graves, Ingrid Superstar, Nico, Ultra Violet, Ivy Nicholson, Valerie Solanas, and Bettina Coffin. The scenes are separated by shots of Baker reflectively smoking a cigarette. It's a simple premise—one that certainly fits the notion of a sexploitation film by presenting an opportunity to display a number of female bodies while also being a test of Baker's seductive power. In terms of casting, *I, a Man* had a lot of potential. Nico, the attractive lead singer of The Velvet Underground, was no doubt expected to be a box office draw. Ingrid Superstar could be counted on to provide comic relief. Valerie Solanas, the author of the *SCUM Manifesto* (Society for Cutting Up Men) and a confirmed lesbian, and Ivy Nicholson would add unpredictable, potentially volatile elements to the film.

There appears to be a conceptual framework for Baker's various sexual escapades. In the first scene, Cynthia May and Baker lie in bed, but her parents are expected to come home, which is the reason she wants him to leave. Because of this, Baker persuades May to have sex under the bed, deliberately frustrating the viewer from being able to see any of the sexual action other than their feet. In the final scene, Bettina Coffin lies on a daybed with her dress pulled down, exposing her bra and breasts, while Baker keeps asking where they've met. She originally says Gregory's, but then claims not to know and doesn't consider it important. Like an amnesiac or someone spoofing Alain Resnais's *Last Year at Marienbad* (1961), Baker obsessively returns to the issue. He asks questions such as "Where are we? When did we get here? Was I here when you arrived? Did we come together? Was it a bright day? Was it a cloudy day? Was it cold? Was it warm? Summer time? Christmas time?" Coffin eventually remembers that they met at Max's Kansas City. As a result of this confusion, Baker contends that their relationship is based on a lie and questions whether he should have sex with her. He is turned off by the fact that she has a husband, even though he vaguely admits to being in a relationship himself.

The scene starts to feel very much like an absurdist play rather than

soft-core porn. Coffin often looks directly at the camera when she's not engaging Baker's eyes. She answers most of his questions with the response, "Right," indicating her desire to agree with him, as if he's a psychopath whom she doesn't want to upset. Baker starts to open his shirt, gets up, and moves offscreen as if to undress, but Coffin says, "Well, wait a minute, why don't we talk awhile?" She continues, "You know, I'd like to talk to you, not just make love every minute. I like to work up to it." He answers, "Who said I was going to make love to you?" As a result, Coffin gets defensive and pulls up the top of her dress.

Tom Baker is a more traditional actor than most of Warhol's regular superstars. He attempts to do standard improvisation, which makes him a fish out of water in this film. Baker considered the best scene in *I, a Man* to be the one with the young and attractive Bettina Coffin. Until this point, it's safe to say that *I, a Man* fails to deliver as a sexploitation film. The scenes with Nico and Ultra Violet fizzle. Baker and Nico merely flirt, while he and Ultra Violet French kiss and, in a close-up, she moves her long skinny tongue in and out like a snake. The scene with Coffin, by contrast, is the only truly erotic one in the entire film. Warhol must have realized this because he saved it for last. Coffin is also the only woman in the film who genuinely appears to want to have sex with Baker. Unlike Baker, who discloses almost nothing about himself because he's too busy role-playing, Coffin reveals as much personal information about herself as you'd find in any psychoanalytic session.

According to Baker, the scene with Bettina Coffin was actually the first to be shot, followed by scenes with Ivy Nicholson and then Valerie Solanas.[8] These three scenes are the most intriguing in the film, even though Nicholson's wound up being truncated. Mary Harron's biopic on Valerie Solanas, *I Shot Andy Warhol*, provides a context for Ivy Nicholson's scene in *I, a Man*, in which she discovers that Baker doesn't have any clothes on. The fictional Ivy yells, "I told you I wasn't going to do this if he was nude. I told you this. I told you this a hundred thousand times." She slaps the Paul Morrissey character (Reg Rogers) in the face and screams, "I am Mrs. Andy Warhol. I deserve some respect. You're a fucking untalented liar, and I don't know what the fuck he sees in you." Tom Baker provides his version of the events involving Ivy:

> She had stipulated that she would not appear on camera with me in the nude. Shortly after the scene began, for lack of something to do, I walked out of frame, quite obviously going behind the camera, and removed the towel I was wearing in order to put on my pants. Ivy, clad only in unlaundered bikini underwear, exploded in an emotional fury and stormed out of

the room in tears, claiming all the while she had been betrayed. It was only after much cajoling on everyone's part, and many apologies from myself that she returned to complete the scene.[9]

This context is necessary to understand the tension we perceive in the scene between Baker and Nicholson in *I, a Man,* especially her extremely distraught emotional state and his desire to end the scene as quickly as possible.

I, a Man went through a number of variations, even subsequent to its theatrical release at the Hudson. In the current version, which contains scenes with the eight women already mentioned, the first half must have seemed very confusing to viewers expecting to see soft-core pornography. Baker's first two encounters don't result in any sex. There's a close-up shot of Baker playing the guitar in the bathroom. He eventually strips naked, briefly revealing his genitals. As he gets dressed, the camera focuses on him tightening his belt buckle, an action that is repeated in strobe cuts.

In his third encounter, roughly twenty minutes into the film, Baker sits at a table with Ingrid Superstar. He asks her to show him her breasts. She replies, "You want to see my fried eggs?" Baker feels her breasts and says, "Think how these are going to look in five years." Ingrid responds, "I just hope they don't turn into runny eggs, you know." Baker gets her to lie on the table and think of someone dead. After throwing out several names, Ingrid finally suggests John Wilkes Booth. Baker takes off his shirt and asks her to repeat five times, "Why did you kill Lincoln?" After finding out that she has an architect lover, Baker demands that she pay him for spending time with her.

The inclusion of Valerie Solanas guaranteed that *I, a Man* would become an important historical document, regardless of the artistic merits of the film. And, as strange as it might seem within the context of a sexploitation film, the scene with Solanas in many ways epitomizes the real power and energy of Warhol's cinema. Valerie's hatred of men stemmed from her own personal history. She reportedly was sexually abused by her father as a child and resorted to prostitution as a means of survival. In the *SCUM Manifesto,* Valerie writes with a venomous rage, mixed with absolute hilarity, about the inherent inferiority of the male species: "Eaten up with guilt, shame, fears and insecurities and obtaining, if he's lucky, a barely perceptible physical feeling, the male is, nonetheless, obsessed with screwing; he'll swim through a river of snot, wade nostril-deep through a mile of vomit, if he thinks there'll be a friendly pussy

awaiting him."[10] Valerie talks about females "who'd sink a shiv into a man's chest or ram an ice pick up his asshole as soon as look at him."[11]

Set on a dark stairwell (which suggests a potential site of sexual molestation), Tom Baker's attempt to convince Valerie to let him into her apartment bristles with subtext. Even if a viewer does not know anything about Valerie, there's a creepy quality to the scene, but Warhol is of course interested in creating a situation with built-in dramatic conflict. The two characters have opposite goals. Baker wants to get inside her apartment, and Valerie wants to prevent this at all cost. Given her personal background and his ostensible desire to have sex, the situation also has the potential to develop into psychodrama. That's why Mary Harron's re-creation of the scene doesn't measure up to the actual situation.

The scene begins with a pulsating stairwell that has been lit to look like a German Expressionist set, with the verticals suggesting prison bars. Valerie comes up the stairs, followed by Baker. When they arrive at the door to her apartment, he asks, "You got the key?" Valerie searches her pockets, has second thoughts, and suddenly asks, "Hey, what am I doing up here with a finko like you?" A strobe cut restages it on the landing just below, and we hear Valerie repeat the last part of her dialogue. She then says, "I can't figure it out—you're a fink." This makes Baker laugh. He responds, "You don't even know me." They talk about the fact that she supposedly grabbed his ass in the elevator. He wants to go inside, but Valerie indicates that her roommate is there, and adds that she's squishier than he is. Valerie asks, "But what else have you got?" He says, "I don't talk about those things, baby." Baker suggests that they explore each other's bodies, but Valerie insists, "Look, I've got the upper hand. We must not forget that."

Valerie squeezes Baker's ass once more in an attempt to get rid of him, but he trails after her. At the landing, he says, "Listen, Valerie, just stop here for a second. I just want to see something." They disappear into the shadows, but he has his hands on her. Valerie says, "Hey, come on, man. I mean, like this is rape. I don't dig that shit." Baker takes off his shirt, while Valerie struggles, "Hey, come on, man! Goddamn it. Hey, come on! What's this shit, man?" She protests, "My roommate's very jealous. She's possessive. She's very possessive." After strobe cuts, the two smoke cigarettes in a different location on the stairs. Valerie claims not to like his "tits" and they argue about them. Baker finally says, "What is it in your head that you don't dig about men?"

In the strobe cuts that follow, Valerie waves off the camera and then

later smiles for a very brief moment—a decidedly mixed message that matches the bizarre dynamics of the situation. Alluding to the SCUM Manifesto, Baker asks, "What is it some philosophy you have in life that you don't . . . ?" Valerie, however, turns the tables on him by inquiring whether Baker likes men. He indicates that he hasn't "balled" men since he was young. He argues that in pursuing women, he's following his "instincts." Valerie responds that she's also following hers, and asks pointedly, "Why should my standards be lower than yours?" Since they both share the same instincts, Baker suggests a possible threesome with her roommate, but Valerie indicates that her roommate wouldn't like him. After strobe cuts, the camera moves closer to Valerie, as her face, especially her eyes, moves in and out of the light. Baker tries to block her way, but Valerie claims not to actually live there and, in a mind-blowing gender reversal, says, "I want to go home. I want to beat my meat." She pushes past him, and, in another shot, Valerie asks the crew whether she should go all the way down the stairs, and she heads out.

Baker claims that he never felt that Valerie posed a personal threat. Instead, he says, "Just the opposite, I found her intelligent, funny, almost charming, and very, very frightened."[12] Baker never explains why Valerie seemed frightened, but it's clear that he had been given enough information about her to push the scene as far as possible—the hint of possible rape, the allusions to her manifesto, and the biological basis for her sexual politics, all of which are guaranteed to make Valerie feel uncomfortable and threatened. Warhol listed Valerie in the published credits under a silly pseudonym: "Valeria Solanis."[13] Although she reportedly felt humiliated when she actually saw the film, she nevertheless wrote Warhol a postcard dated August 25, 1967: "Dear Andy, I've been noticing gross misspellings of my name in articles & reviews connected with 'I, A Man.' Please note correct spelling."[14] In true Warholian fashion, even Valerie appreciated the value of publicity.

It's hard to figure out what most audience members made of I, a Man, but Warhol provides his own anecdotal take on the film's reception:

> Late one afternoon in September, Paul [Morrissey] and I went over to the Hudson Theater to check out what kind of audience I, a Man was pulling in. We'd be opening Bike Boy there in a couple of weeks, and we wanted to see if the audience was laughing or jerking off or taking notes or what, so we'd know whether it was the comedy, the sex, or the art they liked.
>
> We walked into the Hudson and sat down on a couple of scruffy-looking seats. There were a few college-type kids sitting together down front, and some raincoat people, alone, scattered here and there . . .
>
> We didn't stay too long—just long enough to see that the kids thought it

was hilarious. On our way out, the box office guy told us that during lunch hour was when business was the best.[15]

While parts of *I, a Man* are comedic, such as the scenes involving Ingrid Superstar and Valerie Solanas, and might have appealed to a few college students, it's doubtful that much of the film would have satisfied the raincoat crowd. Warhol's comment that most people came at lunch suggests that the audience consisted mostly of businessmen looking for sexual titillation. He was only too aware that pornography is really a game of how much you can get away with. Warhol wasn't making the rules, but merely responding to them, and later he admitted that he found the conventional standards of what constitutes smut very confusing.[16]

Despite Warhol's upbeat characterization of the audience's response, Paul Morrissey claims, "*I, a Man* didn't do well so after the first week the theatre manager asked for another and suggested that this time it be a motorcycle film as they were also doing great business over on 42nd Street."[17] Neither Warhol nor Morrissey happened to know any motorcyclists, but, as luck would have it, they happened to find one outside an East Village restaurant and offered him the lead role in their next film.[18]

BIKE BOY

Beginning with the years following World War II, the motorcyclist has been a figure of rebellion in American popular culture, as exemplified by Marlon Brando in *The Wild One* (1953). Kenneth Anger's *Scorpio Rising,* a homoerotic film that strongly influenced Warhol, also focuses on the image of the motorcyclist, using montage editing to create connections between a gang of motorcyclists, Christianity, and Nazi imagery. The film is about how leaders of each of the three groups use ritual to create a death cult. In addition to *Bike Boy,* a motorcycle also features prominently in two other Warhol films, *Couch* and the unfinished *Batman Dracula.* What no doubt attracted Warhol to the subject is the way the figure of the motorcyclist functions as an icon of both masculinity and gay desire.

Juan A. Suárez notes that "images of bikers started cropping up in homoerotic physique magazines of the 1950s, the most popular of which was *Physique Pictorial.*"[19] Suárez explains:

> It was marketed as a physical culture magazine, but the insertion of models in elaborate fetishistic scenarios reveals a libidinal fantasy investment that can hardly be justified as interest in health and bodybuilding alone. The

magazine was edited by Bob Mizer, who was also its main photographer and head of the photo studio Athletic Model Guild, source of the most widely disseminated gay erotica of the time.[20]

In *Bike Boy* (1967–68), Warhol cleverly deconstructs the power of this iconic image through his extended portrait of a biker named Joe Spencer.

Bike Boy begins with a close-up of Spencer's face. In a series of strobe cuts that focus mostly on his muscular upper torso and other parts of his body, including his genital area, we watch Joe take a very long shower. He is bathed in warm golden light against a background of black shower tiles. Spencer continually looks offscreen for some sort of direction. He's obviously soaped up the various parts of his body and rinsed under the shower head numerous times already, but he obviously doesn't have a clue about Warhol's intent to make his naked body the fleeting object of the camera's gaze. When Joe runs out of things to do, he stares at the camera. After about five minutes, he starts to dry himself off with a green bath towel before getting dressed. Spencer then dries his hair. He addresses the camera, but we can't hear what he says. In an alternation between an extreme close-up and a close-up, he meticulously combs his hair into a ducktail. After a series of strobe cuts, the camera frames his face, as in one of Warhol's *Screen Tests*, with his body positioned at a slight angle. He smiles briefly and then stares at the camera until the roll flares out.

Spencer then has a series of episodic encounters. In a clothing store two salesmen (art students Bruce Haines and George McKittrich) dress him in an outlandish outfit made of chains, so he ends up looking like a gladiator. They whip him lightly with a belt, deliberately prolong the measurement of the inseam on his pants, and spray him with fruity-smelling cologne. To them Joe is merely dressed in a fetishistic costume—the kind you might see in leather bars on Christopher Street. Warhol further toys with gay stereotypes. Besides the gay clothing salesmen, Ed Hood plays a florist. Pretending to be a friend, he ridicules the swastika on Joe's arm by connecting him via a *Daily News* headline to the slain American Nazi Party leader George Lincoln Rockwell, and reveals the fact that Joe doesn't actually have a working motorcycle. He also goads Joe into an outrageous description of engaging in bestiality with sheep.

Spencer has been set up from the start. The shower scene goes on for an interminable length of time, the clothing salesmen treat him as a comic figure, and Ed Hood, playing the role of friend and confidant, manipulates Joe into revealing a side of him that most people wouldn't

want to expose to public view. The scene with Ingrid Superstar is an obvious setup as well. Joe leans against the wall, posing for the camera as if he's Marlon Brando. His demeanor and eye rolls suggest that he's been stuck in a kitchen with a crazy woman, while she sits on the counter reciting a series of banal monologues about eggs and soup and nonsensical recipes, unable to get his attention because he's obviously been directed to ignore her. Unbeknownst to Joe, Ingrid gradually exposes her naked breasts, creating a discrepancy between the affectation of his sexual pose and her genuine sexual display. Although Joe smugly thinks otherwise, the joke is on him.

In the scene where Anne Wehrer wants a ride on his motorcycle, Joe never admits that his bike is actually being repaired at a garage. He instead makes various excuses that include not having any money, being reticent about accepting money from her, desiring to have sex right there, being a hustler, and wanting to charge her five dollars for the ride (which might also include having sex). He is revealed to be so lacking in his own personal identity that he's willing to become a mindless, chameleon-like follower—to dress in a codified manner (the biker uniform) and to assume the role demanded of motorcyclists as rebellious, violent, sexually promiscuous, crude, misogynistic, and socially oppressed. Not that this is a documentary portrait. Bruce Hainley is quite right in asserting, "In fact, the inability to separate what's 'real' from what's 'performance' is a central dynamic of Warhol's filmmaking."[21]

Joe's next encounter is with Brigid Berlin. She lies on the couch with a man who pretends to be her husband. Brigid goes right to the heart of the matter by calling Joe a "faggot" and puncturing his hypermasculine pose. Spencer, who sits drinking a can of Budweiser throughout the scene, retaliates by calling her a dyke. When she denies it, Joe says, "The hell you ain't. You got a face of a damn dyke . . . ready to slice your throat when you look at 'em." Referring to the camera, Brigid responds, "Cut this damn thing off!" In this case, Warhol doesn't.

Joe finds Viva more attractive than Brigid, whom he claims isn't his type and doesn't turn him on. He seems far more interested in the prospect of making it with Viva, who calls him on his clichéd tattoos, especially the swastika, and his morbid obsession with death symbols. She also undercuts his claims of being harassed by the cops by positing the idea of a surveillance society—she implies he's paranoid to think the cops are watching only him or other motorcyclists, when they're really watching everyone. Despite his professed interest in having sex with her, Joe tries to evade it for as long as possible. He switches the topic from

sex to motorcycle clubs; Viva asks, "How did we get from sex to bike clubs?" He also claims not to have brushed his teeth, but Viva indicates she hasn't either, removing that stumbling block.

Joe's description of having sex with women seems more appropriate to a butcher shop. He makes it sound as if he's filleting a piece of meat: "Boy when I get 'em in bed, lay them out flat, you know. First I strip 'em down, you know. I lay 'em flat on that bed, you know. I go like that, you know, rub my hands, and (makes a sound) . . . right in bed I go." Viva later tells him, "You sound like a meat cleaver." He answers, "Nah, I'm just a saw." After kissing Viva very briefly, he comments, "Boy, you're a cold little bitch." He kisses her longer and seems satisfied. He asks, "How was that?" She answers, "Not too good." He does it again, but Viva yanks his hair back, and insists, "More delicately." He responds, "Oh, but you're a woman." Spencer begins a litany of complaints about the female sex. Viva tells him, "Relax . . . you're coming like a bulldozer." He suggests she'll have fun when he's fucking her. She counters, "Well, I mean, how am I going to have fun while you're fucking me, when you can't even give me any fun when you're kissing me?" Joe shakes his fist at her. Viva says, "Doesn't sound much like love to me."

Joe claims that Viva's not going to be able to handle what he's going to do to her, but she challenges him. Following a strobe cut, we see him aggressively get on top of her. They make out on the couch with their clothes on. He slips off his boots. After a smoke, Joe disrobes Viva, who lies naked while he also strips. In various strobe cuts, Warhol has Spencer repeat the action of pulling off his pants. Joe stands up naked. The action repeats. He keeps giving Viva a drag from his cigarette, but as he stands, the limpness of his penis is obvious. The camera frames only his lower torso, emphasizing his buttocks as he stands over her. He then sits down next to her on the couch. We see his naked body in the foreground of the shot as Viva's hands embrace him and she looks up at him. She begins to laugh. When he asks why she's laughing at him, Viva tells him, "I'm not laughing at you at all . . . Well, I'm just laughing because you're so funny." Joe responds, "Funny? I ain't funny." The film abruptly ends on his line.

Joe's bravado appears to mask a gnawing sense of his own inadequacy. He talks about his dissatisfaction with life in New York, his outsider status, and difficulties in finding a job. In the scene with Brigid, she mocks him as a "motorcycle queen" and "a leather lady." Spencer claims, "I'm proud of what I am." Brigid asks, "What are you?" He replies, "I'm a bikie, man, and I'm proud of it." Joe later tells Viva, "But,

I don't know, I just enjoy being a bikie, even though I've been pushed around, mocked out, spit on, and stomped on the ground by a lot of different people." His comment reinforces the connection between bikers and sadomasochism. Joe is obviously not very bright, which partially accounts for why he's so easily taken advantage of in *Bike Boy*. In the scene with Brigid, Joe claims to be a Vietnam veteran. When Brigid asks whether they have methedrine over there, he doesn't have a clue what she means. Brigid finally says, "Amphetamine." Joe replies, "Women? Oh, they got plenty of 'em over there." Brigid bursts out laughing. He also tells her a joke: "How much yarn does it take to make a baby?" He answers, "Two balls and six inches." It's the type of sexual humor that might not fly in fourth grade.

In a perverse sense, *Bike Boy* lives up to its billing as an exploitation film. The fractured eroticism of the film's opening shower scene gradually turns into a rather sad portrait of a loutish poser. Brigid Berlin is absolutely right in her assessment of him—he's "a lot of talk." Warhol presents us with an image of an attractive and muscular motorcyclist, but he slowly and somewhat brutally punctures the aura surrounding this mythic figure. By the end of the film, we've grown tired of Joe's posturing—his various threats of violence, his revelations of bestiality, his misogyny, vulgarity, narcissism, bad politics, juvenile jokes, general stupidity, and inability to become sexually stimulated by a naked woman after continually boasting about his sexual prowess. For all his macho bluster, Joe Spencer fails miserably in his bid to be a stud.

THE LOVES OF ONDINE

Following the failed performance of Joe Spencer in *Bike Boy*, another working-class, muscular male body surfaced: Joe Dallesandro, a teenager who had previously posed naked in Athletic Model Guild beefcake photos.[22] The "new" Joe, who became known as "Little Joe"—the nickname primitively tattooed on his arm—turned out to have a much more engaging personality in his debut appearance in *The Loves of Ondine* (1967–68). Whereas Spencer proved to be a loud, obnoxious, and insecure blowhard, Dallesandro is taciturn, shy, and unassuming, which gives him a mystique that Spencer sorely lacked. Spencer seemed to be confused about his own sexual identity. The women in *Bike Boy*—Ingrid, Brigid, and Viva—take it for granted that he's really gay, easily seeing through the hypermasculine pose of his Nazi and skull tattoos and leather outfit. Joe Dallesandro, by contrast, seems free of

pretense; he seems comfortable merely being himself. He could play gay or straight, and seemed to have no inhibitions when it came to either role.

The Loves of Ondine was originally conceived as a much longer component of **** (*Four Stars*). The shortened version (the one that exists today), which was eventually released in pared-down form, was actually shot earlier than *Bike Boy* but was released much later. It was supposed to be a star vehicle for Ondine, who had gained notoriety for his role as the Pope in *The Chelsea Girls*. But, just as Edie stole the spotlight from Gerard Malanga in *Vinyl,* so Joe Dallasandro upstaged Ondine in the film that bears his name. Little Joe was thrown into a scene at the last minute but wound up being so central to *The Loves of Ondine* that the poster for the film features a large image of him striking a sexy pose in his underwear, while Ondine and Viva are reduced to second billing.[23]

In *The Loves of Ondine,* Ondine unfortunately attempts to replicate his infamous tantrum from *The Chelsea Girls* in the opening scene with Pepper Davis. Dressed in a smoking jacket and striped pants, he plays cards and demands that Davis take off her clothes. Although Ondine has never been with a woman before, he claims to be tired of the gay scene. Their attempts at cuddling and initiating sex fall flat almost from the start, causing Ondine to lose patience with someone who has no understanding of what true improvisation requires. He yells, "Don't you understand the difference between reality and pretense?" Davis makes the fatal mistake of mimicking what Ondine says (he suggests that she's nothing but a parrot and ought to seek help from a veterinarian), which causes him to unleash a torrent of misogynistic invective while demanding that she leave.

Ondine at first appears to be much more comfortable with Viva. Unlike Davis, she's willing to strip for him for a price. Ondine pretends to pay for each article of clothing she discards. She removes her blouse, revealing Band-Aids covering her nipples. In a series of strobe cuts, Viva tries to remove his blue bathrobe. The two get into a spat, however, when Viva insists, "Darling, it takes two to make any action." Ondine doesn't want her to pull off his bathrobe. She suggests, "Aren't we having group therapy here?" Loud static obliterates what Viva says next, but when the audio returns, Ondine becomes insulting once again as she lies next to him in only her panties and a single Band-Aid covering her right nipple. He claims Viva should be beaten and calls her "the most know-it-all young turd I've ever seen."

Ivy Nicholson is the next woman to try to satisfy Ondine. She climbs

on top of him, but he implores her to get off. He concludes, "I don't think men should have sex with women. I think it's boring . . . and it's against civilization. Let's put it that way." He repeats, "I like to torture women," adding, "including my mother." The film cuts to a food fight between members of a Latino musical group, the Bananas, one of whom is naked, while we hear Beatles songs in the background. In an impromptu interview, one of the musicians tells a story about being raped as a child. After unleashing another tirade against Nicholson, Ondine tells a lengthy and disturbing story about being raped on Eighth Avenue.

Ondine, who has behaved obnoxiously with the women, heaps praise on the shirtless Joe Dallesandro, who seems both shy and extremely polite. As the two lie on the bed together, Joe sincerely tells Ondine, "I'm a little nervous now. I can't get relaxed." He later adds, "I just can't think of anything to say, anything to speak about. It sounds so boring if you keep talking about nothing. I don't like to talk about nothing . . . 'nothing' doesn't excite me." Ondine and Joe decide to engage in college wrestling, but Joe, who strips to his jockey shorts, first has to demonstrate the various moves. At one point, Joe gets Ondine in a full nelson and pushes Ondine's face into his crotch. Ondine comments, "College wrestling is so much fun." As Ondine struggles, his "wife," Brigid Berlin, storms into the room. He tries to introduce Joe as his college wrestling instructor, but the heavyset Brigid sits on Joe's back as he kneels in a defensive position. After Brigid forces Joe to leave, she tells Ondine, "You're getting just like Patrick now." The fact that Ondine and Brigid play a married couple with a troubled son named Patrick makes it obvious that the scene was actually shot for *Imitation of Christ* and that *The Loves of Ondine* is comprised of scenes of Ondine that have been compiled from a variety of sources.

It is easy to see why Joe Dallesandro would steal the limelight from Ondine. After three episodes in which Ondine verbally abuses women— Pepper Davis, Viva, and the high-strung Ivy Nicholson—it's fair to say that he comes across as rather unlikable. He rails against Davis for her lack of imagination, but a case easily could be made that Ondine suffers from the same problem. He's beginning to repeat himself—something Warhol tried very hard to avoid—almost as if he is relying on stock tricks, like a bad Method actor. Warhol's style of acting demanded spontaneity, whereas Ondine is starting to become a caricature of himself. In *Afternoon*, Warhol tried to instigate conflict between Ondine and Arthur Loeb, but, as we saw, shouting, fighting, name calling, and verbal putdowns don't necessarily create dramatic tension when they lack motivation.

The scene with Joe Dallesandro works precisely because Ondine really does seem to express desire for the athletic teen. He's overly nice and solicitous of Joe, who makes a startling confession about his own nervousness in suddenly finding himself in a scene with a much older and experienced performer. Although they only wrestle, the scene has an erotic subtext that's utterly lacking in the scenes with the women. In the prelude to the college wrestling match, Joe's comments about his performance anxiety take on the connotations of a young virgin about to have sex for the first time. Joe Spencer also admitted to feeling nervous in his sex scene in *Bike Boy*, but it didn't resonate with the same authenticity. Of course, once Joe actually wrestles, he seems very natural. His confidence blossoms and he takes control of the situation, even maneuvering Ondine's face into the crotch of his jockey shorts, much to the older performer's delight.

Ondine's behavior, both inside and outside of films, later became an issue, and finally he was banned from the Factory, as Paul Morrissey and Fred Hughes attempted to change it from a hangout to an actual place of business.[24] Ondine's heavy amphetamine abuse no doubt accounted for some of the problems. Moreover, he resented Morrissey's growing influence. Ondine would make one final film for Warhol, *Imitation of Christ,* along with Brigid Berlin, Nico, and Taylor Mead, who had recently returned from Europe. Luckily, Ondine's send-off turns out to be very funny.

IMITATION OF CHRIST

Edie Sedgwick's flirtation with Bob Dylan and his entourage was at the center of the well-documented rift between Andy Warhol, his superstar, and the rock musician. According to Warhol, Edie came to know Dylan through a Cambridge connection, Bobby Neuwirth, who functioned as Dylan's road manager. Warhol offers his own version of the tension that eventually developed between Dylan and him:

> I liked Dylan, the way he'd created a brilliant new style. He didn't spend his career doing homage to the past, he had to do things his own way, and that was just what I respected. I even gave him one of my silver Elvis paintings in the days when he was first around. Later on, though, I got paranoid when I heard rumors that he had used the Elvis as a dart board up in the country. When I'd ask, "Why would he do that?" I'd invariably get hearsay answers like "I hear he feels you destroyed Edie," or "Listen to 'Like a Rolling Stone'—I think you're the 'diplomat on the chrome horse,' man." I

didn't know exactly what they meant by that—I never listened much to the words of songs—but I got the tenor of what people were saying—that Dylan didn't like me, that he blamed me for Edie's drugs.[25]

Despite his seemingly measured response and insistence that he never personally gave Edie drugs, Warhol found ways to retaliate by poking fun at both Edie and Dylan in such films as *Poor Little Rich Girl, Beauty # 2, Space, More Milk Yvette,* and *Imitation of Christ.*

Imitation of Christ takes its title from the fifteenth-century inspirational work of the Augustinian monk Thomas à Kempis, who promoted the notion of renouncing personal vanity and the physical world in favor of more spiritual concerns. The film is an extended portrait of Patrick Tilden-Close, an actor and good friend of Bob Dylan's who also reportedly had an affair with Edie. Tilden-Close is so high on drugs throughout *Imitation of Christ* that the film can be easily read as a parody of the mystical trappings surrounding hippie culture (embodied by Dylan) so detested by Warhol and the Factory crowd.

The film was first shown as a nearly eight-hour installment of **** (*Four Stars*), in 1967, but was released in 1969 in an abridged form. Besides Tilden-Close as Patrick, it features a cast of superstars, including Brigid Berlin and Ondine as Patrick's frustrated parents, Nico as a maid, Andrea Feldman, Tom Baker, and Taylor Mead. Despite the allusions to Thomas á Kempis and Brigid Berlin's attempts to give the film narrative coherence, it is largely episodic and lacking in plot development. Tilden-Close's drugged state, however, adds an element of unpredictability to his performance, so that non sequiturs replace normal exchange of dialogue and various scenes teeter on the verge of breaking down. The scene between Tilden-Close and Andrea Feldman in the bedroom turns out to be riveting because it contains elements of pure psychodrama, as Feldman demands to have sex with Tilden-Close, who seems intent on avoiding it at any cost.

Imitation of Christ begins with a profile shot of Tilden-Close. As he shifts his head and stares at the camera, we hear a Bob Dylan song being sped up on a record player. Tilden-Close covers his mouth with his hand; the camera zooms in closer on his face. The emphasis, in terms of his performance, is all in the flitting movements of his eyes. We hear Dylan's "A Hard Rain's A-Gonna Fall." Warhol initially distorts the lyrics by playing the record at an extremely slow speed. Tilden-Close looks screen left, and then toward us with an agitated demeanor that suggests he's high on drugs. As he places a hand to his head, the camera zooms

in closer on him. The image turns black and then returns as Tilden-Close looks momentarily bemused. The camera reframes the actor's agitated expressions before zooming out once again. This first shot, which focuses solely on Tilden-Close, lasts roughly ten minutes.

Tilden-Close sits on the patio with Nico. He complains, "And the food is terrible, and there's a lot of pain, right?" Framed in the doorway, Tilden-Close talks about being in some type of institution where a bunch of guys wanted to make love to him. He tells Nico, "They thought I was just beautiful." He whistles to emphasize his sense of his own good looks, before admitting, "Finally I kissed the guy and gave him a hug." The scene cuts to Ondine preparing to give Brigid Berlin a shot of amphetamine as the two lie together in bed. When they're not getting high, Brigid and Ondine play a married couple concerned about their hippie son. As Ondine tries to stick the needle into her buttocks, she responds, "You're not even near the putting green." After a strobe cut, Ondine asks, "Where's Patrick?" Tilden-Close, who's positioned off-screen, answers, "Right here." Ignoring his reply, Brigid responds, "I hope he's in his room sleeping." After more strobe cuts, Brigid lies with her arms around Ondine as he opens her brassiere. "I have my period," she tells him. He responds, "If it weren't for you, Brigid, I would be a homosexual, a raging faggot. You're the only thing that keeps me straight."

After Brigid expresses a desire for Tilden-Close to go back to bed, he can be seen on the right side of the frame. He gestures to the camera with his finger and crosses in front of it before reappearing from screen left and sitting in a lotus position on the bed with his parents. Brigid and Ondine discuss Patrick's childhood while he plays with a tie and eventually places it around his neck as if he might strangle himself. Brigid complains to Ondine that Patrick has come in wearing one of her nightgowns and discusses a shopping trip the day before. Brigid comments, "He probably got hippie boots or something. He's getting to look a little flowery. In school they're going to tell him to cut his hair." We hear Patrick talking offscreen. Brigid yells, "Now who's he talking to out there?" Ondine answers, "To himself" and adds, "See that. He's a really good subject. I mean he does everything. He listens to himself and talks to himself at the same time. And he does both well."

Brigid suggests that Patrick was born "so high," and neither parent seems capable of taking charge when it comes to supervision. Brigid fears that Patrick's been spending all his money on "faggots." As Brigid and Ondine wait for Patrick, whom they've summoned to their bedroom, Ondine indicates that Patrick might be rummaging through her handbag.

Brigid responds, "You might inherit a habit, but you don't inherit para-noia." In their back-and-forth banter, Brigid insinuates that Ondine is not actually Patrick's father, and he in turn hints that she might be sleeping with their son. Brigid sends Ondine off to talk with Patrick and suggests that he should make him take "confession." She then laments the good life she might have had instead of having to deal with Patrick's obsession with "cops."

In the next scene, Nico feeds Patrick spoonfuls of Kellogg's Corn Flakes at the kitchen table. Afterward, she cuts his hair with a safety razor and combs it while speaking French to him. Patrick at one point responds, "I'm so dead." Then, he takes a bath and mumbles incoher-ently. He sits on the bed with Andrea Feldman, who smokes a ciga-rette menacingly. A flurry of strobe cuts follow and the song "You Better Run" by the Rascals plays on the sound track. Andrea asks Patrick to sit down and then keeps repeating, "Do you like to shoot up?" She lies on top on him, and the two roll around on the bed after another series of rapid strobe cuts. Andrea at times assumes the role of dominatrix, but Patrick is much too high to respond to her sexually. In a later scene, Nico reads several passages from *Imitation of Christ* in her heavily accented voice. Patrick interrupts by trying to seduce her. She initially resists, and then removes her blouse, but Tilden-Close refuses to take off his clothes and once again seems incapable of any type of sexual response. He then sits on the bed with his mother. Brigid tells him, "I guess I'm not sup-posed to understand you. I don't understand what the hippies are . . . except that I hate them."

Imitation of Christ appears largely improvised, which might account for several narrative discrepancies. Tilden-Close, for instance, discusses experiences in California (some of the film was actually shot at The Castle in Los Angeles) when the movie is supposed to be set in New York.[26] At one point, Tilden-Close talks about his mother seeing fairies, but it's unclear whether he's discussing his actual mother or his fictional mother, Brigid Berlin. While the film never fully develops into a psychodrama (the scene with Andrea Feldman and Tilden-Close borders on it), the protago-nist's fragile mental state as the result of his being on drugs gives the film the same unpredictability as other Warhol films in which the performer is high. While pretending to be a social problem film involving the dif-ficulties of parents raising children during the hippie era, *Imitation of Christ* can easily be read as Warhol's response to Bob Dylan blaming him for Edie's drug problems by suggesting that Dylan's close friend's serious drug problem creates the same sort of guilt by association.

THE NUDE RESTAURANT

After working with Tavel's scenarios, Warhol more or less abandoned scripts and focused on the "superstar." As he explained: "Mainly, the stars improvise their own dialogue. Somehow, we attract people who can turn themselves on in front of the camera. In this sense, they're *really* superstars. It's much harder, you know, to *be* your own script than to memorize someone else's. Anyhow, scripts bore me. It's much more exciting not to know what's going to happen."[27] Viva, whose real name was Susan Hoffmann, was the most verbally proficient of all of Warhol's superstars. She and Taylor Mead play the lead roles in *The Nude Restaurant* (1967), which was shot in a Greenwich Village restaurant in October and featured a draft resister. Along with *Since* and the later *Blue Movie*, *The Nude Restaurant* is one of the most overtly political Warhol films. The film also reflects his growing interest in the medium of television, which he believed had radically altered the nature of film. While on a college tour in 1968, Warhol reportedly was asked: "Is film the major medium of our time?" He answered: "No, TV."[28]

The Nude Restaurant lacks plot, which Warhol believed was an outmoded concept. He told Leticia Kent, a *Vogue* interviewer, "I don't think plot is important. If you see a movie, say, of two people talking, you can watch it over and over again without being bored. You get involved—you miss things—you come back to it—you see new things. But you can't see the same movie over again if it has a plot because you already know the ending."[29] *The Nude Restaurant* provides its performers with situations in which they simply talk, as in TV talk shows such as *The Alan Burke Show* and William F. Buckley's *Firing Line*, which were popular at the time. Paul Morrissey in a 1971 interview acknowledged that Warhol was attempting to replicate television in certain films:

> And of course the lack of stories is television because you don't have a story on television; you have people talking to one another. But you know our subject-matter that we were putting out on film could never go on to television so we had to make it fit for theatres and therefore we needed a certain length. For the theatre you have to keep it an hour and a half, make it a story . . . but the basic approach is to allow the actors to say whatever dialogue they want to say, which is also like television. Somebody goes on television, they say whatever comes into their head if they want to. People playing parts is again a dead art form, I think. I think it doesn't work any more.[30]

Considered in those terms, *The Nude Restaurant* presents an extended talk show in a restaurant setting.

The Nude Restaurant begins with a long monologue by Viva in close-up about legal problems and the tribulations of being a fashion model and having her hair destroyed, which she compares to Vietnam. A shift in camera framing soon reveals Taylor Mead behind her. As Viva continues to talk, Mead's reactions become the major point of interest in much the same way that Edie steals our attention in *Vinyl* by making her expressions a revealing commentary on the main action. With his two fingers, Mead pretends to cut her hair. He tries on a hat, puts a finger in his mouth, and makes various facial expressions throughout her monologue. After about seven minutes, Viva finally admits that she's run out of things to say, which occurs right in the middle of Taylor yawning. After a strobe cut, the film changes to a two-shot, revealing that both actors are topless. Viva starts talking about her mother. Taylor appears not to be paying attention, but when Viva momentarily stumbles and runs out of words, he chimes in: "Now then your mother said something about hippie . . . you're a hippie or something." Viva indicates that she told her mother that she was too old to be a hippie. Taylor responds, "Yeah, but then you told her off . . . and it was a beautiful scene."

Viva and Taylor make a striking comedic contrast—in terms of height, she's tall and he's short—as she talks and he responds nonverbally. When Viva mentions a one-legged millionaire from Switzerland, Taylor breaks into a huge grin, and his whole body reacts, as if he has heard this story before. Viva becomes very animated in recounting the story, leaning into Taylor and, in the process, allowing her naked breasts to be seen behind her folded arms. She then bares them to the camera as she gesticulates. People can be heard laughing off-camera.

Viva talks nonstop and at such high speed that it becomes difficult to follow her ever-shifting monologue, so it's surprising when Taylor interjects an appropriate question in order to clarify some point. Viva suddenly stops and asks Taylor whether he's getting bored. He answers, "No, I like to listen to just parts of conversation. Sometimes I follow the story, and then I just listen to parts." Taylor suggests that his unconscious is listening. He adds, "Somebody mumbling . . . I think you get almost as much." After he cracks up, Viva rolls her head, moves her tongue around her mouth, and appears genuinely miffed at what she perceives to be a personal slight. She addresses the camera and asks, "Can we turn it off for a minute?" An abrupt cut indicates that her request has been granted. Viva starts to talk about frigidity, seeing a psychiatrist, and having a boyfriend who is interested in sadomasochism.

After indicating that heterosexuality is simply a form of sadomasochism, she concludes, "Forget it. I'd rather be a lesbian."

The second reel begins with Viva dancing with an African American man. Afterward, she holds court with Taylor, Ingrid Superstar, and Julian Burroughs (an underground draft resister named Andrew Dungan who had to appear under a pseudonym).[31] Warhol frames the action so that he can simply pan to create a different configuration of three of the performers. The two women playfully paw Taylor. Ingrid wants to know whether he'd rather be surrounded by women or men. Taylor responds, "Well, there are no 'rathers' in this world, baby. The 'rathers' all flew over the North Vietnam and dropped their bombs long ago." Burroughs, who has a deadpan expression most of the time, smiles at Taylor's political non sequitur.

About forty-five minutes into *The Nude Restaurant*, it is revealed that Viva is a waitress in the restaurant. She waits on Allen Midgette, and the two proceed to engage in an extended and passionate kiss. Viva begins to tell stories about meeting Bishop Fulton J. Sheen, the television personality who had recently denounced the Vietnam War, and then recounts her and her sister's childhood sexual escapades with priests. The camera zooms back at one point to reveal the men sitting with black g-strings. Taylor sings a song to musical accompaniment about having to live with a broken heart. Viva reports that her mother insists that the hippies are dead, but Taylor doesn't believe it. Louis Waldon, a "hippie" who has a garish floral tattoo with a broken heart covering his entire back, joins the conversation at the counter. After Taylor croons again about a "broken heart" (an obvious connection to Waldon's tattoo), he sits down at a table with Julian Burroughs, who announces, "I'm an activist." Taylor responds, "You kill people or what?"

The conversation between Taylor and Burroughs over the war represents a vivid contrast between Burroughs's utter seriousness and Taylor's comic sensibility. "Tell me more about the Resisting [Resistance]," he says to Burroughs, who explains, "We need people who care, Taylor. We don't want dropouts. We want people who take an interest in this society, who want to change it." Taylor responds, "Yes, but I want someone beautiful to live with." Burroughs counters, "Well, anyone who doesn't like war must be beautiful." Taylor answers, "Not necessarily." Burroughs wants Taylor to take in draft resisters and asks him for his address. Taylor is reluctant to give it on camera. He suggests that he's been victimized in the past for being gay and has been in jail nine times. Burroughs asks, "Civil rights activity?" Taylor replies, "No,

personal rights activity," thus making the point that the issue of gay rights is as much a political stance in the pre–Stonewall era as being a war resister.

After Viva joins them at the table, she asks Burroughs if he went to Washington, a reference to the huge peace march against the war that had occurred several months earlier. Viva then indicates that she was reluctant to go because she was "afraid of getting beaten up." She says, "Men are always trying to beat me up." Burroughs comments, "We have to take the pain in order to get the victory." Viva counters, "Well, I'd like to give a little pain." In discussing who is deserving of pain, Burroughs says, "Let's kill Johnson." Viva responds, "Won't do any good." Burroughs adds, "Or Lady Bird." Taylor claims his political button says, "Where is Lee Harvey Oswald now that we really need him?" The film ends with Burroughs making a political plea by indicating that his button reads, "December 4th, the Resistance." As the camera shifts back to him, he looks straight into the camera and continues, "We hope to see you there in front of the Federal Building in several cities across the United States." Viva asks, "Where's the Federal . . . ?"

The Nude Restaurant contains Warhol's idiosyncratic camera movements, strobe cuts, and eccentric framing. It might have been inspired by the release of Arlo Guthrie's song "Alice's Restaurant" in mid-1967. The album cover pictures Guthrie wearing a Derby hat and sitting naked at a formal dinner table. Taylor and Viva wear similar hats at several points in the movie. The references to hippies and the inclusion of a draft dodger also suggest pop references to the song. As a sexploitation film, *The Nude Restaurant* foregrounds women's naked breasts, while the black g-strings recall earlier pornography and mock prevailing restrictions about depicting the lower part of male and female anatomy in commercial movies.

Both Viva and Taylor Mead provide inspired improvised performances, but there's no real sexual tension between any of the characters in the film. It differs from *My Hustler; I, a Man;* and *Bike Boy* in lacking the potential for anything dramatic to happen. The restaurant serves as a pretext for the people to congregate rather than as a location that contributes to the narrative. For the first half of the film, the characters— Viva, Taylor, and Ingrid Superstar—talk directly to the camera or to each other. Only halfway through the movie do we realize that Viva is supposed to be a waitress in the restaurant. She serves a sandwich and some drinks, but otherwise this aspect seems perfunctory. Casting Viva and Taylor in the lead roles almost guarantees that *The Nude Restaurant* will

be somewhat comedic despite the sexual and political nature of most of their conversations.

In the film, Warhol's superstars discuss tabloid topics such as child molestation, the sexual shenanigans of the clergy, frigidity in women, sadomasochism, female dissatisfaction with heterosexual men, gay rights, the hippie movement, the Vietnam War, and draft dodging. As a talk show, the film violates basic tenets of TV culture; not only are the characters partially nude, but the content of *The Nude Restaurant,* of course, would be much too shocking to be broadcast on commercial television. Even for a theatrical movie, it's extremely controversial when Julian Burroughs suggests killing Lyndon or Lady Bird Johnson, alludes to the fact that he's wanted by the FBI, and makes an overt plea for resistance and political action.

LONESOME COWBOYS

Warhol's business manager, Fred Hughes, wanted him to paint more portraits because they were lucrative, but Paul Morrissey was pushing him to make more commercially oriented films. The new film would be a Western that wouldn't be shot in the Factory, like *Horse,* but rather on location in Arizona. Ten half-hour-plus rolls of 16mm color film were purchased for the production.[32] The plan was to shoot two magazines of film per day and end up with roughly a two-hour feature. In anticipation, Morrissey wrote up a two-page treatment that attempted to develop plot and character.[33]

As in *Horse,* Warhol and Morrissey wanted to make a true Western rather than the Hollywood version. They wanted to film what they believed had been left out of most Westerns, namely the cowboys' sexual attraction to each other. Given the relative scarcity of women in the Old West—the only women mostly appeared in saloons and brothels—the film would focus on the gay male camaraderie that existed between the cowboys. They intended the film to be a kind of exposé involving the "secret life" of cowboys, much like Ang Lee's commercial success, *Brokeback Mountain* (2005), a film that took in $178 million at the box office worldwide.[34] This proves that Warhol's "high concept" for *Lonesome Cowboys* (1967–68) was way ahead of its time.

Lonesome Cowboys was supposed to be a Romeo and Juliet story, but in the assignment of names there was the usual gender reversal, so that it switched to being Romona and Julian. Romona is played by Viva, who runs a brothel and, like Juliet in the Shakespeare play, has a nurse (Taylor

Mead). She tries to seduce Julian (Tom Hompertz), thereby incurring the wrath of the other cowboys. As a performer, Viva was completely different from Edie or any of the other female superstars. She aggressively pulls Joe Spencer's hair during the kissing scene in *Bike Boy*, and Ondine complained that there was nothing "nice" about her in *The Loves of Ondine*, which is why she was cast in the Romeo rather than Juliet part. Viva was always complaining about how inadequate men were sexually. She was also highly verbal, which was one reason Warhol was so interested in her becoming the new superstar:

> I knew that we were probably going to have more trouble with the censors soon—at least if our movies kept getting attention—and I guess I must have known in the back of my mind that it would be a smart idea to have at least one really articulate performer in each movie. The legal definition of "obscenity" had that "without redeeming social value" phrase in it, and it occurred to me that if you found someone who could look beautiful, take off her clothes, step into a bathtub, and talk as intellectually as Viva did ("You know, Churchill spent six hours a day in his tub"), you'd have a better chance with the censors than if you had a giggly teenager saying, "Let me feel your cock."[35]

But in terms of the initial Romeo and Juliet concept, Warhol and Morrissey were saying one thing publicly, but actually doing something different.

Even though the film was eventually advertised as a Romeo and Juliet story, this aspect of the film is not clear until the very end. There are two lovemaking scenes between Romona and Julian that book-end the film. The opening scene—in which we struggle to see the naked characters writhing together on the ground in dim light—lasts roughly eight minutes, but it feels longer because it turns out to be nothing more than an extended tease. The bulk of the narrative entails not so much a love story between Romona and Julian as an open conflict between Romona and Mickey (Louis Waldon), who doesn't want her messing with any of his "gay" brothers. The open hostility between the cowboys and Romona eventually escalates into near rape. In addition, the cowboys are more into each other than into her, so Romona becomes even more resentful and hostile toward them. In a sense, she has secretly been cast as the antagonist rather than the protagonist of the film. As the publicity poster indicates, *Lonesome Cowboys* represents "the true story of what it was like to live the life of a cowboy in the Old West . . . a story of men among men and the woman who tried to interfere."[36]

The night scene between Eric Emerson and Joe Dallesandro is crucial to Warhol's notion of the Western genre. Eric explains the nature of cowboys, and, hence, the implications of the film's title:

See, you're out here so much. You can have so much love in your body that you can't . . . you know, you feel lonesome. And you get such a lonesome feeling because you've been alone for so long and you build up such a love for yourself . . . from feeling so much that you can't find anybody that you love as much as yourself . . . so you're always lonesome. And like it's the greatest feeling in the world to be lonesome . . . it's the deepest. It's . . . it tears your heart right out. [Laughs] But, you know, the lonesomeness is covered over by all the feeling of love that you have.

In his rambling monologue, Emerson associates the phenomenon of the mythic figure of the cowboy with loneliness, which stems from a narcissistic self-love.

In this sense, the cowboy becomes an iconic gay figure, even though Eric ends by suggesting that women like Romona relieve men of the burden of their loneliness. Joe asks about paying Romona money—she does run a brothel after all—but Eric insists, "Romona does it for the glory of the fuck." If women, as embodied by Romona, represent the forces of "civilization" in contrast to the "wilderness," the cowboys, especially Eric, resist her efforts to teach them to consider the feelings of their "partner" in lovemaking. The cowboys refuse to be tamed. Their rugged individualism, restlessness, refusal to settle down, self-absorption with their own bodies, and attraction to other men define their behavior, and ultimately frustrate women, which is why Viva seems so perfectly cast in the film.

Lonesome Cowboys was shot in January 1968 near Tucson, Arizona, where some John Wayne movies had been filmed, as well as the TV series *Death Valley Days*. It won best film at the San Francisco Film Festival, which was something of a surprise, but Warhol had trouble finding a commercial distributor. His supposed intention was to make *Lonesome Cowboys* a box office hit, but he was never terribly interested in having any sort of conventional plot, which put him in direct conflict with Paul Morrissey. When Taylor Mead took Morrissey's treatment too seriously, Warhol reportedly told him to play down the plot elements, insisting that the cast improvise rather than follow the treatment or any type of script.[37] He felt that for his performers to read other people's words would seem phony.[38]

As usual, there was tension between the performers' personalities and their roles. There are times when the male performers really start to abuse each other, such as the fight scenes, where Eric and Joe flip each other really hard. The fight scene makes overt the Western genre's connections with masculinity. As Peter Gidal comments: "The masculine rit-

ual is performed with a naturalness that is unprecedented; it exposes the sick confrontations in the usual Western, where perversely *latent* homosexual wishes are played out to the full, disguised by the acceptable notions of gun-fights, round-ups, brawls."[39] In *Lonesome Cowboys,* the homosexuality of the cowboys is out in the open. The fight scene, for instance, is completely sexualized.

The cowboys, especially Eric, also get rough with Viva in the rape scene, in which she screams for Warhol (not Morrissey) to intervene. The onlookers watching the actual filming were not amused either, which is how the FBI became involved. It was reported that Warhol was filming pornographic material in front of children, which prompted an investigation. The account of an FBI agent sounds strangely like a mainstream movie review:

> All of the males in the cast displayed homosexual tendencies and conducted themselves toward one another in an effeminate manner.
>
> One of the cowboys practiced his ballet and a conversation ensued regarding the misuse of mascara by one of the other cowboys.
>
> There was no plot to the film and no development of character throughout. It was rather a remotely-connected series of scenes which depicted situations of sexual relationships of homosexual and heterosexual nature.[40]

The usual confusions abound in *Lonesome Cowboys.* For one thing, it's extremely hard to follow the narrative thread. There are two Julians: the character Julian (Tom Hompertz) and the actor Julian Burroughs (Andrew Dungan). At times, the actors mix up each other's fictional and real names. There's little attempt at realism or verisimilitude for what is ostensibly a period piece. Viva's costume suggests she might be going on a fox hunt rather than playing in a Western. She runs a brothel, but we never see any of her prostitutes other than the transvestite sheriff (Francis Francine), and Viva later admits that the brothel is only a cover for her own promiscuous sexual activities. We hear offscreen directions to the actors.[41] An airplane can be heard on the sound track several times, while the camera zooms in on power lines in one of the later shots. We see tourists in the background of another. The performers drink beer in pop-top cans and smoke filtered cigarettes. The cowboys smoke marijuana and discuss surfing in California and the generation gap. Joe Dallesandro and Taylor Mead dance to a Beatles song. When the sheriff dresses up in drag, Romona suggests that he looks like an Indian, implying that drag queens have always been an essential part of the genre. All of these things help to deconstruct the conventional Western.

In his article on *Lonesome Cowboys,* Mark Finch argues that Warhol

produces the look but not the substance of porn, because he can't even bother to follow through with the pretense.[42] As is often the case with Warhol films, *Lonesome Cowboys* promises sex, only to withhold it. Improvised talk, in fact, becomes a substitute, especially in the scenes between Romona and Julian and between Joe Dallesandro and Eric Emerson. In the first instance, Julian's silence and passivity undercuts Romona's sexual advances, whereas sex becomes reduced to mere subtext in the second example.

There are actually two versions of *Lonesome Cowboys*. There's the restored version, certified by the Andy Warhol Foundation, but also a more commercial version, which contains a song over the beginning, a credit sequence, and overdubbed voiceover narration by the characters, especially Viva and Taylor Mead. This latter version must have been an attempt to clarify elements of the plot and make it more palatable to viewers, who would have struggled to understand the dialogue. In addition, the very dark, underexposed opening sex sequence was timed to be much brighter, for obvious reasons.

As for the exhibition and distribution of *Lonesome Cowboys*, James Kreul shows that Sherpix aggressively utilized Art Theater Guild venues and film trade publication advertising to generate business.[43] Sherpix capitalized on the prize that the film had won at the San Francisco Film Festival by exploiting the short delay between the festival screening and the film's commercial run, which enabled it to generate good word-of-mouth. *Lonesome Cowboys* ran for nine weeks in San Francisco and nineteen weeks in Los Angeles.

Sherpix made a 35mm blow-up—the first Warhol film to be distributed in the larger format—thus expanding the number of theaters where the film could play. *Lonesome Cowboys* opened in New York City at the Fifty-fifth Street Playhouse and the Andy Warhol Garrick Theater on Bleecker Street, where Morrissey claimed it grossed $35,000 to $40,000 during the first week.[44] Although the film eventually encountered censorship problems in Atlanta, *Lonesome Cowboys* nevertheless had a major impact. It turned out to be a breakthrough, especially in terms of the subsequent development of the more commercial Warhol-produced films that would be directed by Paul Morrissey.

SAN DIEGO SURF

In *Lonesome Cowboys,* Eric Emerson and Julian (Tom Hompertz) discuss surfing and eventually inform Mickey (Louis Waldon) of their inten-

tions to head for California. This bit of improvisation might have been based on actual plans. Several months after the filming of *Lonesome Cowboys,* Warhol talked about doing a surfing movie in San Diego, presumably to work again with Hompertz, a San Diego–based surfer who, although not much of a performer, had strikingly good looks and a chiseled, muscular body. Warhol explains: "In May, Paul, Viva and I went out west together to talk at a few colleges, and once we were out there, we started filming a surfing movie in La Jolla, California."[45] The resulting film, *San Diego Surf* (1968), includes much of the cast from *Lonesome Cowboys:* Tom Hompertz, Viva, Taylor Mead, Louis Waldon, Ingrid Superstar, and Eric Emerson, as well as a newcomer, an African American woman named Nawana Davis. For Warhol, the surfer was like the cowboy or the motorcyclist—another pop culture icon of gay masculinity.

In the film, Viva is married to Taylor Mead, a rich property owner who is supposedly a golf and tennis champion, but he can't manage to climb the social ladder of La Jolla because he's not a surfer. On the verge of getting divorced from Viva, Taylor indicates that he plans to marry Nawana Davis, an irresistible dancer who is the "wealthiest girl in La Jolla." Nawana, however, considers Taylor to be a stalker, but she's trying to give him some "soul." Despite Taylor's professed interest in her, he really has his eye on two men: Joe Dallasandro, a newcomer who's also trying to learn how to surf, and Tom Luau (Tom Hompertz), a local Hawaiian surfer. A subplot involves Ingrid Superstar, who might be two months pregnant, and Viva's attempts to find her a husband, even though Ingrid already has a steady boyfriend, Eric Emerson, who admits that his three previous marriages were a way of compensating for his homosexuality.

In one memorable scene, Taylor sings a song to a baby whom he holds in his arms. Viva complains to Joe that Taylor is not a caring parent. After she takes the infant from him, Taylor suggests that if he and Joe have a baby, he'll be better, to which Viva mockingly replies, "In whose womb?" We hear the sound of motorcycles outside, which causes her to launch into a tirade: "Damn motorcycles out there. The whole neighborhood's going to pot. First they let the hippies in. Then they let the motorcyclists in. The next thing you know we're going to have the Ku Klux Klan racing down the streets." As Viva scoops up another child, the baby suddenly slips out of her arms, but Joe somehow manages to catch the falling infant. Obviously ruffled, Viva blames Taylor, who quickly retorts, "You were nearly a complete failure as a mother."

In the film's final scene, Taylor lies on a surfboard and begs Tom to urinate on him. Tom discreetly takes down his pants and stands up, so that the framing only shows his legs. While Taylor pretends to masturbate and squeals about suffering and the cruelty of surfers, his face is sprayed with a foamy liquid (beer). Taylor is clearly ecstatic at what he considers to be his initiation into surfing and insists that he's "a real surfer now." The film ends with a shot of Tom standing at the beach, while Joe, who is also sitting there, gets up and leaves the frame.

Warhol was well aware that *San Diego Surf* was a dismal failure. He wrote: "Everybody was so happy being in La Jolla that the New York problems we usually made our movies about went away—the edge came right off everybody."[46] Interestingly, he adds: "From time to time I'd try to provoke a few fights so I could film them, but everybody was too relaxed even to fight. I guess that's why the whole thing turned out to be more of a memento of a bunch of friends taking a vacation together than a movie. Even Viva's complaints were more mellow than usual."[47] Joe Dallesandro suggests that there wasn't a very clear idea for the movie prior to filming.[48] Looking at the material, it's hard to imagine how the film could have been interesting given its narrative premise and lack of a central core. Victor Bockris attributes the film's failure to another growing issue. He writes:

> While most artists have pregnancy periods between projects, since 1962 Warhol had not stopped once. Now *Lonesome Cowboys* lay fallow, undeveloped and unedited. The attitude at the Factory was, according to Louis Waldon, "we'd made a good start with this new approach and now we'd do another one." But Warhol was abdicating his power and letting the films drift into Morrissey's hands. The *Surfing Movie,* or *San Diego Surf,* as it was alternatively called, was almost completely Morrissey's idea and doing.[49]

Warhol was not the only one who perceived problems with the surfing film. Its participants considered it to be a failure as well, and some, like Viva, placed the blame squarely on Morrissey. According to Bockris:

> Andy's detachment soon resulted in an all-out revolt on the set when the whole cast stormed off the beach and ran into the house, and Viva started screaming at Andy to take control of the movie. When he ran into his room she turned on Paul, who was cringing on the couch, and yelled at Louis [Waldon], "If you're a real man you'll beat the shit out of him and save this film from his cheap commercial tricks."[50]

The episode pointed to deep divisions within the Factory. For years, Billy Name and Gerard Malanga had prevailed with the avant-garde

faction, while Paul Morrissey and Fred Hughes now represented more commercial interests.

Aesthetically and conceptually, *San Diego Surf* is much less compelling than *Lonesome Cowboys*. In the latter film, the shy, nearly mute Tom Hompertz provides a stark contrast to the talkative Viva, who clearly wants to have sex with the young hunk, and feels growing frustration. Having Viva married to Taylor Mead in *San Diego Surf* robs the film of similar sexual tension between its lead characters. In narrative terms, there's nothing at stake. That an openly gay and effeminate performer would be attracted to other men would have little impact on Viva—in fact, at one point, she begs Joe Dallesandro to take Taylor off her hands.

By contrast, in *Lonesome Cowboys*, there is sexual competition between Viva and the other cowboys over Tom, as well as among the group of "brothers" over their common object of desire. The tension between Viva and the cowboys fuels the dramatic tension in *Lonesome Cowboys*. Several scenes have an element of unpredictability. The fight between Eric Emerson, Louis, and Joe Dallesandro turns into a real rather than staged battle. At Emerson's instigation, the cowboys rough up and molest Viva to the point where she screams for Warhol to intervene. The contradictions within the narrative—the shifts between the staged and the documentary-like events—add to the film's sense of uncertainty. *San Diego Surf*, by contrast, is dramatically flat. It amounts to a series of vignettes between characters who don't have contrary agendas. The only potentially explosive situation that could have been exploited was the real-life relationship between Ingrid Superstar and Eric Emerson; they broke up after shooting, which left Ingrid in tears.[51] The psychodramatic aspect, the hallmark of the very best Warhol films, is sorely missing in *San Diego Surf*.

On a formal level, the film isn't very interesting or innovative either. Even though Warhol can be seen operating a camera in a documentary on the making of the film, the final cut was edited by Morrissey, leaving it unclear how much of the footage in the film can be attributed to Warhol. The film lacks Warhol's patented strobe cuts and idiosyncratic camera movements. The staging of shots is rather pedestrian. The camera, for instance, often moves from a frontal wide shot to a closer framing. In the final scene, where Tom Hompertz supposedly urinates on Taylor, the act is constructed through editing. Hompertz lowers his pants as he stands up, so we see his pant legs. The film then cuts to a shot of urine supposedly splashing on Taylor's face. It's the type of

scene where believability requires seeing the entire action take place within the homogenous space of the frame, as Bazin argued in his example of the Jean Tourane animal film in "The Virtues and Limitations of Montage."[52] Even though the final scene of degradation has shock value, the way it is filmed seems phony—the quality Warhol always seemed to hate the most.

In addition, *San Diego Surf* is a surfing movie that doesn't show actual surfing or, for that matter, even big waves. That might sound Warholian on some level, but here it works against the film for the simple reason that the shots of the ocean are merely intercut with the narrative. Warhol wasn't interested in fidelity to genre expectations per se. After all, he worried that *Horse*, which was shot in the Factory, was too much "like a real Western."[53] Like *Horse*, *San Diego Surf* could have been shot in the Factory. In fact, the final scene of Tom Hompertz urinating on Taylor Mead was actually shot there. If the whole film had been staged there, the artifice would have been obvious. But because the film is shot on location, audience expectations change. In *Lonesome Cowboys*, the pop-top cans of soft drink, sounds of airplanes, filtered cigarettes, allusions to Superman, and so forth, announce the film's contrivance, whereas *San Diego Surf* pretends to be something that it's not. That certainly wasn't the case with Warhol's next film, the notorious *Blue Movie*.

BLUE MOVIE

Valerie Solanas's near-fatal shooting of Andy Warhol on June 3, 1968, turned out to have a profound effect on his career as a filmmaker. With Warhol recovering from a bullet wound to the stomach, Paul Morrissey made a film of his own, *Flesh*, over a six-week period. Warhol's near-death experience effectively ended his own filmmaking practice. In October of 1968, however, he made a final film before shifting into the role of producer of Morrissey's more commercial efforts. The idea reportedly came from Viva, who wanted to make a film in which she would actually have sexual intercourse on the screen. Warhol had previously made a number of films that flirted with the premise, such as *I, a Man*.[54] In *Lonesome Cowboys*, Viva and Tom Hompertz attempted to have sexual intercourse, but the act was never consummated.[55] The new idea was much simpler. There would be no real plot. The film would focus on an afternoon sexual escapade between Viva and Louis Waldon, who had had a previous sexual relationship. Warhol explains: "I'd always wanted

to do a movie that was pure fucking, nothing else, the way *Eat* had been just eating and *Sleep* had been just sleeping."[56]

Just as *Eat* and *Sleep* turned out to be much more complicated than Warhol's description, so too is *Fuck,* or *Blue Movie,* as it eventually came to be called. To make *Blue Movie,* four 33-minute rolls of film were shot on a single afternoon in the Greenwich Village apartment of David Bourdon.[57] According to Callie Angell: "This full-length version was screened for the press and shown at a benefit for *Film Culture* magazine at the Elgin Cinema on June 12, 1969; by the time the film opened at the Garrick in July, the first reel had been removed, shortening the film to 100 minutes."[58] All four reels comprise the restored version, which was finally shown as part of the "Views from the Avant-Garde" program at the New York Film Festival in 2005 with a personal appearance by Viva, who has prevented the film from being screened otherwise.[59] The title is a play on the film's subject matter as well as the fact that Warhol neglected to use the appropriate orange filter necessary to correct the tungsten-balanced color film for the sunlight that streamed into the apartment, which gave most of the footage a bluish cast.

Blue Movie begins with a close-up of Viva and Louis Waldon lying in bed with their clothes on. They talk about strychnine-laced drugs and the fact that blood is actually blue before the oxygen in the air causes it to change color. Waldon mentions that a friend managed to steal two unsigned paintings of Franz Kline from his house after he died. He asks her whether the two of them might be able to sell them for his friend. The conversation soon switches to the sexual act that they have to perform—they seem a bit unclear about the details—and the fact that it cannot be faked. Viva wishes they could get rid of everyone else there, presumably the crew, whom she refers to as the "ghosts." Louis suggests that Viva probably was out "fucking" someone named David the night before. She thinks it's unwise to use actual names. Waldon starts to undress on his own, but Viva asks him to unzip her outfit and indicates she forgot to wear underwear. He suggests she can wear his.

Viva asks him whether he was the one who gave her gonorrhea, but then indicates that she never actually had it and tells a story about a filmmaker who blamed her for a sexually transmitted disease. When she was tested and turned out not to have anything, she refused to talk to the person ever again. Waldon then discusses a woman who gave gonorrhea to him. Still in his underwear, he kneels over her, but she quickly indicates that she's not going to "suck his cock." Waldon then tells a funny story about Viva once performing fellatio on him before decid-

ing that it was boring. She asks him how many women he's slept with. He claims to have slept with 250, a number that doesn't impress her. They talk about Viva kissing two women in a bar several days earlier. As Waldon tries to arouse her, he suggests that her nipples look like "dried apricots." They also allude to a prior sexual encounter.

The first reel contains numerous cuts, including strobe cuts, but the second reel, in which Viva and Waldon have sexual intercourse, doesn't have any cuts or camera movement. The performers position or move their bodies rather than the camera. The second reel deals with Viva and Waldon's performance anxiety about having sex on camera. When Waldon wonders why Viva's hiding her body, she indicates that it's to prevent the "ghosts" from seeing her. Louis asks whether he was too rough the last time they had sex. She indicates that she would prefer that he be more like the time before that. Viva doesn't want to remove Waldon's pants unless he's "hard," which he suggests is her job. She calls his penis "disgusting" and tries to reposition him so that his "ugly cock and balls" are not facing the camera. Viva also criticizes Waldon for not being very romantic.

The doorbell rings unexpectedly, but nothing comes of it, even though Viva fantasizes that it might be another boyfriend. She worries that, for a sex film, they're doing very poorly. From a position on top, Viva tries to insert Waldon's penis into her vagina, but he rolls on top of her. She wishes Waldon would be harder, while he, in turn, jokes that he's going to give her a baby. Their lovemaking in *Blue Movie* is neither sensational nor shocking, nor does it last for an extended period of time. Near the end of the reel, Waldon accuses Viva of picking up guys at a bar. After first denying this, Viva counters that she only picked up those recommended by Taylor Mead, and all of them turned out to be terrible.

In reel 3, Viva's long story about getting stopped by the police for not wearing a brassiere in East Hampton segues into a long political discussion about Vietnam, her refusal to vote in national elections as a form of protest, Mayor John Lindsay's endorsement of Richard Nixon, and her assessment of politics as being something completely old-fashioned. Viva claims to be an anarchist and a radical. She tries to get Waldon to perform oral sex, but he claims that she promised to give him a blow job instead. In reel 4, the bluish cast of the light becomes much warmer in color. It also contains faster cutting. In an extended sequence, Viva and Waldon make themselves something to eat. We also see shots of the sunset out the window. Although we can't actually see it, Viva supposedly gives Waldon a blow job, but then complains about the awful taste. The

film ends with the two of them taking a shower. She washes his penis. He angles for another blow job, but Viva claims not to be in the mood. The two end up making animal sounds.

Blue Movie was released at the Andy Warhol Garrick Theater on July 21, 1969. Ten days later the police seized it on grounds of obscenity. Warhol would later highlight the contradictions of obscenity laws by publishing a transcription of the dialogue for *Blue Movie* along with over a hundred photographs.[60] Despite the aura that comes from being labeled pornographic, *Blue Movie* doesn't follow the conventions of pornography. It shows heterosexual sex as a natural occurrence between two people rather than as a spectacle. The camera doesn't move in closer for a better view of the action, but remains a passive recorder of what transpires in front of it. Even though it was reportedly her own idea, Viva wasn't thrilled with the results, especially the "sex scene, which she felt was flat, perfunctory and quite unlike the beautifully choreographed balletic mystical love scene she had envisioned."[61] Whatever she had imagined for *Blue Movie,* the usually uninhibited Viva underestimated the difficulty of having to perform such an intimate sexual act in front of the cold scrutiny of the camera. Just as Henry Geldzahler lost his protracted battle with the camera during his portrait, so Viva loses hers.

Although pornographic films routinely show hard-core sexual acts, they involve a level of staged performance. The camera changes everything, especially when the act needs to be performed within certain parameters, such as a single reel of film. It affects spontaneity, which was a hallmark of the type of amateur performers Warhol employed in his films. It's clear from the outset of *Blue Movie* that Viva, much more than Louis Waldon, feels extremely uncomfortable and self-conscious in the situation. She twice expresses a desire for the "ghosts" or crew members not to be there. She telegraphs the fact that she and Waldon have to perform an authentic act of sexual intercourse. She indicates that she's unclear exactly what they're supposed to do and suggests it needs to be clarified at a "commercial break," which is code for when the camera position moved or between reel changes. She even comments during the filming that she and Waldon are doing very poorly. Viva's painfully aware that she and her sex partner are struggling in an effort to create the necessary chemistry.

Viva's performance anxiety becomes palpable in the second reel, where she and Waldon are expected to have sexual intercourse. She doesn't want him to remove his underwear unless he's already hard. It's almost as if she is projecting male anxiety about penis size onto Waldon—the way Joe

Spencer's inability to get an erection undermined his credibility in *Bike Boy*. Or perhaps she simply feels that his displaying a limp penis reflects poorly on her. Waldon attempts to pass it off as "natural," but Viva turns it into an issue. She also accuses Waldon of not being romantic, which is certainly an odd response given the premise of the movie. While Waldon could be faulted for not being tender—he seems more interested in having her perform oral sex on him—Viva's usual complaints about male inadequacy seem less humorous within the context of this film.

Her disparaging remarks are certainly not a turn-on, but Viva's sudden ambivalence and anxiety about performing in the movie only cause her to become more aggressively critical as it progresses. Waldon refers to her nipples as "dried apricots," which is hardly a compliment, but in general he seems far more easygoing. Rather than a desire for sexual intercourse—the ostensible focus of the film—both Waldon and Viva would seem to prefer the other to perform oral sex. *Blue Movie* rather quickly and subtly develops into a battle of the sexes under the camera's pressure for the couple to have sexual intercourse. It is this tension that makes *Blue Movie* fascinating to watch. Otherwise, as Viva rightly surmised, the film isn't terribly erotic. Indeed, *Blue Movie* fails as pornography. If the police at the time prevented audiences from seeing the film, a final irony is that it continues to remain unreleased even today, not because of legal issues, but due to Viva's continued refusal to allow it to be exhibited publicly.

In many ways, it seems entirely fitting that Warhol's last film would depict an explicit on-camera sexual act between a man and a woman. Instead of providing sexual titillation, Warhol had gone all the way. His last two films both ran into censorship problems, but *Blue Movie* took the sexploitation film to its limits. Warhol later commented: "Why, I wondered, hadn't they gone over to Eighth Avenue and seized things like *Inside Judy's Box* or *Tina's Tongue*? Were they more 'socially redeeming,' maybe? It all came down to what they wanted to seize and what they didn't, basically. It was ridiculous." [62]

In 1966, Warhol had taken out an advertisement in the *Village Voice* offering to endorse just about "anything," so it's not surprising that while recovering from his injuries he would encourage Paul Morrissey to make *Flesh* under his brand. [63] Morrissey had shot a number of short films prior to working at the Factory and had been pushing Warhol to make more commercially oriented movies. If Warhol thought he had found his major superstar in Edie, Morrissey believed he had found his

in Joe Dallesandro, whose naked body would soon become the ticket to box office success.

Why Warhol handed over the reins to Morrissey has been a major source of speculation over the years, but it's certainly consistent with his philosophy. Warhol had gone about just as far as he could with cinema. It also became obvious from films such as *Soap Opera, Outer and Inner Space, Since,* and *The Nude Restaurant* that he had become increasingly fascinated by video and television. Even though Warhol stopped making his own films, he continued to produce those made by Morrissey, while actively pursuing other creative interests.

The next major phase of Warhol's film career was as the producer of a number of Morrissey's features, most notably *Flesh, Trash, Women in Revolt,* and *Heat.* Warhol was involved with them to some degree, but the new films, while borrowing many of the stylistic features of his work, turn out to represent a significant aesthetic departure.

Paul Morrissey Films

Confidential Stories

Of Warhol's myriad collaborators, Paul Morrissey poses the most controversial questions about authorship. Morrissey began working at the Factory in 1965 and gradually became more involved with the production of the films. Morrissey clearly wanted to make commercial films that would make money. Warhol wasn't opposed to making money—he loved money enough that the dollar sign became an iconic image in his paintings and silk screens—but he wanted to push the boundaries of the medium by continuing to do things that he hadn't done previously.[1] Tavel notes that Warhol "insisted always that [ideas] be very different and always do something new."[2] Since Warhol's death, however, Morrissey has forged a revisionist history of Warhol's filmmaking through published interviews and his own Web site, where he makes a number of startling claims regarding authorship. In 1997, for instance, Morrissey begins an essay: "From 1965 until 1974 I was the manager of Andy Warhol, a commercial illustrator for newspapers and magazines who having entered the Art market, then decided to produce film experiments."[3] The quote is remarkably revealing. In a single sentence, Morrissey manages to minimize Warhol's prominence as one of the most important visual artists of the twentieth century by asserting his own importance as "the manager of Andy Warhol" and reducing Warhol's oeuvre to his early career as a commercial illustrator.

In the same catalogue essay, Morrissey takes credit for giving Warhol the courage to move the camera in *My Hustler*—a puzzling claim to any-

one familiar with Warhol's use of the mobile camera in *Elvis at Ferus; Tarzan and Jane Regained, Sort Of . . . ; Soap Opera; Poor Little Rich Girl; Restaurant; Afternoon; Space;* and so forth. Morrissey goes on to suggest, "I gradually began to choose the performers in front of the camera and make more and more suggestions as to what they should improvise about, and in what tone of voice to do it."[4] Thus, Morrissey insinuates that he is the real director of many of Warhol's films. He then goes on to credit Warhol with being "as good a producer as any filmmaker could hope for."[5] Furthermore, in the accompanying filmography, Morrissey declares himself the "director" starting with *The Chelsea Girls,* while listing Warhol as the "producer" of films beginning in 1963.[6] Because Warhol's aesthetic involved not trying to direct or control many of the elements of his films (especially the performers), Morrissey's claim to be the director hinges on a false premise of what constitutes direction and authorship. Although Warhol was open to suggestions regarding ideas and performers, the evidence suggests that he had very clear ideas about the way he wanted his films to look.

Morrissey would have us believe otherwise. He suggests that Warhol was actually incapable of directing a film, so Morrissey became the de facto director. He writes:

> In actual fact the great majority of the experiments was boring. Early on I realized that very little could be just left to chance as Andy would have liked and as I had let happen most of the time. Even Andy gradually came to understand this. It might have been nice to produce something that had no direction and where no choices or ideas had any bearing on the result, but in actual fact this never did happen. The scenes that eventually did work were the result of many choices and conclusions drawn from previous experiments and gradually the so-called "non-directed" experiments took on a great deal of direction.[7]

The inherent contradictions of Morrissey's statement should be readily apparent. But what's even more confounding is his assertion that the scenes that actually worked were really directed by him, a claim that has been refuted by others associated with Warhol, such as Billy Name.[8]

It's curious that Morrissey never claimed authorship for Warhol films at the time they were made, even for *Flesh,* a film for which Morrissey clearly deserves credit as director. Victor Bockris writes:

> A lot of people at the Factory criticized Morrissey for taking advantage of the situation and trying to promote himself as a filmmaker on his own. When the film [*Flesh*] was released, however, Paul chose to play down his own role and listed Andy's name as director on the credits. A Warhol film was compa-

rable in his mind to a Walt Disney production. Besides, he thought, the idea of a "director's cinema" was "snobbish and trashy." Paul was, he said, "just doing a job for Andy."[9]

Morrissey might have understood that Andy Warhol was a "brand" like Walt Disney, but he subsequently altered his assessment of his own role.[10] Because Warhol often worked to subvert his own authorial control in his films, it should be noted that authorial control and authorship are two separate issues.

The idea that Warhol was completely passive in creating his films is one of the many myths perpetrated about his work. Reva Wolf describes an incident in filming a segment of *Couch* in which Jack Kerouac attempted to commandeer the scene and Warhol adamantly resisted. Kerouac wanted Ginsberg to sit on a toilet, whereas Warhol insisted that it had to involve the couch. Wolf writes:

> The exchange between Kerouac and Warhol concerning the toilet is perhaps the most revelatory regarding Warhol's filmmaking procedures. It demonstrates concretely how very mistaken is the commonly held assumption that Warhol's role as a director consisted of simply turning on the camera and walking away (even though he may have on occasion done just that). This exchange, in which Kerouac endeavored to virtually be the director, shows that, on the contrary, Warhol was extremely engaged in the production of his films. Some input from the actors was acceptable (and often desirable), such as Kerouac's suggestion that they sit off rather than on the couch, but the basic scenario and visual composition were Warhol's, and he was capable of being insistent if someone—in this case, Kerouac—tried to change them.[11]

Wolf's statement needs one qualification. At Warhol's instigation, Ronald Tavel did write scenarios for a number of Warhol's most important works, even if Warhol often tried to subvert them during production.

In a 1968 Pacifica Radio interview with Bruce Haines and George McKittrich, the two clerks from the clothing store scene in *Bike Boy*, Haines offers his own insights into what actually occurred on set during the production of a Warhol film. Although numerous superstars were present during the filming of the scene, which was shot in San Francisco, Haines, an art student at the time, insists that Warhol was very much the force behind the film. According to Haines:

> [Warhol] is working completely alone in this crowd. And even . . . he's not even working that closely with Paul [Morrissey]. Paul is doing the technical aspect of it. Andy is behind that camera. He is seeing what he wants to see through that. And he's telling no one else what he wants to see. He's telling no one else when he wants to flip the switch—flip it off and on, off and on.[12]

Even this novice performer intuited that it was Warhol and not Morrissey who was the guiding presence behind the unscripted *Bike Boy*.

Other evidence reinforces the idea that Warhol had strong aesthetic opinions. In an audiotape that accompanies the book *The Andy Warhol Museum*, there's a recorded phone conversation between Warhol and Sam Green about a female client who wants to reject her commissioned portrait because her husband didn't think it was flattering. Warhol has difficulty understanding the reasoning behind this. To him, the woman is "treating it [the painting] like a photograph."[13] Even though the painting was based on a Polaroid, Warhol insists on the distinction between a painted portrait and a photograph in terms of representation. He refuses to back down.

We also know that Warhol became angry when Gerard Malanga attempted to pass off one of his own silk screens of Che Guevara as a work by Warhol. Malanga's actions, in fact, caused an irreparable rift in their relationship.[14] If Warhol were alive today, he no doubt would have been shocked to read in the special "Andy is 80" commemorative issue of *Interview*, the very magazine he founded, the introduction to an interview with his one-time collaborator: "Paul Morrissey directed a dozen films that were produced by Andy Warhol, starting with *Chelsea Girls* in 1966 and ending with *Blood for Dracula* in 1974."[15] Yet, as I intend to demonstrate, the films that can realistically be said to be Morrissey's are quite different from Warhol's films. For the purposes of my argument, my analysis of Morrissey films is limited to the four films that bear resemblance to Warhol's films, namely *Flesh, Trash, Women in Revolt,* and *Heat*. I do not analyze *L'Amour* (1972), *Flesh for Frankenstein,* aka *Andy Warhol's Frankenstein* (1973), or *Blood for Dracula,* aka *Andy Warhol's Dracula* (1974). They have an entirely different mode of production and thus do not illustrate the fundamental differences between the films of Warhol and those of Morrissey.

FLESH

Although Paul Morrissey claims authorship for *The Chelsea Girls, The Loves of Ondine, Imitation of Christ,* and *Lonesome Cowboys* on his personal Web site, most critics and scholars generally regard *Flesh* (1968–69) as his first film.[16] Warhol was still recovering from his gunshot wounds when the film was shot. He himself acknowledged that Morrissey was fully in control of *Flesh,* whereas he merely functioned as the film's producer.

There are some similarities between Warhol's films and *Flesh*, such as the use of disjunctive strobe cuts, which are also found in *My Hustler; Bufferin; I, a Man; Bike Boy; The Nude Restaurant; Lonesome Cowboys;* and *Blue Movie*. *Flesh* also features Warhol performers Louis Waldon and Joe Dallesandro. It also contains a completely silent sequence, typical of Warhol, in which the naked Dallesandro sits on the floor and feeds part of a cupcake to a baby. Yet *Flesh* contains many elements that clearly differentiate it from Warhol's work. For Tony Rayns, the main difference has to do with the issue of authorial control:

> Although it constantly threatens to erupt in films like *The Loves of Ondine* and *Lonesome Cowboys,* the underlying schism between Warhol cinema and Morrissey cinema was more or less contained until 1968, when Morrissey profited from Warhol's absence in hospital by making *Flesh:* a film that borrows some of Warhol's actors and methods but categorically rejects the arbitrariness and detachment that were the foundation stones of Warhol's cinema.[17]

Jonas Mekas made a similar point about the relationship between Morrissey and Warhol's cinema when *Flesh* was released:

> The film is a good illustration of what Andy Warhol isn't about. Probably the most important difference is that *Flesh* is constructed, plotted, and executed with a definite calculation to keep one interested in it. The hero goes through a series of "sex-novel" adventures, designed to "cover the ground," to "give an insight"—like a *Confidential* story. And it works. I think the film achieves what it set out for itself to achieve. But a Warhol film never gives you an impression that it wants to make itself interesting.[18]

Callie Angell echoes Mekas's point about Morrissey's desire to maintain viewer interest. She writes:

> *Flesh* is a clearer illustration of Morrissey's very different approach to filmmaking: despite some obvious concessions to the Warhol style, Morrissey's first version of a "Warhol" film is a carefully structured narrative that works at maintaining the interest of its viewers—and is thus the polar opposite of Warhol's earlier films, which repeatedly sought to subvert or offend normal audience expectations.[19]

Mekas and Angell are absolutely right in their assessments. There is an ingratiating quality to *Flesh* that Warhol films never adopt, which is why Mekas ultimately considers it to be a mere "caricature" of a Warhol film.[20]

Flesh was conceived as a response to Hollywood's appropriation of material that previously had been the domain of the underground. Warhol had explored the world of the male hustler in *My Hustler*. The suc-

cess of the musical *Hair* (1968) and the production of John Schlesinger's *Midnight Cowboy* (1969) proved that mainstream culture had taken notice of the underground. Various members of the Warhol crowd— Viva, International Velvet, Taylor Mead, Ultra Violet, and Paul Morrissey—were even recruited to be extras in *Midnight Cowboy*. As Warhol reasoned, perhaps they had been too early with *My Hustler*. Under contractual obligation to deliver a film but still in the hospital, Warhol reportedly suggested to Morrissey: "Maybe now *is* the smart time to do a film about a male hustler. Why don't you do another one—this time it can be in color."[21]

Morrissey intended *Flesh* to be a star vehicle for Joe Dallesandro. The film begins with an extended close-up of Joe's sleeping face on a pillow—an allusion to Warhol's early film, *Sleep*. This is followed by two progressively wider shots of the naked Joe lying on the bed, framed to emphasize the round curve of his buttocks. His wife (Geraldine Smith) walks in front of the camera and hits him with some clothing and then his pillow in an effort to wake him up. When he fails to do so, she pulls his hair and acts abusively toward him. After the two kiss (an allusion to Warhol's *Kiss*), Joe gets an erection while making out with Geraldine. Seemingly shocked, she asks, "What are you doing—clothes on?"

Geraldine wants him to raise $200 for her friend's abortion. This provides the pretext for what follows: a series of episodic incidents in which Joe attempts to earn the money by being a male hustler. *Flesh* is structured very much like a porn movie in the sense that the narrative becomes a very thin excuse to create situations that will serve to display Dallesandro's naked body. The inclusion of Joe's erection makes the film remarkably explicit, indicating how much things had changed from the days of *My Hustler* or the black g-strings of *The Nude Restaurant*. Since *Flesh* represents an attempt to be a more "authentic" version of *Midnight Cowboy*, Morrissey includes documentary-like, telephoto shots of Joe hustling on the street. His attempt to create a sense of gritty realism is certainly uncharacteristic of Warhol, who worried that bringing Mighty Byrd into the Factory for *Horse* made it seem too much like a real Western.

Following the documentary shots, we cut to Joe with a customer, who pays him $20. Afterward, Joe is picked up by an elderly man who gets him to assume classic Greek poses in order to draw his naked body. Joe later talks with two other hustlers on the street, including a novice, which serves as an excuse for the viewer to learn more intimate details about this particular subculture. As such, it functions much like Paul

America's interrogation of Joe Campbell in *My Hustler*. The novice wants to know how Joe can tell whether a potential client can pay for a trick, but Joe responds, "You don't worry about it. It's *[sic]* only gonna suck your peter, man."

Two transvestites, Jackie Curtis and Candy Darling, sit and read old Hollywood fanzines. The camera pans to Geri Miller's hands clutching Joe's buttocks as she performs oral sex. Geri, who is Joe's girlfriend, also bares her breasts and insists that she wants to have implants, which will make her more attractive as a topless dancer. In making their assessments, both Joe and Jackie fondle Geri's breasts. The intent of the scene is to broaden the appeal of the film to include heterosexual men. In the next scene, Joe visits Louis Waldon, a john who's very much in denial about the nature of their relationship.

The scene cuts to the laughter of Geraldine and her pregnant friend (Patti D'Arbanville) as they lie on a bed and discuss drugs and perverts. There's a close-up of the two women snuggling together, suggesting that they are, in fact, lesbians. Joe tries to go to sleep between them, but Patti climbs over him to cuddle with Geraldine. There are a number of strobe cuts of Geraldine fondling Patti's buttocks as Joe watches from beside them. He winds up being excluded—an outcast in his own home. The function of the scene is to exploit heterosexual men's supposed fascination with lesbianism.

Flesh is different from a Warhol film in several significant ways. For one thing, Morrissey conventionalizes certain stylistic traits of Warhol's films in order to appeal to the commercial market. Whatever might be said about Warhol, he was never interested in making conventional films. He had a well-known abhorrence of plot and often subverted any move in that direction. Scenes in Warhol films have a degree of unpredictability. There is a sense that anything might happen, even in the works that were scripted by Tavel. Except for Joe's unexpected erection in the opening scene, which seems to startle Geraldine Smith, each scene in *Flesh* clearly has a specific function in accordance with pre-established parameters. There's no edge to any of them, no chance that one might take off in some unexpected direction, as was often the hidden agenda in a Warhol film. This is very much related to performance. As Mekas put it, "In a Warhol film, even when an 'actor' acts, it looks like he's living it; in a Morrissey film, even when an actor lives it, it looks like he's acting. Which is all fine. Only that the two authors are after different things."[22]

Like Warhol, Morrissey relies on improvisation, but the differences in their approaches are fundamental. In Morrissey, there isn't the same ten-

sion between actor, role, and situation or between performers that one finds in Warhol films. Joe Dallesandro gives a naturalistic but restrained performance in *Flesh,* mostly because there is really no dynamic between him and any of the other performers. There's no sense, for instance, that the scene between Joe and Louis Waldon can go anywhere beyond Waldon's final announcement that he wants to suck Joe's cock. In a Warhol film, the scene would be an open situation in which the potential for spontaneous behavior would always be maximized.

The standoff between Joe Campbell and Paul America in the bathroom scene of *My Hustler,* for example, bristles with sexual tension and subtext, whereas the scene between Dallesandro and Waldon appears flat. Nor can anything dramatic possibly occur in the final scene, where Joe returns home to find that his wife has become involved in a lesbian relationship. Somewhat sadly, Joe's only option is to fall asleep. By Morrissey's next film, *Trash,* the disjunctive strobe cuts disappear altogether and the performances become much more conventional, as Joe Dallesandro "acts" the part of a strung-out drug addict, and the camerawork simply serves the narrative. The self-distributed *Flesh* played for a year in New York City, where it grossed approximately $2,000 a week, but the film received commercial distribution in Germany, where it was reportedly seen by 3 million viewers.[23]

TRASH

Even more than *Flesh, Trash* (1970) attempts to comment on the relaxed mores brought about by 1960s hippie culture, a development that the politically conservative Morrissey absolutely detested. Joe Dallesandro, with his long hair, headband, promiscuity, and serious drug problem, represents the fallout from the Haight Ashbury and the East Village scenes—the degradation that Morrissey saw as resulting from failed experiments with personal freedom, which left many casualties in its wake.[24] Ironically, this aspect of *Trash,* which had a long and successful theatrical run and reportedly grossed $1 million domestically and $3 million worldwide, was largely misunderstood by most mainstream viewers.[25] Rather than being seen as what Maurice Yacowar calls Morrissey's attempt to expose drug users "as worse than the Bowery winos because they self-righteously disguised their weakness as championing liberty," *Trash* was instead viewed as a chic comedy that celebrates rather than critiques this subculture, largely because the film so heavily features both sex and drugs.[26]

In fact, the narrative becomes an excuse to view Dallesandro and various women naked or to watch him shoot up. It provides a glimpse of what most people thought had been going on in the underground for years. After the credits, we see a grainy shot of Dallesandro's naked buttocks, as someone else's hands paw them, suggesting the act of fellatio. The camera pulls back to reveal this to be the case, but Geri Miller indicates that "it's not working." She implies that Dallesandro's difficulty in getting an erection stems from his drug use. Her solution is to dance on the nearby stage in order to arouse him. Against a backdrop that includes strands of flickering Christmas lights, a shiny Mylar drape, and three white film screens that move up and down, Geri strips and dances to a catchy rock tune, as her enormous, recently implanted breasts shimmy to the beat of the music. Not only does Morrissey provide the spectacle of a fully naked female stripper, but he cuts to a medium shot of Joe, also naked, which allows an extended look at his genitals.

The failure of men to satisfy women sexually is also a recurrent theme in Warhol's films, including *Beauty # 2; Bike Boy; I, a Man; Imitation of Christ;* and *Lonesome Cowboys*. For example, *Lonesome Cowboys* begins with an extended sex scene between Romona (Viva) and Julian (Tom Hompertz), but Warhol frustrates the viewer by shooting the scene at night in extremely dim light, so that it's nearly impossible to see the action. There is an enormous difference between Warhol's approach and how sex is treated in Morrissey's films. As *Trash* illustrates, Morrissey is far more interested in the display of naked bodies.

Of course, Warhol made a career of pushing the boundaries of prevailing censorship laws. The infamous *Blue Movie* was seized by police on grounds of obscenity, but even there, sex is not shown for its titillating qualities. As Tony Rayns explains:

> By documenting its own time-frame (one afternoon and evening) and limiting its subject to conversation and sexual relations between two people (Viva and Louis Waldon), the film succeeds in upholding the principles of concentration, arbitrariness and serendipity that were cornerstones of Warhol's cinema from the start. The domestic intimacy of the content and the obvious absence of directorial control (both Viva and Louis make it clear that they themselves determine what happens) turn the film into a flow of random thought associations, gestures, mannerisms, whims, speech-slips, in fact a glossary of unconscious self-expression, all brought into focus by the fact that the two people on screen are adults who have agreed to be filmed chatting and making love.[27]

In other words, Viva and Louis Waldon are permitted the freedom to improvise for the camera. Surprisingly, this leads to references to the

Vietnam War. In *Trash,* as Geri and Joe lie naked on the couch, unable to have sex, she asks him, "Does politics turn you on?" Joe answers, "I don't know?" Geri then asks, "Well, like, do you think we should have war?" He asks, "Why? Does it matter?"

The scene with Geri is tangential to the film's main plotline, which more or less deals with Joe's live-in relationship with Holly Woodlawn, an excitable transvestite and inveterate junk collector. The film's title, in fact, is a play on Holly's fascination with trash, both discarded objects and drug users like Joe, and, by extension, everyone else in the film. While Holly is trying to talk to him, Joe nods off, causing her to throw a small tantrum over his drug use, which not only renders him sexually impotent but also incapable of engaging in normal conversation. Morrissey cuts from this scene to Joe nodding off on the street with his dog. Joe then walks down St. Mark's Place, talks with an acquaintance, and later that night runs into Andrea Feldman, who wants him to get her some LSD, even though she only has a dollar. At her place, Joe aggressively slaps Andrea around and tries to rape her, but he still can't get an erection.

In his book on the films of Paul Morrissey, Maurice Yacowar sees films like *Flesh, Trash,* and *Heat* as breaking from Warhol's work in several ways. He writes: "Technically, Morrissey adopted plot, characterization, more controlled sound and color, the impulse to expressive camera and editing work, and working professionals. Morrissey's technical advances always had a purpose, however, or at least a telling effect."[28] Such strategies were attempts to make Warhol's filmmaking style more conventional. Although there's a slight semblance of plot, *Trash* entails a series of episodic incidents involving Dallesandro as the object of desire of various women, as we've seen in the first two scenes with Geri and Andrea.

In the next scene, Holly brings home a sixteen-year-old boy (Johnny Putnam) whom she's met outside the Fillmore East, and ends up exploiting him sexually. Joe later breaks into a fancy apartment in order to steal. Instead of being frightened or scared, the woman (played by Jane Forth, another reportedly underage performer) gets Joe to take a bath, shave, and clean up—another excuse to display Joe's naked body. She then tries to get him to have sex with her and her husband, Bruce (Bruce Pecheur), who's excited to watch Joe shoot up. But after Joe starts to nod out, Bruce throws the still naked junkie out of their apartment, along with his clothes. Back home, Holly masturbates with a beer bottle because Joe still can't get an erection. Following a scene in which

Holly catches Joe cheating with her sister, a social worker, Mr. Michaels (Michael Sklar) investigates Holly's claim for welfare on grounds that she's pregnant, but discovers the ruse when a pillow slips out from underneath her sweater.

Unlike a typical Warhol film, which always contains unpredictable elements, virtually every scene in *Trash* (as in *Flesh*) has a clearly defined structure. While the macrostructure is episodic, each scene contributes to the larger narrative. Each leads to an endpoint that's been fixed in advance by the director and actors. The scene with Andrea will end in rape, the one with Jane Forth and her husband will conclude with Joe being thrown out, Holly's masturbation scene will end with their clasped hands and a pan to Joe's face, the social worker will discover Holly's welfare scam and be chased away by Joe, and so forth. That's not the case in Warhol's films, even when he worked with a script, because Warhol or the performers managed to subvert such expectations, or because the situations provided an impetus for the unpredictable to happen.

In Warhol's films, scenes have an endpoint, but the duration of a particular scene is defined not by the narrative, but usually by the length of film stock that's running through the camera. This is what gives his films a sense of arbitrariness and detachment that is sacrificed to authorial control in Morrissey's work. True improvisation has been sacrificed as well. Although Morrissey's early films are not necessarily scripted, it becomes patently obvious that the performers are not the same free agents they were in Warhol's earlier work.

The difference in sensibility is also reflected in the performances. Writing in the *New York Times,* the art critic and poet Peter Schjeldahl suggested that *Trash* "may be edging toward an entente with conventional narrative cinema." He observes:

> It possesses in its handling of characters a measure of wit and warmth not generally present in Warhol works, which—and the great, harsh "Chelsea Girls" remains the supreme example—tended to fix the vagaries and vulnerabilities of actors in a gaze so frostily cool that the effect was often harrowing. Compared to "The Chelsea Girls," "Trash" is a positive idyll, accepting and rejoicing in the kinky or glamorous affectations of its stars. In this way, as well as in its doting allusions to 1930's musicals and Depression comedies, "Trash" is high camp to the core—more engaging, but rather slighter, than past movies by Warhol himself.[29]

Despite its abject subject matter, Morrissey manages to tame what was most threatening and subversive in the earlier Warhol films by creating

pathos for his characters—something Warhol never wanted his audience to feel—and by ultimately turning *Trash* into a lighthearted farce.

WOMEN IN REVOLT

The specter of Valerie Solanas hangs over *Women in Revolt* (1971), Morrissey's satire of the women's movement. The film features three transvestites—Candy Darling, Jackie Curtis, and Holly Woodlawn—in the lead roles. Darling, Curtis, and Woodlawn had appeared previously in *Flesh* and *Trash*, but the use of gender reversal in the context of the women's movement adds another layer of mind-boggling parody. Or, as Jim Hoberman puts it: "The revolt defining *Women in Revolt* is a revolt against gender that revolts against itself: Men who wish to be women impersonate women who, so they imagine, wish to liberate themselves to be like men." [30] It is perhaps not a coincidence that Morrissey cast transvestites in dealing with the subject of women's liberation, given Valerie Solanas's unflattering take on drag queens in her political tract, the *SCUM Manifesto:*

> The male dares to be different to the degree that he accepts his passivity and his desire to be female, his fagginess. The farthest-out male is the drag queen, but he, although different from most men, is exactly like all the other drag queens; like the functionalist, he has an identity—he is female. He tries to define all his troubles away—but still no individuality. Not completely convinced that he's a woman, highly insecure about being sufficiently female, he conforms compulsively to the man-made stereotype, ending up as nothing but a bundle of stilted mannerisms. [31]

The constant allusions to Solanas in *Women in Revolt* are deliberate, especially because they shape the plot.

Women in Revolt tells the story of three women who become involved in a movement entitled "PIGs"—Politically Involved Girls. Led by Jackie Curtis, they decide that men have an unfair advantage and together seek to gain control of their lives. Candy, a rich socialite who has been having a tawdry affair with her brother, becomes a lesbian. Holly Woodlawn, a fashion model and kept woman, is the most man-obsessed of the trio; she rebels against a guy named Marty, who's paying her rent. As he tries to rape and beat her, Holly yells, "I love cunt" and "Women will be free." Her friend Jackie, mimicking Solanas, insists that men are only after "pussy."

Women in Revolt uses a parallel structure to cut back and forth between scenes of the three characters. As Jackie sings the virtues of wom-

en's liberation and treats a man named Dusty like he's a houseboy, he claims that the movement has turned her against him. In a reversal of male abusiveness, Jackie tosses a drink in his face, slaps him, and throws lighted matches at him. She again references the SCUM *Manifesto* by insisting that males are inferior. When Holly arrives with a man carrying a houseplant, Jackie throws him out of her apartment, shouting, "Will you take your genitals and beat it?" As Jackie and Holly later make out passionately, Jackie decides to get Candy Darling to join their movement by insisting, "We need a beauty to stand alongside of us." They browbeat Candy into using her social connections to aid their cause. She introduces them to a wealthy woman named Mrs. Fitzpatrick (played by another transvestite, Sean O'Meara), who writes them a blank check and promptly dies.

Following this extremely long and convoluted setup, the film follows the trajectories of the three women's careers. Candy, who now wants to be a Hollywood star, wows an agent, Max Morris (Michael Sklar), with camp impersonations of Joan Bennett, Lana Turner, and Kim Novak. When she refuses to accept a job for $75 at Grossinger's Hotel in the Catskills, Max calls her a "nobody," but Candy responds, "I'm everybody, all the time." After Candy resists the agent's attempt to seduce her on the casting couch, he suggests that sex rather than talent has been the gateway for actresses into the business, which echoes Tavel's remarks to Mario Montez in *Screen Test # 2*. After he rejects her as nothing more than a "dime-store cutie," Candy consents to have sex.

Jackie, who's still a virgin, hires the well-known bodybuilder Johnny Minute (Johnny Kemper) to initiate her into heterosexual sex, but he forces her to perform oral sex. She eventually gags and falls back on the couch after he climaxes. Jackie says, "So that's it? Maybe it was good for you, but it didn't do anything for me." Johnny agrees to have sexual intercourse with her for more money. He climbs on top of her but she remains fully clothed. Morrissey cuts to a close-up of his naked buttocks and then to a wider shot as he asks, "You gonna come?" Jackie responds, "I don't know. I think I'm going to go." He lightly slaps her across the face and calls her a dyke as she fakes an orgasm.

Morrissey cuts to hands ripping pages of a calendar, indicating the passage of time. Holly staggers through the snowy streets of New York City with a wine bottle in her hand. In a phone conversation, Jackie explains that she now has a baby and that Johnny Minute has spent all of her money, but insists it was worth it. A photo session involving Candy is interrupted by a reporter who interviews her about her new

film. After she credits Jackie and PIGs for her success, the columnist brings up the "dirt" about her—the suicide of her parents, her incestuous relationship with her brother, and her sleeping with various directors to get parts in foreign films where she does very little. He calls her "a girl that stopped at nothing, including lesbianism, to get to the top." Alluding to the title of her new film, the reporter remarks, "I don't think you're a Blonde on a Bum Trip; I think you're a Bum on a Blonde Trip."

Following the box office success of *Trash*, *Women in Revolt* was originally intended to showcase Holly Woodlawn, but Candy Darling ends up becoming the film's major focus, even though she gives the most theatrical performance of the three main characters. Although Candy's persona was that of a Hollywood actress, she is clearly "acting" in *Women in Revolt*. Her dialogue feels scripted rather than spontaneous. There's nothing in any of Morrissey's films that approximates the sheer brilliance of Eric Emerson's improvised lines to Joe Dallesandro in *Lonesome Cowboys*: "You gotta have something . . . that just comes like animal. You know, ah, we're all animals: dogs, cats. Cats? Where do they carry their purses? You know, do they tie it to their tail, a little ding-a-ling, their bells." Despite Morrissey's claims that his films were entirely based upon the personalities of his actors, he sought to gain greater control over every aspect of the film, including their performances.

Morrissey's concern with plot is often undercut by his propensity for parody and farce. Much of this has to do with the fact that the motivation of his characters remains somewhat inconsistent. If men are so obsessed with "pussy," as Jackie Curtis claims, then why is she still a virgin? Why would she have to pay Johnny Minute to have sex with her? If Jackie believes that men are inferior to women, hence the lengthy scene where Jackie abuses Dusty, why would she hire a gigolo to service her, especially one who exploits, abuses, and fails to satisfy her sexually? Despite her unhappiness with having a baby and Johnny's squandering of her money, why does Jackie become impressed by having Mr. America's baby? Candy and Holly are as inconsistent in their behavior. There does not seem to be any motivation for Holly's becoming a derelict other than to serve as an allusion to Valerie Solanas's personal biography.

In addition, the extended setup could be simplified. Candy's family could finance PIGs rather than having to introduce Mrs. Fitzpatrick. Her writing a blank check just prior to dying seems to be an awkward plot contrivance. There's no real dramatic arc to the decline of the three main characters, whose fortunes merely plummet after they succeed in

getting Mrs. Fitzpatrick's money. And despite being heavily edited rather than edited in-camera, as was Warhol's preference, the film still contains several unnecessary scenes, such as the one with Candy's father or the one of Holly urinating on the street. But such criticisms of *Women in Revolt* really stem from those conventions of narrative filmmaking that Morrissey—at least at this point—seems unable or unwilling to embrace.

HEAT

In *Heat* (1972), the third film in what constitutes the Joe Dallesandro trilogy, Morrissey moves even closer to mainstream cinema by employing slicker production values and far more conventional staging of shots, including the use of eye-line matches and reaction shots. He also casts a professional actress, Sylvia Miles (who was nominated for an Oscar for her brief performance in *Midnight Cowboy*), mixed in with Warhol regulars such as Dallesandro, Andrea Feldman, and Eric Emerson. The location of *Heat* has moved from New York City to Hollywood, reflecting Warhol and Morrissey's continued fascination with the film industry.

Joey Davis (Joe Dallesandro), a former child actor whose major claim to fame was a five-year stint on a television show entitled *The Big Ranch*, is now an actor and musician trying to reignite his career. By making Joey into a character whose career has already peaked in childhood, Morrissey employs an exaggerated example of Warhol's notion of everyone's fifteen minutes of fame. Joey shows up at a sleazy hotel run by the overweight and tough-talking Lydia (Pat Ast), who is willing to trade rent for sexual favors. Other guests include a young lesbian named Jessie (Andrea Feldman) who has a baby and lives with her girlfriend, Bonnie, much to the consternation of her mother, a wealthy and aging Hollywood actress named Sally Todd (Sylvia Miles) who is trying to keep her daughter's relationship out of the tabloids. Emerson plays a mentally challenged and mute young man who wears a dress and is prone to masturbation.[32] He and his brother, Gary, have a nightclub act in which they have sex with each other only on stage, but apparently not in real life, another Warholian notion involving the reversal of public and private spheres.

Once again, the good looking Joe Dallesandro, whose long hair serves as a symbol of his masculinity, is the object of everyone's desire—male and female alike. Lydia, Jessie, Sally, and her ex-husband's lover, Harold (the painter Harold Stevenson under the pseudonym Harold Childe)— all want a piece of Joey. There is no frontal nudity in *Heat,* but Joey

engages in a form of sex with Lydia while wearing only a jock strap. When he has sexual intercourse with Sally Todd, who bares her rather large breasts to the camera, Joey is shot so that we only see his naked body from behind. He will later receive oral gratification from Jessie and Harold.

Heat begins with a tilt down from a blue sky with a palm tree visible on the left side of the frame to reveal Joey. The camera zooms out as we see him standing in the loading dock in the remains of the recently vacated lot of the Fox Studio, an image that will serve as a metaphor for the lives of Joey and the rest of the characters we meet in the film, which depicts the aftermath of a once glorious industry now in ruins. From shots of Joey walking around the studio, the film cuts to a close-up of Eric Emerson, who wears a dress and strolls down to the pool. As Joey turns up at the motel, Eric pushes his brother into the pool. Lydia yells, "Hey, don't throw that kid in the pool. You know I don't allow things like this here." As Eric dives into the water, Lydia tells Joey, "Some of these people around here are just downright disgusting. This LA is going to the dogs, but not here, not in this place." Morrissey employs parallel editing between the events occurring at the pool and Joey and Lydia on the stairs. She recognizes Joey as someone who used to be on TV.

As Joey lies in a reclining beach chair at poolside, Jessica, dressed like a Greek peasant, asks, "Aren't you Joey Davis? Oh, I'm such a big fan of yours. You probably don't remember me. I saw you on the TV show, *The Ranch.*" Her question suggests the imagined intimate relationship that fans have with celebrities—as if Joey somehow had the ability to see members of his viewing audience from inside their television sets. The camera zooms out into a two-shot of them talking as Jessie explains that her mother used to be on the same show. Jessie describes her: "She's a damn tall girl, a cheap chorus girl, a whore all over town." When Joey visits Jessie in her room, Sally shows up and naturally remembers him.

Jessie takes Joey to visit her mother in Bel Air, but she has to leave when Bonnie calls and threatens to kill herself. After Joey takes a dip in the pool and Sally gives him a tour of her thirty-six-room mansion, they begin kissing. The film cuts to Joey completely naked on her bed. Once the two of them make love, however, Sally's insecurities begin to surface. When he presses her to help him get a job, she brags, "The name of Sally Todd means something in this business." But the next time we return to them, Sally is in tears and has completely fallen apart because she doesn't want Joey to leave her. From a scene where Joey initiates lovemaking on the stairs, Morrissey cuts to a session with a Hollywood

gossip columnist and a producer named Ray who turns out to be unimpressed with Joey. When Joey eventually attempts to leave Sally for good, she tries to shoot him, but the gun doesn't have any bullets and the camera ends up framing the undulating water in the swimming pool.

In *Heat*, Morrissey portrays Joey as a typical male hustler, a guy who's continually on the make in his quest to become a Hollywood celebrity. He's willing to trade his body for rent, clothes, or a nice place to stay—all the while feeling nothing but contempt for those who desire him. Stephen Koch describes this dynamic eloquently:

> In revenge for this dispossession, the hustler arranges to be paid and secretly (or not so secretly) despises those who adore him. And what do his customers do? They perform on his body—so miraculously passive for all its "butchness"—an adoring act of revenge, revenge on that body that, by virtue of seeming to be for itself, is made for *them,* robbed in triumph of its "masculine will." The very act of adoration constitutes this revenge.[33]

Morrissey portrays Hollywood as a world of has-beens now reduced to appearing on game shows as former celebrity players—celebrity is a role they now play—or washed-up child stars.

The trajectory of Morrissey's early films moves from an imitation of Warholian filmic strategies toward conventional storytelling in terms of plot, characterization, dialogue, and the staging of shots. As we have seen, each film steps further away from Warhol's emphasis on the performers themselves and his disinterest in authorial control, so that by *Heat*, which broadly parodies Billy Wilder's *Sunset Boulevard* (1950), the performers have become subservient to story. In reviewing the film upon its release, Peter Schjeldahl notes how Morrissey betrays what's central to Warhol's own films:

> In truth, there is absolutely no way in which a Warhol-style movie can make it as either sustained parody or genuine social comedy. This is because a Warhol film is never really about its plot or characters; these are pretexts. Above all, it is about the narcissistic self-extensions of its "superstar" actors, who play out their own funny or harrowing freakiness before a voyeuristic camera. By subjecting his actors' self-display to a relatively tight script in "Heat," Morrissey has by no means turned that display to effect. He has merely robbed it of tension and surprise.[34]

Sylvia Miles might bear some resemblance to the character she's playing, but there's no question that she's performing a highly theatrical role.[35] Eric Emerson serves as another case in point. He is mute in *Heat* for a simple reason—he was extremely unpredictable, as we saw in *The*

Chelsea Girls and *Lonesome Cowboys*. One never knew what he was going to do or say. Morrissey wants to control all the elements of his work; his performers actually have become "characters" with highly prescribed roles. In the case of Emerson, his muteness becomes a straitjacket that serves as a metaphor for Morrissey's co-optation of the Warhol radical aesthetic into a more commercial brand.

Morrissey's films represent a shift from an episodic structure toward a causal narrative with a greater emphasis on plot, especially in *Heat*, *Women in Revolt*, and the little seen *L'Amour*, which was shot in Paris, had a budget of nearly $100,000, and represented an attempt to make a commercial film.[36] Right after this, Morrissey made two commercial films back to back on a combined budget of $800,000 at the famed Cinecittà Studios in Rome for producer Carlo Ponti: *Flesh for Frankenstein* aka *Andy Warhol's Frankenstein*, and *Blood for Dracula* aka *Andy Warhol's Dracula*.[37] *Flesh for Frankenstein* was shot on 35mm film, released in 3-D, relies on scripted dialogue rather than improvisation, and employs special effects, music underscoring, and so forth.[38] Joe Dallesandro, who appears in both, is virtually the only remnant from the earlier films. In fact, these two films are conventional genre movies that contain scenes of blood and gore typically found in horror films, but share nothing in common with Warhol's own films, including his early and unfinished *Batman Dracula*. It's safe to say that no one would mistake them for Warhol films (except as films to which he lent his name). Even Dallesandro complained that making the two films for Ponti "was a total fucking sell-out," and he and Morrissey parted ways afterward.[39]

Morrissey always aspired toward greater professionalism, which mirrored the "amateur versus professional" battles that took place between Shirley Clarke and Jonas Mekas in the early 1960s over this very issue.[40] Warhol's lack of concern with production values placed him squarely in the amateur camp, which derived from the tradition of Mekas and Maya Deren.[41] Warhol saw his films as "experiments" rather than polished works in a professional sense, whereas Morrissey considered Warhol's inclinations toward amateurism as serious impediments to breaking into Hollywood. The ultimate difference appears to be that while Warhol always wanted his films to be accepted as mainstream, unlike Morrissey, he was adamant that it would have to be on his rather than the industry's terms.

Conclusion

The Factory of the Future

Even though Morrissey's films operate according to entirely different aesthetic principles, Warhol both endorsed and produced them for one simple reason: they made money. As Callie Angell explains:

> Warhol was well aware of these differences in approach, and his abdication of the director's role in favor of Morrissey can be understood as a complex and deliberate shift in his stance from artist/filmmaker to artist/business-man: if good business was the best art, and if films directed by Andy Warhol weren't good business, then the best art might be good business generated by Paul Morrissey's films.[1]

Whatever the logic, it was a brilliant strategy. Warhol managed to keep the artistic integrity of his own work intact, while letting Morrissey make the mainstream films to which he always aspired. To Morrissey's credit, his films actually succeeded in achieving the type of commercial breakthrough that, for the most part, had eluded Warhol's own.

Warhol always had fantasies that his film experiments would be embraced by the industry he ridiculed, but *The Chelsea Girls* was the first to play in a commercial theater. It grossed $130,000 in New York City alone in the first nineteen weeks of its release.[2] It was predicted to gross $1 million, and might have under different circumstances.[3] Although a major distributor, Trans-Lux, was interested in handling the film nationally, and its president, Richard Brandt, thought it could play in a hundred theaters, *The Chelsea Girls* was instead handled by the Film-

Makers' Distribution Center, which proved to be inexperienced at commercial distribution.[4] Even so, the film had a theatrical run, not only in New York City and Los Angeles, but also in numerous smaller markets around the country. According to David Bourdon, following *The Chelsea Girls*, Warhol's films began to make money:

> After *Chelsea Girls*, Warhol concentrated almost entirely on movies that he produced and distributed under a corporate entity called Andy Warhol Films, Inc. He no longer had to sell his paintings in order to subsidize his movies, because *Chelsea Girls* earned enough money to produce his next two features, and every movie afterward made a profit. Andy and Paul Morrissey (who became a studious reader of *Variety*) now felt themselves to be part of the commercial movie establishment. But at the same time, they still hoped that a studio would put them in charge of a big-budget film. They frequently discussed projects with various movie moguls, but none was willing to put up a dime without seeing a script.[5]

As Bourdon indicates, the sexploitation features made money as well, at least in relation to their minimal production costs. According to figures taken from *Variety, My Hustler* grossed a remarkable $71,400 (roughly $468,500 in today's currency) in its six-week run at the Hudson in 1967, while *I, a Man* made almost $35,000 ($229,680 today), which suggests that the former film was more successful due to its appeal to a gay niche audience.[6] Although the *Variety* figures only report the box office for the first four weeks of its theatrical run, *Bike Boy* grossed $32,000 ($210,000 today), by all accounts a success.[7] Like *The Chelsea Girls, Lonesome Cowboys* (which was blown up to 35mm and distributed by Sherpix) and *Blue Movie* drew large audiences in commercial runs before running into censorship issues.

The Morrissey films popularized Warhol for the masses by making his brand more mainstream, and many people today assume that *Flesh, Trash, Women in Revolt*, and *Heat* were actually made by Warhol. Morrissey went on to produce very different kinds of films—*Forty Deuce* (1982), *Mixed Blood* (1984), and *Spike of Bensonhurst* (1988)—in his subsequent career. In trying to assess Warhol's legacy at the time of a film retrospective at the BFI in 2007, Amy Taubin interviewed filmmaker Gus Van Sant for *Sight & Sound*. She begins by noting: "Who better to consider that question than Gus Van Sant, the most Warhol-like film-maker around?" In responding to whether he had seen many Warhol films, Van Sant answered:

> I've never even seen *The Chelsea Girls*, but I have seen some of the Screen Tests because they're in a lot of museums now. I once saw an original of a

Screen Test—not a print or a video—and it was amazing. He shot Plus-X reversal, which is the same filmstock I used on my 1985 film *Mala Noche*. It's really contrasty and rich, especially if it's underexposed. The first Warhol film I saw was *Trash*.[8]

As Van Sant's response indicates, even sophisticated independent film-makers don't necessarily differentiate between Warhol films and early Morrissey features. As Angell suggests, the Morrissey films "are probably the best known 'Warhol' films simply because they have been the most widely seen."[9] Jim Jarmusch, on the other hand, has indicated that he saw *The Chelsea Girls* at an underground cinema program at a local art theater in Akron, Ohio, in the late 1960s.[10] In another interview, he demonstrates that he understands the distinction: "I love Jack Smith's films, and I like some of Warhol's 'Warhol' films like *Nude Restaurant—Lonesome Cowboys, Blow Job*. He made hundreds of them."[11]

One reason that Warhol films are not as well known as those of Paul Morrissey is that they have rarely been screened since they were first made. Even at the time, some films were screened only once, and others were never publicly shown. Warhol's decision to withdraw his films from circulation around 1970 remains a matter of debate and speculation. Amy Taubin summarizes:

> The reasons (directly and obliquely stated at various times by various people, including Warhol himself) reveal the typical, perhaps irreconcilable Warholian oppositions between aesthetic and economic value, high and mass culture. There was the art market notion that the films would gain in value from their unavailability. There was the Hollywood industry notion that the films depressed Warhol's potential value as a commercial film director. Hollywood types, it seemed, were incapable of the kind of selective vision practised by the art world, which managed to ignore the films entirely, although during the period of his greatest work (1961 to 1968) Warhol devoted as much time to film as he did to painting.[12]

Callie Angell also suggests that Warhol withdrew the work because scarcity would increase its value—at least discursively:

> As Warhol understood, the absence of his films, whether physically unwatchable or simply unavailable, has consistently worked to increase their value in the marketplace of cultural discourse, where a growing body of recollections, descriptions, and interpretations, projected on the often blank screens of Warhol's cinema, has come to replace direct experience of the films themselves.[13]

Critics and scholars are as guilty of this as anyone else. Some of the misleading descriptions of Warhol's films result from faulty memory, but

some were inaccurate to begin with. Commentators even wrote about films they hadn't actually viewed. This especially proved to be the case with *Sleep* and *Empire*—a problem that persists even to this day.[14]

To compound matters, Warhol often altered the films he screened in public from showing to showing, much like Jack Smith. Koch, for instance, describes *Horse* as beginning with what now constitutes the second reel, Larry Latreille and the horse.[15] *Variety* indicates that *The Nude Restaurant* begins with a scene of Viva in a bathtub with a young man, which sounds like a scene from the unreleased *Tub Girls* and is no longer part of the film.[16] The reviewer comments on Warhol's habit "of adding new material to his films and subtracting some other footage while they are in the midst of their runs at the Hudson" and notes that a second bathtub scene involving a young man and two women had been replaced by another scene in which Viva talked about past experiences involving a lecherous priest.[17] Although the performers are misidentified, Warhol also invented humorous pseudonyms as a spoof on the press, such as listing Ed Hood as Ed Wiener in *My Hustler*.[18]

In Warhol's final interview, he contributed to the notion that his films didn't actually have to be seen. He indicated that he wasn't excited about his upcoming film retrospective at the Whitney by suggesting: "They're better talked about than seen."[19] Amy Taubin, who quotes Warhol to this effect, concludes: "It's terribly sad to think that Warhol had lost faith in the films as films, that he was unaware that the intervention he had made, specifically through the films, in the society of the spectacle was as profound as what Godard had done in roughly the same extended 60s moment."[20]

If Warhol had truly lost faith, however, it seems likely that he would have done so earlier, because no major filmmaker has been as severely criticized in the mainstream press. *New York Times* critic Howard Thompson, for instance, opens his review of *Bike Boy*: "Andy Warhol is back with another of those super-bores, this one called 'Bike Boy.' It opened yesterday at the Hudson Theater. It belongs in the Hudson River."[21] A more positive review for *Lonesome Cowboys* in *Variety* begins: "'Lonesome Cowboy' [sic] is Andy Warhol's best movie to date, which is like saying a three-year-old has graduated from smearing feces on the wall to the occasional use of finger paints."[22] Yet Warhol remained undeterred. Despite such criticism, he never seemed to waver or to lose faith in the notion that he was re-imagining cinema as we know it.

There are also pragmatic explanations for Warhol's remark. By 1987, Warhol himself hadn't made a film in almost twenty years. He had moved

on to other endeavors that were a logical outgrowth of his film work. He had turned his attention to making video and television, media better suited than film to his desire to record events continuously. He also published a novel, started *Interview* magazine, wrote his memoirs in various forms, and continued his art career by making photographs and paintings, including his successful commissioned portraits and later collaborations with Jean-Michel Basquiat. Considering how many films Warhol made in the 1960s, distributing them would have been an enormous and time-consuming project. Despite the resources of three major museums, the task of restoring and preserving the films (already nearly a thirty-year endeavor as of this writing) still remains incomplete. In light of this, Warhol's response is perfectly understandable. In a sense, he might have thought of the films, deteriorating in storage, as time capsules—something better to be boxed up and put away (like his other artifacts), and he could move on with his artistic life rather than to become hemmed in by his previous accomplishments. Part of Warhol's brilliance was his uncanny knack for knowing exactly when it was time to change directions and move on.

Even though the films have been gradually returning to circulation, they were shot in 16mm rather than 35mm format. They are distributed today by a single entity, the Circulating Film Library at the Museum of Modern Art. The films tend to play at galleries and museums, as part of various retrospectives of Warhol's overall work, and at independent film showcases. For instance, a number of them screened as part of the "Other Voices, Other Rooms" exhibition at the Stedelijk Museum in Amsterdam, Moderna Museet in Stockholm, and at the Wexner Center for the Arts in Columbus, Ohio. There have been recent retrospectives of his films at the Dia: Beacon, the Museum of the Moving Image, and the British Film Institute. Although there have been "unauthorized" DVD versions of some of his films, there has been no attempt to make them widely available to the home video market, largely due to concerns over piracy issues. In contrast, Paul Morrissey's films have remained in circulation since they were made and are distributed on DVD.

There are still many films that have yet to be restored and preserved, such as *Haircut (No. 2)* (1963), *Batman Dracula* (1964), *Suicide, Bitch, Prison* (all 1965), *The Andy Warhol Story, The Bob Dylan Story, Bufferin Commercial* (all 1966), and *Tub Girls* (1967). Most notably, **** *(Four Stars)* (1967) was only screened once in its entirety. Until it becomes available, Warhol's epic twenty-five-hour film remains a singular historical event. In order to assess his work properly, scholars need

to have access to Warhol's entire film oeuvre. Nearly all of his best-known films have been restored and made available in 16mm format at this point, including his silent *Screen Tests,* but there have been important discoveries along the way. Although screened publicly at the time it was made, *Outer and Inner Space,* one of Warhol's most brilliant films, had been virtually forgotten for over three decades until its rediscovery when it screened at the Whitney Museum in November 1998.[23] *Face* and *The Velvet Underground in Boston* were only restored in 2010. Their historical significance cannot be emphasized enough, especially in terms of filling in gaps relating to the roles of Edie Sedgwick and The Velvet Underground in Warhol's filmmaking.

In approaching a time-based medium, Warhol emphasized the temporality of film through duration and changing the speed in projection to slow down real time in some of his silent films. He created simultaneous time through his use of multiple projection, most notably in *The Chelsea Girls.* Warhol altered sequential time in various films, such as *Eat, Couch,* and *Horse,* and elided time through his use of strobe cuts. The strobe cut, or editing synchronous sound films in-camera, was a technique that Warhol used frequently to emphasize in a blatant way what might otherwise be considered a jump cut. The Auricon camera created a clear frame when it was turned off and on to alert the filmmaker to a new shot during editing, but Warhol turned this into a technique that Crone considers as unique to Warhol as the "blotted-line."[24]

Warhol created one of the first artist videos, *Outer and Inner Space,* even though he recorded this video on film. In *Outer and Inner Space* and *Since,* Warhol explored the limitations of film in comparison to electronic media such as video and television. Most critics see a clear distinction between Warhol's Pop art—his paintings and sculptures—and his work in film, but an interest in popular culture certainly informs Warhol's films throughout the different stages of his career. His films brilliantly explore how the media shape individual identity in a postindustrial age. In a culture obsessed with celebrity, individuals have no identity unless they are recognized by the media. Gene Youngblood points out that the strobe cut, in an oblique way, comments on this by reminding the viewer "that it is, after all, only a movie shot with a camera that can be turned on and off, giving birth to, or killing, cinematic life with the flick of a switch."[25] Thus, the strobe cut functions, at least metaphorically, as a matter of cinematic life and death in some of Warhol's films.

While Warhol's classic minimal films—*Sleep, Eat,* and *Empire*—are clearly related to structural film, his later films have wider implications

for the history of cinema, especially the tradition of independent film. It is easy to see Warhol's influence on filmmakers such as Jarmusch and Van Sant in their use of longer takes and nonprofessional actors. In a unique way, Warhol's films meld together what are often considered three distinct cinematic traditions: avant-garde, documentary, and low-budget fiction. For a time in the 1960s, all three coexisted as part of an attempt to create an alternative practice to mainstream Hollywood, but the traditions eventually split into different factions. The creation of the Association of Independent Video and Filmmakers (AIVF) in 1975 attempted without success to unite the different groups of filmmakers into a cohesive advocacy organization under the rubric "independent," but the divide persists even today. Yet Warhol's films blur the boundaries between the three traditions because he saw the arbitrary nature of these divisions.

If Warhol's sound films get short shrift within the largely non-narrative avant-garde tradition, indie cinema has never recognized the centrality of Warhol's films to its own history because they are not strictly narrative. Warhol receives limited mention in surveys of independent cinema.[26] Judging Warhol in more conventional narrative terms, Jessica Winter, for instance, writes: "Morrissey helmed by far the best of the movies to carry the Warhol brand, including *Flesh* (1968), *Trash* (1970), *Women in Revolt* (1971) and *Heat* (1972)."[27] Levy, on the other hand, sees Warhol as belonging to a first avant-garde that didn't attract any followers.[28]

Yet Warhol's work has been highly influential. His explorations in improvisation and his emphasis on acting over lighting and camera technique provide direct links to John Cassavetes, and his employment of psychodrama precedes that of William Greaves and Norman Mailer during the later 1960s. Warhol's use of transvestites, his use of superstars, and his move into sexploitation films were decided influences on the work of John Waters, especially *Pink Flamingos* (1972). *Vinyl* became the prototype for punk and post-punk filmmakers such as Scott and Beth B and Richard Kern in the late 1970s and 1980s. The former's *The Black Box* (1978) picks up on the sadomasochistic aspects of *Vinyl* in portraying a young man kidnapped and tortured by a pair of sadists, including Lydia Lunch as a sneering, leather-clad dominatrix. That Warhol could be a major influence on both structural and punk film is amusing inasmuch as punk filmmakers considered structural film to be boring, as indicated, for instance, in Nick Zedd's "Cinema of Transgression Manifesto."[29]

Noted screenwriter/director Paul Schrader suggests that viewers today are suffering from narrative exhaustion. He speculates that the aver-

age thirty-year-old has already consumed thirty-five thousand hours of audiovisual narratives.[30] Given the limited number of possible story lines, today's media-makers have resorted to other strategies to make their work seem fresh and less predictable. This has given rise to the popularity of such forms as reality television, documentaries, video games, short-format pieces created specifically for cell phones, and what Schrader calls "anecdotal narrative." In discussing this last term, he explains: "The attraction of films such as *Slacker* and its mumblecore progeny is the enjoyment of watching behaviour unencumbered by the artifice of plot. It is not 'fake,' not 'contrived' (although of course it is)."[31]

Warhol's exploration of the intersection between documentary and fiction has enormous relevance today, as the popularity of reality television so clearly attests. Younger American filmmakers connected to the so-called mumblecore movement—Andrew Bujalski, Aaron Katz, Joe Swanberg, and Ronald Bronstein—usually cite Cassavetes as an inspiration for their films, but their use of non-actor friends, experiments with improvisation, and flexible approaches to scripts (if they even use one) have obvious connections to what Warhol was doing back in the 1960s. Of this group, Bronstein's work with actors in developing *Frownland* (2007) closely approximates psychodrama. Even recent films by Gus Van Sant, such as *Gerry* (2002), *Elephant* (2003), *Last Days* (2005), and *Paranoid Park* (2007), or Steven Soderbergh's *The Girlfriend Experience* (2009) or Jarmusch's *The Limits of Control* (2009) relate directly back to Warhol.

Warhol's films have also influenced performance styles. There are several different types of film acting. Hollywood acting, as embodied by someone like Meryl Streep, is the kind in which the artifice is completely evident in the performance. Every emotion is telegraphed to viewers. In other words, when watching such performances, the viewer is always aware of exactly what the performer is doing—there's never really a suspension of disbelief. Indeed, the performance in question is judged precisely on recognizing the divide between actor and role. Did anyone really believe that Jon Voight was a male hustler? Probably not in the same way as Joe Campbell in *My Hustler*, but mainstream viewers appreciated his characterization rather than its sense of realism.

Think of Sissy Spacek and Tom Wilkinson in the scene where the Fowlers rip each other to shreds in Todd Field's *In the Bedroom* (2001). This is Hollywood acting, as we watch how the two veteran actors build their performances step by step. This is not to imply that what they are doing isn't powerful or emotionally affecting—with artifice it is always a question of degree. In Gus Van Sant's *My Own Private Idaho* (1991),

Mike (River Phoenix) tells Scott (Keanu Reeves) that he loves him as they sit by a campfire. The scene is painful and embarrassing to watch as a result of Mike's vulnerability. River Phoenix doesn't look at Reeves, wraps his arms around himself, assumes a fetal position, and rocks back and forth as he exposes his true feelings for his friend. What I've just described is the artifice that Phoenix adds to a performance that is otherwise more naturalistic and believable than that of Spacek and Wilkinson.

Another type of acting (of course, we could break it down into any number of finer gradations) is naturalism. Nonprofessional performers such as Justin Rice in Bujalski's *Mutual Appreciation* (2005), Cris Lankenau and Erin Fisher in Aaron Katz's *Quiet City* (2007), and Gabe Nevins in *Paranoid Park* provide notable examples. *New York Times* critic A. O. Scott wrote glowingly about the performance of mumblecore actress Greta Gerwig in Noah Baumbach's *Greenberg* (2010):

> Ms. Gerwig, most likely without intending to be anything of the kind, may well be the definitive screen actress of her generation, a judgment I offer with all sincerity and a measure of ambivalence. She seems to be embarked on a project, however piecemeal and modestly scaled, of redefining just what it is we talk about when we talk about acting.[32]

Scott further distinguishes Gerwig's untrained performance by noting: "Part of her accomplishment is that most of the time she doesn't seem to be acting at all. The transparency of her performances has less to do with exquisitely refined technique than with the apparent absence of any method."[33]

Warhol's notion of the "superstar," of course, was someone who simply plays herself or himself, which in some way embodies the ideal of naturalism. In other words, his superstars perform their own personalities for the camera. Warhol had little respect for the predictability of professional performers. He explains:

> Every professional performer I've ever seen always does exactly the same thing at exactly the same moment in every show they do. They know when the audience is going to laugh and when it's going to get really interested. What I like are things that are different every time. That's why I like amateur performers and bad performers—you can never tell what they'll do next.[34]

Warhol chose nonprofessional performers with strong personalities, whose behavior was often unpredictable, such as Edie Sedgwick, Mario Montez, Ivy Nicholson, Ondine, Paul Swan, Marie Menken, Brigid Berlin, Eric Emerson, and Viva. In some cases, their behavior was unpredictable because drugs or alcohol had loosened their inhibitions. Nonetheless,

the power of these performances stems from Warhol creating a dynamic during filming in which dramatic conflict could develop. Warhol's cinema was one in which all human behavior was possible. His actors smoke, eat, drink, take drugs, urinate, have sex with each other—and reveal sides of themselves that are painful to witness. There are even physical assaults. His films confuse the boundary between life and cinema.

Avant-garde cinema continues to shun narrative for its tainted associations with Hollywood, while American independent cinema's emphasis on narrative and documentary considers Warhol's films much too avant-garde. Warhol experimented with cinema's possibilities by challenging its many conventions. How long should a film be? Warhol pushed the limits by making **** (*Four Stars*), a film that lasted twenty-five hours. Warhol made other defining gestures, such as shooting a person sleeping for over five hours or filming an inanimate object, the Empire State Building, for eight hours, shooting the first half of *Poor Little Rich Girl* deliberately out of focus, or commissioning a dialogue script, *Their Town*, for *The Chelsea Girls* and not playing the sound. He wanted to know just how far he could push certain ideas by exploring their limits. As a fine artist, he showed a disdain for industrial standards because he realized that Hollywood's overemphasis on craft had little to do with art.

Warhol made what are often considered technical mistakes an intricate part of the aesthetic of his work. We see flares, punch marks, processing mistakes, a hair in the gate, a blank frame that occurs when the camera was turned on and off, and conventionally awkward camera placement. Warhol created narrative incidents and situations, but he had little interest in plot because he felt it was old-fashioned.[35] His films consistently explore transformation and narrative, and his best work uses dramatic tension created by consistent use of his own brand of psychodrama.

Given the right performers and the right situation, Warhol believed that the film camera and the passage of time had the unique ability to transform events, to turn ordinary incidents, even minimal ones, into a kind of human spectacle that he never found boring. Following his death, Warhol has come to be recognized as arguably the most significant visual artist of the second half of the twentieth century, and his fame appears to grow with each passing year. Yet, largely because his films have been so unavailable, scholars are only now gradually beginning to fathom the range and depth of Andy Warhol's extraordinary achievement in film. Although confined to a brief period during the 1960s, his films clearly rival his accomplishments in painting and sculpture, even if they present much greater challenges to the viewer.

Notes

INTRODUCTION

1. Callie Angell, *Andy Warhol Screen Tests: The Films of Andy Warhol Catalogue Raisonné* (New York: Abrams, in association with Whitney Museum of American Art, 2006), 45.

2. Amy Taubin, "****," in *Who Is Andy Warhol?*, ed. Colin MacCabe with Mark Francis and Peter Wollen (London and Pittsburgh: BFI and The Andy Warhol Museum, 1997), 25.

3. Angell, *Andy Warhol Screen Tests*, 13–14. The *Screen Tests* were influenced by a police brochure on criminals entitled "The Thirteen Most Wanted." Warhol tried to exhibit these mug shots at the 1964 World's Fair, but he ran into censorship issues.

4. Tavel quoted in Patrick S. Smith, *Andy Warhol's Art and Films* (Ann Arbor: UMI Research Press, 1986), 484.

5. Mary Woronov, *Eyewitness to Warhol* (Los Angeles: Victoria Dailey Publisher, 2002), 8.

6. Angell, *Andy Warhol Screen Tests*, 13.

7. Woronov, *Eyewitness to Warhol*, 8–9.

8. Mark McElhatten, "Viva L'Amour," *Film Comment* 42, no. 1 (January/February 2006): 62.

9. David E. James, *Allegories of Cinema: American Film in the Sixties* (Princeton, NJ: Princeton University Press, 1989), 69.

10. John Wilcock, *The Autobiography and Sex Life of Andy Warhol*, ed. Christopher Trela (1971; reprint, New York: Trela Media, 2010), 65. The running time of *Henry Geldzahler* is ninety-nine minutes, but because it is projected at the slower speed of 16 rather than 24 frames per second, Geldzahler did not actually sit for "an hour and a half," but rather for sixty-six minutes.

11. Tavel quoted in David E. James, "The Warhol Screenplays: An Interview with Ronald Tavel," *Persistence of Vision* 11 (1995): 49.

12. Béla Balázs, *Theory of the Film: Character and Growth of a New Art,* trans. Edith Bone (New York: Dover Publications, 1970), 74.

13. Richard Dyer notes that Balázs, in spite of his arguably essentialist view, "is important because he gives expression to a widely held view, namely that the close-up reveals the unmediated personality of the individual, and this *belief* in the 'capturing' of the 'unique' 'person' of a performer is probably central to the star phenomenon." Richard Dyer, *Stars* (London: BFI, 1979), 17.

14. Erving Goffman, *The Presentation of Self in Everyday Life* (New York: Anchor Books, 1959), 252–53.

15. Ibid., 242.

16. Ibid.

17. Tavel quoted in Dorothy Krasowska, "Collaborating with Warhol: An Interview with Ronald Tavel," *Cabinet* 8 (Fall 2002): 43.

18. James, "The Warhol Screenplays," 49.

19. See Smith, 497. Stephen Koch writes: "Tavel reports that one of his assigned tasks as a scriptwriter was to interview potential superstars and discover personal secrets that could then be surreptitiously inserted into a script to induce the inevitable responses of shock or anger or shame or confusion for the camera's placidly witnessing eye." Stephen Koch, *Stargazer: The Life, World and Films of Andy Warhol,* rev. and updated (New York and London: Marion Boyars, 1991), 68.

20. Jackie Hatfield, "Expanded Cinema and Its Relationship to the Avant-Garde," *Millennium Film Journal* 39/40 (Winter 2003): 59.

21. In *Visionary Film,* P. Adams Sitney also uses the terms "trance film" and "psychodrama" to describe a type of film that represents intense interior states of mind enacted in symbolic form, such as Maya Deren and Alexander Hammid's *Meshes of the Afternoon* (1943), Kenneth Anger's *Fireworks* (1947), and Stan Brakhage's *Reflections on Black* (1955). Sitney uses the terms to delineate a particular period in the early history of avant-garde cinema. See P. Adams Sitney, *Visionary Film: The American Avant-Garde* (New York: Oxford University Press, 1974).

22. Eric Bentley, *Thinking about the Playwright: Comments from Four Decades* (Evanston, IL: Northwestern University Press, 1987), 322–23.

23. Ibid., 323.

24. Ray Carney, *Shadows* (London: BFI, 2001), 48.

25. Ray Carney, "No Exit: John Cassavetes' *Shadows*," in *Beat Culture and the New America: 1950–1965,* ed. Lisa Phillips (New York: Whitney Museum of American Art in association with Flammarion, Paris, 1995), 238. For an even more detailed discussion of the scene, see J.J. Murphy, "No Room for the Fun Stuff: The Question of the Screenplay in American Indie Cinema," *Journal of Screenwriting* 1, no. 1 (2010): 180.

26. Sitney, *Visionary Film,* 409.

27. Ibid., 412.

28. A.L. Rees, *A History of Experimental Film and Video* (London: BFI, 1999), 69.

29. Ibid.

30. Callie Angell writes: "As early as 1970, Warhol had withdrawn his films of 1963–68 from distribution, so for nearly two decades they had only rarely been seen." See Angell, *Andy Warhol Screen Tests*, 7.

31. James, *Allegories of Cinema*, 62.

32. Other scholars also divide Warhol's film career into stages. Callie Angell, for instance, distinguishes between the minimal films and early narratives, such as *Tarzan and Jane Regained, Sort Of . . .* and *Soap Opera*. The films made with Edie Sedgwick form an entire separate category, without reference to Tavel or Chuck Wein. The sound portraits are lumped together with the silent *Screen Tests*, and on-location narratives, such as *Lonesome Cowboys* and *San Diego Surf*, are considered separate from the sexploitation films. See Callie Angell, "Andy Warhol, Filmmaker," in *The Andy Warhol Museum*, by Callie Angell et al., (Pittsburgh: The Andy Warhol Museum in conjunction with Distributed Art Publishers, New York, and Cantz, Stuttgart, 1994), 122.

CHAPTER 1

1. Jonas Mekas, "Sixth Independent Film Award," *Film Culture* 33 (Summer 1964): 1.

2. Warhol quoted in Gretchen Berg, "Nothing to Lose: An Interview with Andy Warhol," in *Cahiers du Cinema in English,* no. 10 (1967). Reprinted in *Andy Warhol: Film Factory,* ed. Michael O'Pray (London: BFI, 1989), 56.

3. Patrick De Haas, *Andy Warhol: The Cinema as "Mental Braille,"* trans. Sally Shafto, *Les Cahiers de Paris Expérimental* 21 (2005): 50.

4. Paul Arthur recognized the narrative aspects of the early films, such as *Eat, Haircut,* and *Blow Job.* See Arthur, "Flesh of Absence: Resighting the Warhol Catechism," in O' Pray, 152.

5. Marshall Deutelbaum, "Structural Patterning in the Lumière Film," in *Film before Griffith,* ed. John L. Fell (Berkeley and Los Angeles: University of California Press, 1983), 299–310. I am indebted to David Bordwell for recommending this article.

6. Gerard Malanga, *Archiving Warhol* (London: Creation Books, 2002), 40. Malanga describes the audience's reaction at the Bridge Cinema as "people were walking out or booing or throwing paper cups at the screen."

7. Jonas Mekas, "Movie Journal," *Village Voice* (11 March 1965): 12. For a description of the Los Angeles screening of *Sleep,* see Mekas, "Movie Journal," *Village Voice* (2 July 1964): 13.

8. Warhol quoted in Andy Warhol and Pat Hackett, *POPism: The Warhol '60s* (New York: Harper & Row, 1980), 50.

9. Tavel quoted in David E. James, "The Warhol Screenplays: An Interview with Ronald Tavel," *Persistence of Vision* 11 (1995): 51.

10. Ibid.

11. Rainer Crone, "Form and Ideology: Warhol's Techniques from Blotted Line to Film," in *The Work of Andy Warhol,* ed. Gary Garrels (Seattle: Bay Press, 1989), 89.

12. For a highly detailed and precise segmentation of *Sleep,* see Branden W.

Joseph, "Andy Warhol's *Sleep:* The Play of Repetition," in *Masterpieces of Modernist Cinema,* ed. Ted Perry (Bloomington and Indianapolis: Indiana University Press, 2006), 179–209.

13. Warhol suggests that *Sleep* was shot in a weekend; John Giorno indicates that it was shot over multiple weeks. See Warhol and Hackett, 33. See also John Giorno, "Andy Warhol's Movie 'Sleep'," in *You've Got to Burn to Shine: New and Selected Writings* (New York and London: High Risk Books, 1994), 137.

14. See Joseph, "Andy Warhol's *Sleep,*" 179–209. See also Callie Angell, *The Films of Andy Warhol: Part II* (New York: Whitney Museum of American Art, 1994), 11.

15. Warhol quoted in Warhol and Hackett, 49–50. Callie Angell indicates that fifty-two original 100-foot rolls were shot for *Sleep.* See Angell, *Films of Andy Warhol,* 10–11. At 24 fps, this would equal 2 hours and 24 minutes; at 16 fps, 5200 feet would amount to a running time of 3 hours and 37 minutes.

16. It should be noted that *Geography of the Body* was photographed by Marie Menken, who later became a major avant-garde filmmaker herself, as well as a performer in Warhol's films.

17. See Fred Camper, "The Lover's Gaze," *Chicago Reader* (27 April 2000), http://www.chicagoreader.com/chicago/the-lovers-gaze/Content?oid=902142 (accessed February 9, 2011).

18. Hujar, who appears in a number of Warhol's *Screen Tests,* would die of AIDS in 1987.

19. Giorno, "Andy Warhol's Movie 'Sleep'," 162.

20. See Georg Frei and Neil Printz, eds., *The Andy Warhol Catalogue Raisonné 01: Paintings and Sculpture, 1961–1963* (New York and London: Phaidon, 2002), 78–85.

21. In *Freddy Herko* (1964), one of Warhol's silent *Screen Tests,* Herko smokes a cigarette and several times gets up and repositions his entire body within the frame. The lighting is dark and moody as Herko moves in and out of shadows. At one point only a sliver of his face is all that remains visible on the right side of the frame. He then leans on his arm. It's easy to view *Freddy Herko* as a minimal dance piece confined to the cramped space of the camera frame. Besides its formal interest, there's something very brooding about Herko's *Screen Test*—the way he purses his lips, manipulates the cigarette he smokes, and seems to withdraw into himself like a doomed character in a *film noir.* Not long after this filming, Herko would dance out of the fifth floor window of a Village apartment to his death, making him one of the early casualties of the Warhol scene.

22. Lancaster quoted in Gary Comenas, "Mark Lancaster Interview," in *Warholstars: Andy Warhol Films, Art and Superstars,* http://www.warholstars .org/andywarhol/interview/mark/lancaster.html (accessed January 22, 2011).

23. Ibid.

24. Stephen Koch, *Stargazer: The Life, World and Films of Andy Warhol,* rev. and updated (New York and London: Marion Boyars, 1991), 48.

25. For an exhaustive study of *Blow Job,* see Roy Grundmann, *Andy Warhol's Blow Job* (Philadelphia: Temple University Press, 2003).

26. Koch, 48.

27. Ibid.

28. See Callie Angell, *Andy Warhol Screen Tests: The Films of Andy Warhol Catalogue Raisonné* (New York: Abrams, in association with Whitney Museum of American Art, 2006), 38–41.

29. Douglas Crimp, "Face Value," in *About Face: Andy Warhol Portraits,* ed. Nicholas Baume (Hartford and Pittsburgh: Wadsworth Atheneum and The Andy Warhol Museum, 1999), 114.

30. Wayne Koestenbaum, *Andy Warhol* (New York: Viking, 2001), 84.

31. Koch, 50.

32. Angell, *Films of Andy Warhol,* 13.

33. Ondine quoted in Koch, 12.

34. Warhol quoted in Malanga, 87.

35. Malanga, 87.

36. Ibid., 39.

37. See Eva Meyer-Hermann, ed., *Andy Warhol: A Guide to 706 Items in 2 Hours 56 Minutes* (Rotterdam: NAi Publishers, 2008), 238.

38. See "Man Dies in Leap off Empire State Building," *New York Times* (31 March 2010): A10. See also Douglas Fogle, ed., *Andy Warhol/Supernova: Stars, Deaths, and Disasters, 1962–1964* (Minneapolis: Walker Art Center, 2005), 50–53.

39. Angell, *Films of Andy Warhol,* 16.

40. Angell, *Andy Warhol Screen Tests,* 153. Palmer, the subject of the later Warhol film *John and Ivy* (1965), would later share co-writing and co-directing credit on the film that documented the tragic decline of Edie Sedgwick, *Ciao! Manhattan* (1972).

41. The Museum of Modern Art, *MoMA Highlights,* rev. ed. (New York: The Museum of Modern Art, 2004), 240.

42. Malanga, 39.

43. Ibid., 85.

44. Briony Fer, "Focus: Night Sky # 19, 1998," in *Vija Celmins* (New York: Phaidon, 2004), 102.

45. Arthur, 149.

46. Throughout *Empire,* there appear to be slight variations in light exposure. Are these fluctuations of light due to someone fiddling with the aperture, to the loss of light as the sun sets, or to some type of flashing of the print that occurs periodically throughout the film? Aperture changes remain a possibility given the overexposure at the film's beginning. Malanga, who was an eyewitness to the shooting of the film, claims: "The first two reels are over-exposed because Andy was metering for night light, but it was all guess work."
Once night falls, however, it is logical to assume that the film would have been shot with the aperture of the camera wide open; otherwise there would not have been enough light to obtain a proper exposure. As a result, continuous changes in aperture would no longer seem to be a plausible explanation. Callie Angell writes: "The most dramatic events in *Empire* are events of light. Shot on Tri-X negative stock pushed to ASA 1000, and with the lens aperture wide open, the film begins with an image of total whiteness in the midst of which, as the sun sets and the light decreases, the shape of the Empire State Building gradually flickers into view."

An examination of the film print itself suggests that the light alterations are not caused by naturally occurring light changes as the sun sets. According to Angell: "The light flares appearing throughout the film seem to have been caused during the original developing, when the Tri-X film was pushed-processed from ASA 400 to ASA 1000 under lab conditions that were unsuited for the highly light-sensitive film." No source is given for the technical data, but it can be presumed to come from three possible sources: Mekas, Palmer, or Malanga. In fact, nine years later, Malanga writes: "At John's instructions, I placed an order with Eastman Kodak, which maintained facilities on 72nd Street and York Avenue (now occupied by Sotheby's, ironically) for fourteen 1200-foot rolls of black and white Tri-X stock, which totalled 8 hours/10-minutes unedited running-time, though we had no way of knowing that we'd end up with two unexposed reels." Malanga's quote raises the question: Was he the original source for Angell, or could it be the other way around?

Unfortunately, Angell's explanation, which came prior to Malanga's in print, raises as many questions as it answers. For one thing, Kodak Tri-X Reversal 7278 does not have an ASA of 400, but rather an exposure index of 200 ASA for daylight and 160 ASA for tungsten (3200 K). In addition, there is simply no such Kodak stock as Tri-X Negative. If the film were indeed 400 ASA, this would suggest that Warhol used Kodak 4-X Negative 7224 stock, which coincidentally was first released in 1964. The square and triangle symbols on the film stock verify that it was issued in 1964, so Warhol used fresh rather than outdated film. Kodak 4-X Negative 7224 film is rated 500 ASA for daylight and 400 ASA for tungsten (3200 K). More probably, Mekas would have shot this film stock at the latter speed because of the floodlights on the Empire State Building tower. Kodak 4-X Reversal film was not developed until 1967, so we can rule that out as a possibility.

Angell indicates that the film was pushed one-and-a-half stops in the film lab. Even with new high-speed stock, 400 ASA would not have been sufficient speed to capture the remaining lights once the tower light on the Empire State Building was turned off in the final reel. So it makes perfect sense that the film would have to be either preflashed, flashed, or "pushed" during processing in the lab. What does Angell mean that the film was pushed "under lab conditions that were unsuited for the highly light-sensitive film?"

In 16mm film at the time, reversal rather than negative stock was the norm. Negative film is more difficult for labs to handle, but pushing a film involves either altering the temperature of the chemistry or the amount of time in which the film is developed. It has nothing to do with the light sensitivity of the film. But pushing a film is always a risky process. In this case, there are indications that the lab did a poor job, as evidenced by the blotches, flashing, specks, and white circles that intermittently occur throughout the film. See Malanga, 39, 90; Angell, *Films of Andy Warhol*, 16–17. Malanga seems to suggest that Warhol shot twelve 1200-foot rolls of film to make *Empire*. The final version, however, consists of ten rolls. According to Angell, "The negative for the tenth reel is missing, and has been duplicated from a 1964 print." See Angell, *Films of Andy Warhol*, 17.

I am grateful to filmmaker Erik Gunneson, who spent many years working in a film lab, for his input and insight regarding these issues.

47. Angell, *Films of Andy Warhol,* 16.

48. A.L. Rees, *A History of Experimental Film and Video* (London: BFI, 1999), 69.

49. Angell, *Films of Andy Warhol,* 20.

50. Ibid.

51. Koestenbaum, 101–2. In discussing the film, Geldzahler reports: "I was horrified, because Andy didn't stand behind the camera. He didn't tell me to move. He put the magazine on, he loaded it, he started it, he went to make some phone calls, and he'd come back once in a while and wave at me." Geldzahler quoted in John Wilcock, *The Autobiography and Sex Life of Andy Warhol,* ed. Christopher Trela (1971; reprint, New York: Trela Media, 2010), 65.

52. David Bourdon, *Warhol* (New York: Abrams, 1989), 147. See also Frei and Printz, *Andy Warhol Catalogue Raisonné 01,* 355. The authors identify the same film source, but their entry contains some ambiguity.

53. Warhol and Hackett, 43.

54. Ibid., 44.

55. Bourdon, 189.

56. I am indebted to Greg Pierce of The Andy Warhol Museum for identifying Walter Dainwood and Binghamton Birdie (Richard Stringer) as the two performers. For biographical information, see Angell, *Andy Warhol Screen Tests,* 38–39, 56–57.

57. Warhol quoted in Joseph Gelmis, *The Film Director as Superstar* (New York: Doubleday, 1970), 71. For a discussion of Warhol's fascination with television, see Lynn Spigel, *TV by Design: Modern Art and the Rise of Network Television* (Chicago and London: University of Chicago Press, 2008), 251–83.

58. Although not a strobe cut, this was, I'm assuming, done in-camera rather than through editing, even though the commercials have been edited in with the footage Warhol shot.

59. Deutelbaum, 310.

CHAPTER 2

1. Tavel quoted in David E. James, "The Warhol Screenplays: Interview with Ronald Tavel," *Persistence of Vision* 11 (1995): 59.

2. Ibid.

3. Steven Watson, *Factory Made: Warhol and the Sixties* (New York: Pantheon, 2003), xii.

4. The symposium connected to the exhibition "Andy Warhol: Other Voices, Other Rooms" at the Wexner Center for the Arts, Columbus, Ohio, was entitled "Andy Warhol: Outer and Inner Dichotomies." It occurred on November 15, 2008. Featured speakers at the symposium included Wayne Koestenbaum, Callie Angell, Richard Meyer, Mary Woronov, Thomas Crow, Eva Meyer-Hermann, and Morgan Fisher.

5. See Don Thompson, *The $12 Million Stuffed Shark: The Curious Economics of Contemporary Art* (New York: Palgrave Macmillan, 2008), 12.

6. Ibid., 65.

7. Ibid., 66.

8. Andrew Sarris, "Films," *Village Voice* (9 December 1965): 21.

9. Tavel quoted in Dorothy Krasowska, "Collaborating with Warhol: An Interview with Ronald Tavel," *Cabinet* 8 (Fall 2002): 43.

10. Ronald Tavel, "The Banana Diary (The Story of Andy Warhol's *Harlot*)," *Film Culture* 40 (Spring 1966): 44. Reprinted in *Andy Warhol: Film Factory*, ed. Michael O'Pray (London: BFI, 1989), 66.

11. For biographical information on Philip Fagan, see Callie Angell, *Andy Warhol Screen Tests: The Films of Andy Warhol Catalogue Raisonné* (New York: Abrams, in association with Whitney Museum of American Art, 2006), 217–18.

12. Tavel quoted in Patrick S. Smith, *Andy Warhol's Art and Films* (Ann Arbor: UMI Research Press, 1986), 481.

13. See Ronald Tavel, "Introduction, Script: *Screen Test 1*," 1–2, http://www.ronald-tavel.com/pdf/04.pdf (accessed June 4, 2010).

14. Eric Bentley, *Thinking about the Playwright: Comments from Four Decades* (Evanston, IL: Northwestern University Press, 1987), 326.

15. Ronald Tavel, "Introduction, Script: *Screen Test 1*," 4.

16. Ibid., 3.

17. James, "The Warhol Screenplays," 48.

18. Angell, *Andy Warhol Screen Tests*, 216–41.

19. Ibid., 218.

20. Tavel quoted in Patrick S. Smith, 482.

21. James, "The Warhol Screenplays," 52.

22. Andy Warhol, *The Philosophy of Andy Warhol* (New York and London: Harcourt Brace Jovanovich, 1975), 54.

23. Warhol explains that "since Mario only dressed up as a woman for performances—out in the world, he would never be in drag—he was more like a show business transvestite than the social-sexual phenomenon the true drags were." Andy Warhol and Pat Hackett, *POPism: The Warhol '60s* (New York: Harper & Row, 1980), 223. It should be noted that Warhol created a series of photographic self-portraits in drag. See Nicholas Baume, ed., *About Face: Andy Warhol Portraits* (Hartford and Pittsburgh: Wadsworth Atheneum and The Andy Warhol Museum, 1999), 71–76.

24. Warhol and Hackett, 91.

25. Jack Smith, "The Perfect Filmic Appositeness of Maria Montez," *Film Culture* 27 (Winter 1962–1963): 32.

26. Douglas Crimp, "Mario Montez, for Shame" in *Regarding Sedgwick: Essays on Queer Culture and Critical Theory*, ed. Stephen M. Barber and David L. Clark (New York and London: Routledge, 2002), 57–70.

27. Krasowska, 45.

28. Tavel quoted in Patrick S. Smith, 485.

29. Amy Taubin, "*****," in *Who Is Andy Warhol?*, ed. Colin MacCabe with Mark Francis and Peter Wollen (London and Pittsburgh: BFI and The Andy Warhol Museum, 1997), 29–30.

30. Ibid., 30

31. James, "The Warhol Screenplays," 52.

32. Watson, 159.

33. Menken herself also made this claim about Albee's *Who's Afraid of Vir-*

ginia Woolf? Roger Jacoby quotes her as saying, "That's supposed to be me and Willard arguing about my miscarriage." See Roger Jacoby, "Willard Maas and Marie Menken: The Last Years," *Film Culture* 63–64 (1977): 122.

34. Watson, 197.

35. Ronald Tavel, "Introduction, Script: *The Life of Juanita Castro*," 3, http://www.ronald-tavel.com/pdf/07.pdf (accessed June 6, 2010).

36. John Wilcock, *The Autobiography and Sex Life of Andy Warhol,* ed. Christopher Trela (1971; reprint, New York: Trela Media, 2010), 189–90. See also Patrick S. Smith, 494.

37. Juana Castro, "My Brother Is a Tyrant and He Must Go," *Life* 57, no. 9 (28 August 1964): 22–33.

38. Ibid., 29.

39. Tavel quoted in *Edie: An American Biography,* ed. Jean Stein, with George Plimpton (New York: Knopf, 1982), 237.

40. Patrick S. Smith, 499–500. Tavel also attributes the behavior of the actors to having to perform under pressure.

41. See Stanley Milgram, "Behavioral Study of Obedience," *Journal of Abnormal and Social Psychology* 67 (1963): 371–78. For an even more detailed discussion, see Stanley Milgram, *Obedience to Authority: An Experimental View* (New York: Harper & Row, 1974).

42. Tavel quoted in Patrick S. Smith, 498.

43. Ibid., 496.

44. Tavel quoted in James, "The Warhol Screenplays," 52.

45. Patrick S. Smith, 498.

46. This initial image was most likely intended to be a camera test, but it nevertheless becomes part of the film.

47. I am indebted to my colleague Erik Gunneson for suggesting this possible connection.

48. Ibid., 488. See also James, "The Warhol Screenplays," 52.

49. Patrick S. Smith, 497.

50. Watson, 200.

51. Stephen Koch, *Stargazer: The Life, World and Films of Andy Warhol,* rev. and updated (New York and London: Marion Boyars, 1991), 69.

52. Watson, 199.

53. Patrick S. Smith, 501.

54. Ibid.

55. Stein, 232.

56. Koch, 70.

57. Gary Indiana, *Andy Warhol and the Can That Sold the World* (New York: Basic Books, 2010), 110.

58. Patrick S. Smith, 479.

59. Tavel quoted in Stein, 234.

60. Geldzahler quoted in Stein, 229.

61. Ronald Tavel, "Introduction, Script: *Space,*" 1, http://www.ronald-tavel.com/pdf/013.pdf (accessed June 10, 2010).

62. Ibid., 2.

63. Tavel quoted in Stein, 280.

64. Ibid., 282.

65. Koch, 75.

66. Ronald Tavel, "Introduction, Script: *Hedy, or the Fourteen Year Old Girl*," 10, http://www.ronald-tavel.com/pdf/015.pdf (accessed June 5, 2010).

67. Koch, 77.

68. Wayne Koestenbaum, *Andy Warhol* (New York: Viking, 2001), 70.

69. Ibid.

70. Koch, 77.

71. Ibid., 76.

72. Douglas Crimp, "Coming Together to Stay Apart," a lecture delivered at various institutions including the Dia: Beacon in New York in 2005, the Carnegie Mellon School of Art in Pittsburgh in 2005, and the University of Manchester in England in 2007. See http://www.warholstars.org/tavel_crimp.html (accessed June 28, 2010).

73. Tavel quoted in James, "The Warhol Screenplays," 54.

74. Tavel quoted in Krasowska, 45.

CHAPTER 3

1. Tavel quoted in David E. James, "The Warhol Screenplays: An Interview with Ronald Tavel," *Persistence of Vision* 11 (1995): 54.

2. Ibid.

3. Andy Warhol and Pat Hackett, *POPism: The Warhol '60s* (New York: Harper & Row, 1980), 109.

4. Stephen Koch, *Stargazer: The Life, World and Films of Andy Warhol*, rev. and updated (New York and London: Marion Boyars, 1991), 66–67.

5. Jean Stein, ed., with George Plimpton, *Edie: An American Biography* (New York: Knopf, 1982), 282.

6. Warhol and Hackett, 109.

7. Callie Angell, *Andy Warhol Screen Tests: The Films of Andy Warhol Catalogue Raisonné* (New York: Abrams, in association with Whitney Museum of American Art, 2006), 209.

8. Warhol and Hackett, 110.

9. Ironically, Wein, due to poor timing, only manages to say Warhol's first name before the film ends abruptly.

10. Callie Angell, *The Films of Andy Warhol: Part II* (New York: Whitney Museum of American Art, 1994), 22.

11. Jonas Mekas, "Movie Journal," *Village Voice* (29 April 1965): 13.

12. Callie Angell, "Andy Warhol, Filmmaker," in Callie et al., *The Andy Warhol Museum* (Pittsburgh: The Andy Warhol Museum in conjunction with Distributed Art Publishers, New York, and Cantz, Stuttgart, 1994), 144 (see footnote 39).

13. Edie was in a serious automobile accident in December 1964. See Marilyn Bender, "Edie Pops Up as Newest Superstar," *The New York Times* (26 July 1965): 26.

14. Edie was rumored to be linked romantically to Bob Dylan and later became passionately involved with his manager, Bobby Neuwirth.

15. Rainer Crone, "Form and Ideology: Warhol's Techniques from Blotted

Line to Film," in *The Work of Andy Warhol,* ed. Gary Garrels (Seattle: Bay Press, 1989), 90. I would take issue, however, with Crone's suggestion that Warhol "rejected any sort of story line."

16. Callie Angell cites *Bufferin* (1966) as "the first film in which Warhol broadly experimented with the 'strobe cut,'" and suggests that Warhol used two isolated strobe cuts in *My Hustler,* which was shot on Labor Day weekend of 1965. See Angell, *Films of Andy Warhol,* 28. If Warhol's suggestion that *Restaurant* was shot in May 1965 is correct, this film would be an even earlier example of the use of the technique. See Warhol and Hackett, 111.

17. Steven Watson, *Factory Made: Warhol and the Sixties* (New York: Pantheon, 2003), 215.

18. The Cambridge crowd included Ed Hood, Dorothy Dean, Ed Hennessy, Donald Lyons, and Arthur Loeb. See ibid., 203.

19. Dorothy Dean, in fact, did have a drinking problem. Hilton Als, "Downtown Chronicles: Friends of Dorothy," *New Yorker* (24 April 1995): 88.

20. Warhol and Hackett, 110.

21. See Als, 88.

22. Warhol might be alluding to *Restaurant.*

23. Béla Balázs, *Theory of the Film: Character and Growth of a New Art,* trans. Edith Bone (New York: Dover Publications, 1970), 60.

24. According to the review in the *New York Times,* the show opened on May 12, 1965. See Jean-Pierre Lenoir, "Paris Impressed by Warhol Show," *New York Times* (13 May 1965): 34.

25. Warhol and Hackett, 113.

26. Ibid., 114.

27. Ibid. Timothy Leary and Richard Alpert, two psychologists at Harvard, were instrumental in popularizing LSD.

28. Tony Scherman and David Dalton, *Pop: The Genius of Andy Warhol* (New York: Harper, 2009), 256.

29. "You've Lost That Lovin' Feelin'" by the Righteous Brothers went to number 1 on the *Billboard* chart the week of February 6, 1965, and stayed there the week of February 13. By February 20, it had dropped to number 2. See "Billboard Hot 100," *Billboard* 77, no. 6 (6 February 1965): 32.

30. Warhol and Hackett, 110.

31. Hansen quoted in Melissa Painter and David Weisman, *Edie: Girl on Fire* (San Francisco: Chronicle Books, 2007), 59.

32. Warhol quoted in Gretchen Berg, "Andy Warhol: My True Story," *East Village Other* 1, 23 (1 November 1966): 9.

33. Warhol and Hackett, 109.

34. Tavel quoted in James, "The Warhol Screenplays," 57.

35. Andy Warhol, *The Philosophy of Andy Warhol* (New York and London: Harcourt Brace Jovanovich, 1975), 160.

36. Victor Bockris, *Warhol: The Biography* (Cambridge, MA: Da Capo Press, 2003), 229.

37. Koch, 66.

38. For biographical details on Gino Piserchio, see Angell, *Andy Warhol Screen Tests,* 154.

39. Scherman and Dalton, 269.

40. Koch, 81–82. Besides confusing an edited cut with an in-camera strobe cut, Koch often mixes up the actors.

41. Ibid., 79.

42. Ondine quoted in Stein, 212.

43. Paul America quoted in Guy Flatley, "How to Become a Superstar—And Get Paid, Too," *New York Times* (31 December 1967): 57. In the same article, Paul America claims to have become paranoid after making *My Hustler:* "I was constantly on LSD and I saw cameras coming at me everywhere I went. Even the Con Ed men were shooting me from down in their manholes. It was that tiny bathroom that did it."

44. Warhol and Hackett, 125.

45. For biographical details about Wein, see Angell, *Andy Warhol Screen Tests,* 209.

46. Ibid.

CHAPTER 4

1. Nicholas Baume, "About Face," in *About Face: Andy Warhol Portraits,* ed. Nicholas Baume (Hartford and Pittsburgh: Wadsworth Atheneum and The Andy Warhol Museum, 1999), 86. Bob Colacello writes: "History seems to have a knack for turning the conventional wisdom of any given era on its head: Andy Warhol is now hailed for having revived a dead art form, paving the way for such currently celebrated portraitists as Chuck Close and Alex Katz." Bob Colacello, "Andy Warhol's Portraits: A Personal View," *Dia's Andy: May 2005–April 2006* (New York: Dia Art Foundation, 2005), 54.

2. Baume, 91.

3. Janis Londraville and Richard Londraville, *The Most Beautiful Man in the World: Paul Swan, from Wilde to Warhol* (Lincoln and London: University of Nebraska Press, 2006), 3.

4. Ibid., 113–16.

5. Callie Angell, *The Films of Andy Warhol: Part II* (New York: Whitney Museum of American Art, 1994), 23.

6. Contrary to Angell's contention, Swan's biographers suggest that, according to Gerard Malanga, Warhol was indeed laughing at Swan's expense. See Londraville and Londraville, 233–34.

7. Emily W. Leider, "Foreword," in Londraville and Londraville, xix.

8. Londraville and Londraville, 7.

9. Ibid., 11.

10. Paul Morrissey, "Warhol and Morrissey," trans. Asa Eriksson, *Stockholm International Film Festival 1997 Catalogue,* 225.

11. Susan Sontag, "Notes on 'Camp'," in *Against Interpretation* (New York: Delta, 1966), 275.

12. Ibid., 280.

13. Tavel quoted in Patrick S. Smith, *Andy Warhol's Art and Films* (Ann Arbor: UMI Research Press, 1986), 479.

14. See Mary Jordan's documentary film on Smith: *Jack Smith and the Destruction of Atlantis* (2006).

15. Patrick S. Smith, 479.

16. Callie Angell, *Andy Warhol Screen Tests: The Films of Andy Warhol Catalogue Raisonné* (New York: Abrams, in association with Whitney Museum of American Art, 2006), 169. See also Tony Scherman and David Dalton, *Pop: The Genius of Andy Warhol* (New York: Harper, 2009), 345.

17. Mary Woronov, *Swimming Underground: My Years in the Warhol Factory* (London: Serpent's Tail, 2000), 25.

18. Victor Bockris relates a story of Warhol running into one of his lovers on the street in the company of Bourscheidt, causing Andy to become so upset he immediately changed all the locks in his house. See Victor Bockris, *Warhol: The Biography* (Cambridge, MA: Da Capo Press, 2003), 263.

19. Angell, *Andy Warhol Screen Tests,* 34.

20. David Bourdon, *Warhol* (New York: Abrams, 1989), 404.

21. Scherman and Dalton, 153–54.

22. Wolf suggests that "Malanga's references to stolen paintings in *Bufferin* at once describe a potentially real occurrence and constitute a literary conceit, in the tradition of Genet." Reva Wolf, *Andy Warhol, Poetry, and Gossip in the 1960s* (Chicago and London: University of Chicago Press, 1997), 120–21.

23. Bockris, 262.

24. Malanga quoted in a diary entry, dated September 4, 1966, in Victor Bockris and Gerard Malanga, *Up-Tight: The Velvet Underground Story* (New York: Cooper Square Press, 2003), 53.

25. Malanga quoted in a diary entry dated October 30, 1966, in ibid., 63.

26. Angell, *Andy Warhol Screen Tests,* 34.

27. Bockris, 262.

28. Gerard Malanga, *Archiving Warhol* (London: Creation Books, 2002), 62. This would have been only five days after Barzini agreed to marry him, as indicated by a diary entry dated November 2, in ibid., 59.

29. Scherman and Dalton, 399.

30. Logan Bentley, "Once a 'Vogue' Star, Benedetta Barzini Is Now Fashion's La Pasionara," *People Weekly* 8, no. 2 (11 July 1977): 89–90, 93.

31. Andy Warhol and Pat Hackett, *POPism: The Warhol '60s* (New York: Harper & Row, 1980), 60.

32. Douglas Fogle, "Spectators at Our Own Deaths" in *Andy Warhol/Supernova: Stars, Deaths, and Disasters, 1962–1964,* ed. Douglas Fogle (Minneapolis: Walker Art Center, 2005), 17.

33. Andy Warhol, *The Philosophy of Andy Warhol* (New York and London: Harcourt Brace Jovanovich, 1975), 91.

34. Gary Indiana, *Andy Warhol and the Can That Sold the World* (New York: Basic Books, 2010), 6.

35. Warhol and Hackett, 5.

36. Greg Pierce, "On Factory Diaries, 1970–1982," in *Andy Warhol: A Guide to 706 Items in 2 Hours 56 Minutes,* ed. Eva Meyer-Hermann (NAi Publishers: Rotterdam, 2008), 126.

37. Bockris, 97.

38. Wayne Koestenbaum, *Andy Warhol* (New York: Viking, 2001), 38–39.

39. Rheem's *Screen Test* exhibits a technical problem. The film had slipped in the gate of the Bolex during filming as a result of improper threading, blurring Rheem's image, as Warhol zooms in and out and tilts up and down, altering the focus and composition. Rheem more or less sits there impassively, his prim and proper appearance creating a stark contrast to Warhol's arbitrary camera movements. The mechanical slippage of Rheem's image obviously mirrors what Warhol was doing in his silk screens. Rheem's *Screen Test* is included in *13 Most Beautiful . . . Songs for Andy Warhol's Screen Tests* (2009), a DVD compilation that consists of thirteen *Screen Tests* set to music by Dean Wareham and Britta Phillips.

40. Indiana, 50.

41. Warhol and Hackett, 275.

42. See Bockris, 108.

43. According to Callie Angell, the four-year-old child joined his mother in New York City in the summer of 1966. See Angell, *Andy Warhol Screen Tests*, 145. In terms of trying to date this sound portrait, Tally Brown mentions the fact that Christmas is coming soon, and Nico also has a poinsettia, which suggests that it might have been filmed in late 1966.

44. Richie Unterberger indicates that Ari eventually left New York City sometime in April or May 1967. He writes: "It's probably around now that Nico's son Ari comes down with jaundice. Living in New York with a single mother who's preoccupied with her musical career—and one who, it is later alleged, coats his gums with heroin powder to make him easier to manage, and allows him to run free at the Dom and drink alcohol from other patrons' filthy glasses—isn't the best environment for a four-year-old boy. (Years later, journalist Richard Goldstein describes Nico's son as the 'worst-behaved child I have ever seen in my life; he just went around kicking people!') And so the boy is sent to live with Alain Delon's mother, Edith Boulogne, near Paris, and will see his mother only sporadically over the next 15 years." See Richie Unterberger, *White Light/White Heat: The Velvet Underground Day-By-Day* (London: Jawbone Press, 2009), 143.

CHAPTER 5

1. Jackie Hatfield, "Expanded Cinema—Proto, Post-Photo," in *Experimental Film and Video*, ed. Jackie Hatfield (Eastleigh, U.K.: John Libbey Publishing, 2006), 237.

2. For a brief overview of multiple projection, see Sheldon Renan, *An Introduction to the American Underground Film* (New York: E.P. Dutton, 1967), 229–36.

3. A selection of these columns are reprinted in Jonas Mekas, *Movie Journal: The Rise of a New American Cinema, 1959–1971* (New York: Collier Books, 1972), 208–21.

4. Paul Morrissey claims that he, not Barbara Rubin, was the person who discovered The Velvet Underground. Morrissey insists: "I found them. Who else found them? Barbara Rubin was nobody, nobody; she was just a groupie for Bob Dylan and asked Gerard [Malanga] to film a friend of hers whose band was

playing at the Café Bizarre." Morrissey quoted in Tony Scherman and David Dalton, *Pop: The Genius of Andy Warhol* (New York: Harper, 2009), 301. For detailed information about the important film career of Barbara Rubin, see Daniel Belasco, "The Vanished Prodigy," *Art in America* 93, no. 11 (December 2005): 61–67.

5. Andy Warhol and Pat Hackett, *POPism: The Warhol '60s* (New York: Harper & Row, 1980), 144.

6. Ibid., 145. Callie Angell indicates that Warhol and Malanga met Nico in Paris through Denis Deegan. Callie Angell, *Andy Warhol Screen Tests: The Films of Andy Warhol Catalogue Raisonné* (New York: Abrams, in association with Whitney Museum of American Art, 2006), 61, 145. It would seem unusual for Warhol not to remember having met Nico previously.

7. Morrissey quoted in Victor Bockris and Gerard Malanga, *Up-Tight: The Velvet Underground Story* (New York: Cooper Square Press, 2003), 11.

8. Warhol and Hackett, 146.

9. For a detailed description of the Up-Tight event at the Film-Makers' Cinematheque, see Bockris and Malanga, 7.

10. Ibid.

11. For a detailed description of the Up-Tight event at Rutgers, see John Wilcock, *The Autobiography and Sex Life of Andy Warhol*, ed. Christopher Trela (1971; reprint, New York: Trela Media, 2010), 163–66.

12. Warhol indicates that as part of the EPI, he showed such films as *Harlot, Couch, Blow Job, Sleep, Empire, Kiss, Face, Camp,* and *Eat,* among others. Warhol and Hackett, 163.

13. Branden W. Joseph, "'My Mind Split Open': Andy Warhol's Exploding Plastic Inevitable," *Grey Room* 08 (Summer 2002): 81.

14. Warhol and Hackett, 162. Morrissey soon changed the name from "Erupting" to "Exploding." Joe Harvard, *The Velvet Underground and Nico* (New York and London: Continuum, 2004), 27.

15. Warhol and Hackett, 162.

16. Callie Angell, "Andy Warhol: *Outer and Inner Space*," in *From Stills to Motion and Back Again: Texts on Andy Warhol's Screen Tests and Outer and Inner Space,* by Geralyn Huxley et al. (Vancouver: Presentation House Gallery, 2003), 13.

17. Warhol and Hackett, 119.

18. Reva Wolf, "Introduction," in *I'll Be Your Mirror: The Selected Andy Warhol Interviews, 1962–1987,* ed. Kenneth Goldsmith (New York: Carroll & Graf, 2004), xxii.

19. Ibid., xxii–xxiii.

20. See Lisa Dillon Edgett, transcription, "What Edie Said in *Outer and Inner Space,*" in Huxley et al., 27–39.

21. Wolf, xi.

22. Nicholas Baume, "About Face," in *About Face: Andy Warhol Portraits,* ed. Nicholas Baume (Hartford and Pittsburgh: Wadsworth Atheneum and The Andy Warhol Museum, 1999), 93.

23. J. Hoberman, "Nobody's Land: Inside *Outer and Inner Space,*" in Huxley et al., 21.

24. Callie Angell, *The Films of Andy Warhol: Part II* (New York: Whitney Museum of American Art, 1994), 25.

25. For a tabloid description of the life and death of Lupe Velez, see Kenneth Anger, *Hollywood Babylon* (New York: Delta, 1975), 230–39.

26. Callie Angell suggests that *Lupe* may have premiered in a three-screen version. See Angell, *Films of Andy Warhol*, 25. One source for this is Archer Winsten's review. He writes about Edie: "She is on the screen in triplicate, well photographed (a rarity) in color, occasionally in quadruplicate, which is plenty, particularly in view of the fact that she sleeps, has her hair cut interminably, and doesn't really do much." Winsten is describing multiple images of Edie rather than screens. In the double-screen version, she does appear in triplicate due to seeing her reflection in the mirror. In the final image in the bathroom, there would be four images of Edie. Archer Winsten, "Reviewing Stand: Andy Warhol at Cinematheque," *New York Post* (9 February 1966): 55.

27. One wonders, however, whether there might be some additional level of subtext in having Edie play the role. The ending of *Beauty # 2*, for instance, suggests that Edie might have been pregnant at the time the film was made.

28. Bosley Crowther, "The Screen: Andy Warhol's 'More Milk, Yvette' Bows," *New York Times* (9 February 1966): 32.

29. Anger, 238.

30. The events surrounding Stompanato's death are described in ibid., 268–77.

31. Following the traumatic event involving Johnny Stompanato, Cheryl Crane did indeed become a juvenile delinquent. She was sent to reform school and spent time in a mental institution. For detailed biographical details of Crane's life, see Cheryl Crane with Cliff Jahr, *Detour: A Hollywood Story* (New York: Arbor House, 1988).

32. See Cheryl Crane with Cindy De La Hoz, *Lana: The Memories, the Myths, the Movies* (Philadelphia and London: Running Press, 2008), 9.

33. The purpose of the sweaters was to emphasize Turner's buxom figure. See ibid., 27. Warhol not only emphasizes Montez's flat chest, but also his masculine arms and legs. Warhol suggests that Mario was offended at similar shots in *Hedy*. He quotes him as saying, "I can see you were trying to bring out the worst in me." Warhol and Hackett, 91.

34. In actuality, according to Cheryl Crane, it was her mother's previous husband, Lex Barker, rather than Johnny Stompanato, who sexually abused her. Crane with De La Hoz, 149.

35. Bockris and Malanga, 21.

36. Malanga provides a slight variation of the text contained in Leigh's book. Michael Leigh, *The Velvet Underground* (New York: Macfadden, 1964), flyleaf. I am indebted to Gerard Malanga for indicating the original source.

37. Warhol and Hackett, 157.

38. Quoted in Lynne Tillman, *The Velvet Years: Warhol's Factory, 1965–67* (New York: Thunder's Mouth Press, 1995), 72.

39. Richard Witts, *The Velvet Underground* (Bloomington and Indianapolis: Indiana University Press, 2006), 36.

40. Callie Angell suggests that *The Velvet Underground and Nico* was shot sometime in January 1966, possibly in preparation for their engagement in Feb-

ruary at the Film-Makers' Cinematheque. See Angell, *Films of Andy Warhol*, 27. Ari, however, is wearing shorts, and other people, including Warhol, Moe Tucker, and the police officers are wearing short-sleeve shirts, which would be unlikely if the film was actually shot in January. Richie Unterberger, who cites Angell as a source, also indicates that this film was shot in January and that it was shown at the Film-Makers' Cinematheque in February 1966. He writes: "on the documentary DVD *The Velvet Underground under Review*, Billy Name suggests that the footage is projected onto the band during these February performances." Richie Unterberger, *White Light/White Heat: The Velvet Underground Day-by-Day* (London: Jawbone Press, 2009), 76. In addition, Bockris and Malanga describe the program: "The whole ensemble was now playing in front of two movies 'Vinyl' and 'The Velvet Underground and Nico: A Symphony of Sound' being shown silently next to each other." Bockris and Malanga, 7. "According to Paul Morrissey, however, the footage is not shot until after the second week of the Velvets' month-long residency at the Dom in April and marks 'the only time they ever played at the studio [Factory],' but other accounts—and the January 3 rehearsal tape—suggest otherwise." Unterberger, 76. To complicate matters further, Warhol indicates that the film was possibly shown as part of an Up-Tight event at Rutgers. He writes: "We screened *Vinyl* and *Lupe* and also movies of Nico and the Velvets while they were playing. It was fantastic to see Nico singing with a big movie of her face right behind her." Warhol and Hackett, 153. John Wilcock attended and wrote about the Up-Tight events at Rutgers and Ann Arbor. As the Velvets were playing at Rutgers, "the movies were playing, movies of Nico, the bland, blonde singer. Nico's face, Nico's mouth, Nico sideways, backwards, superimposed on the walls and the ceiling, on Nico herself as she stands onstage impassively singing." Wilcock, 164. Angell indicates that *Screen Tests* of Nico had already been shot by the time of the Rutgers event. Angell, *Andy Warhol Screen Tests*, 146. As has already been mentioned in discussing *Ari and Mario*, Angell suggests that Ari didn't join his mother until summer 1966. Ibid., 145. My best guess would be that *The Velvet Underground and Nico* was shot sometime in the summer of 1966.

 41. Unterberger, 76.

 42. David E. James, *Allegories of Cinema: American Film in the Sixties* (Princeton, NJ: Princeton University Press, 1989), 94.

 43. According to Paul Morrissey, "Edie had a small role in *Chelsea Girls*, but she came in later to ask us to take out the section of the film she was in. She told us that she had signed a contract with Bob Dylan's manager, Albert Grossman." Quoted in *Edie: An American Biography*, ed. Jean Stein with George Plimpton (New York: Knopf, 1982), 283.

 44. Hirsch, "*The Chelsea Girls,*" *Variety* (18 January 1967): 6.

 45. Jonas Mekas, "Movie Journal," *Village Voice* (29 September 1966): 27.

 46. Ibid.

 47. Jack Kroll, "Underground in Hell," *Newsweek* (14 November 1966): 109.

 48. Ibid.

 49. Ibid.

 50. Ibid.

51. Tavel provided the scripts for *Hanoi Hannah* and *Their Town*, which were incorporated into *The Chelsea Girls*, but refused to have anything to do with their production. Patrick S. Smith, *Andy Warhol's Art and Films* (Ann Arbor: UMI Research Press, 1986), 503.

52. Scherman and Dalton, 344–45.

53. Ibid., 345.

54. See Warhol and Hackett, 164.

55. Ibid., 165.

56. In describing Ondine's violent behavior, Warhol confuses Pepper Davis with Ronna Page, though Ondine will later create a similar outburst with Davis in *The Loves of Ondine*. Warhol writes: "During the filming of *Chelsea Girls*, when Ondine slapped Pepper in his sequence as the Pope, it was so for real that I got upset and had to leave the room—but I made sure I left the camera running. This was something new. Up until this, when people had gotten violent during any of the filmings, I'd always turned the camera off and told them to stop, because physical violence is something I just hate to see happen, unless, of course, both people like it that way. But now I decided to get it *all* down on film, even if I had to leave the room." Warhol and Hackett, 180–81.

57. Stephen Koch, *Stargazer: The Life, World and Films of Andy Warhol*, rev. and updated (New York and London: Marion Boyars, 1991), 87.

58. Hirsch, 6.

59. Wayne Koestenbaum, *Andy Warhol* (New York: Viking, 2001), 123.

60. Steven Watson, *Factory Made: Warhol and the Sixties* (New York: Pantheon, 2003), 290.

61. Koch, 97.

62. Mekas, *Movie Journal*, 257.

63. Grace Glueck, "Warhol Unveils * of '****' Film," *New York Times* (8 July 1967): 15.

64. See James Kreul, "New York, New Cinema: The Independent Film Community and the Underground Crossover, 1950–1970" (PhD diss, University of Wisconsin-Madison, 2004), 405–37.

65. David Bourdon, *Warhol* (New York: Abrams, 1989), 254–56.

66. For a more detailed account of Nico's departure, see Bockris and Malanga, 78–79.

67. Renan, 250–51.

68. Unterberger, 152.

69. Sterling Morrison, "Introduction," in Bockris and Malanga, 4.

70. Bockris and Malanga, 35.

CHAPTER 6

1. Andy Warhol and Pat Hackett, *POPism: The Warhol '60s* (New York: Harper & Row, 1980), 204.

2. Ibid.

3. P. Adams Sitney, *Visionary Film: The American Avant-Garde* (New York: Oxford University Press, 1974), 409.

4. Stephen Koch, *Stargazer: The Life, World and Films of Andy Warhol,* rev. and updated (New York and London: Marion Boyars, 1991), 100.

5. For a detailed account of Warhol's love of porn, see Warhol and Hackett, 294–95.

6. Ibid., 228.

7. David Bourdon, *Warhol* (New York: Abrams, 1989), 257.

8. Tom Baker, "Underground in an Aboveground Society," in *Andy Warhol,* ed. Adriano Aprà (Rome: Minerva Pictures Group, 2005), 57–58.

9. Ibid., 57.

10. Valerie Solanas, *SCUM Manifesto* (London and New York: Verso, 2004), 37.

11. Ibid., 61.

12. Baker, 58.

13. Howard Thompson, "The Screen: Andy Warhol's 'I, a Man' at the Hudson," *New York Times* (25 August 1967): 28.

14. A photograph of this note appears in Glenn O'Brien, "Warhol Memorabilia Philia: Our Pop Archaeologists Dig into the Vaults of the Andy Warhol Museum," *Interview* (June/July 2008): 76. For Solanas's reaction to the film, see Steven Watson, *Factory Made: Warhol and the Sixties* (New York: Pantheon, 2003), 352.

15. Warhol and Hackett, 236.

16. Ibid., 294.

17. Paul Morrissey, "Warhol and Morrissey," trans. Asa Eriksson, in *Stockholm International Film Festival 1997 Catalogue,* 219.

18. Ibid.

19. Juan A. Suárez, *Bike Boys, Drag Queens, and Superstars: Avant-Garde, Mass Culture, and Gay Identities in the 1960s Underground Cinema* (Bloomington and Indianapolis: Indiana University Press, 1996), 156.

20. Ibid.

21. Wayne Koestenbaum: "Idol Chat: The Films of Andy Warhol—Wayne Koestenbaum Talks with Bruce Hainley," *Artforum* 40, no. 10 (Summer 2002): 151.

22. See Michael Ferguson, *Little Joe Superstar: The Films of Joe Dallesandro* (Laguna Hills, CA: Companion Press, 1998), 36. See also Watson, 237–38.

23. The movie poster for *The Loves of Ondine* has been reproduced in Callie Angell, *The Films of Andy Warhol: Part II* (New York: Whitney Museum of American Art, 1994), 32.

24. Ferguson, 49. See also Tony Scherman and David Dalton, *Pop: The Genius of Andy Warhol* (New York: Harper, 2009), 433.

25. Warhol and Hackett, 108.

26. See Callie Angell, *Andy Warhol Screen Tests: The Films of Andy Warhol Catalogue Raisonné* (New York: Abrams, in association with Whitney Museum of American Art, 2006), 202.

27. Leticia Kent, "Andy Warhol, Movieman: It's Hard to Be Your Own Script," *Vogue* (1 March 1970): 167.

28. Scherman and Dalton, 418.

29. Kent, 167.

30. Morrissey quoted in Derek Hill, "Andy Warhol as a Film-Maker: A Discussion between Paul Morrissey and Derek Hill," *Studio International* 181, no. 930 (February 1971): 58.

31. Watson, 346–48.

32. Bourdon, 269.

33. Watson, 368.

34. See http://boxofficemojo.com/movies/?id=brokebackmountain.htm (accessed March 14, 2011).

35. Warhol and Hackett, 229–30.

36. Reprinted in Ferguson, 61.

37. Watson, 369.

38. Bourdon, 271.

39. Peter Gidal, *Andy Warhol: Films and Paintings* (New York: Studio Vista/Dutton, 1971), 126.

40. Margia Kramer, "The Warhol File," in *Andy Warhol: Film Factory,* ed. Michael O'Pray (London: BFI, 1989), 178–80.

41. David Bourdon writes: "From the sidelines, [Taylor] Mead muttered that Morrissey spoiled the actors' moods by giving too many directions." As a result, Mead suggested that Warhol should fire him. Bourdon, 276.

42. Mark Finch, "Rio Limpo: 'Lonesome Cowboys' and Gay Cinema," in O'Pray, 112–15.

43. For a discussion of the distribution of *Lonesome Cowboys,* see James Kreul, "New York, New Cinema: The Independent Film Community and the Underground Crossover, 1950–1970" (PhD diss., University of Wisconsin-Madison, 2004), 500–501.

44. Ferguson, 63.

45. Warhol and Hackett, 269.

46. Ibid.

47. Ibid.

48. Ferguson, 64.

49. Victor Bockris, *Warhol: The Biography* (Cambridge, MA: Da Capo Press, 2003), 292.

50. Ibid., 294.

51. Ibid.

52. André Bazin, "The Virtues and Limitations of Montage," in *What Is Cinema?* vol. 1, trans. Hugh Gray (Berkeley, Los Angeles, and London: University of California Press, 1967), 41–52.

53. Patrick S. Smith, *Andy Warhol's Art and Films* (Ann Arbor: UMI Research Press, 1986), 166.

54. As previously indicated, Warhol intended for the musician Jim Morrison to have sexual intercourse in *I, a Man.* David Bourdon writes: "According to the artist [Warhol], Morrison had actually agreed to bring a young woman to the Factory and to have sex with her in front of the camera." Bourdon, 257. It should be noted that anal intercourse appears to occur in the threesome involving Kate Heliczer, Rufus Collins, and Gerard Malanga in *Couch,* but this wasn't a commercial feature film.

55. According to David Bourdon, Viva actually wanted to have sex with Tom Hompertz on camera, but he was too inhibited. Bourdon, 276.

56. Warhol and Hackett, 294.

57. Callie Angell, *Films of Andy Warhol*, 36.

58. Ibid., 37.

59. Amy Taubin, "Afterglow: Amy Taubin Revisits Blue Movie, Andy Warhol's Ultimate Film—In More Ways than One," *Film Comment* 42, no. 1 (January/February 2006): 59.

60. Andy Warhol, *Blue Movie* (New York: Grove Press, 1970).

61. Bockris, 315.

62. Warhol and Hackett, 295.

63. Patrick S. Smith, 167.

CHAPTER 7

1. For a detailed discussion of Warhol's "Dollar Bills" series, see Georg Frei and Neil Printz, eds., *The Andy Warhol Catalogue Raisonné 01: Paintings and Sculpture, 1961–1963* (New York and London: Phaidon, 2002), 131–50.

2. Tavel quoted in David E. James, "The Warhol Screenplays: An Interview with Ronald Tavel," in *Persistence of Vision* 11 (1995): 55.

3. Paul Morrissey, "Warhol and Morrissey," trans. Asa Eriksson, *Stockholm International Film Festival 1997 Catalogue*, 212.

4. Ibid.

5. Ibid., 213.

6. Ibid., 216.

7. Ibid., 214.

8. Billy Name emphatically denies Morrissey's claims that he actually directed Warhol's films. Name suggests that Morrissey's role was "logistical, not directorial," in a manner similar to that performed earlier by Name and Gerard Malanga. Name is quoted as saying: "Anything Paul claims about taking a directorial hand in anything pre-fall 1968 is horseshit. Because Andy would not have it. They had discussions about it. Andy had to tell Paul that when he said he didn't want them [the performers] to act, or wanted it to be 'wrong,' he meant it. These were the only times I remember Andy feeling that he had to tell somebody what his art was, and to quit trying to stop him from making it. It was the only time I ever heard Andy stand up for his aesthetic to anybody: when he finally had to tell Paul, 'NO!'" Tony Scherman and David Dalton, *Pop: The Genius of Andy Warhol* (New York: Harper, 2009), 352.

9. Victor Bockris, *Warhol: The Biography* (Cambridge, MA: Da Capo Press, 2003), 314.

10. Ronald Tavel, who functioned much more as a writer and director of Warhol works than Morrissey, was also upset about not receiving enough credit for his collaboration with Warhol. In a 2002 interview he said, "Of course it bothers me. Look at the credits on this pirated edition of *Kitchen*. Nowhere on the dust jacket am I mentioned, even though I wrote, directed, and appeared in it. That was intentional on Andy's part—to write me out of history." Tavel

quoted in Dorothy Krasowska, "Collaborating with Warhol: An Interview with Ronald Tavel," *Cabinet* 8 (Fall 2002): 45.

11. Reva Wolf, *Andy Warhol, Poetry, and Gossip in the 1960s* (Chicago and London: University of Chicago, 1997), 137–38.

12. Haines quoted in *"Bike-Boy:* Two Superstars/Bruce Haines and George McKittrich; Interviewed by Claire Clouzot and Lee Meyerzove" (Los Angeles: Pacifica Radio Archive, 1968).

13. Warhol quoted in Track 16 of the CD by Steven Rowland that accompanies *The Andy Warhol Museum,* by Callie Angell et al. (Pittsburgh: The Andy Warhol Museum in conjunction with Distributed Art Publishers, New York, and Cantz, Stuttgart, 1994).

14. Steven Watson, *Factory Made: Warhol and the Sixties* (New York: Pantheon, 2003), 351, 373–74.

15. Nelson Lyon, "Paul Morrissey: The Director of Warhol's Best Known and Most Commercial Films Goes on Record about Their Work and His Old Partner's Talents and Weaknesses," *Interview* (June/July 2008): 107.

16. See http://www.paulmorrissey.org/film.html (accessed November 4, 2010). Maurice Yacowar attributes the following films to Morrissey: *My Hustler; The Chelsea Girls; **** (Four Stars); Imitation of Christ; The Loves of Ondine; I, a Man; Bike Boy;* and *Lonesome Cowboys.* Maurice Yacowar, *The Films of Paul Morrissey* (Cambridge, New York, and Melbourne: Cambridge University Press, 1993), 135–36.

17. Tony Rayns, "Death at Work: Evolution and Entropy in Factory Films," in *Andy Warhol: Film Factory,* ed. Michael O'Pray (London: BFI, 1989), 162.

18. Jonas Mekas, "Movie Journal," *The Village Voice* (9 January 1969): 51.

19. Callie Angell, *The Films of Andy Warhol: Part II* (New York: Whitney Museum of American Art, 1994), 35.

20. Mekas, 51.

21. Warhol quoted in Andy Warhol and Pat Hackett, *POPism: The Warhol '60s* (New York: Harper & Row, 1980), 281.

22. Mekas, 51.

23. Yacowar, 23–24.

24. Ibid., 27.

25. Jon Davies, *Trash* (Vancouver: Arsenal Pulp Press, 2009), 122.

26. Yacowar, 39.

27. Rayns, 168–69.

28. Yacowar, 30.

29. Peter Schjeldahl, "'Trash': One of the Cleanest Dirty Movies?" *New York Times* (25 October 1970): D15.

30. Jim Hoberman, "Women in Revolt: Late, Last, or Post Warhol?" in *Andy Warhol: The Late Work—Texts,* ed. Mark Francis (Munich, Berlin, London, and New York: Prestel, 2004), 39.

31. Valerie Solanas, *SCUM Manifesto* (London and New York: Verso, 2004), 50–51.

32. This portrayal of Eric Emerson in *Heat* appears to be Morrissey's pay-

back for the various legal actions Emerson filed against Andy Warhol. For a discussion of the lawsuits, see Scherman and Dalton, 370–71.

33. Stephen Koch, *Stargazer: The Life, World and Films of Andy Warhol,* rev. and updated (New York and London: Marion Boyars, 1991), 125.

34. Peter Schjeldahl, "What's So Hot about 'Heat'?" *New York Times* (26 November 1972): D12. I do not take the reviewer's use of the phrase "tight script" to mean a full-blown conventional screenplay, but instead see it as a comparative term. Whatever the case, there is certainly a scripted aspect to *Heat,* as I have tried to indicate.

35. Schjeldahl writes of Sylvia Miles's performance: "Sylvia Miles, as the Gloria Swanson character, is simply thrown to the wolves, and, as much as she seems to love it, a spectator must be allowed to demur. Her experienced screen presence and actressy locutions only call attention to the pointlessness of a role lousy with lines like, 'I'm not just your mother, I'm a woman; I have my own needs and desires.' Of course such speeches are *meant* to be ridiculous, but their archness, when delivered with the full chutzpah of a barrelhouse acting style, is drowned in a feeling of exploited and misspent energy." Ibid.

36. Yacowar, 65.

37. Bob Colacello, *Holy Terror: Andy Warhol Close Up* (New York: Cooper Square Press, 1990), 145.

38. According to Bob Colacello, *Frankenstein* became a huge box office success, garnering $4 million domestically and $20 million internationally. Ponti disputed the figures, which led to a lawsuit. See ibid., 147.

39. Michael Ferguson, *Little Joe Superstar: The Films of Joe Dallesandro* (Laguna Hills, CA: Companion Press, 1998), 138.

40. For a discussion of the "integrated professional" and the "maverick" in relation to Jonas Mekas and Shirley Clarke, see James Kreul, "New York, New Cinema: The Independent Film Community and the Underground Crossover, 1950–1970" (PhD diss., University of Wisconsin-Madison, 2004), 161–66.

41. See Maya Deren, "Amateur versus Professional," *Film Culture* 39 (Winter 1965): 45–46.

CONCLUSION

1. Callie Angell, "Andy Warhol, Filmmaker," in *The Andy Warhol Museum,* by Callie Angell et al. (Pittsburgh: The Andy Warhol Museum in conjunction with Distributed Art Publishers, New York, and Cantz, Stuttgart, 1994), 139.

2. Tony Scherman and David Dalton, *Pop: The Genius of Andy Warhol* (New York: Harper, 2009), 365. See also Vincent Canby, "Cannes Will See Warhol Picture," *New York Times* (25 April 1967): 37.

3. Scherman and Dalton, 364.

4. See Vincent Canby, "Coast Will See Warhol's Film," *New York Times* (19 January 1967): 35.

5. David Bourdon, *Warhol* (New York: Abrams, 1989), 254.

6. In week 1, *My Hustler* grossed $23,400 at the Hudson (see *Variety* [19 July 1967]: 9); in week 2, $17,500 (see *Variety* [26 July 1967]: 10); in week 3, $11,200, and in week 4, $8,000 (see *Variety* [9 August 1967]: 13); in week 5,

$6,300, and in week 6, $5,000 (see *Variety* [23 August 1967]: 24). At an admission price of $2.50, these figures suggest that the film drew a fairly large audience. In week 1, *I, a Man* grossed $9,000 at the Hudson (see *Variety* [30 August 1967]: 14); in week 2, $6,200 (see *Variety* [6 September 1967]: 10); in week 3, $5,700 (see *Variety* [13 September 1967]: 14; in week 4, $4,800 (see *Variety* [20 September 1967]: 9; in week 5, $5,000 (see *Variety* [27 September 1967]: 10); in week 6, $4,200 (see *Variety* [4 October 1967]: 10).

7. *Bike Boy* showed a revised first-week gross of $12,000 at the Hudson (see *Variety* [18 October 1967]: 15); in week 2, $8,500 (revised), and in week 3, $6,500 (see *Variety* [25 October 1967]: 11); in week 4, $5000 (see *Variety* [1 November 1967]: 10).

8. Amy Taubin, "Roll Forever," *Sight and Sound* 17, no. 8 (August 2007): 16. Callie Angell indicates that *Screen Tests* were shot with Tri-X reversal rather than Plus-X reversal. Callie Angell, *Andy Warhol Screen Tests: The Films of Andy Warhol Catalogue Raisonné* (New York: Abrams, in association with Whitney Museum of American Art, 2006), 22.

9. Angell, "Andy Warhol, Filmmaker," 139.

10. Jonathan Rosenbaum, "Regis Filmmaker's Dialogue: Jim Jarmusch," in *Jim Jarmusch Interviews*, ed. Ludvig Hertzberg (Jackson: University Press of Mississippi, 2001), 111–12.

11. Jarmusch quoted in Cassandra Stark, "The Jim Jarmusch Interview," *Underground Film Bulletin* 4 (September 1985). Reprinted in Hertzberg, 56.

12. Amy Taubin, "****," in *Who Is Andy Warhol?* ed. Colin MacCabe with Mark Francis and Peter Wollen (London and Pittsburgh: BFI and The Andy Warhol Museum, 1997), 25–26.

13. Angell, "Andy Warhol, Filmmaker," 121–22.

14. In a catalogue published on the occasion of the exhibition "Andy Warhol by Andy Warhol" (September 13–December 14, 2008) at the Astrup Fearnley Museum of Modern Art in Oslo, Norway, Aram Saroyan writes: "In *Sleep,* John Giorno, Warhol's boyfriend at the time, sleeps for 6 hours while the camera records it from a single angle. In *Empire State [sic],* another silent epic again from a single camera angle, we see the tallest building in Manhattan go through the night and into the dawn." Saroyan, "Andy Warhol: I'll Be Your Mirror," in *Andy Warhol by Andy Warhol,* ed. Gunnar B. Kvaran, Hanne Beate Ueland, and Grete Årbu (Milan: Skira, 2008), 66.

15. Stephen Koch, *Stargazer: The Life, World and Films of Andy Warhol,* rev. and updated (New York and London: Marion Boyars, 1991), 65.

16. In my research for the book, I have seen *Tub Girls* only once.

17. Byro, "*The Nude Restaurant,*" *Variety* (22 November 1967): 18.

18. See Howard Thompson, "Screen: More Warhol," *New York Times* (6 October 1967): 31.

19. Warhol quoted in Paul Taylor, "The Last Interview," *Flash Art* (April 1987): 43. Reprinted in Kenneth Goldsmith, ed., *I'll Be Your Mirror: The Selected Andy Warhol Interviews 1962–1987* (New York: Carroll & Graf, 2004), 389.

20. Taubin, 26.

21. Thompson, 31.

22. Rick, "*Lonesome Cowboys,*" *Variety* (13 November 1968): 6.

23. J. Hoberman, "In Video Art Before There Was Video Art, Warhol Has a Star Interact with a Tape of Herself Talking," *New York Times* (22 November 1998): AR34.

24. See Rainer Crone, "Form and Ideology: Warhol's Techniques from Blotted Line to Film," in *The Work of Andy Warhol,* ed. Gary Garrels (Seattle: Bay Press, 1989), 70–92.

25. Gene Youngblood, "New Warhol at Cinematheque," *Los Angeles Free Press* (16 February 1968): 12. Youngblood's quote is paraphrased in Crone, 90.

26. See Emanuel Levy, *Cinema of Outsiders: The Rise of American Independent Film* (New York and London: New York University Press, 1999); Greg Merritt, *Celluloid Mavericks: The History of American Independent Film* (New York: Thunder's Mouth Press, 2000); Geoff King, *American Independent Cinema* (Bloomington and Indianapolis: Indiana University Press, 2005); and Jessica Winter, *The Rough Guide to American Independent Film* (London and New York: Rough Guides Ltd., 2006).

27. Winter, 211.

28. Levy, 54–55.

29. Nick Zedd's "The Cinema of Transgression Manifesto" was first published under the pseudonym Orion Jeriko in *Underground Film Bulletin* 4 (September 1985). Reprinted in *Film Threat Video Guide* 5 (1992): 40.

30. Paul Schrader, "Beyond the Silver Screen," *Guardian* (19 June 2009): 5.

31. Ibid.

32. A. O. Scott, "No Method to Her Method: Greta Gerwig Is What We Talk about When We Talk about Acting," Sunday Arts and Leisure Section, *New York Times* (28 March 2010): 1.

33. Ibid.

34. Andy Warhol, *The Philosophy of Andy Warhol* (New York and London: Harcourt Brace Jovanovich, 1975), 82.

35. Leticia Kent, "Andy Warhol, Movieman: 'It's Hard to Be Your Own Script,'" *Vogue* (1 March 1970): 167.

Selected Filmography

I list here only the films that have been described in this book. This filmography is by no means a complete record of Warhol's films. I leave that for the catalogue raisonné. Virtually all of the films included here are those currently in circulation, with the exception of San Diego Surf, *which was never released, and* Blue Movie. *I don't discuss Warhol's commissioned work,* Sunset, *which is something of an anomaly, even though it is available. I generally refrain from discussing the* Screen Tests, *except when they are highly relevant, as in the case of* Ann Buchanan. *I discuss shorter films, such as* Mario Banana # 1 *and* Mario Banana # 2 *and* Shoulder, *only in passing. I don't list* **** *(Four Stars), which, as of this writing, has yet to be restored. The Paul Morrissey films, which Warhol produced, are listed separately.*

Afternoon (1965) 16mm b & w/sound 100 min.
Ari and Mario (1966) 16mm color/sound 66 min.
Beauty # 2 (1965) 16mm b & w/sound 66 min.
Bike Boy (1967–68) 16mm color/sound 109 min.
Blow Job (1964) 16mm b & w/silent 41 min. (16 fps)
Blue Movie (1968) 16mm color/sound 133 min.
Bufferin (1966) 16mm color/sound 33 min.
Camp (1965) 16mm b & w/sound 66 min.
The Chelsea Girls (1966) 16mm b & w and color/sound 204 min. (double screen)
The Closet (1966) 16mm b & w/sound 66 min.
Couch (1964) 16mm b & w/silent 58 min. (16 fps)
Eat (1964) 16mm b & w/silent 39 min. (16 fps)
Eating Too Fast (1966) 16mm b & w/sound 66 min.
Elvis at Ferus (1963) 16mm b & w/silent 4 min. (16 fps)
Empire (1964) 16mm b & w/silent 8 hr. 5min. (16 fps)
Face (1965) 16mm b & w/sound 66 min.

Haircut (No. 1) (1963) 16mm b & w/silent 27 min. (16 fps)
Harlot (1964) 16mm b & w/sound 66 min.
Hedy (1966) 16mm b & w/sound 66 min.
Henry Geldzahler (1964) 16mm b & w/silent 99 min. (16 fps)
Horse (1965) 16mm b & w/sound 100 min.
I, a Man (1967–68) 16mm color/sound 95 min.
Imitation of Christ (1967–69) 16mm color/sound 85 min.
John and Ivy (1965) 16mm b & w/sound 33 min.
Kiss (1963–64) 16mm b & w/silent 54 min. (16 fps)
Kitchen (1965) 16mm b & w/sound 66 min.
The Life of Juanita Castro (1965) 16mm b & w/sound 66 min.
Lonesome Cowboys (1967–68) 16mm color/sound 109 min.
The Loves of Ondine (1967–68) 16mm color/sound 85 min.
Lupe (1965) 16mm color/sound 72 min./36 min. (double screen)
Mario Banana # 1 (1964) 16mm color/silent 4 min. (16 fps)
Mario Banana # 2 (1964) 16mm b & w/silent 4 min. (16 fps)
More Milk Yvette (1965) 16mm b & w/sound 66 min.
Mrs. Warhol (1966) 16mm color/sound 67 min.
My Hustler (1965) 16mm b & w/sound 67 min.
The Nude Restaurant (1967) 16mm color/sound 100 min.
Outer and Inner Space (1965) 16mm b & w/sound 66 min./33 min. (double screen)
Paul Swan (1965) 16mm color/sound 66 min.
Poor Little Rich Girl (1965) 16mm b & w/sound 66 min.
Restaurant (1965) 16mm b & w/sound 33 min.
San Diego Surf (1968) 16mm color/sound 90 min.
Screen Test # 1 (1965) 16mm b & w/sound 66 min.
Screen Test # 2 (1965) 16mm b & w/sound 66 min.
Screen Test: Ann Buchanan (1964) 16mm b & w/silent 4 min. (16 fps)
Shoulder (1964) 16mm b & w/silent 4 min. (16 fps)
Since (1966) 16mm color/sound 67 min.
Sleep (1963) 16mm b & w/silent 5 hr. 21 min. (16 fps)
Soap Opera (1964) 16mm b & w/silent & sound 47 min.
Space (1965) 16mm b & w/sound 66 min.
Sunset (1967) 16mm color/sound 33 min.
Tarzan and Jane Regained, Sort Of . . . (1963) 16mm b & w and color/sound 80 min.
Taylor Mead's Ass (1964) 16mm b & w/silent 90 min. (16 fps)
The Velvet Underground (1966) 16mm b & w/sound 33 min./66 min.
The Velvet Underground and Nico (1966) 16mm b & w/sound 67 min.
The Velvet Underground in Boston (1967) 16mm color/sound 33 min.
Vinyl (1965) 16mm b & w/sound 67 min.

PAUL MORRISSEY FILMS (PRODUCED BY ANDY WARHOL)

L'Amour (1972) 16mm color/sound 90 min.
Blood for Dracula (1974) 35mm color/sound 90 min.

Flesh (1968–69) 16mm color/sound 89.5 min.
Flesh for Frankenstein (1973) 35mm color/sound 95 min.
Heat (1972) 16mm color/sound 103 min.
Trash (1970) 16mm color/sound 103 min.
Women in Revolt (1971) 16mm color/sound 97 min.

I am grateful for information provided by Greg Pierce, Assistant Curator of Film and Video at the Andy Warhol Museum in Pittsburgh, and Claire K. Henry, Curatorial Assistant of the Andy Warhol Film Project. All running times are from the preserved versions of the films currently available. The running times of the silent films are listed at 16 fps.

Selected Bibliography

Angell, Callie. *Andy Warhol Screen Tests: The Films of Andy Warhol Catalogue Raisonné*. New York: Abrams, in association with Whitney Museum of American Art, 2006.

———. *The Films of Andy Warhol: Part II*. New York: Whitney Museum of American Art, 1994.

Angell, Callie, et al. *The Andy Warhol Museum*. Pittsburgh: The Andy Warhol Museum in conjunction with Distributed Art Publishers, New York, and Cantz, Stuttgart, 1994.

Anger, Kenneth. *Hollywood Babylon*. New York: Delta, 1975.

Balázs, Béla. *Theory of Film: Character and Growth of a New Art,* trans. Edith Bone. New York: Dover Publications, 1970.

Baume, Nicholas, ed. *About Face: Andy Warhol Portraits*. Hartford and Pittsburgh: Wadsworth Atheneum and The Andy Warhol Museum, 1999.

Bentley, Eric. *Thinking about the Playwright: Comments from Four Decades*. Evanston, IL: Northwestern University Press, 1987.

Bockris, Victor. *Warhol: The Biography*. Cambridge, MA: Da Capo Press, 2003.

Bockris, Victor, and Gerard Malanga. *Up-Tight: The Velvet Underground Story*. New York: Cooper Square Press, 2003.

Bourdon, David. *Warhol*. New York: Abrams, 1989.

Buchloh, Benjamin H.D., ed. "Andy Warhol: A Special Issue." *October* 132 (Spring 2010).

Carney, Ray. *Shadows*. London: BFI, 2001.

Colacello, Bob. *Holy Terror: Andy Warhol Close Up*. New York: Cooper Square Press, 1990.

Coplans, John, ed. *Andy Warhol*. New York: New York Graphic Society, 1970.

Crimp, Douglas. "Mario Montez, for Shame." In *Regarding Sedgwick: Essays*

on *Queer Culture and Critical Theory*, ed. Stephen M. Barber and David L. Clark. New York and London: Routledge, 2002.

Danto, Arthur C. *Andy Warhol*. New Haven and London: Yale University Press, 2009.

Dia's Andy: May 2005–April 2006. New York: Dia Art Foundation, 2005.

Doyle, Jennifer. *Sex Objects: Art and the Dialectics of Desire*. Minneapolis and London: University of Minnesota Press, 2006.

Doyle, Jennifer, Jonathan Flatley, and José Esteban Muñoz, eds. *Pop Out: Queer Warhol*. Durham and London: Duke University Press, 1996.

Dyer, Richard. *Stars*. London: BFI, 1979.

Ferguson, Michael. *Little Joe Superstar: The Films of Joe Dallesandro*. Laguna Hills, CA: Companion Press, 1998.

Fogle, Douglas, ed. *Andy Warhol/Supernova: Stars, Deaths, and Disasters, 1962–1964*. Minneapolis: Walker Art Center, 2005.

Frei, Georg, and Neil Printz, eds. *The Andy Warhol Catalogue Raisonné 01: Paintings and Sculpture, 1961–1963*. New York and London: Phaidon, 2002.

———. *The Andy Warhol Catalogue Raisonné 02: Paintings and Sculptures, 1964–1969*. New York and London: Phaidon, 2004.

Garrels, Gary, ed. *The Work of Andy Warhol*. Seattle: Bay Press, 1989.

Gidal, Peter. *Andy Warhol: Films and Paintings*. New York: Studio Vista/Dutton, 1971.

———. *Andy Warhol Blow Job*. London: Afterall Books, 2008.

Giorno, John. *You've Got to Burn to Shine: New and Selected Writings*. New York and London: High Risk Books, 1994.

Goffman, Erving. *The Presentation of Self in Everyday Life*. New York: Anchor Books, 1959.

Goldsmith, Kenneth, ed. *I'll Be Your Mirror: The Selected Andy Warhol Interviews, 1962–1987*. New York: Carroll & Graf, 2004.

Grundmann, Roy. *Andy Warhol's Blow Job*. Philadelphia: Temple University Press, 2003.

Harron, Mary, and Daniel Minahan. *I Shot Andy Warhol*. New York: Grove Press, 1995.

Hatfield, Jackie. "Expanded Cinema and Its Relationship to the Avant-Garde," *Millennium Film Journal* 39/40 (Winter 2003): 50–65.

———, ed. *Experimental Film and Video*. Eastleigh, U.K.: John Libbey Publishing, 2006.

Honnef, Klaus. *Andy Warhol, 1928–1987: Commerce into Art*. Cologne: Taschen, 2000.

Huxley, Geralyn, et al. *From Stills to Motion and Back Again: Texts on Andy Warhol's Screen Tests and Outer and Inner Space*. Vancouver: Presentation House Gallery, 2003.

Indiana, Gary. *Andy Warhol and the Can That Sold the World*. New York: Basic Books, 2010.

James, David E. *Allegories of Cinema: American Film in the Sixties*. Princeton, NJ: Princeton University Press, 1989.

———. "The Warhol Screenplays: An Interview with Ronald Tavel." *Persistence of Vision* 11 (1995): 45–64 .

Joseph, Branden W. "'My Mind Split Open': Andy Warhol's Exploding Plastic Inevitable." *Grey Room* 08 (Summer 2002): 80–107.

———. "Andy Warhol's *Sleep:* The Play of Repetition." In *Masterpieces of Modernist Cinema,* ed. Ted Perry. Bloomington and Indianapolis: Indiana University Press, 2006.

Koch, Stephen. *Stargazer: The Life, World and Films of Andy Warhol,* rev. and updated. New York and London: Marion Boyars, 1991.

Koestenbaum, Wayne. *Andy Warhol.* New York: Viking, 2001.

Kreul, James. "New York, New Cinema: The Independent Film Community and the Underground Crossover, 1950–1970." PhD diss., University of Wisconsin-Madison, 2004.

Le Grice, Malcolm. *Abstract Film and Beyond.* Cambridge, MA, and London: MIT Press, 1977.

Levy, Emanuel. *Cinema of Outsiders: The Rise of American Independent Film.* New York and London: New York University Press, 1999.

Lippard, Lucy R., et al. *Pop Art.* London: Thames & Hudson, 1966.

Londraville, Janis, and Richard Londraville. *The Most Beautiful Man in the World: Paul Swan, from Wilde to Warhol.* Lincoln and London: University of Nebraska Press, 2006.

MacCabe, Colin, ed., with Mark Francis and Peter Wollen. *Who Is Andy Warhol?* London and Pittsburgh: BFI and The Andy Warhol Museum, 1997.

Madoff, Steven Henry, ed. *Pop Art: A Critical History.* Berkeley, Los Angeles, and London: University of California Press, 1997.

Malanga, Gerard. *Archiving Warhol.* London: Creation Books, 2002.

Mekas, Jonas. *Movie Journal: The Rise of a New American Cinema, 1959–1971.* New York: Collier Books, 1972.

Meyer, Richard. *Outlaw Representation: Censorship and Homosexuality in Twentieth-Century American Art.* Boston: Beacon Press, 2002.

Meyer-Hermann, Eva, ed. *Andy Warhol: A Guide to 706 Items in 2 Hours 56 Minutes.* Rotterdam: NAi Publishers, 2008.

Michelson, Annette, ed. *Andy Warhol.* Cambridge and London: The MIT Press, 2001.

O'Pray, Michael, ed. *Andy Warhol: Film Factory.* London: BFI, 1989.

Painter, Melissa, and David Weisman. *Edie: Girl on Fire.* San Francisco: Chronicle Books, 2007.

Peterson, James. *Dreams of Chaos, Visions of Order: Understanding the American Avant-Garde Cinema.* Detroit: Wayne State University Press, 1994.

Ratcliff, Carter. *Warhol.* New York and London: Abbeville, 1983.

Rees, A.L. *A History of Experimental Film and Video.* London: BFI, 1999.

Renan, Sheldon. *An Introduction to the American Underground Film.* New York: E.P. Dutton, 1967.

Scherman, Tony, and David Dalton. *Pop: The Genius of Andy Warhol.* New York: Harper, 2009.

Sitney, P. Adams. *Visionary Film: The American Avant-Garde.* New York: Oxford University Press, 1974.

———, ed. *Film Culture Reader.* New York and Washington, DC: Praeger, 1970.

Smith, Patrick S. *Andy Warhol's Art and Films.* Ann Arbor: UMI Research Press, 1986.

Solanas, Valerie. *SCUM Manifesto.* New York and London: Verso, 2004.

Sontag, Susan. *Against Interpretation.* New York: Delta, 1966.

Spigel, Lynn. *TV by Design: Modern Art and the Rise of Network Television.* Chicago and London: University of Chicago Press, 2008.

Stein, Jean, ed., with George Plimpton. *Edie: An American Biography.* New York: Knopf, 1982.

Suárez, Juan A. *Bike Boys, Drag Queens, and Superstars: Avant-Garde, Mass Culture, and Gay Identities in the 1960s Underground Cinema.* Bloomington and Indianapolis: Indiana University Press, 1996.

Thompson, Don. *The $12 Million Stuffed Shark: The Curious Economics of Contemporary Art.* New York: Palgrave Macmillan, 2008.

Tillman, Lynne. *The Velvet Years: Warhol's Factory, 1965–67.* New York: Thunder's Mouth Press, 1995.

Unterberger, Richie. *White Light/White Heat: The Velvet Underground Day-by-Day.* London: Jawbone Press, 2009.

Warhol, Andy. *The Philosophy of Andy Warhol.* New York and London: Harcourt Brace Jovanovich, 1975.

Warhol, Andy, and Pat Hackett. *POPism: The Warhol '60s.* New York: Harper & Row, 1980.

Watson, Steven. *Factory Made: Warhol and the Sixties.* New York: Pantheon, 2003.

Wilcock, John. *The Autobiography and Sex Life of Andy Warhol,* ed. Christopher Trela. 1971. Reprint, New York: Trela Media, 2010.

Witts, Richard. *The Velvet Underground.* Bloomington and Indianapolis: Indiana University Press, 2006.

Wolf, Reva. *Andy Warhol, Poetry, and Gossip in the 1960s.* Chicago and London: University of Chicago Press, 1997.

Woronov, Mary. *Eyewitness to Warhol.* Los Angeles: Victoria Dailey Publisher, 2002.

———. *Swimming Underground: My Years in the Warhol Factory.* London: Serpent's Tail, 2000.

Yacowar, Maurice. *The Films of Paul Morrissey.* Cambridge, New York, and Melbourne: Cambridge University Press, 1993.

Index

Page references in italics indicate illustrations.

TEXT
10/13 Sabon Open Type

DISPLAY
Sabon Open Type

COMPOSITOR
BookMatters, Berkeley

INDEXER
Carol Roberts

PRINTER AND BINDER
Sheridan Books, Inc.